the photographic image
in digital culture

The advent of the image-oriented computer in the mid-1980s is having a radical effect on the central place of photography in visual culture. What does this new technology of images mean for the ways in which we encounter and use images in everyday life: in advertising, entertainment, news, evidence? Within our domestic and private worlds, how does it influence our sense of self and identity, our view of the body and our sexuality? Are we now entering a post-photographic era?

The Photographic Image in Digital Culture examines and questions the impact of digital technologies on the importance of the photographic image. Contributors investigate such issues as the representation of the body, surveillance and pornography; the role of images in the processes of memory, history and identity; popular myths of digital futures and technological utopias; the forms and conventions of new media; photography's place within image technologies and its continuing relationship to documentation, art, the imagination and political change.

The editor: Martin Lister is Head of the Field of Cultural and Media Studies at Newport School of Art and Design, Gwent College of Higher Education. He is co-author of *Youth, Culture and Photography* (1988) and is a project director and contributor to the forthcoming CD Rom *Silver to Silicon*.

The contributors: Martin Barker, Frank Boyd, Andrew Dewdney, Ruth Furlong, Beryl Graham, Michelle Henning, Sarah Kember, Martin Lister, Michael Punt, Kevin Robins, Don Slater, Ian Walker.

comedia

series editor: *david morley*

the photographic image
in digital culture

edited by martin lister

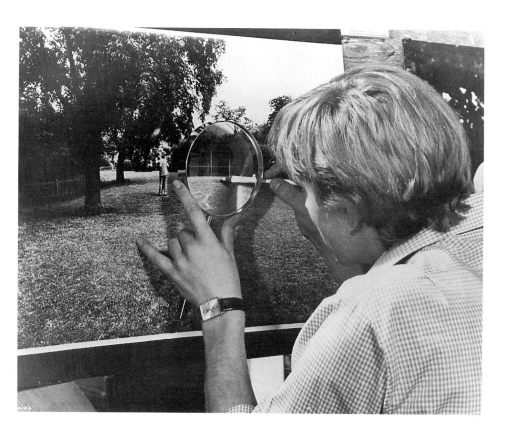

london
 and new york

First published 1995
by Routledge
11 New Fetter Lane, London EC4P 4EE

Simultaneously published in the USA and Canada
by Routledge
29 West 35th Street, New York, NY 10001

Typeset in Franklin Gothic and Monotype Spectrum by Solidus (Bristol) Limited
Printed and bound in Great Britain by Biddles Ltd, Guildford and King's Lynn

Book design: Richard Earney

British Library Cataloguing in Publication Data
A catalogue record for this book is available from the British Library

Library of Congress Cataloging in Publication Data
The photographic image in digital culture/edited by Martin Lister
 p. cm. – (Comedia)
 Includes bibliographical references and index
 1. Photography–Social aspects. 2. Images, Photographic.
 3. Photography–Philosophy. 4. Mass media and the arts.
 5. Popular culture–History–20th century. 1. Lister, Martin, 1947-
 II. Series.
 TR183.P48 1995
 770'.1–dc20 94-38082

ISBN 0-415-12156-6 (hbk)
ISBN 0-415-12157-4 (pbk)

contents

illustrations

contributors

Martin Barker is Head of the School of Cultural Studies at the University of the West of England. He is the author of, among other things, *Comics, Ideology, Power and the Critics*, published by Manchester University Press. He is currently writing two books; one on the television and violence debate and another on the tradition of the Last of the Mohicans (1995).

Frank Boyd Formerly a member of the arts organisation 'Freeform', he is now Director of the ARTEC (Art and Technology Centre) in London, which, in addition to its innovative one-year multimedia training course, established a creative and experimental multimedia workshop in 1991.

Andrew Dewdney, formerly Director of Photography at Watershed Media Centre, Bristol, is now Head of Film and Photography at Newport School of Art and Design. He is an originator, project director and contributor to the CD Rom *Silver to Silicon* (1995).

Ruth Furlong has worked in television and radio production. She is currently conducting research at the University of Wales, Cardiff, into the relationship of gossip to communication technologies. Her current post is Senior Lecturer in Cultural and Media Studies at Newport School of Art and Design.

Beryl Graham, formerly of Projects UK in Newcastle, is now a freelance curator and writer based in San Francisco and Newcastle. She is currently researching interactive art for a Ph.D at the University of Sunderland, and is developing 'Serious Games', an exhibition of interactive artwork, for the Laing Art Gallery in 1996.

Michelle Henning teaches Cultural Studies at the University of the West of England. She also produces visual work in various media, exhibiting in temporary spaces, artist-initiated and touring exhibitions. Her work was recently exhibited in the Ikon Gallery's touring exhibition, 'Telling Tales'. She is a contributor to the exhibition and CD Rom *Silver to Silicon*.

Sarah Kember is a lecturer in Media and Communications at Goldsmiths' College, University of London. She is the author of the forthcoming book, *Women and Children First. Photography, New Technology and Subjectivity*, to be published by Manchester University Press.

Martin Lister is Head of the Field of Cultural and Media Studies, Newport School of Art and Design, Gwent College of Higher Education. He has written widely on the cultural politics of photographic education and new technologies. He is an

originator, project director and scriptwriter for the CD Rom *Silver to Silicon*.

Michael Punt is an artist and film maker whose research is into the history of early cinema. His contribution to this book draws on his research as an Assistente in Oplieding at Film-en televisiewetenschap, Universiteit van Amsterdam.

Kevin Robins is Reader in Cultural Geography at the Centre for Urban and Regional Development Studies at the University of Newcastle-upon-Tyne. He is co-editor (with Les Levidow) of *Cyborg Worlds: The Military Information Society*, published by Free Association Books, and is the co-author (with David Morley) of *Spaces of Identity* (Routledge, 1995).

Don Slater is a lecturer in sociology at Goldsmiths' College, University of London, with a special interest in theories of consumer culture, advertising and marketing. He has also written widely on photography and critical theories of the image since being editor of *Camerawork* in the early 1980s.

Ian Walker is a photographer, writer and lecturer in the History and Theory of Photography at Newport School of Art and Design. He recently completed a Ph.D at the University of Sussex on the relationship between Surrealism and Documentary Photography.

acknowledgements

Thanks to Celia Jackson for tracking down some of the images used in this book, for seeking permission to reproduce these and others and preparing them for publication. Thanks also to Richard Ross for preparing the index.

introductory essay

martin lister

On any socially significant scale, digital images first became visible on computer and television screens, and on the pages of magazines and newspapers, in the late 1980s. This followed on from the emergence of a new generation of powerful personal computers, graphic interfaces and image manipulation software which, over the same period, began to hum and blink in small studios and facilities houses, colleges of art, media and design, homes and schools.

The drama of the technological developments has been startling. The pace of change in how images can be produced, circulated and consumed has been rapid and continues to increase exponentially in the 1990s. Shadowing these developments there has been a tidal wave of journalistic and critical attention. The press and popular journals have reported the 'death of photography' and issued warnings of the 'you can no longer trust your eyes' variety (Hughes 1990, Matthews 1993, Mitchell 1994). Cultural theorists have become (often disingenuously) preoccupied with the 'loss of the real'. Scholarly papers with titles which echo Benjamin's 'The Work of Art in the Age of Mechanical Reproduction' abound; transposing the 'Mechanical Age' to the Electronic, the Cybernetic, the Digital, the Post-Photographic Age, Era, or Culture. Epochal change is sensed.

Within this scenario the fate of the photographic image has become the subject of wide, and sometimes wild, speculation.

Weaving through these initial attempts to grapple with the significance of technological change in the means of image production there is a bewildering range of voices and concerns. A central focus on what the changes mean for the historic culture of the photographic image, in its still, cinematographic and televisual forms, has been rapidly subsumed within a broader spectrum of ideas and speculations. This entails ideas about a post-photographic age, a technological and media revolution, and the emergence of Hypermedia. From there the talk and the connections spread to hyperreality, virtual worlds, cyberspace, interactive global communication, and beyond to artificial intelligences, neural networks, cyborg culture, an anxiety about the edges of the body and the limits of the machine, to nano-technology, genetic engineering and a dawning post-biological age. It is as if the universal machine, the computer, is replacing more than the vast range of specialist, dedicated, single task machines and practices of an industrial and mechanical age. It can also seem that it is rendering impossible any focused thought on the cultures which it enters.

This collection of essays is intended as a contribution to gaining such a focus. Or at least, a number of focal points within a panoramic scale of change which fuses the real and the imagined in unprecedented ways. It also has a strategy. It does not attempt to pursue an ever expanding set of connections from the particular to the global. Nor does it risk the generality and abstraction of attempts to map the simultaneous complexity of postmodernity, features that have characterised so much thinking in the area. It looks, instead, at a number of concrete and social sites in which new image technologies interact with the established uses, values, and meanings of photographic images. It is based upon the premiss that little understanding of the significance of new image technologies will be gained without relating them to photographic culture. For the social sites of photographic production and consumption are precisely those in which the new image technology is being put to work. The meanings and beliefs which have been historically invested in the photographic image *in those sites*, the domestic world, the forms of public media, the surveilling of the body and social groups, the spaces of leisure and entertainment, are those with which any new image technology will have to negotiate. Even as such technologies eventually come to create or be given new meanings.

Whilst it may be perceived to be working against the grain of current techno-euphoria this book of essays is not a luddite or techno-phobic enterprise. No positions are taken for or against one set of technologies or another; the interest is in the way they can be understood and used. It is clearly recognised that new theoretical and critical tools may be needed in order to understand new objects. But it is also recognised that these are best achieved by a process of critique, reflection and testing of the adequacy of older accounts in the face of, and within,

new situations. There is no ignorance of the 'big' new ideas in these essays, each contributor is aware of the wider dimensions of change and how they are being theorised. In these essays, 'significance' is not directly read off from the new image technologies, as we read the temperature off a thermometer. The aim is to trace the ways in which they are being represented and imagined, used, experienced, and invested with meaning in the varied circumstances of everyday life. In this introductory essay I attempt to clear some of the ground for the work that is done in these essays. To offer some outlines of what is involved in thinking about cultural and technological change in these ways, with particular reference to the photographic image.

Sifting the current debate

Broadly, the impact of the digital upon the photographic, of one image technology upon another, is being discussed within two very different registers. One is particular and local, bearing upon the work that photographers have traditionally done. It considers the perceived threats to that work, its meaning, and the way that consumers of images continue to understand it (Ritchin 1990a, 1990b). The other is global and epochal, and deals in ideas about historic shifts in science, technology and visual culture.

In the first register, a set of new technological procedures are being anxiously seen to undermine a practical tradition of visual representation. One which has been central in the experience of modern cultures: photography. The body of the photographer moving about the social and physical world, a trained and knowing 'eye', the camera fondly thought of as an extension to this seeing body, and then the darkroom in which another range of craft skills was practised, has imploded into the small grey, plastic box of the personal computer. In this register, fears are expressed for the continuance of the skills, the social functions, and the political responsibilities associated with the photographer's vocation or profession. Particularly for the genres of reportage and documentary. And for the consumer of photographic images, surely a good part of the world's population to different degrees, the belief in a meaningful link between the appearance of the world, and the precise configuration of a material image, can no longer be assumed.

Several of the essays in this book deal precisely with these issues which surround the current and future place of the still chemical photograph. For other contributors, the term 'the photographic image' (as used in the title of this book) denotes something which is both more generic and less casual than 'photograph'. It is meant to encompass more than the discrete chemical photograph, the framed print, the ten-eight in the developing tray, the snaps collected from Quick Print. It is used to point to a whole range of images which have been consumed on a massive and historical scale, which, while originating in a camera, are subject to processing by other graphic and reprographic technologies, and are crucial

elements of several major forms of representation and communication: news-papers, magazines, books, supersite posters, educational and publicity material, and the constituent images of film and cinema. It is also a term which stretches to include images which share some of the mechanical, lens-based and analogue features of the chemical photographic process but which are registered by electromagnetic means: broadcast television and video.

Taken together, these are images which have played a key role in the ways sense has been made of modern experience. To paraphrase Susan Sontag, we live in a world where a chief activity has long been the production and consumption of photographic images. It is one where such images have come to determine our demands upon reality, where they are coveted as substitutes for first-hand experience, and have become indispensable to the economy, to politics, and in the pursuit of private happiness (Sontag 1977: 153).

In an image-based economy, these images have an imperious scope: they are enlisted to produce desire, encourage commodity consumption, entertain, educate, dramatise experience, document events in time, celebrate identity, inform and misinform, offer evidence. Change, then, in how such artifacts are produced, consumed and understood, is a matter of some historical moment.

In the second register, this transition from the photo-mechanical image, a material analogue with its compelling sense of a referent in a prior reality, to the immaterial digital constructions and hybrids whose sources may be mathematical and 'virtual' as much as empirical, is being seen as a key element in a radical transformation of visual culture. We are thought to be in the midst, perhaps the early moments, of this transformation. The drama of the changes occurring is being likened to the great shifts in Western visual culture; from the schemas and symbols of medieval imagery to the perspectival realism of the Renaissance and from the autographic to the photographic in the early nineteenth century. As with those historical changes, much more than a technological change in how images are made is seen to be at stake. It is within this discourse that nothing less than epochal change is proposed. Changes in the nature of how the world is imaged are taken (however problematically) to be changes in how the world is seen. And these ideological changes in turn are thought to relate to shifts in how the world is known (and in some versions, is no longer knowable) and to the identities of those who do the seeing and knowing. Beyond this, reference is made to the current upheavals in the economic, scientific, political and productive arrangements of the societies and communities in which we live and gain those identities.

In a short space of time, these two scenarios have become entangled. The particular, more vocational and defensive debate concerning the displacement of photographic practice by the use of digital technology, has been subsumed within the more generalising and speculative discourse about epochal change.

Thinking change: cultural and media studies

New image technologies have entered a culture pervaded by a heady mixture of millenarian futurology, the visionary excesses of postmodern thought, and of utopian promise and cultural pessimism. This is a culture marked by the fragmentation of social theory and policy, a suspicion of history, the radical economic, political, and cultural restructurings of everyday life within late capitalism, and the processes of cultural globalisation. Out of this matrix, something like a new discourse on the visual has emerged. It is one that stresses and celebrates rupture and discontinuity in visual culture and trades in stark oppositions between the old and the new. It is in danger of marginalising much of the imaginative richness, political engagement, and rigour, that has charac- terised much practice, theory, and critical thought which has been centred on the photographic image. (This is more fully explored by Kevin Robins in Chapter 1 of this volume.)

Somewhere within this maelstrom of ideas about actual and speculative developments in science, technology and culture, a body of critical thought about nineteenth- and twentieth-century technological forms of visual representation appears to go largely unreferenced. In recent years, much commentary on new image technology has poured forth from popular scientific, art, and media journals, together with sections of the academic press. Most, however, seems blind, and in its turn has blinded many, to traditions of critical and theoretical work which, since the late 1960s, have been at the centre of debate about visual culture. As Tim Druckery has put it,

> Electronic media can't simply ignore theoretical questions of representa- tion that the fields of photography and film have been grappling with over the last two decades. As representation is enveloped in algorithms, (the algorithms of the simulation or the algorithms of corporate marketing) theory becomes more essential than ever. If educators are to teach their students about digital imaging then some clear directions and analyses should be presented.
>
> (Druckery 1991)

This essential 'grappling with questions' can be found within a number of disciplines. They include historical, sociological and ethnographic studies of the media, cultural studies and cultural theory, and critical and social histories of art, photography and film. While by no means a homogeneous field, but one in which debates and differences abound, such studies seldom support any direct causal relation between technological and cultural change. In their detail and the cogency of their arguments, what they demonstrate instead is the historical and social shaping of media technologies and the ways in which they are themselves conceived, defined, imagined and used within the cultures of everyday life.

Might this be the reason that they are largely ignored in the new discourses

of the technoculture? Precisely because they lack the thrill and erotic charge of a vision which does see technology as an autonomous, powerful and uncontrollable force? Because they do not detach us from the weight of history or shift the responsibility for the difficulties of the present to the 'other' of a continually promised but deferred technology. A technology which can then be blamed or celebrated according to our predilection for the kinds of future it is seen to promise or threaten?

Whatever the reasons, these sustained analyses of the photographic image and its cultures have, as yet, been only marginally engaged with current change. For the most part, the dominant discussion of new image technologies has omitted or avoided being mired in issues of social and material realities. It has been carried on at some distance from the historical and political differences and inequalities which must still exist alongside the image worlds, simulations, and simulacra which preoccupy and fascinate us.

In the 1991 Gulf War, the new image technology and communication systems of 'surveillance, simulation and strike' operated 'across, and through, two different levels of reality, the virtual and the material' (Robins and Levidow 1991). This is a world in which some people (pilots and audiences) experience simulations or TV images while other people, the targets, get burnt alive. This is also a world in which some people have computers and some don't. Yet, in discussions of the new digital technoculture there is often an overworking of collective pronouns. It is always 'we' who will 'all' be 'on-line' in the near future. It is 'our' world which is shrinking, becoming one global community, hyperreality, etc. With Jonathan Crary, we should remember, 'That western patterns of technological consumption could ever be extended to a world of now six, soon to be ten billion people boggles the most elementary economic, not to mention ecological, common sense.' Bearing this in mind, we have to face up to an, 'inescapable yet continually evaded truth'. That 'participation in the emerging information, imaging, and communications technologies *will never* (in the meaningful future) expand beyond a minority of people on this planet' (Crary 1994).

Our concern then, with new technologies, cannot stop short at celebrating their abstract potential. Technologies simply do not have single and inevitable outcomes and neither do they spring upon a culture from nowhere; they are prefigured, desired and invested in (Williams 1974, 1985). Suggesting that the digital image is a 'relentless abstraction of the visual', a technology which 'relocates vision' and severs it from the observer, Crary warns that if we are to 'avoid mystifying it by recourse to technological explanations', there are many other questions to be asked and answered. Not least some historical ones. To comprehend current change we are faced with questions about the ways of seeing that we may be leaving behind, and about the *degree* of the break involved in this. We will need to consider the possibility of the coexistence of older and newer forms of vision, and above all, what this will mean for our ability to

martin lister

know, feel, and make sense of the world (Crary 1993).

We cannot, as Druckery sees, ignore these issues and allow new image technologies to rest in a 'cyberspace' beyond critical attention and questioning. This is not least because, as we shall see, the promise of new image and information technologies is being seen in ways which revive and re-work older visions for older image technologies. Particularly those technologically determinist ones which look at technology in its non-human otherness. Where, by inflating the role a technology may play in shaping the message it transmits, a technology is singled out as an easily identified and autonomous prime mover (Lury 1992: 371–4). In this mode, Sadie Plant has asserted that

> Cyberfeminism is information technology as fluid attack, an onslaught on human agency ... introducing systems of control whose complexity overwhelms the human masters of history.... No one is making it happen: it is not a political project ... it has nevertheless begun ... *a programme which is running beyond the human.*
>
> <div align="right">(Plant 1993:13. My emphasis)</div>

This is a manifesto which, in a continuing struggle against capitalist forms of patriarchy, puts technology in the place of politics, intellect and imagination. Despite its motivation, it replaces human agency, individual or collective, with essential, external forces. It is not a new mythology: we hear the echoes of Marshall McLuhan (1964) speaking of the telephone, or the television and the inherent and inevitable properties of a medium which have effects that supersede what they are used for and by whom. In such ways, the cultural and political questions which have accompanied photography, film and television are indeed 'more essential than ever'. Far from being transcended they are, arguably, being re-focused and newly posed.

The dramatic 'impact' of digital technology on the production, circulation, and consumption of photographic images, is being too easily seen as the impact of one singular and monolithic technology on another. Flowing from this, the social and cultural significance of the impact is being too readily read off from what are presumed to be the essential characteristics of each technology.

In what follows I attempt to sketch and foreground a less tidy view. This requires that the photographic image, as the target of digital technology, is viewed as a cultural and not a technological object. When this is done the assumption that its meanings and values will simply change, in fundamental and inevitable ways, is not so clear. The point is not to deny change, but to seek its dimensions in the untidiness and complexity of the lived rather than in rapidly conceived and overly abstract schemas of technological revolution.

In doing so we can follow Hal Foster when he reminds us that

> There is no simple Now: every present is nonsynchronous, a mix of different times. Thus there is never a timely transition, say, between the

modern [we might read the photographic], and the postmodern [read 'the digital'], our consciousness of a period not only comes after the fact: it also comes in parallel.

(Foster 1993)

We can use this insight to remind ourselves that technological change is in tension with elements of historical and cultural continuity. In the present context this involves stressing the way in which the cultural forms, institutions and discourses which have developed around the photographic image, and have invested it with meaning, have become the shaping context of a new technology. We may then begin to see the extent to which the new image technologies are in an active relation, of some dependence and continuity, with a 150-year-old photographic culture.

The photographic image: a view from the technoculture

Something new in your head, yeah. Silicon, coat of pyrolitic carbons. A clock right? Your glasses gimme the read they always have, low temp isotropic carbons. Better biocompatibility with pyrolitics, but that's your business, right?

Molly was strolling past the enormous circular reception desk at the rear of the lobby. 12:01:20 as the readout flared in her optic nerve.

W. Gibson, *Neuromancer*, pp. 64 and 79

Don't stay fixated on screens. Screens might become obsolete sooner than you think, … A laser microscanner will paint realities directly on your retina; it's just a question of when it will happen.… The people we have working on it think we can achieve a resolution of 8000 by 6000 scan lines.

Thomas A. Furness, former director of the US Air Force's VR research programme. Quoted by Howard Rheingold from an interview at the Human Interface Technology Laboratory, University of Washington, in H. Rheingold, 'Virtual Reality', p. 194

In quite untenable ways, the rhetoric surrounding new image technologies has constructed an idea of their 'newness' by setting up some false dichotomies and oppositions with lens based media. (The social and historical dimensions of a technology's 'newness' are discussed at length by Michelle Henning in Chapter 10 of this volume.) Almost overnight, it seems, the photographic image and other analogue visual media (film, television and video) became realist images viewed by passive dupes. Simple mirrors held up to mundane realities at which we passively gaze. 'Media which we are familiar with as passive will become active' claims the video artist Simon Biggs, writing about the future of video. He dismisses virtual reality hardware as defunct before it has hardly left the

laboratory. He leaps over research aimed at scanning information on the retina (there is no mention of whose retina or why!), and speaks of 'more advanced research' which is aimed at 'the direct stimulation of the optic nerve as a means of dispensing with inflexible and difficult to use hardware' (Biggs 1991: 71). In three sentences we lurch from the familiar video camera to a Gibsonian world of post-biological surgery and neural prostheses.

Kevin Robins has characterised what he has called the 'techno-fetishistic' approach to new image technologies (Robins 1995). This is an approach toward technology which he characterises as euphoric, exultant and full of a 'sense of omnipotence' at the opening up of 'unbounded possibilities'. He quotes, elsewhere, from an article titled 'From Today Photography is Dead':

> Photographers will be freed from our perpetual constraint, that of having, by definition, to record the reality of things, that which is really occurring…. Freed at last from being mere recorders of reality, our creativity will be given free rein.
>
> (Robins 1991: 56)

As Robins argues, claims for 'What is "superior" about the post-photographic future becomes clear, then through contrast with what is seen as an inferior, obsolete, photographic past.' What digital technologies are being claimed to offer is at least partly achieved by a highly selective attention to the history of the photographic image.

Photographic realism (resurrected)

This casting of photographic images (not always negatively as in the current cases) as slavish imprints of physical reality, as mirrors held up to the world, or as open windows through which it can be directly seen, are as old as photography itself (Snyder and Allen 1975, Snyder 1980). In the current tendency to oppose photography to digital imagery we are actually witnessing a continuation of an old debate about photography. This is the debate between those who have stressed the photographic image's privileged status as a trustworthy mechanical analogue of reality and those who have stressed its constructed, artifactual, and ideological character. The former position stresses the automatic means by which a photograph is produced, the latter the myriad decisions, conventions, codes, operations and contexts which are in play both when the photograph is made and when it is made sense of by a viewer (Barthes 1977).

This vexed and often tedious argument about something called the *photographic medium* is now being cast as a debate *between* photography and the digital image. In this new opposition, what were formerly two broad and often contradictory ways of understanding photographs themselves have been parted. One view, the realist, stays attached (in a less subtle but newly zealous form) to photography; the other,

what could be called the the constructivist position, has been transferred to the digital. The same debate continues but from different sites. And it looks as if the realist position has a new, if rather crude, currency. In its earliest forms it was often used to distinguish photography (again negatively) from a romantic view of painting as the expressed subjectivity of a gifted individual or from a waning classicism in which worthwhile images were refined by the artist's intellect. In its early twentieth-century forms it was used to claim something essential and unique about photography as it claimed its own place within high modernist culture. Now it is being used to distinguish a suddenly sad and earthbound photography from the creative realms of the new digital technologies.

Realist theories give priority to the mechanical origins of the photographic image. They argue that the mechanical arrangement of the photographic camera means that 'physical objects themselves print their image by means of the optical and chemical action of light' (Arnheim 1974). Photographs are spoken of as '"cosubstantial with the objects they represent", "perfect analogons", "stencils off the real", "traces", or as "records" of objects or of images of objects' (Snyder and Allen 1975). Hence, what is stressed is a guaranteed causal link with the physical world; photographic images are automatically produced and are passive in the face of reality. It is this quality of the photographic image that Barthes (op. cit.) calls its 'being thereness'. It is argued by realists that this is the source of the photographic image's special force as evidence. In his application of semiotic theory to the photograph, Barthes built upon this concept of 'indexicality' for different reasons; to show how it lends enormous power to the photograph's symbolic and mythological properties by masking them as natural or real and not historical and cultural. But in many versions of realist theory, the photographic image is seen as more or less short-circuiting the filter of ideas, cultural codings, and intentions which the producer is conventionally thought to bring to other kinds of representations. In this way it is claimed that, due to the kind of technology which produces a photographic image, it is distinctly and absolutely different from all other kinds of representation. Such theories appeal deeply to common sense. They resonate strongly with positivistic beliefs about the facts of a situation being transparently clear to us when open to inspection by vision.

However, such accounts have their source in a restricted view of how photographic images come to have meaning. Such realist theories are fixated with the historical difference between the technological means employed in photography and all other kinds of autographic and manual means of image making and reproduction. This technological difference has been abstracted – isolated and generalised – as a principle which can be used to explain the special significance of the photographic image.

One important outcome of this insistence on defining 'the photographic' in technological terms has been a related preoccupation with trying to read beneath all of its varied and contradictory social uses (the different practices of fashion and

surveillance photography for instance, or between a surrealist's and a documentarist's use of the technology). This was in order to find its essential and unifying characteristics as a 'medium'. As John Tagg (1988: 14–15) has pointed out, it is more helpful to think of 'photographies' which have different 'histories' than it is to think of a singular medium with a singular, grand and sweeping history. The conventional history of photography has been written like The History of Literature or Art. It would be better understood as like a history of writing. By which Tagg means that it is better understood as a technique which is employed in many different kinds of work. Writing for instance is a technique employed in the different tasks of making shopping lists, surveyors' reports, advertising copy, poems, etc. These cannot be usefully understood as if they all belonged to one grand, selective and linear enterprise held together by a unifying idea and a defining set of canonical works. Neither can photography.

Yet, recently, in the face of the biggest radical shift in the technology of images since the emergence of photography itself, the polarised terms of the old debate seem to have returned in a particularly crude way. The monolithic view of photography is being resurrected. Its technological basis again becomes its defining feature. And this is contrasted with a digital technology which itself is rapidly gaining the status of a new essentialised 'medium'. But this time, not one which guarantees access to reality but one which celebrates that impossibility and offers to construct virtual ones instead.

Photographic meanings

The question of how our belief in the special veracity and evidential force of the photographic image gets attached to the material image itself can be approached by considering the photographic image in more historical and sociological ways (Tagg 1988: 3–5) This can also lead us to question the view that there is a fundamental cultural break between the photographic and the digital. Instead of focusing attention upon the photograph as the product of a specific mechanical and chemical technology, we need to consider its technological, semiotic, and social hybrid-ness; the way in which its meanings and power are the result of a mixture and compound of forces and not a singular, essential and inherent quality.

Over a period of 150 years photographic images have contributed to how we see and think about the world, ourselves and others. But they have not achieved this historical shaping of perception in isolation or through technological means alone. First, the still photographic image has circulated, eventually on a global scale, via other graphic and technical processes and predominantly alongside the meanings of the printed word. As John Tagg puts it,

> With the introduction of the half-tone plate in the 1880's, the entire economy of image production was recast ... half tone plates at last enabled the economical and limitless reproduction of photographs in books, magazines and advertisements, and especially newspapers. The problem of printing images immediately alongside words and in response to daily changing events was solved.... The era of throwaway images had begun.
>
> (Tagg 1988: 56)

From this time on the discrete chemical photographic print is, relatively, a rarity. Yet, the chemical process itself came to stand at the centre and as the originating point of the modern world's web of reprographic processes and print media. The path from chemical photograph to its social availability and circulation in the magazine, newspaper, book, etc., is complex and mediated. For the modern saturation of experience by images to have occurred, the photo-mechanical process was a necessary but by no means a sufficient cause. This depended upon a convergence of photography with print, graphic, electronic and telegraphic technologies. With the emergence of digital technology this convergence is exponentially increasing. It can be seen, at least in part, as an acceleration of historical processes already surrounding the photographic image. In the cycle of cultural production and reception, which passes through many technical, social and political stages, the meanings of a photographic image or a text can be fixed or changed at a number of points. In this respect the opposition between an isolated photo-chemical technology (seen as having automatic, guaranteed and fixed meanings) and hybrid 'new media' (as having more open and layered meanings) depends, to a considerable extent, upon collapsing the cultural form of the photographic image into the technological form of the chemical photograph. Once we reflect upon the technological and social complexity of how we meet the photographic images which circulate in everyday life, this particular opposition is greatly diminished.

Second, at the point of reception or consumption, photographic images are seldom, if ever, met in isolation. They are embedded and contexted in other sign systems. Primarily, these are those of the written word, graphic design and institutional connotations. As Barthes (1977: 15) puts it, the photograph is at the centre of 'a complex of concurrent messages'; in a newspaper these are the text, the title, the caption, the layout, and even the title of the newspaper or publication itself: a photograph can change its meaning as it passes from the page of the conservative to the radical press.

Apart from this close relationship with the written word, photographic images become meaningful by the context of the spoken word and casual, oral culture. For still images, this is particularly the case in the domestic world where snapshots are virtually an occasion for talk, reminiscence and commentary. This is also the case with the educational uses of photographs, in the classroom, lecture

theatre or public event. While having an obvious relationship to text, the meanings of photographic images in newspapers and magazines may also be inflected as they are spoken about or argued over. If we extend the definition to the images of cinema, television and video then their crucial relationship to sound and speech is obvious, although more complex than we ordinarily imagine (Ellis 1991: 127–44, Altman 1980). But for current purposes it is the very fact of the connection itself which is important; between the technological forms of sound and visual reproduction. Writing about photography and film in 1936, Walter Benjamin pointed out that the photographic image actually called forth a new relationship between the visual image, the human voice and speech.

> Just as lithography virtually implied the illustrated newspaper, so did photography foreshadow the sound film, [because,] Since the eye perceives more swiftly than the hand can draw, the process of pictorial reproduction was accelerated so enormously that it could keep pace with speech.
>
> (Benjamin 1973: 221)

The sheer pervasiveness of photographic images, in all major areas of social and cultural life, is also the grounds for their intertextuality. The meanings of any particular photographic image are not freestanding and autonomous, as if fenced off from all others. Each one or each cultural form in which they circulate, is a small element in a history of image production and a contemporary 'image world'. Photographic images belong to a kind of 'second nature'; a dense historical environment of mass-produced images, symbolic objects, spectacles and signs (Buck-Morss 1991). Within this environment, the photographic image gains its meaning by a continual borrowing and cross-referencing of meanings between images. The still photograph quotes a movie, the cinematographer adopts the style of an advertising photographer, the music video mimics an early silent movie, etc.

If what a photograph refers to is at least partly the way the world is represented in other images, then another kind of distinction between the photographic and the digital becomes less sharp. The frequently made observation that digital images are reworkings of received images, are built from the fragments and layers of other images, is better understood as a meta-form of processes long involving the photographic image; not a radical difference but an acceleration of a shared quality.

Each of these relationships between the photographic image and other technologies of representation and communication takes place within social institutions and forms of organisation: media organisations, entertainment industries, bureaucracies, families, educational establishments, workplaces, cities. It is mainly in the way that photographic technology was understood, and used, within institutions in the nineteenth and early twentieth centuries, that

photographs came to have their distinctive significance(s). John Tagg (1988) and others (Sekula 1983, McGrath 1984, Green 1984) have carefully researched the manner in which still photographs have gained their various statuses as art, evidence or document – the meanings that we now take for granted and see as actual properties of the 'chemically discoloured' pieces of paper themselves (Tagg 1988: 4).

In *The Burden of Representation*, John Tagg researched early uses of photographs as evidence in courts and public enquiries, as medical and police records, and as saleable commodities which photographers wanted to own and copyright. He traces the way in which all these uses had to be fought for, or 'produced' as he puts it. It was not, to start with, self evident that a photographic image was more truthful than any other kind of image. Neither was it evident that an image produced by a machine could be owned by an individual; that it could have an author. It was by appealing to other sources of power and authority, and connecting the photographic image to them, that these values were established. Principally, these sources of authority were the new social sciences, civic authorities, courts of law, the premises of capitalist economics, and traditional ideas about artistic creation where the artist is thought to have 'given' something of 'themselves' to their work.

The significance of photographic images can not then be fully grasped without looking to the systems of ideas, and the ways of ordering knowledge and experience, in which they became implicated from the middle of the nineteenth century. And then, having been produced and made meaningful in these ways, they come to be understood within yet other sets of ideas and beliefs. The theories of the 'realists' for example, whose thinking separated the photograph from its social embeddedness and sought its significance in its technological means of production.

That I take a photograph to give me 'the facts' of a situation is 'guaranteed' by the extent to which I consciously or unconsciously accept the principles of empirical scientific method. That I read a photograph as the 'subjective expression' of an artist's idiosyncratic way of seeing the world depends upon my having the idea that this is what art and artists do (and that it is appropriate to see a photograph in this way). When a photograph is a poignant token of my past life, it is so because of a powerful compound of my belief in its scientific basis and my desire for what I have lost.

We need, then, to think about photography as a set of practices with different purposes. Whilst they share a technological basis we do not get very far thinking about these different practices in technological terms alone. We now also need to recognise that digital technology has more than one relationship to this range of photographic practice. Even in these early years, digital image technology is being used in more than one way and these ways inevitably owe much to the established forms, discourses and institutions of photographic production.

Digitisation

In the final section of this introduction, I will argue that beneath the technological surface of digital image production, important cultural continuities are at work. In a fuller account than it is possible to give here, we would need to think separately about the digital coding of the analogue chemical photograph, and the *simulation* of 'chemical' photographs by digital means; the production of 'photographic' images which have no specific or causal referent in the world of objects and events. Third, it would probably be useful to distinguish the latter from the scenarios of virtual reality. As these ultimately centre upon an aspiration to dissolve material images altogether; the removal of any material interface between vision and image.

The first two uses of digital technology: the recoding and the simulation of photographs, bear very directly upon what can be done with the photographic image. The third, while being quite remote from the practical production of photographic images, is frequently seen as part of a teleology of the cinema – a progressive technological fulfilment of the cinema's illusionistic power. It is important to stress that beyond research laboratories and 'shoot-em-up' arcades 'virtual realities' are not socially available in any meaningful way. The apparatus is presently more of a 'discursive' than a material object. That is, it is something that is reported rather than seen, something that is talked and speculated about, and represented in other media: cinema, TV, novels, comics, rather than used (Hayward 1993. And see Martin Barker's contribution to this volume, Chapter 9). However, while not at the centre of this essay's concerns, 'VR' has much to do with the notion of a 'digital culture' and the ideological context into which photographic images are now entering. It is, surely, the imagined and desired object into which the 'hard copy' and screen based image manifestations of digitisation are frequently and confusingly collapsed. Not only by techno-theorists but also by manufacturers of popular computer software.

However, closer to the present in which images have their meaning, the digitisation of chemical photographs and video stills was immediately seen to have implications for the continuing (and already problematic) status of photo-reportage, journalism and documentary practice. At the same time, the use and recontexting of digitally scanned and digitally *simulated* photographs, has been primarily applied to entertainment, corporate training and education, in the form of interactive multimedia. It may be useful to see these two developments as pulling in two directions. Broadly, the use of digital technology within documentary and reportage traditions is leading to a defensive preoccupation with issues of authorship and integrity (see Ian Walker's contribution (Chapter 11) for a fuller discussion of these issues). While within multimedia practice there is, at least at an ideological level (copyright issues are still fiercely pursued, if confused, at the level of material production and product control), a celebration

of 'interactivity', of openness, and the dissolution of concepts of original, singular, authorship. (See Barthes 1977: 142–8, Foucault 1979: 108–19, Lury 1992: 380–5, on concepts of authorship.) This has been a longstanding tension within photographic culture which may now be stretched to breaking point.

The historical use of photographs as 'evidence' and reliable documentation has long been in continual contradiction with other uses of photographs, particularly as art, and in advertising and corporate publicity. As Sekula has put it,

> the hidden imperatives of photographic culture drag us in two contradictory directions: toward 'science' and a myth of 'objective truth' on the one hand, and toward 'art' and a cult of 'subjective experience' on the other. This dualism haunts photography, lending a certain goofy inconsistency to most commonplace assertions about the medium.
>
> (Sekula 1986: 160)

Sekula points to the way that photographic images are seen, now as the product of an autonomous technological force, now as a matter of aesthetics, pleasure, expression and subjective interiority. This problematic position of photography as it has been caught up in philosophical and institutional divisions of science and art, has always troubled its theorists. Yet it is unlikely that it has troubled its practitioners and institutions to the same extent, on one side of the line or the other. At present, it seems that the advent of digital 'post photography', despite its capacity to confound realist/constructivist categories, is still being thought about with the 'goofy inconsistency' that Sekula points to. Practitioners and institutions with an investment in 'myths of objective truth' are attempting to shore up these ideological partitions (Ritchin 1990b: 36, Mitchell 1992: 8). On the other hand, in both popular and more formal, academic ways, the technology is being siezed upon as confirming the dissolution of the science/art, objective/subjective, divide and, in particular, the image's status as any kind of reliable index of a prior reality. (See Michael Punt's contribution to this volume (Chapter 2) for a discussion of the way that the photographic image has been discursively framed as science and technology.)

In a short section of his book *The Reconfigured Eye*, entitled 'Digital Images and the Postmodern Era' (Mitchell 1992), William Mitchell proposes that the emergence of digital imaging can be seen as a means to

> expose the aporias in photography's construction of the visual world, to deconstruct the very ideas of photographic objectivity and closure, and to resist what has become an increasingly sclerotic tradition.
>
> (Mitchell 1992: 8)

At one level, Mitchell could well be pointing to the way in which a software programme such as Adobe Photoshop can operate rather like a practical demonstration of photographic semiotics. Within a couple of hours' use, such a

programme opens up, in principle at least, the post-production manipulations of photographic representation: manipulations which previously would have been the outcome of several months' apprenticeship in the chemical darkroom. Digital software becomes a heuristic tool for *understanding* photographic representation.

Mitchell goes beyond this. By means of what can only be described as a homology – a sense of a 'fit' or resonance – he suggests that a (digital) medium which 'privileges fragmentation, indeterminacy, and heterogeneity and that emphasises process or performance' is the technological counterpart to some propositions of cultural and linguistic theory. He sees 'post-photographic' practice as analogous to 'poststructuralist' theory, both embraced within a world characterised as 'postmodern'. Where the search of the high modernist heroes of photography, such as Paul Strand and Edward Weston, for a kind of 'objective truth assured by a quasi-scientific procedure and closed, finished perfection', is anachronistic and no longer supportable.

He points to the open-endedness of the digitised image and the manner in which image manipulation software is designed to facilitate change, alteration and recombination of elements. He sees this as being in contrast to the 'one to one' relationship which the photographic image conventionally has to the scene or object which it represents. He then draws an analogy with poststructuralist theories of language and meaning. The emphasis in such theories is upon the polysemic nature of signs, their capacity to mean more than one fixed thing. It is also upon their 'indeterminacy', the way that language and sign-systems are always in process as they are used. They never reach a final destination of fixed, settled meaning; that is any kind of 'closure'. It is in the emergent form of interactive multimedia that such ideas might be thought to find their analogy in the production of digital image 'texts'.

Multimedia, whether encoded on CD Rom or in its promised 'on-line' forms, raises many questions and issues. Some of these are discussed in the contributions to this book. (See, particularly, Andrew Dewdney and Frank Boyd (Chapter 7) for a fuller discussion of the institutional and cultural forms of current multimedia production and use, also the contributions of Don Slater (Chapter 6) and Ruth Furlong (Chapter 8), for discussions of new image technologies in domestic contexts.) I confine myself here to the multimedia 'text', where the consumer or user is seen to be empowered by being able to navigate through a potentially immense range of knowledge and information. In making their own connections, choosing their own pathways, by being active in making their own sense of the material, they are thought to be newly included in the construction of meaning. By looking at what is involved in this emergent cultural form, we can take up again the discussion of cultural continuities between the photographic and the digital image. For it looks as if the dispersed social and technological complexity of photographic meaning, which was discussed earlier, has found a kind of concentrated technological form in multimedia production.

Interactivity

Once digitised the photographic image (in its still and increasingly in its moving forms) can be stored on compact disc. In 'multimedia' CD Rom production, digital technology is used to bring about a convergence of the still photographic image with film, video, recorded sound and speech, textual, graphic and autographic material. What it basically enables is an unprecedented kind of editing, within and across previously distinct media, to build new kinds of audio-visual structures or 'architecture'. In common with traditional film editing this involves the practice of selecting, cutting, combining, juxtaposing, and narrative re-organisation of material from diverse places and times. Crucially, in this form, digital technology also extends the producer's editing and selection function (the choice of what to view and when), through mouse, keyboard or touch screen, to the consumer. This offer of *choice and non-linear* access to content has come to be described as 'interactivity'.

'Convergence' is again a striking feature of the form, as the temporally sequenced and spatially distributed activities of reading a book, looking at still images, watching a film, TV, video tape, listening to a lecture, asking questions at a tutorial (the model of an Open University course springs to mind) may be simultaneously drawn upon in a piece of multimedia educational software. It is, however, in the concept of interactivity where the most radical difference between the viewer of digital images, rather than photographic ones, is claimed.

The concept of interactivity signals some real changes in the relationship between a viewer and a text. Multimedia audiences or users cannot, for instance, be thought of as gazing distractedly, as 'delegating their look' as the TV viewer has been observed to do (Ellis 1991: 112). They do not experience sound and image as it weaves in and out of other domestic activities and relationships, in the manner of TV viewing. Nor, in comparison to the 'viewing subject' of cinema, can they be thought of as being swept along by a narrative's tensions and resolutions; secretly aligning their own looking with that of the camera and the actors with whom they identify (Ellis 1991, Mulvey 1981). These are, currently at least, relevant comparisons, as it is the TV and/or computer monitor in domestic space or video projection in public space which are being used as models for the reception and exhibition of interactive multimedia. The replacement of the term 'viewer' with that of multimedia 'user' is intended to signify the way attention is differently engaged. Nothing 'happens' or proceeds without their initiation. Any sustained involvement requires concentration and motivation, whether the programme in question is a game, pornography, or an educational or database package. Is, however, this contrast with our use of older media as absolute as it is typically claimed to be?

'Digital' interactivity takes place within certain given conditions and structures. The breadth of choices, selections, and pathways open to a user of a multimedia

CD Rom may be of a limited or an extensive kind, but in either case they are circumscribed by a multitude of prior decisions. Ones that are made by the designers, scriptwriters, and programmers. These are based upon the priorities and product specifications of the institutions in which they work. They carry forward preconceptions of markets and audiences, and the ideologies and discourses *through* which they work and which inform their narratives, treatments, and selections of content.

In *this* sense multimedia production is not qualitatively different from any other form of media or cultural production. This is not simply a case of its early limits, its primitive technical constraints, and its necessary borrowing of conventions from analogue media, needing to be overcome through a romantic struggle for new forms. It has to be the case. All orderings of knowledge, experience and data, all collections and sequences of images, are just that: orderings, narratives and classifications of what would otherwise be 'just one damned thing after another' (this in fact being a criticism of some CD products). The important questions are about the purposes and bases on which such selection and ordering is undertaken. Or about what kinds of structure and organisation are designed to hold them. The issue then rapidly becomes one of *the necessary limits* of interactivity, and how and by whom they are set. It is not one of 'interactivity' as some kind of abstract, utopian potential. If we include this element of structuring and encoding in our understanding of interactive multimedia production then over-simple contrasts with the presumed passivity of the 'old' media's viewers must again be questioned.

The myth of couch potatoes

> Television viewing, the choices that shape it and the many social uses to which it is put, now turn out to be irrevocably active and social processes. People don't passively absorb subliminal 'inputs' from the screen. They discursively 'make sense' of or produce 'readings' of what they see. Moreover, the 'sense' they make is related to a pattern of choices about what and when to view which is constructed within a set of relationships constituted by the domestic and familial settings in which it is taking place. The 'rational consumer in a free and perfect market' so beloved of advertisers, audience research departments and rational-choice econo-mists alike, is a myth.
>
> (Hall, in Morley 1986)

If 'interactivity' concerns the relationship of viewers or users to media texts, in particular the role of the viewer/user in contributing to what the text means and how it is used, we need to see that the notion of 'digital' interactivity is tending to obscure another one. This is a concept of 'interactivity' which has been at the centre of debate about older media for some twenty years (Graddol and

Boyd-Barrett 1994, Morley 1992, Turner 1992). It is centred upon the study of television, and its audiences in particular. But it can be seen more broadly to concern the complex processes by which photographic images, visual narratives and audio-visual representations gain their meanings through a process of interaction. This involves, first: the meanings encoded in a media text by its producers. Second: the identities, motivations, interests and cultural competencies of their audiences, as they are drawn upon to make sense of or decode these meanings. Third: the specific social and cultural sites in which viewer and image meet. There being all the difference in the world between 'reading' photographic images in books, streets, galleries, and off small and large screens, let alone the computer monitor. (See Ian Walker's contribution in this volume (Chapter 11) for a discussion of the meanings of the photographic image's changing contexts.)

This important area of theory is not being recognised in much of the thinking about new image technologies. In fact, it is in danger of being obscured by a less satisfactory one: this being an abstract, a-social notion of interactivity. It is centred upon the resurrection of the idea of 'choice' by a free-floating, 'rational consumer' and their more tangible activity of pressing keys, moving cursors and clicking mice at the end of a fibre optic cable. (See Don Slater's discussion, Chapter 6, of 'mobile privatisation' in relation to this.)

As noted earlier, in contrast to interactive multimedia use, the activity of watching television or (non-interactive) cinema is becoming newly characterised as a passive activity undertaken by disenfranchised dupes. This is, of course, not a new idea. A tradition is being tapped here that flows from some of the earliest responses to mass media and culture which tended to see them as debasing, depoliticising or trivialising rubbish. (Differently represented by the British 'culture and civilisation' tradition in the 1950s, and the ideas of the German Frankfurt School. For an outline of the former see Turner 1992: 42–5, and for a history of the latter, see Jay 1973.) It is not that such judgements can have some local and critical substance, but that they are based upon a severely restricted view of the social, cultural and semiotic processes which are involved in consuming images, artifacts and media texts. We are not likely to get far in a theory or practice of interactive multimedia *unless* the very evident sense of the user's overt physical interaction with digital hardware is thought through within the context of these wider and complex forms of social, cultural and political interaction. There is nothing in the new image technologies which points to why they should be excepted from such processes.

All this leads us to consider, yet again, that while there are differences to attend to, *there is no clean break*, except in the trivial 'mouse clicking' sense and the assertive myths of marketing hype, between the older analogue photographic media and the digital.

With this recognition we come full circle. We are returned to the fact that multimedia texts are designed frameworks and structures, holding selective

contents, in which a necessarily constrained interactive function is offered to the user/consumer. It is also the case that the signifying powers of the photographic images carried on digital media, the ideological frameworks in which multimedia texts are built, and the conventions which are established to make them meaningful, have to come from somewhere. This 'somewhere' is, in the first instance, the skills, practices and conventions which have been historically developed around the still and moving photographic image. And like the photographic image itself, the range of other signifying and discursive systems which contribute to its meaning. New kinds of production conventions, forms of exhibition, institutions, and new audience or consumer practices are likely to develop for multimedia. They do not, however, exist as pure forms waiting to be divined. They are being built in negotiation with the forms of a photographic culture.

The contributions

The majority of the essays in this book were written or contributed in response to a short paper which was circulated in 1993. In that paper, six social and cultural categories were pointed to as representing some of the major ways in which the photographic image has shaped, and been shaped by, aspects of late nineteenth- and twentieth-century culture. They were further proposed as sites in which we were beginning to experience the products of new image technologies. Where their interaction with the uses and values of photographic culture might be seen. These were: the domestic image; the public media; surveillance, the state and the law; the city; leisure and entertainment; work and education. In a re-worked form these headings survive as the organising principle of the book.

Part I: Visual culture and technological change

In this Part, two essays have been added which discuss ways in which the history of photographic culture and current change might be understood. With the emergence of new image technologies, photography and film in the past, and now digital imaging, questions have been raised about their significance as culture. Are they art, entertainment, science or technology? What projects, values and drives of Western culture do they represent and facilitate? As these questions are grappled with, the resources of a culture are brought into play, its rationalism, empiricism, its positivism and romanticism, as a struggle to define and comprehend a new technology is played out. In different ways, the essays in this Part address this process.

Kevin Robins argues the importance of holding on to a sense of the complexity of image cultures. He sees the need to do this in the face of a rationalist austerity which has accompanied the 'post-photographic' and which threatens to exclude

other important ways of using and valuing images. He identifies much of the contemporary discourse about new image technologies as an older rationalist tradition 'masquerading in the drag of postmodernism'. He locates the conflation of post-photography with technological 'progress' in a restrictive and teleological 'logic' of images flowing from the Enlightenment and nineteenth-century positivism. Following a critical discussion of this 'logic' of images, he sets out a way of constructively proceeding against 'the digital grain'. His point is to contest an 'imaginatively closed understanding of our changing image culture'. He calls for a recovery of the sense of images as represented in the thought of Barthes, Berger and Benjamin, as forces for political and imaginative freedom.

The social construction of science and technology, and their shifting relationship to the visual image and entertainment, are also central to Michael Punt's contribution. He takes his cue from the apparently novel conjuncture, in digital image technology, of discourses that we have come to understand as distinct and strongly bounded: those of science, technology, and entertainment. He examines three paradigmatic images, an eighteenth-century painting, an early film by Edison, and video footage of the NASA *Challenger* disaster. In seeking what they might reveal about how technological change has been represented and understood in the industrial past he is proposing an archaeology of 'digital photography'. His project is to see in these images a fuller picture than technological determinism offers of the negotiations between a new technology and the fears and hopes of those 'who own it, those who use it and all of us who interpret it'.

Part II: The body and surveillance

Within twenty years of its emergence, photography was taken up as a means of surveillance, categorisation and control. From the 1870s on, it was used in the social classification and control of workers, vagrants, criminals, the sick and the insane, the urban poor and colonised races. Photography represented a dramatic example of a new visual technology coinciding with new forms of industrial and urban society, of medicine and social science, and of the needs of the state to monitor and regulate society through the collection of information. Within this context, the female body was subjected to the vision of a gendered camera from the earliest days of photography.

Beryl Graham looks at the way in which digital image technology, in the form of interactive CD Roms, has been harnessed to pornographic purposes as speedily as was photography in the nineteenth century. She traces the historical parallels and marks out some differences between photographic and computer-based pornography. In a final section she discusses the way in which the politics of pornography and sexuality are being played out in the new arena of digital media.

In Sarah Kember's first contribution, she discusses the way in which women's bodies were viewed and located by medical photography, and suggests that this process continues in the exponential growth of new medical image technologies which now seek 'the invisible and the unknown'. This essay offers a substantial critical review of the issues and debates raised by these developments and the new technologies involved.

In her second contribution, Sarah Kember places the tragic murder of the young child, James Bulger, within a web of concerns about the contemporary representation of childhood. Much of the media reporting of this case centred on the role of computer enhanced surveillance images in the detection of James Bulger's abductors. These images are placed within the context of historical representations of childhood and the author shows how they have been caught up in a current demonisation of childhood, technology and crime.

Part III: Domestic leisure and entertainment

Photographic images have been central to modern forms of biographical memory and to class, family, generational and gender identity. The successive image and communication technologies of the nineteenth and twentieth centuries, the telephone, photography, radio, film and television, have all had crucial outcomes in the domestic sphere. As Ruth Furlong points out in her contribution, 'In the discourses predicting the future of any new technology, home is a familiar theme', and the process of selling a new technology to the public, whether it be radio or virtual reality, involves its domestication.

In this Part, Don Slater considers the changing place of the popular snapshot and the family album within the enormous and transient flow of images which now pass through the home in digital and electronic forms. He argues that, while the domestic photograph is relatively untouched by technological change, its value is being changed by other developments in the wider use and meaning of images in everyday life. Using the metaphor of a domestic 'pin board' of haphazardly collected images, in contrast to the traditional 'family album', he reflects upon our shifting relationships to the present, to history, and to public and private worlds.

Ruth Furlong's ethnographic study of boys' use of video and computer-based media within their homes, questions postmodern discourses on new technologies and the body. Instead of the tendency to 'leave the body', which postmodern thought often claims to be the effect of immersion in electronic and digital image worlds, she finds a very physical, gendered, messy and resistant body alive and well.

Martin Barker, in his detailed study of the representation of digital culture in the images and narratives of popular comics, also challenges some currently fashionable ideas about the cyborg body. In outlining the social, economic and

political history of the computer, and the role which comics have played in 'imagining the future', he challenges Claudia Springer's assertion that there is a singular popular culture of 'cyborg imagery' (Springer, 1991). He argues that such accounts are overdetermined by the prior agendas of postmodernist theorising. He offers a fuller picture which takes account of the history of comics and their audiences, the history of images of computers and the role played by these images in circulating preferred views of computer technologies as a social good. This essay includes an important bibliography and comic-ography for the study of this area.

Part IV: Art and public media

The photographic image has, of course, been central to the modern forms of advertising, news, social documentary and reportage. The truism that it is through the photographic image that we have come to know the world which is remote to us in time and space can hardly be gainsaid. The role of the photograph in making concrete the dreams, fantasies and objects of desire which capitalism promises us is, likewise, well recognised. In this Part, Ian Walker and Michelle Henning reflect upon whether and how these functions of the photographic image may be changing in the context of new image technologies.

Photographic historian Ian Walker takes Sophie Ristelhueber's photographs of the 1991 Gulf War as a focus for considering what, in the context of electronic imaging and reporting, photography *can still do*, rather than what it cannot. He finds that photography has a special power to 'speak in considered retrospect'. Any over-simple opposition of photography's presumed objectivity and its recent deconstruction by digital image technology is avoided in his informed reading of war photography and the recent self-reflexivity of documentary work. He considers that it is in the strategies, political and aesthetic, in the work of artists using photography, like Ristelhueber, and not in the genre of documentary, that the future of photography may lie. This prospect raises some old questions about art and about popular culture, and their respective possibilities for political and cultural transformation.

Walter Benjamin's 1936 essay, 'The Work of Art in the Age of Mechanical Reproduction' has become a touchstone in many recent attempts to think through current changes in image technology. While vigilant about the dangers of a-historically lifting his account wholesale into the present day, Michelle Henning explores some of Benjamin's difficult ideas through a reading of a contemporary cigarette advertisement. The advertisement hovers, in an undecidable way, between photography and digital imaging. She uses this as a starting point for a suggestive set of reflections on the current relationship of new technologies to historical and ideological continuities.

References

Altman, R. (1980) 'Moving Lips: Cinema as Ventriloquism', *Yale French Studies*: 60.

Arnheim, R. (1974) 'On the Nature of Photography', *Critical Enquiry*, 1, September: 155.

Barthes, R. (1977a) 'The Death of the Author', in Barthes, *Image Music Text*, London: Fontana.

———— (1977b) 'The Photographic Message', in Barthes, *Image Music Text*, London: Fontana.

Benjamin, W. (1973) 'The Work of Art in the Age of Mechanical Reproduction', in H. Arendt (ed.), *Illuminations*, Glasgow: Fontana/Collins.

Biggs, S. (1991) 'Media Art and Its Virtual Future', *LVA Catalogue*: 69–72.

Buck-Morss, S. (1991) *The Dialectics of Seeing; Walter Benjamin and the Arcades Project*, Cambridge, Mass.: MIT Press.

Crary, J. (1993) *Techniques of the Observer*, Cambridge, Mass.: MIT Press.

———— (1994) 'Critical Reflections', *Artforum*, February: 58–9.

Druckery, T. (1991) 'Second Generation Slackers', *Afterimage*, October: 4, 17.

Ellis, J. (1991) *Visible Fictions: Cinema: Television: Video*, London and New York: Routledge.

Foster, H. (1993) 'Postmodernism in Parallax', *October*, 63: 5–6.

Foucault, M. (1979) 'What is an Author?', in J. V. Harari (ed.), *Textual Strategies: Perspectives in Post-Structuralist Criticism*, Ithaca, NY: Cornell University Press, 108–19.

Gibson, W. (1993) *Neuromancer*, London: HarperCollins.

Graddol, D. and Boyd-Barrett, O. (1994) *Media Texts, Authors and Readers*, Clevedon, Avon: Multilingual Matters and Oxford University Press.

Green, D. (1984) 'Classified Subjects', *Ten-8*, 14: 30–7.

———— (1986) 'Veins of Resemblance', in P. Holland, J. Spence and S. Watney (eds), *Photography/Politics:Two*, London: Comedia.

Hayward, P. (1993) 'Situating Cyberspace; The Popularisation of Virtual Reality', in P. Hayward and T. Wollen (eds), *Future Visions; New Technologies of the Screen*, London: BFI Publishing.

Hughes, L. (1990) 'No Longer in the Eye of the Beholder', *The Guardian*, 4 September.

Jay, M. (1973) *The Dialectical Imagination*, London: Heinemann.

Lury, C. (1992) 'Popular Culture and the Mass Media', in R. Bocock and K. Thompson (eds), *Social and Cultural Forms of Modernity*, Cambridge: Polity Press.

Mcgrath, R. (1984) 'Medical Police', *Ten-8*, 14: 13–18.

McLuhan, M. (1964) *Understanding Media*, London: Routledge & Kegan Paul.

Matthews, R. (1993) 'When Seeing is not Believing', *New Scientist*, October: 13–15.

Mitchell, W. J. (1992) *The Reconfigured Eye: Visual Truth in the Post-Photographic Era*, Cambridge, Mass.: MIT Press.

————— (1994) 'When Is Seeing Believing?' *Scientific American*, February: 44–9.

Morley, D. (1986) *Family Television: Cultural Power and Domestic Leisure*, London: Comedia.

————— (1992) *Television, Audiences and Cultural Studies*, London and New York: Routledge.

Mulvey, L. (1981) 'Visual Pleasure and Narrative Cinema', in T. Bennett *et al.* (eds), *Popular Television and Film*, London: BFI.

Plant, S. (1993) 'Beyond the screens: Film, Cyberpunk and Cyberfeminism', *Variant*, 14, Summer.

Rheingold, H. (1991) *Virtual Reality*, London: Secker & Warburg.

Ritchin, F. (1990a) *In Our Own Image: The Coming Revolution in Photography*, New York: Aperture.

————— (1990b) 'Photojournalism in the Age of Computers', in C. Squiers (ed.), *The Critical Image*, Seattle: Bay Press, 28–37.

Robins, K. (1991) 'Into the Image: Visual Technologies and Vision Cultures', in P. Wombell (ed.), *PhotoVideo*, London: Rivers Oram Press.

————— (forthcoming, 1995) 'Post-photography, The Highest Stage of Photography', in T. Triggs (ed.), *Communicating Design*, London: Batsford.

Robins, K. and Levidow, L. (1991) 'The Eye of the Storm', *Screen* 32 (3): 324–8.

Sekula, A. (1983) 'Photography between Labour and Capital', in B. H. D. Buchloh and R. Wilkie (eds), *Mining Photographs and Other Pictures: A Selection from the Negative Archives of Sheddon Studio, Glace Bay, Cape Breton, 1948–1968*, Nova Scotia: The Press of Nova Scotia College of Art and Design/University College of Cape Breton Press.

————— (1986) 'Reading An Archive: Photography between Labour and Capital', in P. Holland, J. Spence and S. Watney (eds), *Photography/Politics:Two*, London: Comedia.

Snyder, J. (1980) 'Picturing Vision', *Critical Enquiry*, 6, Spring: 499–526.

Snyder, J. and Allen, N. W. (1975) 'Photography, Vision, and Representation', *Critical Enquiry*, 2, Autumn: 143–69.

Sontag, S. (1977) *On Photography*, Harmondsworth: Penguin Books.

Springer, C. (1991) 'The Pleasure of the Interface', *Screen*, 32 (3).

Tagg, J. (1988) *The Burden of Representation*, London: Macmillan.

Turner, G. (1992) *British Cultural Studies*, London and New York: Routledge.

Williams, R. (1974) *Television Technology and Cultural Form*, London: Fontana.

————— (1985) *Towards 2000*, Harmondsworth: Penguin Books.

visual culture
and technological change

part I

will image move us still?

kevin robins

1

Also if we are moved by a photograph it is because it is close to death.
Christian Boltanski

The 'death of photography'

The death of photography has been reported. There is a growing sense that we are now witnessing the birth of a new era, that of post-photography. This, of course, represents a response to the development of new digital electronic technologies for the registration, manipulation and storage of images. Over the past decade or so, we have seen the increasing convergence of photographic technologies with video and computer technologies, and this convergence seems set to bring about a new context in which still images will constitute just one small element in the encompassing domain of what has been termed hypermedia. Virtual technologies, with their capacity to originate a 'realistic' image on the basis of mathematical applications that model reality, add to the sense of anticipation and expectation.

What is happening to our image culture – whatever it may amount to – is generally being interpreted in terms of technological revolution, and of revolutionary implications for those who produce and consume images. Philippe Quéau (1993: 16) describes it as 'the revolution of "new images"', claiming that it is 'comparable with the appearance of the alphabet, the birth of painting, or the invention of photography'. It constitutes, he says, 'a new tool of creation and also of

knowledge'. The notion of techno-cultural revolution has been widely accepted and celebrated by cultural critics and practitioners, and such ready acceptance has tended to inhibit critical engagement with post-photography. Indeed, it has encouraged a great faith in the new digital technologies, based on the expectation that they can empower their users and consumers. A great deal of what passes for commentary or analysis amounts to little more than a simple and unthinking progressivism, unswerving in its belief that the future is always superior to the past, and firm in its conviction that this superior future is a spontaneous consequence of technological development. The fact that technological development is seen as some kind of transcendent and autonomous force – rather than as what it really is, that is to say embedded in a whole array of social institutions and organisations – also works to reduce what is, in reality, a highly complex and uneven process of change to an abstract and schematic teleology of 'progress'. The idea of a revolution in this context serves to intensify contrasts between past (bad) and future (good), and thereby to obscure the nature and significance of very real continuities.

From such a perspective, old technologies (chemical and optical) have come to seem restrictive and impoverished, whilst the new electronic technologies promise to inaugurate an era of almost unbounded freedom and flexibility in the creation of images. There is the sense that photography was constrained by its inherent automatism and realism, that is to say, by its essentially passive nature; that the imagination of photographers was restricted because they could aspire to be no more than the mere recorders of reality. In the future, it is said, the enhanced ability to process and manipulate images will give the post-photographer greater 'control', while the capacity to generate (virtual) images through computers, and thereby to make images independent of referents in 'the real world', will offer greater 'freedom' to the post-photographic imagination. What is supposed to be superior about the post-photographic future becomes clear, then, through contrast with what is seen as an inferior, and obsolete, photographic past.

The new technologies are associated with the emergence of a wholly new kind of visual discourse. This, it is argued, has profoundly transformed our ideas of reality, knowledge and truth. For William Mitchell, 'an interlude of false innocence has passed':

> Today, as we enter the post-photographic era, we must face once again the ineradicable fragility of our ontological distinctions between the imaginary and the real, and the tragic elusiveness of the Cartesian dream.
> (Mitchell 1992: 225)

Jonathan Crary conceives of the new order in terms of a new 'model of vision':

> The rapid development in little more than a decade of a vast array of computer graphics techniques is part of a sweeping reconfiguration of relations between an observing subject and modes of representation that

effectively nullifies most of the culturally established meanings of the terms *observer* and *representation*. The formalisation and diffusion of computer-generated imagery heralds the ubiquitous implantation of fabricated visual 'spaces' radically different from the mimetic capacities of film, photography, and television.

(Crary 1990: 1)

We are, says Crary, 'in the midst of a transformation in the nature of visuality probably more profound than the break that separates medieval imagery from Renaissance perspective' (ibid.).

The technological and visual revolution associated with new digital techniques is understood, furthermore, to be at the very heart of broader cultural revolution. There is the belief that the transformation in image cultures is central to the historical transition from the condition of modernity to that of postmodernity. Digital imaging is seen as 'felicitously adapted to the diverse projects of our postmodern era' (Mitchell 1992: 8). The postmodern order is considered to be one in which the primacy of the material world over that of the image is contested, in which the domain of the image has become autonomous, even in which the very existence of the 'real world' is called into question. It is the world of simulation and simulacra. Gianni Vattimo (1992: 8) writes of the erosion of the principle of reality: 'By a perverse kind of internal logic, the world of objects measured and manipulated by techno-science (the world of the *real*, according to metaphysics) has become the world of merchandise and images, the phantasmagoria of the mass media.' In the face of this 'loss of reality', we must come to terms with 'the world of images of the world' (ibid.: 117). The discussion of post-photography is caught up in this projection of the world as a 'post-real' techno-sphere – the world of cyberspace and virtually reality. Within this postmodern agenda concerning reality and hyperreality, it is again philosophical questions (of ontology and epistemology) that are the focus of attention and interest. The sentiment that postmodern sophistications have now overtaken modern ingenuousness brings with it the sense of cultural and intellectual 'progress'.

What I have outlined here, in schematic form, constitutes the conceptual and theoretical framework for most accounts of the 'death of photography' and the birth of a post-photographic culture. It is the story of how the image has now progressed from the age of its mechanical production to that of its digital origination and replication. It is the story of how new technologies have provided 'a welcome opportunity to expose the aporias in photography's construction of the visual world, to deconstruct the very ideas of photographic objectivity and closure, and to resist what has become an increasingly sclerotic pictorial tradition' (Mitchell 1992: 8). In this respect, we can say that the discourse of post-photography has been extremely effective, significantly changing the way in which we think of image and reality. It has managed to persuade us that photographs were once 'comfortably regarded as causally generated truthful reports about things in the real world', and it

has convinced us of how unsophisticated we were in such a regard. It has convincingly argued that 'the emergence of digital imaging has irrevocably subverted these certainties, forcing us to adopt a far more wary and more vigilant interpretive stance' (Mitchell 1992: 225). We are warned against the seduction of naïve realism. Now, we have become more reflexive, more 'theoretical', more 'knowing', in our relation to the world of images.

The death of photography, an image revolution, the birth of a postmodern visual culture: there is the sense of a clear historical trajectory of the image. The significance and implications of the 'image revolution' have already been discursively fixed and contained. The certainties of the photographic era have been deconstructed, and we are now ready, it seems, to come to terms with the fragility of ontological distinctions between imaginary and real. What more is there to be said? We could easily bring the discussion to an end at this point. Perhaps we should be satisfied that so much is already known about the future of images and image culture. Perhaps we should be content with this discursive organisation and ordering of post-photographic culture. But I am not. So, let us keep the discussion going. Digital culture as we know it is distinctly unimaginative and dismally repetitive. Despite its theoretical sophistication and even 'correctness', there is something restrictive and limiting in the organisation and order of its theoretical schema. Theoretical structures can work to actually inhibit or restrict our understanding; they may simply confirm and reinforce what is already known; they can function to invalidate or devalorise other ways of understanding and knowing. It is with this in mind that I want now to consider what is being commonly said about the historical trajectory of images.

Whatever might be 'new' about digital technologies, there is something old in the imaginary signification of 'image revolution'. It involves a metaphysics of progress: the imagination of change in terms of a cumulative process in which whatever comes after is necessarily better than what went before. Cornelius Castoriadis describes its general logic:

> On the one hand, it forbids judgement on any and all particular events or instances of reality, since they all form necessary elements of the Grand Design. At the same time, however, it allows itself to pass an unrestricted positive judgement on the totality of the process, which is, and can only be, good.
>
> (Castoriadis 1992: 223)

It is a rationalistic schema, concerned with the project of rational mastery and empowerment (over nature and over human nature). In the next part of my argument, I shall be concerned with how the theory of the image is caught up in this teleological vision. In so far as it is implicated in the technological imaginary, I shall argue, it assumes an abstract and deterministic form, closing off alternative lines of inquiry and judgement.

Following this critique, I want to consider other ways in which we might look at what is happening in the culture of images. I take as my starting point, not the question of technologies and technological revolution, but rather the *uses* of photography and post-photography. Where the prevailing interest is in the information format of image technologies, my concern is with what might be called the existential reference of images to the world. Photographs have provided a way of relating to the world – not only cognitively, but also emotionally, aesthetically, morally, politically. 'The range of possible emotional expression through images is as wide as it is with words', says John Berger (1980: 73), 'We regret, hope, fear, and love with images.' These emotions, guided by our reasoning capacities, provide the energy to turn images to creative and moral-political ends. Such sentiments and concerns are uncomfortably at odds with the new agenda of post-photographic culture. These uses of photography now seem to mean strangely little to those who are primarily concerned with exposing the aporias of photography's construction of the visual world. Shall we just forget about such uses? Will they have no place in the new order? Because they are so important, I shall argue, we must begin to find a new basis for making them relevant again.

The progressivist agenda constructs a false polarisation between past and future, between photography and digital culture. According to its grand design, the new technologies must be good technologies (it assumes, that is to say, the thesis of the rationality of the real). From such a deterministic perspective, it is no longer relevant to take seriously the virtues of photographic culture, nor is it meaningful to question the virtues of post-photographic culture. Should we not be challenging this affirmative logic? Is not the whole process more complex, and isn't the appropriate response one of greater ambivalence? What alternative principles are there that would allow us to more critically evaluate and assess the transformations in image culture?

The rationalisation of the image

John Berger makes the point that, when the camera was invented in 1839, Auguste Comte was completing his *Cours de Philosophie Positive*. Positivism and the camera grew up together, and what sustained them as practices 'was the belief that observable, quantifiable facts, recorded by scientists and experts, would one day offer man such a total knowledge about nature and society that he would be able to order them both':

> Comte wrote that theoretically nothing need remain unknown to man except, perhaps, the origin of the stars! Since then cameras have photographed even the formation of stars! And photographers now supply us with more facts every month than the eighteenth century Encyclopae-dists dreamt of in their whole project.
>
> (Berger 1982: 99)

Photographic documentations of the world were about its cognitive apprehension. For the positivist, photography represented a privileged means for understanding the 'truth' about the world, its nature and its properties. And, of course, such visual knowledge of the world was closely associated with the project for its practical appropriation and exploitation. In this respect, the camera was an instrument of power and control. Photography has other, more creative capacities, as I shall go on to argue in the next section, but this capacity for visual arrogation has been, and remains, a dominant factor.

In his book, *The Reconfigured Eye*, William Mitchell reflects on this spirit of positivism in the context of his account and analysis of post-photographic technologies and culture. He intends to dissociate them from its legacy. The camera, Mitchell points out, has been regarded as 'an ideal Cartesian instrument – a device for use by observing subjects to record supremely accurate traces of the objects before them' (Mitchell 1992: 28). In so far as there appears to be no human intervention in the process of registering and recording an accurate image, photography has been regarded as the model of impersonal and objective neutrality. As Mitchell notes, 'the photographic procedure, like … scientific procedures, seems to provide a guaranteed way of overcoming subjectivity and getting at the real truth' (ibid.). This idea of photographic documents as truthful reports about things in the real world may be seen as functional to the culture that invented it: 'Chemical photography's temporary standardisation and stabilisation of the process of image making effectively served the purposes of an era dominated by science, exploration and industrialisation' (Mitchell 1994: 49). The uses of positivism were directly linked to the objectives of industrial capitalism.

Mitchell, like John Berger, is highly critical of this aspect of photographic history. In considering other possibilities, however, his agenda is quite unlike that of Berger (to whom I shall return shortly). Mitchell's hopes and expectations are invested in the new digital technologies, which, he argues, are 'relentlessly destabilising the old photographic orthodoxy, denaturing the established rules of graphic communication, and disrupting the familiar practices of image production and exchange' (Mitchell 1992: 223). The point is that they make the intentional processes of image creation apparent, such that 'the traditional origin narrative by which automatically captured shaded perspective images are made to seem causal things of nature rather than products of human artifice … no longer has power to convince us' (ibid.: 31). Digital images now constitute 'a new kind of token', with properties quite different from those of the photographic image. These new images can be used 'to yield new forms of understanding', and they can also be made to 'disturb and disorientate by blurring comfortable boundaries and encouraging transgression of rules on which we have come to rely' (ibid.: 223). They have subverted traditional notions of truth, authenticity and originality, compelling us to be more 'knowing' about the nature and status of images. It is in this particular respect that Mitchell considers digital imaging to be so

'felicitously adapted' to the structure of feeling of what we are pleased to call 'our postmodern era'.

I would concede that there is a certain justification for this idea of progression to a higher stage of visual sophistication and reflexivity, but only in the limited terms of what must be seen as essentially a scientific teleology of the image. Mitchell is concerned centrally with philosophical and formalist issues, with questions of theoretical and methodological 'progress'. In this respect, he makes his point. But images do not and cannot exist in a pure domain of theory. New images are, of course, substantively implicated in furthering the objectives of what is now called post-industrial or information capitalism (for it was the needs of this system that effectively summoned them into existence). The 'image revolution' is significant in terms of a further and massive expansion of vision and visual techniques, allowing us to see new things and to see in new ways. In this context, the teleology of the image may be seen precisely in terms of the continuing development of ever more sophisticated technologies for 'getting at the real truth'. The objective remains the pursuit of total knowledge, and this knowledge is still in order to achieve order and control over the world. (What would give us grounds to think that it was otherwise?) Though he does not pursue its real consequences, it is something that Mitchell is actually quite aware of:

> Satellites continue to scan the earth and send images of its changing surface back.... These ceaselessly shed skins are computer processed, for various purposes, by mineral prospectors, weather forecasters, urban planners, archaeologists, military-intelligence gatherers, and many others. The entire surface of the earth has become a continuously unfolding spectacle and an object of unending, fine-grained surveillance.
>
> (Mitchell 1992: 57)

More than the Encyclopaedists dreamt of, indeed! Wouldn't the positivists have jealously understood this? Doesn't it suggest the continuing desire, by scientists and experts, to record observable, quantifiable facts?

It is in the context of this teleological worldview that I would accept that the scientists and the experts now have a far more sophisticated attitude to what used to be called 'the facts'. The process of getting at the truth is considered to be vastly more complex than was assumed in the nineteenth century. New technologies have massively extended the range and power of vision, and also the techniques for processing and analysing visual information. They have also blurred the boundaries between the visible and invisible. Fred Ritchin (1990: 132) describes the advent of what he calls 'hyper-photography': 'One can think of it as a photography that requires neither the simultaneity nor proximity of viewer and viewed, and that takes as its world anything that did, does, will, or might exist, visible or not – anything, in short, that can be sensed or conceived.' New dimensions of reality are opened up to the powers of observation. With

computer-graphics work stations, it becomes possible to 'see' things that are otherwise inaccessible to the human gaze: 'The procedure is to employ some appropriate scientific instrument to collect measurements and then to construct perspective views showing what would be seen if it were, in fact, possible to observe from certain specified viewpoints' (Mitchell 1992: 119). In this way, simulation technologies massively enhance scientific endeavour. It is now actually possible 'to visualise the interior of a dying star or a nuclear explosion. The mind can go places where no physical being will ever be likely to go':

> Astrophysicist Michael Norman sums up the wonder of it all as he stands before the projected video animation of a tumultuously swirling tip of an extragalactic jet that may be a million light-years long: 'Look at that motion! The best telescope can only represent these evolving gigantic jets as frozen snapshots in an instant in time. My simulation lets me study them close up in any colour at any speed.'
>
> (Ward 1989: 720, 750)

New technologies are not only amplifying the powers of vision, they are also changing its nature (to include what was previously classified as invisible or unseeable) and its functions (making it a tool for the visual presentation of abstract data and concepts). Techniques and models of observation have, indeed, been transformed in ways the positivists could scarcely have imagined.

On this basis, it is possible to construct a logic of development which is about the shift from a perceptual approach to images (seen as quotations from appearances), to one more concerned with the relation of imaging to conceptualisation. The representation of appearances is ceasing to be the incontrovertible basis of evidence or truth about phenomena in the world. We are seeing the rapid devaluation of sight as the fundamental criterion for knowledge and understanding. Of course, this questioning of photographic meaning and veracity is by no means an entirely new occurrence. Allan Sekula (1989: 353) reminds us that even at the high point of nineteenth-century positivism there was always 'an acute recognition of the *inadequacies* and limits of ordinary visual empiricism'. None the less this questioning has now reached a critical stage, opening the way to a new and more sophisticated model of vision and knowledge. Jean Louis Weissberg (1993: 76) argues that we are in fact moving from an era of 'knowledge through recording' to one of 'knowledge through simulation'. In this latter case, he argues, 'the image no longer serves to re-present the object . . . but, rather, signals it, reveals it, makes it exist'. The aim is to create a 'double' of the reality, one that approximates to the referent, not only in terms of appearances, but also in terms of other (invisible) properties and qualities that it possesses. Through progression from simulation of the object by means of digital images to the higher stage of 'simulating its presence', it becomes possible 'to take the image for the object' (ibid.: 77–8). It is possible, that is to say, to experience it and to

interact with it as if it were an object in the real world. And when this becomes the case, we can say that we 'know' the object in a more complex and comprehensive sense. Experiential apprehension is grounded in conceptual and theoretical apprehension.

We should consider this logic in relation to the evolving accommodation between empiricist and rationalist aspects of Enlightenment thinking. The point, which Ernest Gellner makes very forcefully, is that there has always been a powerful symbiotic relationship between empiricism and rationalism in the modern world: 'The two seeming opponents were in fact complementary. Neither could function without the other. Each, strangely enough, performed the task of the other' (Gellner 1992: 166). Visual empiricism was no exception in this respect. If, in the history of photographic observation, there has always been the danger of a naïve empiricism, there has also been an acute awareness that visual experience and evidence could only perform its task, for certain purposes at least, if it were incorporated within systems of rational procedure and analysis (this is precisely Allan Sekula's point). The advent of post-photography has simply served to make this all the more clear. Within the broader scientific and philosophical context, we have come to recognise that the compromise between rationalism and empiricism is increasingly on the terms of the former. Horkheimer and Adorno (1973: 26) described it as 'the triumph of subjective rationality, the subjection of all reality to logical formalism'. In the particular sphere of post-photography, too, it is apparent that rationality is the ascendant and dominant principle. We can describe its logic of development in terms of the increasing rationalisation of vision.

I have described these developments in terms of a 'logic', because that, it seems, is how our culture can make best sense of them. The idea of necessary (and inevitable) progression appeals to us, and our culture finds it entirely reasonable to interpret this trajectory in terms of increasing rationality. The project of rationalism, initiated by Descartes, has been about the pursuit of cognitive certainty and conviction. This entails, as Ernest Gellner (1992: 2) observes, that we must 'purge our minds of that which is merely cultural, accidental and untrustworthy'. In so far as culture is associated with 'error' – 'a kind of systematic, communally induced error' – the Cartesian ambition involves 'a programme for man's liberation from culture' (ibid.: 3, 13). Reason must dissociate itself from cultural accretion; to realise its potential for enlightenment it must become self-sufficient and self-valorising.

We can make sense of the pursuit of photographic truth in the context of this rationalist programme, though we would have to acknowledge photography's spontaneous and desirous affinity with the cultural, the accidental and the untrustworthy. As John Berger (1982: 115) argues, the Cartesian revolution created a deep suspicion of appearances: 'It was no longer the look of things which mattered. What mattered was measurement and difference, rather than visual

correspondences.' Its complicity with appearances, and thereby with the meanings cultures attach to appearances, always put photography on the side of 'error'. We may then understand developments in photographic technology and culture in terms of the ongoing struggle to purge the medium of its 'impurities'. Positivism may be seen as a preliminary attempt to rationalise the image (though now we will say that it lacked the means, and that its ideas of cognitive truth were simplistic). The 'digital revolution' (with its new means and new approach to cognition) takes the Cartesian project in image culture to a 'higher stage'. This is what Mitchell's 'reconfigured eye' represents. In characterising this supposed revolution, Jonathan Crary (1990: 1–2) describes how the new technologies are 'relocating vision to a plane severed from a human observer'. The idea of a 'real, optically perceived world' has been undermined, he argues, and 'if these images can be said to refer to anything, it is to millions of bits of electronic mathematical data'. What are these new – de-personalised, de-contextualised – 'techniques' of observation but the fulfilment of the rationalist programme? The rationalisation of the image has been a dominant force in the development of photography and post-photography, and accounts of that development (only) in terms of this particular 'logic' have come to seem both coherent and compelling.

In most recent discussion, digital culture has generally been accepted on its own terms. There has been broad assent to its agenda of progress, and growing interest in the new techniques of observation made possible by post-photographic technologies (because this coincides with what we expect of 'technological revolutions'). This has meant that it has not been considered as a *culture*. To do so would involve the de-familiarisation of the Cartesian programme. What is it, we would have to ask, that drives the rationalisation of vision (assuming that it surely cannot be reason alone)? We would have to consider not only what is positively desired and pursued, but also what is at the same time being denied and repressed. In general terms, how are we to understand the hostility to what is 'merely' cultural, accidental and untrustworthy? What does it mean to seek 'liberation' from our culture? More particularly in relation to digital culture, how are we to make sense of the distrust of appearances, the 'look of things', and ultimately, perhaps even the visual itself?

Looking at the world again

In posing such questions, I want now to change the focus of the discussion. The debate on post-photography has become obsessed with the 'digital revolution' and how it is transforming epistemological paradigms and models of vision. The overriding concern is with formal and theoretical issues concerning the nature and the status of the new images. Strangely, we seem now to feel that the rationalisation of vision is more important than the things that really matter to us (love, fear, grief ...). Other ways of thinking about images and their relation

to the world have been devalued (we are being persuaded that they are now anachronistic). There is even the danger that the 'revolution' will make us forget about what we want to do with images – why we want to look at them, how we feel about them, how we react and respond to them. In the discussion that follows, I want to identify some other possibilities inherent in a changing image culture. I shall begin from experiences of images (rather than from new technologies and techniques), and from ways of thinking about image culture that are grounded in such experiences. Then I shall seek to locate these in the broader contexts of those aspects of modern culture that have been concerned, not with scientific and technological rationalisation, but, rather, with imaginative and political freedom. If the idea of postmodernity really means anything at all, surely it must be around such concerns of creative and democratic emancipation. It is in the context of these (modern and postmodern) agendas that we should now be thinking about the uses of images.

Are there ways, then, of proceeding constructively against the digital grain (without just becoming a counter-revolutionary, that is to say)? For me, this is a matter of whether it is possible to introduce, or re-introduce, what might simply be called existential dimensions into an agenda that has become predominantly conceptual and rationalistic ('severed from a human observer'). It is about our capacity to be moved by what we see in images. Let us begin with a deliberatively 'primitive' view of photographic images. For Roland Barthes, in *Camera Lucida*, the preliminary question is 'what does my body know of Photography?' (Barthes 1982: 9). Cognition is experienced here as a complex process, mediated through the body and suffused with affect and emotion. Where some images have left him indifferent and irritated, important others have 'provoked tiny jubilations, as if they referred to a stilled centre, an erotic or lacerating value buried in myself' (ibid.: 16). Barthes' project is to explore the experience of photography 'not as a question (a theme) but as a wound: I see, I feel, hence I notice, I observe, and I think' (ibid.: 21). One is in love with certain photographs, and one may be 'pricked' by pity at the sight of others. For Barthes, understanding the representational nature of these images cannot be separated from understanding the sensations – the touch – of desire or of grief that they provoke.

John Berger, who is similarly concerned with the nature of the relation between seer and seen, also works to (emotionally) deepen our understanding of photographic apprehension and cognition. Berger wants to explore other kinds of meaning than those valorised by reason. He is intent on reconnecting photography to 'the sensuous, the particular, and the ephemeral' (Berger 1980: 61). Against the grain of rationalism, Berger puts great emphasis on the value of appearances: 'appearances as signs addressed to the living . . . there to be *read* by the eye' (Berger 1982: 115). Appearances, he insists, are oracular in their nature:

> Like oracles they go beyond, they insinuate further than the discrete phenomena they present, and yet their insinuations are rarely sufficient to make any more comprehensive reading indisputable. The precise meaning of an oracular statement depends on the quest or need of the one who listens to it.
>
> (ibid.: 118)

The image reveals new possibilities: 'Every image used by a spectator is a going further than he could have achieved alone, towards a prey, a Madonna, a sexual pleasure, a landscape, a face, a different world' (Berger 1978: 704). What Berger emphasises is the relation between sight and imagination. 'Appearances', he argues, 'are both cognitive and metaphoric. We classify by appearances and dream with appearances.' It is creative imagination that illuminates and animates our apprehension of the world: 'Without imagination the world becomes unreflective and opaque. Only existence remains' (Berger 1980: 68).

Yet another aspect and quality of visual knowing is made apparent in Walter Benjamin's small history of photography. 'With photography,' Benjamin (1979: 242) argues, 'we encounter something new and strange.' Photographic technology can give its products 'a magical value'. Its beholder 'feels an irresistible urge to search such a picture for the tiny spark of contingency, of the Here and Now, with which reality has so to speak seared the subject' (ibid.: 243). Benjamin understands the nature of this visual magic with the help of Freud. 'For it is another nature', he says, 'that speaks to the camera than to the eye: other in the sense that a space informed by human consciousness gives way to a space informed by the unconscious' (ibid.). Benjamin thinks of the 'optical unconscious' as being in continuity with the 'instinctual unconscious' discovered by psychoanalysis. His well-known formulation remains tantalisingly brief and elliptical. We can appropriate it, I think, to explore the conflictual nature of knowledge and of feelings about knowledge. Consider Thomas Ogden's concise and lucid observation on the nature of unconscious processes:

> The creation of the unconscious mind (and therefore, the conscious mind) becomes possible and necessary only in the face of conflicted desire that leads to the need to disown and yet preserve aspects of experience, i.e., the need to maintain two different modes of experiencing the same psychological event simultaneously. In other words, the very existence of the differentiation of the conscious and unconscious mind stems from a conflict between a desire to feel/think/be in specific ways, and the desire not to feel/think/be in those ways.
>
> (Ogden 1986: 176)

We can see visual experience in terms of these processes of division. Visual cognition is grounded in feelings of both pleasure and displeasure: the desire to see coexists with the fear of seeing. The ambivalence in all object relations is, of

course, apparent in our relation to the objects of visual knowledge.

These various and different meditations on the nature of photography all serve the present argument in so far as they contradict any idea of purely rational seeing and knowing. In their distinctive ways, they aim to show us how vision also serves psychic and bodily demands, and how much it is also needed in the cause of sublimation and imaginative transformation. These existential aspects of image use have been most keen, no doubt, in the encounter with death and morality. Images have always been linked with death, and a particular kind of meditation on death has been a consistent theme in modern reflections on photographic culture. 'All photographs are *memento mori*,' says Susan Sontag (1979: 15). 'To take a photograph is to participate in another person's (or thing's) mortality, vulnerability, mutability.' Death is 'what is utterly mysterious for man', Pierre MacOrlan observed, and the power of photography resides in its relation to this mystery:

> To be able to create the death of things and creatures, if only for a second, is a force of revelation which, without explanation (which is useless), fixes the essential character of what must constitute a fine anxiety, one rich in forms, fragrances, repugnances, and, naturally, the association of ideas.
>
> (MacOrlan 1989: 32)

Roland Barthes (1982: 92) describes photographers as 'agents of Death', and photography as corresponding to the intrusion into modern societies of 'an asymbolic Death, outside of religion, outside of ritual, a kind of abrupt dive into literal Death'. Photographs relate to anxieties and fears in the face of mortality, and may then enable the imaginative possession and modification of those feelings.

But it can be otherwise. Another kind of response, which has been closely associated with the project of modern rationalism, can be to deny or disavow our mortal nature. As Horkheimer and Adorno (1973: 3) argue, the logic of rationality and rationalisation aimed at 'liberating men from fear' through the imperious force of reason: 'Nothing at all remains outside, because the mere idea of outsideness is the very source of fear Man imagines himself free from fear when there is no longer anything unknown' (ibid.: 16). Through rational control and mastery (over both nature and human nature), rationalism and positivism, 'its ultimate product', have sought to occlude the sources of mortal fear. We may consider digital technology and discourse as being in continuity with this project of rational subjection. Electronic images are not frozen, do not fade; their quality is not elegiac, they are not just registrations of mortality. Digital techniques produce images in cryogenised form: they can be awoken, re-animated, brought 'up to date'. Digital manipulation can resurrect the dead. William Mitchell (1994: 49) thinks of dead Elvis and the possibility now that we could be presented with 'a sharp, detailed "photograph" of him in a recognisably contemporary setting'. 'Bringing back Marilyn' is the example that occurs to Fred Ritchin (1990: 64).

Death-defying simulation is linked to powerful fantasies of rational transcendence. 'To lose sight of the unbearable,' says Régis Debray (1992: 33), 'is to diminish the dark attraction of shadows, and of their opposite, the value of a ray of light.' 'The death of death', he suggests, 'would strike a decisive blow against the imagination.' Of course, there is reason to believe that the rationalist dream will always be cloyed. With Roland Barthes (1982: 92), we must inquire as to the anthropological place of death in our culture: 'For Death must be somewhere in society' Do we really think it could be nowhere?

I am concerned that we should hold on to a sense of the complexity of image cultures, and, particularly, that we should continue to recognise the significance of other than rational uses of the image. In the context of the emerging digital culture, however, such concerns can only appear to be perverse and problematical. From the austere perspective of post-photography, they will seem 'innocent' and nostalgic. This version of a 'postmodern' image culture is devoted precisely to the critique and deconstruction of such dubious notions. The new information format is understood in terms of the emancipation of the image from its empirical limitations and sentimental associations; it is a matter, that is to say, of purifying the image of what are considered to be its residual realist and humanist interests. This is, in fact, the programme of rationalisation masquerading in the drag of postmodernism. What is so striking about it is its arrogance (in the sense intended by W. R. Bion (1967: 86) when he speaks of 'the arrogance of Oedipus in vowing to lay bare the truth at no matter what cost'). With its singular commitment to the rationalisation of vision, digital cultural has tended to deny or to devalue other uses of the image. It is no longer concerned with the image as transitional between inner and outer realities. If imagination means anything at all in this progressivist scheme, it is certainly not what John Berger (1980: 73) calls 'the primary faculty of the human imagination – the faculty of being able to identify with another person's experience' (which is all that could help Oedipus in his suffering). Belief in 'perfect' images seems to be inhibiting our relation to 'good enough' images. Consider Barthes' (1982: 53) observation that ultimately 'in order to see a photograph well, it is best to look away or close your eyes'. In a context of change (arrogantly called 'progress'), can we now sustain a vital *culture* of images?

The first question is whether we can see possibilities in this historical moment. Are we able to re-describe the context in which our image culture is being transformed, in such a way as to achieve a more radical understanding of what we could mean by 'postmodern'? It is a question of subverting the ideology of modernity (and postmodernity) as the progressive emancipation of rationality. We might begin from *Dialectic of Enlightenment* – in some ways a founding text of postmodernism – and its exploration of how, from the primordial 'cry of terror', a history of fear has shadowed the history of reason. The fear that is repressed returns as a cultural malady. For Horkheimer and Adorno, 'Enlightenment

behaves like Sophocles' tragic hero, Oedipus: it surely did liberate the species from the awful power of nature but also brought with it a new plague' (Rocco 1994: 80). The logic of rational mastery is always defeated by what still remains 'outside'. And mastery itself, moreover, may be associated with an (irrational) sense of loss, and with cultural undercurrents of melancholy and apocalyptic depression (Jay 1994). To say that we are postmodern would then involve recognition of how Enlightenment has failed by the same token that it has succeeded. We might understand postmodern sensibility in the way that Mladen Dolar (1991: 23) intends, when he says that 'it doesn't imply a going beyond the modern, but rather an awareness of its internal limit, its split ...' Following his insight, we might see postmodernity, imagined in a fundamentally counter-teleological sense, in terms of possibilities for allowing the return of what modern culture has repressed or disavowed. The real question then is whether we could look those possibilities in the face. The story of Oedipus is one of the struggle to evade painful realities through 'turning a blind eye' and of the retreat into omnipotence (Steiner 1985). There is a need to live with the unhappy conclusions that realistic insight would demand. A postmodern culture would have to look back at the repressed fears and unconscious forces that have haunted reason's progress.

And it should then be about their imaginative and political transformation. The modern world was not shaped by reason and Enlightenment alone. Johann Arnason reasserts the cultural and intellectual significance of Romanticism, emphasising the importance of the interrelation and interaction between these two cultural currents, and arguing that it is precisely 'this cultural configuration (rather than an irresistible logic or an uncompleted project of Enlightenment alone) [that] should be placed at the centre of a theory of cultural modernity' (Arnason 1994: 156). And of postmodernity, too. This other current is important in terms of the critique of Enlightenment (though, of course, there are as many problems with Romantic culture as with Enlightenment culture; each has come to our century in a debased form). It has been concerned with rationality's Other, with what was repressed by, and what remained 'outside', reason's comprehension. It also drew attention to our embeddedness in human cultures (and consequently in the cultural, accidental and untrustworthy). We can only come to terms with our human 'condition' in the context of particular human cultures. As David Roberts (1994: 172) argues, where Enlightenment pursued the principle of 'radical *abstraction* from the given', Romantic thinkers held on to that of cultural and historical '*incarnation*'. And where Enlightenment aspired to rational transcendence, the Romantic emphasis was on the powers of creativity and imagination necessary for the achievement of human and political emancipation.

It is in this spirit that Cornelius Castoriadis counters the openness of radical imagination against the closure of rationalist empire. What makes us human, he maintains, is not rationality, but 'the continuous, uncontrolled and uncontrollable surge of our creative radical imagination in and through the flux

of representations, affects and desires' (Castoriadis 1990: 144). Castoriadis seeks a productive accommodation between unconscious, imaginative and reasoning powers (which also involves confronting the fear of death) in the cause of human autonomy. It is a matter of achieving 'a self reflecting and deliberative subjectivity, one that has ceased to be a pseudo-rational and socially-adapted machine, but has on the contrary recognised and freed the radical imagination at the core of the psyche' (ibid.: 145). This, of course, involves recognising the existence of other people, whose desires may be in opposition to our own. Consequently, the project of autonomy 'is necessarily social, and not simply individual' (ibid.: 147). For Castoriadis, the project of bringing forth autonomous individuals and the project of an autonomous society are one and the same. What if we conceive the possibilities of postmodernism in this tougher and more radical way?

The point, let me reiterate, is to contest an overly rationalistic and imaginatively closed understanding of our changing image culture. It is to find other meaningful contexts in which to make sense of and make use of images. My suggestions of possibilities are intended to be brief and indicative only (and, surely, there are other lines of flight). What they aim to do is to (re)validate a world of meaning and action that is not reducible to rationality. Recall Barthes' individual encounter with the photographic image, moving from seeing and feeling, through attention and observation, to thought and elucidation. If you like, I am thinking of this kind of open sensibility in a social context, in terms of a broader culture of images. As Johann Arnason (1994: 167) argues, in the terms of Merleau-Ponty, such a project would be about recovering an openness to the world about 'relearning to look at the world'. Visual perception would be linked to 'a rediscovery and articulation of the opening to the world that is constitutive of the human condition' (ibid.: 169). How we look at the world relates to our disposition towards the world.

At this point, we must finally come back to the question of how new images and new technologies fit into this. We should consider again whether or how they might change the way we look at the world. One possibility is opened up by those art and visual historians, working in a Foucauldian tradition, who have sought to identify significant discontinuities and disjunctures in regimes or models of vision. Thus, in relation to the birth of photography, Geoffrey Batchen (1990: 11) argues that we must address ourselves 'not just to optics and chemistry but to a peculiarly modern inflection of power, knowledge, and subject'. Now we are facing the imminent demise of this photographic 'assemblage': 'The desiring assemblage that incorporates both photography and the modern subject is by no means fixed and immutable. Indeed it may already be reconstituting itself along yet another line of flight' (ibid.: see also Crary 1990). The death of photography now augurs a wholly new assemblage. This is what Batchen calls the 'postmodern prospect'. This kind of approach remains rather narrow in its focus, concerned almost exclusively with the relation

between vision and knowledge/power (though, in inscribing epistemological change in some kind of social context, it provides us with a meaningful way of looking at the rationalisation of vision). Within these terms however, it does show us how the look of things can be transformed, through the development of new forms of technological vision and new techniques of observation. At critical moments, it is argued, and usually through the advent of new technologies, the relation between vision and subjectivity can be dramatically changed. Older ways of seeing the world (in Mitchell's terms, 'sclerotic pictorial traditions') are dislodged, and at the same time new kinds of visual description become possible. There are possibilities for creative disruption. But at the same time, I would argue, these 'localised' shifts in techniques of observation may also make sense in the 'global' context of the developing rationalisation of vision. New ways of seeing may not be at odds with existing forms and relations of power in the visual field.

That is one way of thinking about the possibilities that may be available to us now (though it is still, I think, caught up in modernist notions of development and progress). Let me suggest another (which may be more postmodern, in the sense I am trying to elaborate). In this case, what are significant are not new technologies and images *per se*, but rather the re-ordering of the overall visual field and reappraisal of image cultures and traditions that they provoke. It is notable that much of the most interesting discussion of images now concerns, not digital futures, but, actually, what seemed until recently antique and forgotten media (the panorama, the camera obscura, the stereoscope); from our post-photographic vantage point these have suddenly acquired new meanings, and their re-evaluation now seems crucial to understanding the significance of digital culture. In this context, it seems productive to think, not in terms of discontinuities and disjunctures, but, rather, on the basis of continuities, through generations of images and across visual forms.

In his critique of Foucauldian analysis (Crary's version), David Phillips (1993: 137) recommends that we 'take into account the persistence and durability of older modes of visuality'. Against the idea of a sequential narrative of succeeding image cultures, and against the narrative logic of successive epistemological breaks, Phillips argues that 'vision operates instead as a palimpsest which conflates many different modes of perception – a model which applies both to the history of vision and to the perception of a singular observer' (ibid.). This seems to me a very productive metaphor (and one that can help us to resist both technological progressivism and epistemological evolutionism). Rather than privileging 'new' against 'old' images, we might then think about them all – all those that are still active, at least – in their contemporaneity. From such a perspective, what is significant is precisely the multiplicity and the diversity of contemporary images. In working against the grain of progressivist or evolutionary models, we can try to make creative use of the interplay of different orders of images. The coexistence

of different images, different ways of seeing, different visual imaginations, may be seen as an imaginative resource.

This was the fundamental issue in the exhibition, *Passages de l'Image*, held at the Centre Georges Pompidou in 1990. As Raymond Bellour (1990a: 37) expresses it in his contribution to the exhibition catalogue, it is 'the diversity of image forms that is now our problem', and the problem, by which he in fact means the solution, concerns the proliferation of '*passages*' or 'contaminations' between images. The mixes, the relays, the *passages* or movements between images, he suggests, are taking shape in two ways: 'on the one hand, an oscillation between the mobility and immobility of the image; on the other, between maintaining photographic analogy and a tendency toward de-figuration' (Bellour 1990b: 7, cf. Bellour 1990a: 38). There is a sense in which 'we are now beyond the image' (Bellour 1990a:56); a sense in which it is now more productive to think in terms of the hybridity of image forms. We must come to terms with new ways of 'seeing' through what might be called an-optical technologies. We can also recognise the potential of digital manipulation for effecting new forms of hybridisation (this is what William Mitchell (1992: 7) refers to as 'electrobricollage'). The artist, Esther Parada (1993: 445–6) talks about her attraction to digital technology in terms of the possibilities it offers for the 'shifting and blending' and the 'layering' of images (and texts); it allows, she says, 'the materialisation of linkages in time and space that enhance understanding'.

At the same time, we can acknowledge the persistence of photographic vision, and recognise that it will continue to actually replenish itself. Simply because I like it, take the work of Geneviève Cadieux, some of whose images featured in the *Passages* exhibition. Referring to its 'monumentality', Ingrid Schaffner (1991: 56) has argued that Cadieux 'deploys the conventions of sculpture to upset the passivity of our encounter with the plane'. Her photographic images revitalise our sense of seeing, and re-position it in relation to the sense of both touch and hearing (*Hear Me with Your Eyes* is the title of one of her pieces). Régis Durand (1989) emphasises the continuing possibilities – often, again, through the use of large-scale and 'heroic' formats, once associated with the 'fine arts' – for giving the 'force of evidence' inherent in the photographic image a renewed power to move and affect us. Where we might easily be drawn into thinking in terms of 'emergent' versus 'residual' image forms, a cultivated sense of ambivalence may be more imaginatively productive. We should aspire to be open to the force of all modes of visual representation and presentation.

In re-describing the transformation of photography in terms of the layering of images or in terms of *passages* of the image, perhaps we can take a stand against the arrogance of (technological and cultural) modernity. Perhaps we can work towards a better context in which to explore the emotional, imaginative, moral and political aspects of a changing image culture. In an essay on 'Psychoanalysis and Idolatry', Adam Phillips considers the significance of Freud's great collection

of graven images. 'So what was Freud telling his patients and himself by displaying his collection in the rooms where he practised psychoanalysis ...?' he asks (Phillips, A. 1993: 119). There are two speculative responses. Freud was saying that 'culture was history, and that this history ... could be preserved and thought about' (ibid.: 120); 'the dead do not disappear' (ibid.: 118), and on the recognition of this our psychic and cultural well-being may depend. And, second, Freud was also telling his patients and himself that 'culture was plural.... The figurines underlined the fact that there are all sorts of cultural conventions and worlds elsewhere, as many as can be found' (ibid.: 120). Is not Freud's relation to his idols suggestive for how we might now think of our own relations to images? The archaeology of images is linked to psychological excavation. And images are a means of being open to cultural diversity; they represent Freud's 'wishful allegiance to alternative cultures' (ibid.: 119).

We might inflect this disposition in more social and political ways. In contemporary political theory (of the anti-foundationalist kind) the idea of an absolute Truth is also called into question. In such a perspective, neatly summarised by Glyn Daly (1994: 176–7), the world can only be described through competing language games; it is 'permanently exposed to competing redescrip-tions', and, consequently '"truth" will always be conjuncturally put together as the result of a struggle between competing language-games/discourses'. What is significant is precisely the interplay between these competing descriptions, all originating from particular (and limited) positions. Fundamental issues 'will be conjuncturally settled by those narratives – novels, ethnographies, journalist writings, etc. – with which we identify and express our solidarity' (ibid.: 177). In this context, we could give some kind of political (rather than epistemological) meaning to the recognition that images can no longer be 'comfortably regarded as causally generated truthful reports about things in the real world' and that they might, in fact, be like 'more traditionally crafted images, which seemed notoriously ambiguous and uncertain human constructions' (Mitchell 1992: 225). We would then consider our image culture in terms of its productive diversity, and we would be concerned with the possibilities (creative and also technological) for originating 'new' – insightful, open, moving – descriptions of the world.

Everyone recognises themselves in the photo album.

Christian Boltanski

There is a prevailing tendency to think of digital technologies as being 'revolutionary', and to suppose that they are so in their very 'nature'. Throughout this chapter I have been arguing against such a position, suggesting that digital culture may, in fact, be seen in terms of the continuing rationalisation of vision (bringing this 'logic' to a new level of sophistication, and effecting a new accommodation between the rationalist and empiricist aspects of modern culture). I have endeavoured to move the discussion away from this predominantly

theoretical and philosophical perspective, and to open up a more cultural and political agenda concerning the changing image culture. This has meant reasserting the importance of vision (appearances) in cultural experience – beginning from the uses of vision, that is to say, rather than from technological novelty. In emphasising the symbolic importance of images, we can consider their development in the context of the counter-rationalistic tendencies in modern culture (now being critically re-examined by those who are concerned to revalidate imagination and creativity in our culture). I think we can then go further, to consider the increasing multiplicity and diversity of ways of seeing in the context of new (postmodern) ways of thinking about political and democratic life. These ideas remain tentative and exploratory. They are intended to suggest pretexts and contexts through which to find more open and meaningful ways to reappropriate our culture of images. I am not denying the formidable capacities of the new technologies; I am trying to give them some more relevant cultural and political location.

The future of images is not (techno-logically) determined. Different possibilities exist – as long as we can resist the comforts of determinism. To make them exist, we must think very carefully about what it is that we now *want* from images. The 'death of photography' is one of those rare moments in which we are called upon to renegotiate – and to re-cathect – our relation to images (old ones as much as new ones). In the end, images are significant in terms of what we can do with them and how they carry meanings for us. For some, this will indeed be a matter of exploiting the extraordinary power of the new technologies to 'see' the births and deaths of stars. Most of us, however, will have more mundane and personal concerns, because image culture – to adapt Raymond Williams's phrase – remains ordinary. Images will continue to be important – 'technological revolution' notwithstanding – because they mediate so effectively, and often movingly, between inner and outer realities.

References

Arnason, J. P. (1994) 'Reason, Imagination, Interpretation', in G. Robinson and J. Rundell (eds), *Rethinking Imagination: Culture and Creativity*, London and New York: Routledge, 155–70.

Barthes, R. (1982) *Camera Lucida : Reflections on Photography*, London: Jonathan Cape.

Batchen, G. (1990) 'Burning with Desire : the Birth and Death of Photography', *Afterimage*, January: 8–11.

Bellour, R. (1990a) 'La double hélice', in R. Bellour, C. David and C. van Assche (eds), *Passages de l'Image*, Paris: Centre Georges Pompidou, 37–56.

———— (1990b) 'The Power of Words, the Power of Images', *Camera Obscura*, 24: 7–9.

Benjamin, W. (1979) (1931) 'A Small History of Photography', in *One Way Street and Other Writings*, London: New Left Books, 240–57.

kevin robins

Berger, J. (1978) 'In Defence of Art', *New Society*, 28 September: 702–4.

———— (1980) 'Another Way of Telling', *Journal of Social Reconstruction*, 1 (1): 57–75.

———— (1982) 'Appearances', in J. Berger and J. Mohr, *Another Way of Telling*, London: Writers & Readers, 81–129.

Bion, W. R. (1967) *Second Thoughts : Selected Papers on Psycho-Analysis*, New York: Jason Aronson.

Castoriadis, C. (1990) *Le Monde Morcelé*, Paris: Editions du Seuil.

———— (1992) 'The Crisis of Marxism, the Crisis of Politics', *Dissent*, Spring: 221–5.

Crary, J. (1990) *Techniques of the Observer: On Vision and Modernity in the Nineteenth Century*, Cambridge, Mass.: MIT Press.

Daly, G. (1994) 'Post-metaphysical Culture and Politics: Richard Rorty and Laclau and Mouffe', *Economy and Society*, 23 (2): 173–200.

Debray, R. (1992) *Vie et Mort de l'Image: Une Histoire du Regard en Occident*, Paris: Gallimard.

Dolar, M. (1991), ' "I Shall be with You on your Wedding-night": Lacan and the Uncanny', *October*, 58: 5–23.

Durand, R. (1989) 'La force de l'évidence', *La Recherche Photographique*, 7: 9–11.

Gellner, E. (1992) *Reason and Culture: The Historic Role of Rationality and Rationalism*, Oxford: Blackwell.

Horkheimer, M. and Adorno, T. W. (1973) *Dialect of Enlightenment*, London: Allen Lane.

Jay, M. (1994) 'The Apocalyptic Imagination and the Inability to Mourn', in G. Robinson and J. Rundell (eds), *Rethinking Imagination: Culture and Creativity*, London and New York: Routledge, 30–47.

MacOrlan, P. (1989) (1929) 'Elements of a Social Fantastic', in C. Phillips (ed.), *Photography in the Modern Era: European Documents and Critical Writings, 1913–1940*, New York: The Metropolitan Museum of Art/Aperture, 31–3.

Mitchell, W. J. (1992) *The Reconfigured Eye: Visual Truth in the Post-Photographic Era*, Cambridge, Mass.: MIT Press.

———— (1994) 'When Is Seeing Believing?', *Scientific American*, February: 44–9.

Ogden, T. H. (1986) *The Matrix of the Mind : Object Relations and Psychoanalytic Dialogue*, New York: Jason Aronson.

Parada, E. (1993) 'Taking Liberties: Digital Revision as Cultural Dialogue', *Leonardo*, 26 (5): 445–50.

Phillips, A. (1993) *On Kissing, Tickling and Being Bored : Psychoanalytic Essays on the Unexamined Life*, London: Faber & Faber.

Phillips, D. (1993) 'Modern Vision', *Oxford Art Journal*, 16 (1): 129–38.

Quéau, P. (1993) 'La Révolution des images virtuelles', *Le Monde Diplomatique*, August: 16–17.

Ritchin, F. (1990) *In Our Own Image: The Coming Revolution in Photography*, New York: Aperture.

Roberts, D. (1994) 'Sublime Theories: Reason and Imagination in Modernity', in G. Robinson and J. Rundell (eds), *Rethinking Imagination : Culture and Creativity*, London and New York: Routledge, 171–85.

Rocco, C. (1994) 'Between Modernity and Postmodernity: Reading *Dialectic of Enlightenment* Against the Grain', *Political Theory*, 22 (1): 71–97.

Schaffner, I. (1991) 'Skin on the Screen', *Artscribe*, 89: 52–7.

Sekula, A. (1989) 'The Body and the Archive', in R. Bolton (ed.), *The Contest of Meaning: Critical Histories of Photography*, Cambridge, Mass.: MIT Press, 343–88.

Sontag, S. (1979) *On Photography*, Harmondsworth: Penguin Books.

Steiner, J. (1985) 'Turning a Blind Eye: the Cover Up for Oedipus', *International Review of Psycho-Analysis*, 12: 161–72.

Vattimo, G. (1992) *The Transparent Society*, Baltimore: Johns Hopkins University Press.

Ward, F. (1989) 'Images for the Computer Age', *National Georgraphic*, June: 718–51.

Weissberg, J. L. (1993) 'Des "reality shows" aux réalités virtuelles', *Terminal*, 61, Autumn: 75–83.

the elephant, the spaceship and
the white cockatoo: an archaeology of digital photography[1]

michael punt

2

> *As with the 'great man' theory of invention, technological determinism contains within it a kernel of unarguable fact: the state of technology at any given moment in film history imposes certain limits on film production. It marks out what is possible and feasible and thus makes more probable certain types of films and less probable or even impossible other types.[2]*

For all their crass reductionism and selective use of historical evidence technological determinism and the 'great man' theory of invention are seductive and useful models. But as J. L. Comolli was at pains to show, the cinema could easily have been invented in the mid-1800s and that even after its institutionalisation in popular culture, its technological possibilities were not exploited.[3] Geoffrey Batchen reminds us that photography was a viable process for at least a hundred years before Nicéphore Niepce and he lists twenty-four prior claimants to its invention. For him the question is not who invented photography but 'at what moment did photography shift from an occasional, isolated individual fantasy to a demonstrably widespread social imperative?'[4] Batchen's suggestion is that the invention was the articulation of the idea of a machine which writes itself, and this is evident from its name 'photography'.

However, in spite of overwhelming evidence that society is not shaped by the inevitability of technological progress, determinist explanations retain their seductive glamour and rhetorical force. To use Leo Marx's example, this kernel of unarguable fact is like the sunset reflected in the water of the Mississippi. He cites Mark Twain, who began life as an apprentice river pilot.

> [When he learned] ... the pilot's way of seeing beneath the water's surface, the river became a new and wonderful book to him. Now instead of delighting in the reflections of a splendid sunset on the water, he saw in almost every pleasing detail of line or colour the sign of hidden menace: a bluff reef or dangerous current or new snag.[5]

What the pilot sacrificed for his esoteric knowledge was the passenger's passive pleasure of the inevitability of a sunset drifting by. But neither were the pilot's delicate negotiations between ship and currents a totally satisfactory account of the river trip. The sunset will keep on happening, and individually, both pilot and passenger are unable to explain why the ship was cruising the Mississippi. Each sees the cause of the journey in the needs of the other. Leo Marx's claim is that to describe American culture one must synthesise the contradictory experience of both pilot and passenger. His method is to search for what he and other members of the 'myth and symbol' school call paradigm dramas, and to expose within them the 'elucidation of conflicts between radically opposed views of the same persons, events, institutions, policies, and practices'.[6] This method is especially useful in looking at the nineteenth century when new technologies produced significant visible changes to the landscape.[7]

Leo Marx's project suggests an archaeological examination of the representation and interpretation of the American experience which might explain what the pilot and passenger cannot. This essay is an archaeological study which proposes that technological change might be better understood (and its development more intelligently predicted) by examining the conflicting responses to it on the basis of its representation in popular culture. It will interrogate these representations for evidence of both the pilot's and the passenger's experience as a unified discourse which shapes the interpretation of technological change and determines the emphasis of further change. It will look at three technological 'sunsets' (paradigm dramas – each an image of glory) for the navigation marks in the pleasing detail of line or colour, for signs of menace and pleasure which might show traces of the negotiations between technology and those who own it, those who oppose it, those who use it and all of us who interpret it. What it will claim is that from the Enlightenment onwards, science, technology and entertainment formed a single discourse which in the last decades of the nineteenth century abruptly ruptured and fragmented into discrete hard walled frameworks of explanation. It will show how that rupture was a product of a compromise between public spectacle and professional control. It will argue that as our own century closes, there may be a similarly abrupt rupture as science, technology and entertainment reconsolidate in the instrumented realities of digital technologies. This is not to propose a mellow euphoria as old values are reaffirmed. On the contrary its conclusion is that unfamiliar historical and theoretical frameworks must be used to examine digital technologies even though their manifestations may bear a passing resemblance to earlier forms.

For those who are happy to be postmodern passengers, this essay will seem anachronistic and 'nineteenth-century' relative to the current sunset drifting by on the information superhighway – after all late capitalism's oeuvre is consumption and determinist euphoria can be entertaining.[8] Rosalind Williams argues that the dominance of determinist explanations of technological change is an essentially bourgeois delusion. She claims that celebrations of sublime technological achievement place the emphasis on the active spectacle rather than the active spectator, and that this is a device to mask the commodity nature of labour and the commercial determinants of new technology.[9] In this distraction the kernel of truth in the spectacle is exaggerated and deprives culture of any real participation in the construction of meaning.

The first technological 'sunset' is Joseph Wright of Derby's spectacular account of an evening's instructive entertainment experimenting with the latest scientific apparatus. *An Experiment On A Bird In The Air Pump* (Figure 2.1) was finished in 1768. It is a painting which simultaneously doubts the wisdom of science as it celebrates its rationalism. The history of the ownership and reception of this painting appears to be one of increasing popularity and importance. It was initially a

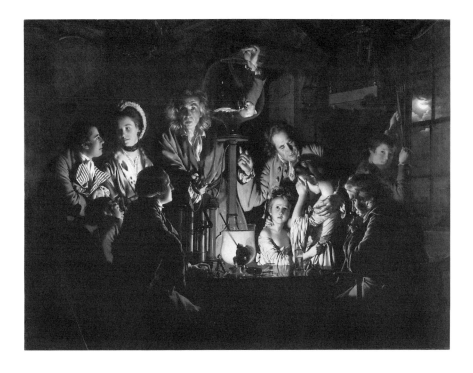

Figure 2.1 Wright of Derby, *An Experiment On A Bird In The Air Pump*, 1768, 72 inches × 96 inches. Reproduced by courtesy of the Trustees, The National Gallery, London.

bourgeois artifact for restricted consumption. It was sold by the artist Joseph Wright to Dr Bates who in turn passed it to Edward Tyrell. He presented it to the National Gallery, London, in 1863 where its audience widened. The National Gallery loaned it to Derby Art Gallery from 1912 to 1947. Whilst there, ownership was transferred to the Tate Gallery, London in 1929, where it hung from 1947 as a popular exhibit until it was reclaimed by the National Gallery in 1986.

For all its contemporary radical speculation and novelty, Wright's painting now resonates with the current appetite for nostalgia and technology. It is a painting which, to a late twentieth-century reader, is tactically ambiguous and all the more satisfactory for that. It both celebrates and challenges the claims of rational science depending on where you chose to stand. But for Wright the painting seems to have been a representation of science, technology and entertainment, as a single dialectical discourse of science and conscience whose *frisson* was in the danger and instability that its new world view proposed. (As a textual economy this discourse will be referred to in this essay as 'science' to distinguish it from twentieth-century science.)[10]

The painting shows a demonstration of a 'scientific' procedure in a bourgeois domestic space. Such demonstrations were a popular diversion for the eighteenth-century intellectual and amateur scientist. The drama of the 'scientific' demonstration shown here is a familiar repetition of established experiments within the matrix of spectacle and domestic organisation into which women and girls were easily integrated. The original appeal of the painting, as Benedict Nicholson points out in the standard work on Wright, derives from a time when 'popular interest in the wonders of science was growing, disseminated by travelling lecturers on pneumatics (the air pump), astronomy (the orrery), optics and other subjects'.[11] Wright himself had a deep interest in 'science'. He was a member of the Lunar Society, which was established in the 1770s, and met monthly to conduct experiments and discuss new developments in what we now call science and technology. To understand the subject matter of this painting it is necessary to consider the cultural (and epistemic) context of the demonstration.

'Scientific' demonstrations, and the lecturers who delivered them, formed a productive and respected strand of 'scientific' research. Venues for such demonstrations varied from the private domestic space depicted by Wright, to public rooms and peripatetic entertainments. Such was the popular enthusiasm for scientific knowledge that by the beginning of the eighteenth century purpose-built halls were offering fixed displays and lectures to the general public. These later became vulgarised in some instances into the mere spectacle of freak shows, conjuring and an excuse for drinking.[12] However these early public displays were not mere popularisation of professional 'scientific' work – they were regarded as 'scientific' work. Their experimental observations were respected and added to the empirical evidence which had to be accounted for. Moreover the constraints and economics of these displays (simplicity, reliability and portability) prompted

michael punt

research into miniaturisation and simplification which frequently led to quite new and significant discoveries.

The lecturers themselves were intensely practical in their problem-solving. Moreover, like the nineteenth-century practical electrician, many of their discoveries were in advance of contemporary theory. They were frequently instrument makers by profession, and in Wright's painting the lecturer could well be demonstrating the various pieces of apparatus to sell them. Instrument maker's shops also frequently served as informal academies and information exchanges. Their method of research practice and its body of knowledge was eventually marginalised towards the end of the nineteenth century by an academic professorate whose institutional structures and theoretical method-ologies sometimes conflicted with the sophisticated techniques of practical scientists.[13]

Experiments with the air pump were a popular part of the repertoire of the itinerant lecturer, and there is evidence that these pumps became a feature of domestic cabinets of curiosities quite soon after their introduction in 1757. The usual demonstration was to place a live animal in the bell jar and evacuate the air. The creature either expired or, if air was readmitted in time, it revived. In the 1760s this destruction of animals was thought to be distasteful, and a bladder or lung glass was frequently used instead. Wright, however, describes the more barbaric version of this experiment and raises the stakes by using an unusual and unlikely animal, a white cockatoo. He shows the bird on the point of expiring, at the moment when the lecturer can, if he wishes, save it from death by opening the valve at the top of the jar. This use of a beautiful and exotic creature is calculated to raise the emotional impact of the picture and Wright describes the possible reactions to this event in his depiction of the audience.

Like Hogarth before him, Wright uses an assembled group to show a spectrum of subjective responses to a social event. In this case they vary from the detached but attentive young men in the foreground, to the two lovers' lack of interest in anything but each other. On the lecturer's left, a consoling father seems unable to impress either daughter with his explanations of the experiment; one refuses to look and the other is frankly sceptical. Of the remaining people, the boy, who, as Frazer observes, reiterates a figure in Hogarth's print, *The Rewards of Cruelty* (a description of an anatomy lesson), waits to see if the cage will be needed again.[14]

The subject of the painting extends beyond a documentary visualisation of a scientific demonstration to include a description of the place of the viewer in a subjective economy of reception. The drawing room is full and intimate, there is much touching and body contact in the onlookers. The composition of the painting is circular with a strategic gap through which the viewer can join with the spectacle. Indeed the lecturer looks beyond his immediate audience to the invisible viewer, inviting approval and even awaiting some sign of recognition before he will readmit air into the jar.

There is an exception to the conviviality. The seated man in the right foreground is detached as he reflects on the philosophical moment of the experiment. He ignores the bird and directs his attention (and ours) to a skull in a jar of fluid illuminated by a candle, seeming to extrapolate from the material demonstration the metaphysical implications. This figure gives yet another window of meaning to the picture – as a vanitas or *memento mori*. The 'philosopher' reminds us of the artificial light source, the candle, which is juxtaposed with the skull to suggest the inevitable reality and unpredictable suddenness of death. Meanwhile, in a gesture which, within the diegetic logic of the painting is inconsistent and equally enigmatic, the lecturer controlling the experiment extends the hand of reason to us the viewer, whom he cannot see.[15]

The riddles of human transience also extend to the formal properties of the painting, particularly in the use of light. Elaborate scientific illustrations were common in the eighteenth century. These were executed by skilled but frequently anonymous artists and were impersonal artifacts. But Wright identifies himself in the painting by a distinctive *mise-en-scène* using dramatic lighting effects. The identifiable source of light not only adds considerable emotional drama to the painting but it also invests it with an illusion of an objective truth. In this picture light is described as the agency which makes the objects visible and representable. Its consummate. representation is evidence of Wright's skill and particular presence as the artist, but the more forcefully the style exerts this, the more we are reminded of the artist's corporeal absence. The objective representation of the scene, its highlights and shadows, can be verified by a simple geometry. But scientific confirmation of reality is simultaneously suggested, by the *memento mori* (and Wright's absent presence) as a human conceit – an artificial code of representation and understanding. This is reiterated by the painting's symbolic use of light. For the Enlightenment, light was a popular metaphor for reason, knowledge and science. Inside the drawing room this logical light casts its geometric system over figures and objects alike. Outside, however, we glimpse the full moon, a heavenly body with a false light whose depicted phase not only regulated the meetings of the Lunar Society, but is also synonymous with romantic love and madness – both present in the drawing room in the lovers' looks and perhaps the unnecessary torment of the white cockatoo.[16]

In 1768, *An Experiment On A Bird In The Air Pump* was not the cultural property of a mass audience, the image was clearly intended for consumption by a privileged elite, in this case Dr Bates and his friends. However, Wright, as an artist of the Enlightenment, regarded himself as speaking on behalf of the generality of man, and we can take the painting as a reflection of a widely held view rather than idiosyncratic vision. This reading of his painting privileges an eighteenth-century discourse of 'science', technology and entertainment. It shows it as an undiffer-entiated mixture in which the exposition of a rule base system for describing the world destabilises and partially disempowers the audience in return for a striking

michael punt

spectacle and a thrilling problematic. It is the entertainment contract of the circus, the roller-coaster, or the live television broadcast in which the maximum of anxiety is experienced with the minimum of danger.

Perhaps the most striking feature of the painting for the modern viewer is the contrast between its familiarity as an idealised image of family entertainment, an intimate group around a glowing attraction, and its unfamiliarity as a scene of serious scientific research. For one thing painters are no longer attracted to such subjects, for another there is a great deal of bodily contact and touching going on, and for another, the casual passer-by is directly invited into the scene by one of the figures of authority – the lecturer. By today's standards the whole *mise-en-scène* seems unscientific, even alien.

Throughout the eighteenth century and for most of the nineteenth, British 'science' was an intensely practical and public matter. William Sturgeon, for example, was a professional soldier who, on resigning his commission, became a boot maker. He also lectured on the natural science from time to time. Of especial interest to him was the Oersted effect which demonstrated a relationship between electricity and magnetism. Demonstrating this required the sophisticated resources of the Royal Society which Sturgeon did not have access to. The imperatives of portability, reliability, spectacle, and above all economy which his activities imposed on him led him ultimately to invent the electromagnet in 1825 in order to show the effect publicly.[17] This invention was of profound theoretical significance since it proposed a unity between what were hitherto the separate sciences of magetism and electricity. During the nineteenth century, as I. R. Morus observes, '[n]o clear line could be drawn between the discourse of the laboratory and the discourse of the lecture theatre'.[18]

Sturgeon, among others, encouraged a wider public to engage with the ideas and practices of science and technology in their work and leisure. Organised instructive entertainments ranged from the proliferation of public lectures on 'science' to special exhibitions and purpose-built halls like the Adelaide Gallery of Practical Science, London. Touring exhibitions and displays took over theatres, opera houses and other public rooms. The Regent Street Polytechnic founded shortly after the Adelaide Gallery was built to meet this demand. It outdid it in scale in every respect with huge projection screens (425 square feet) and, by 1848, a 1,000-seat lecture hall. Richard Altick suggests that after the 1830s there was a perceptible shift in the emphasis of these entertainments away from philosophical fireworks towards chemical fireworks. By the mid-1860s the meaning of this shift had become clear as the attraction of science was institutionally exploited to create a crowd and sell other products, especially alcohol. To some extent the great exhibitions in Paris and at the Crystal Palace sated the public appetite for such displays and attendance declined somewhat. Nevertheless the vogue for massive expositions continued well into the twentieth century, with World fairs at Chicago, Buffalo and St Louis in the decade spanning 1900 attracting 50 million people.[19]

As the nineteenth century wore on, however, attempts were made to relegate those more at home in the lecture theatre to a second order. The resistance of the professorate to the practical electricians was more than the general distaste for practical arts which was inherited from Renaissance 'science'. There was also a conviction (also inherited from the Renaissance) that abstract representations – words and mathematical symbols – were the prerogative of the higher social orders. But the real hierarchical struggle was grounded in the formation of a career structure developed by a professional elite to regulate the control of knowledge.[20]

What seems to be at stake in these debates is the distinction between different kinds of intellectual activity. How these have been valued, how they are socially distributed, and who owns them is a matter of cultural negotiation. The outcome in 'science' was that by the turn of the century technology was differentiated as a discourse which was parasitic on science. Through the founding of a professorate and a career structure within the established academic institutions and Royal Societies, a piece of cultural property was appropriated and formalised in a restrictive discourse, access to which was governed by these institutions.

This struggle for the control of knowledge can be traced quite clearly in the editorial policy of scientific journals. The traditional epistemological method of individual experiments which characterised early 'science' required a system of information exchange which was more rapid than the book; this favoured the learned journal as a public forum. From the *Journal des Scavans*, first published in 1665, a steady increase in international publishing developed to around 700 titles by the time of Wright's painting.[21] Among other things they provide news in the vernacular (not Latin), a framework for critical discourse, an archive, and a college. Such was the strength of popular interest in science that the cumulative number of titles rose between 1800 and 1885 from 750 to 5,100.[22]

In Britain and France the imperatives of social stability also shaped the pattern of scientific publication. Scientific periodicals existed in Britain well before the 1800s, but in the nineteenth century improving scientific journals began to be published at relatively cheap prices as a consequence of 'technological advances in the printing trade, less restrictive legislation and taxation, along with increased demand from a more literate and leisured public'.[23] The proliferation of cheap improving literature during the nineteenth century was also motivated by, among other things, social reformers who saw the dangers of a literate public satisfying their appetites on seditious or pornographic tracts. The dissemination of useful knowledge, particularly scientific knowledge, was popular among the titles.

The British publications of the period were serious journals and built upon the entertainment customs and practices of the privileged. They were designed to structure the leisure time of the reader into a productive entertainment and contributed to a 'trickle down' of middle-class habits. They advocated the

universality of science, claiming that specialist knowledge was not necessary; instead there should be the observation and careful collection of specimens which would lead, eventually, to new knowledge. It was claimed that the farm worker, machine minder or professional were equally capable of contributing to scientific knowledge. This supported professional scientific research with its preference for empirical method. Their form, editorial, and view of science met the demands of social reformers and reflected a bourgeois ideal of controlled change rather than the unpredictable flair of a revolutionary genius. There were different kinds of journals. Between 1820 and 1875 mechanics' magazines directed at artisans were as cheap as one penny per week. Natural history periodicals were initially few and expensive but they too became more common and considerably cheaper, although the titles were reduced in the 1860s. Between these two genres were general science periodicals which became prolific and cheap from the 1830s onwards.

In keeping with the inductivist tradition in science, British journals generally prioritised 'low' scientific method which favoured the true amateur. Editorials were openly antagonistic to the mystifications of the professional scientist and they vigorously rejected theoretical and speculative (high) science.[24] The editors were less concerned with the trajectory of high science than the engagement of their readers in practical (low) science. Many journals were extensively illustrated, they avoided technical language and the practical participation in science was encouraged. In particular the journals promoted fieldwork and the steady accumulation of data as the preferred scientific method. Question and correspondence columns were extensive and they constantly urged their readers to take part in projects and join local groups. They further encouraged reader participation by reporting extensively on the proceedings of amateur scientific societies which increased rapidly at the beginning of the century (using the model of more exclusive gatherings like the Lunar Society).

To some extent this progressive accretion of material which characterised 'low' science was reflected in the production method of the publications. The cheaper journals in particular generated little original copy, but instead relied on previously published articles which they either sub-edited, condensed, or openly collaged. This last method was thought to be in some sense democratic, making expensive material available cheaply whilst at the same time providing the stimulus of variety and novelty. After 1860, however, the journals responded to the pressures of changes in professional practices in the sciences and this production method was easily adapted to produce a different kind of magazine.

Increasing professional specialisation and distinctive branches of science with regulated discourse and claims to expertise led to the demotion of 'low' science with its emphasis on the inductive and experiential.[25] By the end of the century British scientific periodicals had changed. Their primary objective was to make the achievements of professional scientists available to a lay public rather than enlist

the efforts of the layman in scientific activity. They turned their attention to reporting practical achievements and advocating support for the professional scientific project. In their editorial policy, the practical participation in science became less important than keeping abreast of the latest discoveries and inventions. They no longer supported the active participation of the non-specialist but instead offered the more passive spectatorial pleasures of a catalogue of achievements.

The editorial policy of British science periodicals of the late nineteenth century seems to confirm that changes in the professional practice of scientists which sought to marginalise the practical scientist – the itinerant lecturers of Wright's painting and the likes of William Sturgeon – also precipitated a different kind of popular engagement with science and technology. Science and technology became something to be passively witnessed as cultural progress rather than a personal enlightenment to be experienced. Popular practical engagement with science became a more frankly domestic or spectacularly public amusement.[26]

From the vantage point of the late twentieth century it is tempting to see the formation of professional science as an evolutionary teleology. Methods and philosophies are refined to achieve maximum efficiency in response to techno-logical change, particularly in instrumentation. But this idea is coming under critical pressure from a number of historical and philosophical positions. Some of the most provocative use methodologies most usually associated with anthro-pology (Bruno Latour for example) and sociology (Bijker, Pinch, Law, *et al.*) as well as revisionist histories of science (especially Simon Schaffer). The historical evidence of public displays and popular science journals also suggests that this evolutionary teleology is unsustainable. Instead it indicates that, around 1860, a number of things happened which precipitated an abrupt change in the formation of a discourse which had hitherto been a relatively undifferentiated mixture of what we now call science, technology and entertainment. One change was that a part of that discourse (which might at one time have been called natural philosophy) became detached for social and economic reasons, to re-form itself as *science*. Science progressively distanced itself through social (mainly academic) institutions and methodological barriers whilst at the same time acquiring from the popular discourse key pieces of intellectual property.

One means by which the new professional discourse of science became restricted was as a consequence of the suspicion with which human perception and the senses became regarded as unreliable witnesses. Standards of objectivity were set which were unavailable to the amateur observer. Scientists felt the need for instruments which could objectively record the physical world. Unlike the air pump which interrogated the physical world, these instruments made claims about it and formed the technological basis of science. However there was some return to the public domain in the form of the entertainments which these instruments provided. Often they showed the ease with which the perceptions of

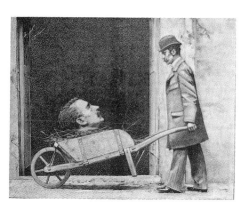
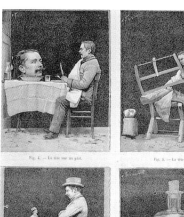
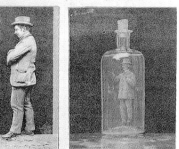
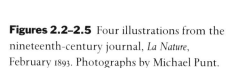

Figures 2.2–2.5 Four illustrations from the nineteenth-century journal, *La Nature*, February 1893. Photographs by Michael Punt.

the layman could be fooled. Among the articles which appeared in popular science journals during the second half of the century were conjuring tricks and games with inventions which either replicated or amplified human perception, for example photography, stereoscopy, microscopy, chronophotography and cinematography. These articles sometimes sit strangely in science journals and strike

the modern reader as rather surreal. *La Nature* (Figures 2.2–2.5), like the other popular science journals, and the public exhibitions, lectures and World fairs, began to delimit science by taking its laboratory apparatus – instruments which were used to support claims about reality – and present them as mysterious marvels by presenting them as amusing spectacles and entertainments.[27]

Science's secessionist impulse provoked plural meanings to be given to its technological innovations. Some instruments were temporarily seen as both professional and public property before they were either withdrawn into the laboratory as with the x-ray, or abandoned to entertainment like the cinématographe. The initial attraction of the cinématographe was as a technological spectacle. For a brief period it occupied an unstable territory between science and spectacle, entertainment and technology. Audiences at the first seances were drawn not so much by the prospect of moving images (which they were quite used to seeing in magic lantern shows and the Mutoscope for example), but by the particular machine ensemble. The cinématographe projected the image and gave an illusion of movement in all planes of recession which seemed to be grounded in the real world. As technological spectacle its chief attraction was the compulsion to look at that which is difficult to understand – namely its own uncertain claims. The film image, like the photograph, seemed at moments to write itself by virtue of the coexistence of its different meanings as science and technology.[28] It produced both a visual analogue and an instrumented reality; on the one hand it replicated vision whilst on the other it stood in for it as a more reliable observer than the human.

This scientific provenance is reflected in the subjects of many films. Miscellaneous scientific and actuality films formed the bedrock of early cinema programmes and remained in the catalogues until well into the teens. *Electrocuting an Elephant* (Figure 2.6) is an interesting example of the genre especially because it typifies scientific films as well as recording an autonomous entertainment which was publicly staged. It is a one-minute film (78 feet) shot by Smith or Porter on the site of an amusement park at Coney Island on 4 January 1903.[29] The destruction of an elephant aroused high emotion in the crowd of onlookers, but this was not reflected in the catalogue listing of the film.[30]

The film shows the electrocution of a rogue elephant. It was described (a little inaccurately) in the Edison film catalogue of February 1903 as follows:

> Topsy the famous 'baby' elephant was electrocuted at Coney Island on January 4, 1903. We secured an excellent picture of her execution. The scene opens with the keeper leading Topsy to the place of execution. After copper plates or electrodes were fastened to her feet 6,600 volts of electricity were turned on. The elephant is seen to become rigid, throwing her trunk in the air, and she is completely enveloped in smoke from the burning electrodes. The current is cut off and she falls forward on the ground dead.

(A crowd of 1,500 people witnessed the event but they are not in evidence. Although there are some figures in the background there are no reaction shots to speak of.)

Topsy was imported at the age of eight in 1875 and trained to perform tricks as entertainments. In 1900 she attacked and killed her first keeper. In the same year at Paris, Texas she killed another. In May 1902 she killed a man at a circus who gave her a lighted cigarette to eat. After this she was sold to the owners of Lunar Park and used in its construction, and as an attraction for visitors to Coney Island. The elephant was destroyed, according to contemporary reports, because she had become bad tempered and chased the workmen from the building site where she was eventually electrocuted.

The original plan was to garotte the animal, but the Society for the Prevention of Cruelty to Animals raised objections on the grounds that it would cause unnecessary suffering. It seems that Edison saw a publicity opportunity in becoming involved, and alternative options were seen in the newer technologies of poisons and electricity. Topsy was given a carrot drugged with 450 grains of potassium cyanide just before a switch was thrown which passed a huge voltage through her body. Had these methods failed then winches were rigged to strangle her. This last strategy was not needed and Topsy died as a result of high voltage electricity (at least as far as the public was concerned).

The electrocution itself was staged as an attraction to which 1,500 people came – a rather small crowd for a Sunday afternoon at Coney Island. Topsy's destruction was fully reported on the front page of *The World*, 5 January 1903. The reporter's account is a highly colourful sensational description written for a popular newspaper.[31] If the absolute accuracy of his report is suspect, he was nevertheless reflecting the specific appetites of his readers. He speaks of a confused amalgam of breathless excitement, astonishment and pity as the beast, described as both vicious and docile, is led to the execution point. The newspaper reports (contrary to the Edison catalogue) that her keeper refused to take part in this event even when he was offered $25. Notwithstanding the purple prose of the unnamed journalist, he reports an inconsistent mixture of responses which uncannily mirrors those in *An Experiment On A Bird In The Air Pump*. He describes the coexistence of fascination, pity, horror and delight. In his account of Topsy's keeper, who fled for Manhattan rather than be nearby 'during the death of his old friend', we find a trace of Wright's sentimental lovers.

For all its resemblance to Wright's painting, the chief difference in *Electrocuting an Elephant* lies in the absence of an audience or an invitation to the viewer to enter into the representation. One way to account for this is by the changes in the popular engagement with science and technology which the periodicals seem to reflect. Edison's film can be seen as scientific instrumentation, it has the appearance of a representation without a point of view. The shots are chronologically sequenced and the cuts between them are unmatched.

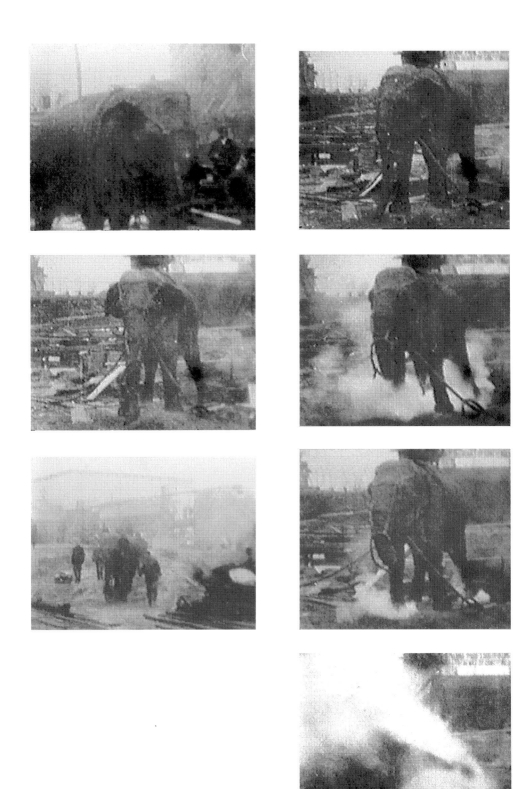

Figure 2.6 Electronically mediated images from *Electrocuting an Elephant*, Edison Manufacturing Company, 1903. (Clockwise from bottom left.)

Information is presented in blocks which are determined by the structure of the event. The first shot shows us that the animal was brought to a specific place, the second that when it was there it was electrocuted until it fell over. The film has the appearance of a scientific record of an event which is unaffected by the instruments of recording. In this sense it is more an instrumental reality than a representation. On the other hand it is evident from the framing of the scenes that the execution had been choreographed for the camera, perhaps even rehearsed, and that the purpose of the film was to present the scientific event as an attraction for passive consumption and draw an audience for Edison's technological achievements.

In Edison's film there are no shots of the audience because, by the turn of the century, the fragmented discourse of science, technology and entertainment required a disembodied observer, who could either remain scientifically detached or passively marvel, depending on which discursive framework they adopted. The lay audience of these films were compensated for their exclusion from the scientific discourse by the thrilling problematic of seeing an image of a bodily collapse and a technological apotheosis to which they had no access. An experience in which the level of anxiety was disproportionate to the danger; a characteristic which became dominant in cinema's entertainment mode.

The cinématographe was eminently suitable as a passive entertainment because it provided the illusion of a pure unmediated representation of reality produced by a machine with no space for human intervention; in twentieth-century jargon, a bachelor machine which 'writes itself'.[32] In science however, the cinématographe reached the limits of its scientific relevance with Janssen, Marey, Demney, Londe *et al.* It showed that it could provide images of the world which could be used to calibrate changes over a period of time which had a claim to truth. But it could not provide authentic data about the spatial organisation of reality without the mediation of an interpreter since it was a technology which was based on an easy deception of the eye. Although Marey's chronophotographs could scientifically calibrate the regularity of a horse's heart, it could not be relied upon to authentically describe its appearance. By the middle of the nineteenth century, the contract between visual perception of the world and the real world was understood as unreliable. As Jonathan Crary points out, Wheatstone's stereoscope, which proved a disjunction between perceptual experience and its cause, was one of the many contributors to this significant epistemic rupture in the nineteenth century.[33] In the prevailing scientific culture the cinématographe could not be relied upon to provide data – the spatial organisation of temporal events – except in highly specific conditions.[34] Its bachelor status was, after all, an illusion. It could however provide information to be interpreted, and instead of being abandoned, the apparatus was developed in a technologically minimal way by speculators and entrepreneurs – itinerant lanternists, showmen, and instrument makers, as a public spectacle to eventually become *the* twentieth-century

institutional entertainment of the cinema.

Early cinema audiences were prepared for this experience of technology as entertainment by, among other things, people like Georges Tissander. He was not only a scholar, the influential editor of *La Nature*, and broker of ideas (it was he who brought Marey and Muybridge together), he was also 'a well-known expert in ballooning and a daring voyager, a lover of the picturesque and the exotic'.[35] Like Felix Nadar, he saw the coupling of daguerreotype and air travel as a means of producing new views and landscapes. The vast photographic panoramas which they produced built upon an established popular audience which Daguerre himself had exploited with travelling exhibitions of large paintings.[36] The military implications of this machine ensemble were not missed. R. M. Eder claims that the cinématographe was a failed attempt to enhance the legibility of stereoscopic photographs in aerial reconnaissance.[37] Although the cinématographe was thought to have only a restricted validity, in a number of modes, high speed photography and especially aerial photography, it formed a powerful homology of the scientific observer's instrumented reality and spatial detachment.

The twentieth-century partitioning of instrumentation and spectacle is strikingly illustrated in a high profile project like the American space programme. Initially it captured a public imagination and an enthusiasm for American science to the extent that it was prepared to support NASA with substantial funds, but this support dwindled as the novelty of the spectacle waned.[38] Russian success in manned space flight in 1957 challenged American self-esteem.[39] In 1961 President Kennedy announced that the objective for the US space research programme was to put a man on the moon (an objective which was finally achieved in 1969). It appealed to the frontier spirit which, in 1894, Frederick Jackson Turner claimed lay at the heart of American culture.[40] But with the natural conclusion to the project, and new robotic technology, further research into manned space flight did not seem entirely necessary. As a consequence NASA failed to attract its accustomed budgets. Eventually a successful bid strategy which could support a rolling budget was accepted. This was a space shuttle programme which was linked to the goal of building an orbiting space station. It involved serial objectives and a high profile public display.

The shuttle programme, unlike Russian, Japanese and the European projects, involved multi-tasked manned flights. In a complex ideological and financial arrangement, American science was given funds for space research in return for the delivery of some basic technology which would provide the spectacle of regular manned flights. These had to have sufficient commercial payloads and satellite maintenance contracts to reform NASA into an economic institution which could also serve national interests. It was a tripartite agreement between the separate interest groups of science, technology and entertainment and their independent paymasters – the government, the military, the rocket industry, research foundations and television networks, etc.

The American space shuttle programme constitutes a re-convergence of science, technology and entertainment, eighty years after Edison electrocuted Topsy, which has much in common with Wright's world.[41] The first launch was on 12 April 1981.[42] Four missions were flight tests combined with earth observation and measurement (earth sciences), astronomical observations, and military research. Subsequent missions included communications projects, commercial satellite delivery, orbit correction and repairs, as well as scientific multidisciplinary projects. The Department of Defence had first option on the payload space on shuttle flights, and between 1985 and 1988 there were three missions which were exclusively military, some linked to the SDI (Star Wars) project which was seen by many as concept dependent on video games. Initially the launches attracted huge television audiences, but by 1986, the time of the shuttle flight 51L, the *Challenger* disaster, public interest had dwindled to the extent that the three main American networks did not carry the launch live. The only coverage was on the Cable News network. Christa McAuliffe, a teacher, the first 'ordinary American' in space, was due to give a lesson from the orbiter as soon as it was stabilised. As a consequence the chief television audience as the *Challenger* exploded were school children. This traumatic public failure of science and technology had a significant impact on future space projects.

The loss of the *Challenger* reduced the fleet of orbiters to three – *Columbia*, *Discovery* and *Atlantis*. Pending the outcome of the inquiry these were grounded for over two years with the cancellation of twenty-seven planned flights. Apart from the destruction of its payload and research projects including essential communications satellites, a unique chance to study Halley's comet was also lost. It precipitated a huge domino effect as the network of scientific experiments, multi-billion dollar military and commercial projects, and the public confidence, which was financing the research, collapsed.

The findings of the accident inquiry concentrated on the technological failure of a flawed joint. The single most likely material cause of the disaster was an eroded gasket which had given problems before, but these were overlooked as pressure from a cynical public greeted each delayed take-off with disdain and derision. Technological causes were overshadowed, however, as institutional failure of NASA management came under scrutiny. The conflicting interests of safety and profitability were exposed along with poor management. Wind shear was also suspected but this was put down to the sideways thrust from the rupture in the rocket casing.

The accident inquiry had access to an abundance of data from sensors in the engines and aboard the shuttle. In addition the shuttle carried five computers which relayed data relating to the performance of the engines and the condition of the craft to the flight centre at Houston. This data could be refreshed at the rate of 25 times per second; it was either displayed on screens or stored directly on tape. The explosion was confirmed by negative radio contact. Mission

Control's response was appropriately scientific:

> Okay everybody, stay off the telephones. Make sure you maintain all your data. Start pulling it together.... Don't reconfigure your consoles, take hard copies of all your displays, make sure you protect any data source you have.
>
> (Mission Control, Houston, 11.29 a.m., 28 January 1986)

NASA personnel quickly analysed this data in an effort to discover the cause of the accident.

The most significant information, however, came not from digital data but from recordings gathered by video cameras. Television coverage of the launch pointed its cameras at the orbiter vehicle, the human stars of the show, so to speak. They showed the incomplete roll and explosion 73 seconds after take-off. However, film taken from the other side of the launch site showed the puffs of smoke leaking from a joint in the solid fuel booster as early as 0.678 seconds into the flight, and flames from the same joint after 14 seconds. These danger signs were missed by Mission Control because two video cameras on the ground were not working. At 58.7 seconds into the flight a small flame burnt through the booster rocket and after 13 seconds or so it burnt through the hydrogen tank in the main rocket and engulfed the shuttle in flame. The orbiter containing the passengers and payload broke free as the whole shuttle ruptured under aerodynamic stress. It is not certain if the crew were alive as it hit the ocean. Control could have spotted the smoke and the flame if light-weight video sensors had been mounted on the craft. Had they done so the orbiter and the crew would almost certainly have been saved by jettisoning the fuel and gliding back in relative safety to the landing site.

Houston's real investment was in science, and this meant digital technology. NASA did not have video sensors on the craft, nor did they worry unduly about the failure of the two ground cameras before take-off. It seems that the camera on the opposite side of the site was not on line. In this instance information conduits were epistemologically and economically partitioned between the conflicting interests in the flight. Science and technology were primarily committed to remote sensing and instrumentation, whilst analogue information in the form of video and television pictures was allocated to entertainment and education. Mission Control's first indication of disaster was from Cable News television pictures.

Science — the rule-bound system of describing the world — has placed its greatest emphasis on objective data. Since Descartes, this has progressively come to mean that human observation is a suspect source of knowledge which must be subjected to constant verification. Data from disembodied instruments, on the other hand, is subjected to initial verification to establish a fundamental link with an event, and thereafter whatever it records is regarded as evidence that the event

has changed. Ensembles of instruments, for example different kinds of micro-scopes, can be cross-referenced to confirm data beyond human perception and build what might be called a scientific realism. This reality is so convincing that the interface between the atomic structure of matter and the mind is now regarded as the x-ray diffraction microscope.[43]

Space science, because of its concentration on the remote and frequently unobservable, provides a show-case for science's instrumental realities. In space technology this has come to mean digital information. In this respect, like sub-atomic science, space science represents a paradigmatic science which is continuous with the distrust of visual evidence which the nineteenth-century professorate showed towards their more practical, but perceptually 'unreliable', colleagues.

As with early cinema, the less 'reliable' aspects of scientific reality, especially the visual, have been recirculated in popular culture as entertainment. The space shuttle programme was conceived, at least in part, within this economy of representation. Scientific 'reliability' since the late 1800s is indirectly proportional to public accessibility. The loss of the *Challenger* crew was avoidable but for science's relegation of the visual. The reality of the American space programme for science (like its conceptual premiss) was burdened by a nineteenth-century attitude to the eye.

The American space programme is not untypical of high science's relationship with the visual. Condescension, however, has turned into unease as the means of digitally manipulating the ubiquitous photograph has become commonplace. The introduction to the domestic matrix in the mid-1980s of cheap personal computers has opened access to the formerly scientific domain of instrumented realities. Even in its most basic and common mode as a word processor it can make truth claims about spacing and layout which are not dependent on the subjective perceptions of the individual. Coupled with the facility to import images (not always from digital cameras) the home computer has spawned what has become known as digital photography. Reactions to this from scientific quarters have been reserved. To take a recent example, William J. Mitchell, author of *The Reconfigured Eye*, complains in *Scientific American*, February 1994, that the unassailable probity of chemical photography was based on its causal relationship with the world, but

> The emergence of digital imaging has irrevocably subverted these certain-ties, forcing us to adopt a far more wary and vigilant interpretative stance. The information superhighway will bring us a growing flood of visual information in digital format, but we will have to take great care to sift the facts from the fictions and falsehoods.[44]

If there is a slight air of panic in Mitchell's article it may not be for the loss of probity. For as he points out (as any other commentator on digital photography

must) 'cut and paste' photomontage has been used extensively by many political regimes, advertisers, film makers and artists in the expectation that their images will be understood as indexical of something visually present in the world. Modern science has also been in the forefront of perpetrating the same sleight of hand with digital photography. In an entertainment/education mode (infotainment) it has allowed its data to trickle down in the form of images which have been allowed to be confused with photographs. For example satellite 'pictures' which use false colour to show the surface temperature, atmospheric conditions or some other non-visual feature of the earth. This digital 'superhighway' (in as much as it is an episteme) has been open for quite some time. As the twentieth century closes, however, there is a new actor in the discourse – the home PC. Digital imaging is no longer the prerogative of science, as Mitchell's panic reveals; entertainment also has a strong purchase on it (hence his pictorial examples which use images of popular culture – Marilyn Monroe, Buzz Aldrin on the moon, etc.).

Mitchell illustrates the destabilising potential of digital photography by juxtaposing these examples with a photograph of two politicians manipulated to make them look unfriendly. The ideological problem of the digital photograph and the PC is public access, and Mitchell uses the collapse of particularly nineteenth-century 'gateways' to expose the danger; 'software for producing digital composites often simplifies the artist's task to such an extent that it may no longer take much time or craftsmanship'.[45]

Mitchell senses that a number of restrictive gateways to science built in the 1860s, particularly access to the instruments which determine reality, may be widening to include technologists and entertainers (this is not the same as everyone).

The example of space exploration perhaps shows the beginnings of a re-convergence of science, technology, and entertainment into a single discourse which, although not as unified, has much in common with Wright's painting. This reversal of fortunes threatens to become more complicated *if* the boundaries of science, technology and entertainment become more diffuse. One consequence of such a change may be that cultural and critical theory might have to regard technology as both continuous with the technological past and discontinuous with it – as a synthesis of the pilot and passenger's view. A premiss for which we have a slender matrix of method.

If the visual image has a future beyond being an amusing distraction (which does not seem entirely certain), then digital photography may force us to think more about those theoretical models and histories of technology which can account for the productive coexistence of contradictory responses to technology in both popular culture and professional practice. Those theories and histories which admit the conflicts between radically opposed views of the same persons, events, institutions, policies and practices. In which case digital photography will

be one sign of a significant epistemic rupture even though its images, its glorious multicoloured sunsets, will, like the American space programme, remain nineteenth-century.

Notes and references

1 The research for this essay was made possible through the financial support of Film-en televisiewetenschap, University of Amsterdam, under the auspices of their ongoing research project, *Representation and the Body*. I am especially grateful to Professor Dr Thomas Elsaesser for his discussion of this material.

2 R. Allen and D. Gomery, *Film History, Theory and Practice*, London: 1985,113.

3 See J. L. Comolli, 'Machines of the Visible', *The Cinematic Apparatus*, ed. T. Lauretis and S. Heath, London: Macmillan, 1980, 121–43.

4 G. Batchen, 'Burning with Desire, The Birth and Death of Photography', *Afterimage*, January 1990, 8–12. Batchen suggests that: 'Replete with the tension of "two in one" (a tension writ large in the daguerreotype, which is of course simultaneously a negative and a positive), the victory of "photography" over its linguistic rivals is a significant one. Moreover, if we look once again at the naming of photography as a form of writing, it becomes apparent that the Greek suffix *-graph* can be translated as either "written" or "that writes". Thus photography is, at one and the same time, light writing itself and/or "writing with light", a system of representation that is projected as both (but never quite either) active and passive, producer and produced, inscribing and inscribed. Here in one brilliant stroke of language, the naming of photography reproduces the fascinating dilemma of its own undecidable historical and epistemological identity' (p. 29).

5 L. Marx, *The Pilot and the Passenger: Essays on Literature, Technology, and Culture in the United States*, Oxford: Oxford University Press, 1988, xv.

6 ibid., x. Marx suggests that *Huckleberry Finn* and Twain's literary style synthesises this necessary contradictory response to understand American culture.

7 See J. Wosk, *Breaking the Frame: Technology and Visual Arts in the Nineteenth Century*, New Brunswick, NJ: Rutgers University Press, 1992.

8 For an example of this determinist euphoria see BBC Television's recent series *The Net*, or Peter Gabriel's introduction to Xplora 1 CD Rom published by Toshiba Information, 1994. In it he claims, for example: 'If you look at the history of technology, many things that were once luxuries for the few are now found in most homes.' For a suggestion of how these luxuries got there, and why some people do not have them, see D. Nye, *The Electrification of America, Social Meanings of a New Technology 1880–1940*, Cambridge, Mass.: MIT Press, 1990, and D. MacKenzie and J. Wajcman (eds), *The Social Shaping of Technology*, Milton Keynes: Open University Press, 1984. For a brief account of interactive media and the third world see J. Barker, 'One Man and his Dog', *Interact, European Platform for Interactive Learning*, 1 (3) (April 1994), 16–17.

9 R. Williams, *Notes on the Underground; An Essay on Technology, Society, and the Imagination*, Cambridge, Mass.: MIT Press, 1990.

10 By sheer coincidence the first two owners have namesakes in cinema. The schizophrenic Bates from *Psycho*, a man literally in two minds, and *Blade Runner's*

megalomaniac Tyrell whose replicant corporation, with the motto 'more human than human' embraces the technological world to excess. But perhaps less coincidental is the fascination of both of these film narratives and the increasing importance of the picture as it is rescued from the obscurity of a provincial gallery, cleaned and reclaimed by its earlier owner as galleries scurry for popularity.

11 B. Nicholson, *Joseph Wright of Derby, Painter of Light*, London: Routledge & Kegan Paul, 1968, 58.

12 For an account of such displays, and earlier scientific exhibitions, see R. D. Altick, *The Shows of London*, Cambridge, Mass. and London: Belknap Press of Harvard University Press, 1978.

13 ibid., 69.

14 D. Frazer, 'Joseph Wright of Derby and the Lunar Society', in J. Egerton (ed.), *Joseph Wright of Derby*, London: Tate Gallery, 1990, 19.

15 Of course the lecturer could also be addressing the artist (Wright) who we cannot see, which sets up a neat paradox . Either way, the strategy of the composition and narrative logic is to embrace an audience, including one beyond the picture plane.

16 The Lunar Society was initiated in 1764 and became established in the 1770s. It met monthly on the Monday nearest the full moon until *c.*1780. Wright's two principal contacts were (according to Frazer) John Whitehurst, an instrument maker, and Dr Erasmus Darwin. Other members included Josiah Wedgwood, Matthew Boulton, James Watt and Joseph Priestley.

17 For an account of Sturgeon and his relationship with the professorate see I. R. Morus, 'Currents from the Underworld, Electricity and Technology of Display in Early Victorian England', *ISIS*, 84 (1993), 50–69.

18 ibid., 55.

19 According to David Nye, in *Electrifying America, Social Meanings of a New Technology 1880–1940*, Cambridge, Mass.: MIT Press, 1990, the most dramatic period of Expositions and World fairs was between 1894 and 1904. Fifty million people attended the fairs in Chicago, Buffalo and St Louis. These fairs 'helped to impose a middle-class progressive order during a convulsive period characterised by political corruption, violent strikes, rapid industrialisation, and enormous immigration from Southern Europe' (p. 33).

20 For an account of these acrimonious exchanges see A. M. McMahon, *The Making of a Profession: A Century of Electrical Engineering in America*, New York: Institute of Electrical Engineers, 1984.

21 See B. Houghton, *Scientific Periodicals*, London: Bingley, 1975.

22 ibid., 102. The latest cumulative figure is for 1970, at which time there were thought to be 75,000 titles.

23 S. Sheets-Pyenson, 'Popular Science Periodicals in Paris and London: The Emergence of a Low Scientific Culture, 1820–1875', *Annals of Science*, 42 (1985), 549.

24 Sheets-Pyenson argues that popular science means, in this context, making the notions of 'high science' available to a lay public, whereas 'low science' refers to a particular research method involving the accretion of data which could be

undertaken by any (non specialist) person.

25 L. Singer and E. Underwood, *A Short History of Medicine*, Oxford: Oxford University Press, 1962, 208, suggest that the great cholera epidemic of 1832 was instrumental in this change. Largely under the influence of a Benthamite Utilitarianism, this epidemic ushered in a period of specialisation in science and medicine.

26 In France and America a similar transformation in the participation in 'science' is evident although each country had different philosophical and entertainment traditions. By the end of the century, French and American popular science journals also favoured spectatorial consumption over public participation in the episteme.

27 *La Nature* coincidentally returns us through a rather anarchic route to the Tate Gallery, London, the one-time resting place of *An Experiment On A Bird In The Air Pump*. For it was discarded copies of *La Nature* which the surrealist, Max Ernst, used to make collages, some of which still hang there.

28 This appeal is consistent with what Tom Gunning calls an aesthetics of astonishment induced by convincing illusions when he argues that *The Arrival of the Train, Photographing a Female Crook*, and *Electrocuting an Elephant* demonstrate 'the solicitation of viewer curiosity and its fulfilment by the brief moment of revelation typical of the cinema of attraction'. T. Gunning, 'The Aesthetics of Astonishment', *Art and Text*, 34 (Spring 1989), 38.

29 It was copyrighted on 12 January and sold for $10.30 under the title *Electrocuting an Elephant*.

30 *Electrocuting an Elephant* had the mnemonic code *unrespited*. It would have been exhibited in a variety of venues as part of vaudeville programmes, by travelling showmen, and at amusement parks. It remained in the Edison catalogue for several years and could well have formed part of nickelodeon presentations.

31 In a lengthy report in *The World*, 5 January, the event is described in contradictory terms. 'While fifteen hundred persons looked on in breathless excitement an electric bolt of 6,600 volts sent Topsy, the man killing elephant, staggering to the ground yesterday afternoon at Luna Park, Coney Island.' When she refused to cross the bridge to the site 'A shout of applause and a murmur of astonishment went up from the crowds waiting on the sides of the roadway and on the housetops to witness the event.' At this moment the reporter tells us that 'hundreds of men, women and children who had gathered to see the execution had looked pityingly upon Topsy as she was led to the death post'. Later in the same report, Topsy's 'patience aroused pity in every spectator'. It is reported that her keeper refused $25 to bring her to the site. When the moment came for her to be electrocuted the spectators cleared the field in case the plan failed and she took off (in fact Topsy was given 450 grains of potassium cyanide just before the switch was thrown).

32 This term is used by Marcel Duchamp to describe the lower part of his seminal work *The Bride Stripped Bare by Her Bachelors, Even*, otherwise referred to as the *Great Glass*. For a discussion of this relative to cinema and 'bachelor machines', see C. Penley, 'Feminism, Film Theory, and the Bachelor Machine', in *The Future Of An Illusion*, London and New York: Routledge, 1989, 57–80.

33 For a discussion of the stereoscope in relation to perception see J. Crary, *Techniques of the Observer*, Cambridge, Mass.: MIT Press, 1990, especially Chapter 4.

34 The main twentieth-century applications of the research undertaken by Marey in Paris during the 1890s has been its use in fatigue study, motion study and time study in industry. A pioneer in this field in America was F. B. Gilbreth and his wife Lillian Moller who were more or less contemporary with Edison, and F. W. Taylor from whom the 'American System' of manufacture originates.

35 F. Dagonet, *E. J. Marey, A Passion for the Trace*, Cambridge, Mass.: MIT Press, 1992, 89.

36 See D. Wood, 'The Diorama in Great Britain in the 1820s', *History of Photography*, 12, 3 (Autumn 1993), 284–95.

37 J. M. Eder, writing a history of cinematography at the turn of the century, sees aerial photography as the true progenitor of the cinématographe. See J. M. Eder, translated by E. Epstrean, *The History of Photography*, New York: Dover, 1978; this is a reprint of Eder's history which was written concurrently with the developments in photography and cinematography and published incrementally.

38 Neil Armstrong's first steps on the moon cost $25 million in 1968; the estimated cost of the shuttle programme is put at a similar figure. See *The Economist*, 1, 2 (1986): 11.

39 For an account of the impact of Russian space technology on America see R. Divine, *The 'Sputnik' Challenge: Eisenhower's Response to the Soviet Satellite*, New York, 1993, and a more measured description in R. Bulkeley, *The Sputnik Crisis and Early United States Space Policy*, Bloomington: Indiana University Press, 1991.

40 F. J. Turner, *The Significance of the Frontier in American History* (1894).

41 The first free flight of the space shuttle was 12 August 1977. This test shuttle was called *Enterprise* after the star ship from *Star Trek*.

42 Material concerning the *Challenger* disaster has been drawn from a number of sources including press and journal articles concerning the explosion and the subsequent inquiry. These appear to have been informed by identical agency reports and so are not individually cited. Other material has been drawn from M. Rycroft (ed.), *The Cambridge Encyclopaedia of Space*, Cambridge: Cambridge University Press, 1990. See also the excellent bibliography, S. D. Herring, *From Titanic to Challenger*, London: Garland 1989, which cites eighty-six American books and articles on the *Challenger* disaster. For an account of the popular treatment of disaster see L. H. Walters *et al.* (eds), *Bad Tidings: Communications and Catastrophe*, Hillsdale, NJ: Lawrence Erlbaum, 1989.

43 For a discussion of scientific realism and microscopes (and the philosophical debates which it has historically provoked) see I. Hacking, *Representing and Intervening*, Cambridge: ?, 1983, also D. Idhe, *Instrumental Realism*, Bloomington: Indiana University Press, 1991.

44 W. J. Mitchell, 'When Is Seeing Believing?', *Scientific American* (February, 1994), 44–9.

45 As an example of how vigilance can detect the false, Mitchell shows a picture of seven images of Edwin F. Aldrin on the moon. He asks: is it likely that all the astronauts, except one, would be holding their arms in precisely the same position? For many the sight of astronauts playing golf on the moon was equally bizarre.

the body
and surveillance

part II

the panic button (in which our heroine goes back to the future of pornography)

beryl graham

3

> *It was not long before thousands of pairs of greedy eyes were glued to the peepholes of the stereoscope, as though they were the skylights of the infinite. The love of obscenity, which is as vigorous a growth in the heart of natural man as self-love, could not let slip such a glorious satisfaction.*
>
> Charles Baudelaire, 'The Modern Public and Photography', 1859[1]

> *[With] Morton Heilig's* Sensorama *machine, a multisensory device designed in 1962 . . . the user sat on a stool facing a small rear-projection movie screen and held on to a pair of handlebars. . . . The ride ended with a visit to a belly-dance show complete with the smell of cheap perfume.*
>
> Nicholas Lavroff, *Virtual Reality Playhouse*, 1992[2]

> *Seedy ROMs a Hit*
>
> Headline, the *Guardian*, 1993[3]

In 1839 the invention of photography was announced. By 1850 a law had been passed in France for prosecuting the sale of obscene photographs in public places. Since photography was used for pornography from almost the moment of its invention, it should come as little surprise to you, gentle reader, that the new media of computer software, interactive CDs, electronic mail and virtual reality are similarly exercising the public imagination.

Computer-based interactive technology is in many ways 'a natural' for pornography. People have, after all, been singing gleefully scurrilous verse about some kind of 'sex machine' since way before the silicon chip was invented. The machinery/technology itself is deeply embroiled with desires of many kinds and is, of course, deeply, densely gendered. The famous 'Turing Test' of 1949 (which continues to be the acid test of whether computers can possess real 'artificial intelligence') has at its centre a computer's ability to differentiate gender.[4] It does not require a great deal of intelligence, however, artificial or otherwise, to discern that when it comes to computer-based pornography, male heterosexuality is unmistakably Top Gun. In addition to the obvious facts of male market dominance, it should perhaps be remembered that the technology of computer-based interactive graphics was developed from a history of war research, and it is

being debated currently that the very basic structure of screen-based information design is based on structures of cognition which predominantly occur in males rather than females. Whilst biological determinism as applied to women's relationship with technology is to be avoided, there is undeniably a whole parcel of gender debates around the equipment itself to be addressed, before starting to talk about pornographic content. It is the combination of pornographic content and new technology, however, that has received much coverage in the general press. Popular conceptions of virtual reality (far in advance of actual technical capabilities) picked up the idea of being immersed in a fake experience and ran with it to a fairly logical conclusion: cybersex, teledildonics, erototronics – 'making safe' the dangers of sex, as it had first 'made safe' the dangers of combat.

Once inside the machine, there are many other structural features that also suggest that computer interaction is tailor-made for pornography. The structure of much interactive entertainment for example is based on a simplistic narrative of suspense and exploration which fits comfortably with the tenuous, episode-linking plot structure of mainstream pornographic film. The features of computer interactivity which are promoted in advertising are those of choice, variety, and the ability to access exactly what you want, when you want it. Charles Baudelaire would not, I think, be surprised at the rapt attention of those whose 'greedy eyes' are now glued to the computer screen.

The cultural histories of the invention of photographic pornography and the invention of computer-based pornography do indeed have much in common, but there are also most definitely some features of computer-based pornography which mark a whole new political and representational context. Bear with me, gentle reader, and we shall boldly explore first some historical parallels between pornographies of the nineteenth and twentieth centuries, second some differences which may mark out computer-based pornography as a new phenomenon, and finally some interventions in sex and computers by those technological 'others'.

Victorian futures: orientalism

> The Orient was a place where one could look for sexual experience unobtainable in Europe.
>
> Edward Said, *Orientalism*[5]

> *Asia Blue* – Japanese beauties in lingerie and less
> Software advertisement, *Future Sex* magazine no. 5

It may not be a coincidence that the cheap female labour of the Pacific Rim which is exploited to manufacture computer circuit boards is also the cheap female labour exploited by sex tourism. Discourses of colonialism and exoticism are still

alive and well in the commercial sector, as well as in the press enthusiasm for 'Cyberspace, the final frontier'.[6] Whilst white Western men might fear the economic power of Japan, they are also enthralled by the technology, and equally enthralled by their own construction of 'oriental' women as fantasy icons of 'real femininity' – small, submissive, delicate, childlike.

That mainstay of Victorian pornography, the Japanese erotic print, is also continuing to make its presence felt on the forms of computer pornography: not only are the flat planes and colours of the prints rather reminiscent of some computer graphics, there is within the prints a highly symbolic rather than representationally realistic use of objects to express class, sexual inclination, etc. Whilst these prints are a historic phenomenon, there are also modern forms: walk into any mainstream software game vendor, and the Japanese 'manga' comics are alongside the disks and cassettes. Whilst not all 'manga' are pornographic, a large subsection are, and in Japan are often read openly by men in public places. Sandra Buckley[7] argues that these popular Japanese porn comics enable a smooth transition into computer-based pornographic symbolic codes. Because Japanese censorship forbids the representation of genitals or pubic hair, a highly coded set of symbols is used, to be read in combination, so that, for example, a frame of a candle followed by a frame of a face in pain means sexual torture, or a certain bowl stands for female genitals in a certain context. Buckley suggests that this existing demand on the audience to read images 'interactively' pre-shadows the interactive structures of computer pornography.

For the modern Western user of computer pornography, this pleasure in being able to 'crack' codes could perhaps explain the willingness of people to 'explore the outer reaches' of the Internet[8] for hours on end in order to track down very poor quality pornographic images which are so barely distinguishable (available in much more detail in any magazine) as to have surely only symbolic sexual value.

Victorian futures: doctors and nurses

I saw everything as no man had ever seen before.... I felt like an explorer in medicine who first views a new and important territory.
Gynaecologist Dr Sims, a developer of the speculum, 1845[9]

One of the principal projects of a science capable of producing multiple bioapparatuses is the project of the synthesisation of the female reproductive apparatus.... The cyber vagina dissimulates and defines the vagina dentata.
Lyne Lapointe and Martha Fleming, 1992[10]

Theorists such as Donna Haraway[11] have been pointing out for many years the important link between discourses of medicine, colonialism, technology and gender: Woman/The Criminal/The Black being the object to be explored, men's

science being the tool of exploration. Again the nineteenth and twentieth *fin de siècle* coincide in their levels of anxiety about sex and sexually transmitted diseases, and their attempt at achieving a safe distance from such things via science and technology, 'getting inside the problem' whilst standing back.

Certainly, 'synthesisation of the female reproductive apparatus' seems to be a recurring theme outside of pornography as well as within. Those of us who missed out on 1960s' consciousness-raising groups can now see exactly where a cervix is, thanks to the award-winning *Cytovision*[12] interactive training tool for cervical smear cytologists, which is shown at many multimedia conferences. A graphic of a section of transparent woman from belly to thigh can be made to rotate with a sliding control in order to reveal the internal position of womb and cervix. Although the image is not as graphically sexualised as the languid 'Anatomical Venuses' used by eighteenth- and nineteenth-century medical students, the author of the programme can testify[13] to the embarrassment of the users/viewers, once they perceive themselves to be visibly in control of the movement and positioning of the 'body'.

One further interesting connection between the Victorian medical scene and sexual technology was the invention in the nineteenth century of the 'pelvic vibrator', a new electrical medical treatment which sometimes produced mysterious convulsions in women, but appeared to be good for nervous complaints . . .

Victorian futures: the Marx thing

> The Oxford English Dictionary can find no instance of the word 'pornography' being used before 1864 (in a decade, it may be noted, which also saw a generalised use of the term 'capitalism').
>
> Jeffrey Weeks, *Sex, Politics and Society*, 1981[14]

> an information society is the purest form of capitalism. When bodies are constituted as information, they can not only be sold but fundamentally reconstituted in response to market pressures.
>
> N. Katherine Hayles, 1993[15]

Compact discs, those glistening rainbow objects of desire, have never promised quite so much as their potential for intimate, headphone-cocooned, *personal* computer, private pornographic experience. Whilst most pornographic forms (apart from perhaps videos and movies) have been rather solitary pleasures, there seems to be something particularly solitary about the computer (or virtual reality); something designed especially for one person, something which makes having one's shoulder looked over particularly irritating.

The lonely pleasures of viewing computer-based porn could be seen as part of the increasing 'privatisation' of the body since the fifteenth century, when 'In

particular, the subject, as did the body, ceased to constitute itself as public spectacle, and instead fled from the public sphere and constituted itself in text – such as Samuel Pepys's diary.'[16] Marx's 'alienation' would perhaps appear to be right at home on the Internet with privatised computer-based pornography, and there has been a certain amount of moral panic about the lack of human contact in virtual sex, and indeed in modern life generally. Our post-industrial culture, however, does not necessarily provide any uniquely new reason for moral panic; artists have been dealing in distanced and vicarious emotional life as a popular recreation since before Charles Dickens's serialisations in *Household Words*, and many a relationship already takes place over the virtual voice of the telephone. As Ann-Sargent Wooster comments, 'the current call for interactivity on the part of video artists is part of a larger societal development of machine-augmented simulacra of intimacy'.[17] The grip of multinationals on both pornography and computer technology would, I think, do little to persuade a resurrected Mr Marx that it wasn't very much 'business as usual' in the post-industrial world just as in the industrial world.

So how is new-tech pornography like photo-pornography?

Hot Magazine Honeys. You've hungered for these honeys through count-less magazines and now you can have them permanently on CD-ROM.
Magazine advertisement, *Future Sex* magazine no. 5

Interotica's current release, *Nightwatch*, allows the voyeur/player to snoop around a plush singles resort via a suite of security monitors.
New Media, 1993[18]

In many ways pornography has made the transition to computer formats without too much of a hiatus: very often the same porn 'stars' (the 'hot magazine honeys') appear both in traditional magazines and in sets of images which have simply been dumped into a digital form. Interactive CDs such as *Penthouse Interactive* use the very old scenario of the viewer playing at being a glamour photographer. The *Nightwatch* CD mentioned above uses a slightly updated scenario of video surveillance, but still revolves around the very familiar photographic fantasies of voyeurism and objectification; in both of these pieces the viewer sees through the eye of the camera. Also familiar is the intimacy and disguisability of the pornographic material itself: small stereoscope pictures to be peeped at through goggles, magazines to be slipped under the bed or between plain brown wrappers, films with their latent images, and now disks (or software via electronic mail) which can have an invisible content unless one knows how to access it.

In looking at the homogeneity of our 'hot magazine honeys' another very obvious similarity comes to mind: those with the real control over the material

are not those with their hands on their stroke-mags, their video pause buttons or their trackballs, but rather those with their hands on the means of production and distribution. Big pornography brand names such as Penthouse have been very quick to move in on the new formats, and will no doubt continue to control the narrow erotic bandwidth of mainstream production. Indeed companies are particularly keen to retain their control in the face of the more free-form interaction and dissemination of material on electronic bulletin boards: Playboy Enterprises Inc. recently won a $550,000 suit against Event Horizons for distribution of digitised photos that originally appeared in *Playboy*.[19]

As already outlined, many features of computer pornography would be very familiar to Victorian photographic pornography-users, but there are some features which are new − features enabled by the technology of interactivity, of 3D computer animation, and of the strange disembodiment of virtual reality.

So how is new-tech pornography different from photo-pornography?

> Perhaps, even in the most fully realised erotic image, suture cannot be sustained since the contradiction of the flat actuality of the paper and the fullness of the body of desire is too great. There must be a mechanism to re-immerse the distanced subject.
>
> John Tagg, 1988[20]

> *Girlfriend* …is a true artificial intelligence program.… She will remember your name, your birthday, and your likes and dislikes.
>
> Magazine advertisement, *Future Sex* magazine no. 4

There is a problem for the user of pornography: it wears out. There is a limit to the amount of times one piece can be read before it loses its erotic charge, and for some people the choice-making structures of interactive software have been seen as an answer to this. As Sandra Buckley says, 'technology provides the variation necessary to keep the players engaged − repetition without boredom − but the boundaries of the game remain constant. Technology achieves a captive audience.'[21] This captive audience, seduced by the power of interactivity to 're-immerse the distanced subject', is also captivated by the lure of the technology itself. Unlike magazines or videos, one has to embark on a relationship with machines which are (for the moment at least) costly, powerful, and draped with a mystique of specialist knowledge which makes computer pornography almost as exclusive as Victorian gentlemen's 'scientific collections'. The equipment itself, unlike a book or magazine, is specifically identified as male, as science, as power. The original lure of photographic technology has become distanced: the readers of porn magazines could only imagine themselves as a real glamour photographer, but now they have a real hands-on relationship with technology at the very

point of consumption of pornography. Maleness can be confirmed by both the content of the porn and the means of reception.

Whilst the specific areas of difference rather depend on which technology is being used for pornography (computer-based software/CDs, electronic mail exchanges, or virtual reality) there are some common areas of difference which are perhaps worth sketching out.

Control and choice

> An intuitive point-and-click interface makes *Virtual Valerie* VIRTUALLY YOURS to play with. She's your cybernetic fantasy and YOU control the action!
>
> When a warped hacker reprograms a Pleasure Droid with the intelligence of a Tactical Fighter, he names his new plaything *Donna Matrix*.
>
> Reactor Inc. publicity material, 1994

Obviously a key pornographic potential which interactivity offers here is *control*, in that the characters 'do what you want them to do' in front of your very eyes, rather than in some imaginative space. *Virtual Valerie*[22] for instance always does exactly as you bid her. The range of choices for what you might 'want her to do', however, is very, very limited. Your options are mostly along the lines of choosing which particular shape of dildo to insert into Valerie (who of course does not have the choice but to be consistently audibly thrilled).

It is this element of control which perhaps sets most political alarm bells ringing. Whilst all pornography can be said to be about control to a large extent, here the control is literal, not in fantasy, and it is *the* selling point. At the same time, any real control over what might happen seems to be getting narrower, in that the range of sexualities represented in even a street-corner porn store is much broader than anything I've seen available in a computer-based format. As well as the obvious political objections, even the medium itself seems to have problems with this amount of control. Pornography is also about space for fantasy, and a certain amount of loss of control, otherwise why not stick to one's own, predictable fantasies? So where is the space for fantasy or chance within the 'control' structuring and the explicit visualisations of interactive computer porn?

Unusually for pornography, with many interactive structures there is a chance of 'losing' at your endeavour. In *Digital Dancing: The Erotic Challenge*, the user chooses one of four stripteasers and then plays the paper-scissors-rock game against the computer. If you win, a brief movie clip of the dancer is played. The more you win, the more the dancer takes off, but if you don't 'win' then you won't see any flesh. In *Virtual Valerie*, if you don't give the right answer to a certain question, then the most terrible thing that can befall a computer nerd happens: the screen goes blank and the computer has to restart. There is also often a strict hierarchy of

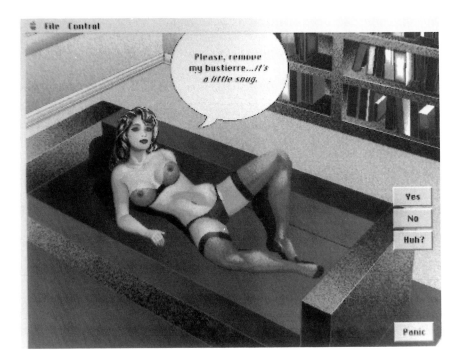

Figures 3.1–3.2 Two images from *Virtual Valerie*. Reactor, Inc., Chicago.

'progression' in the narratives. A typically bizarre example of this progression is that you have to go and look around *Valerie*'s kitchen before you can take off her clothes. Whilst the structuring of sex as a 'game' to 'win' might be equally as dubious as a structure of total control, it perhaps also reveals much of Anglo-Saxon Man's fear of sex, of losing, of not necessarily wanting to be in total control. Significantly, the next CD from the producers of *Virtual Valerie* is to be (by popular demand), *Donna Matrix*, Valerie's firm-handed sister. Donna may be created by a man, but, as her first utterance in the publicity is 'You've been a Very Bad Boy, Blam Blam Blam', perhaps total control is not necessarily what the male audience is wanting here?

Showing it all: the vision thing

> What happens in the *Rape of Europa* … is that the amplitude of the woman's body is set against an infinite, atmospheric space … release was sought from all bodily bounds through the infinite recession of central vanishing point perspective.
>
> John Tagg, 1988[23]

Whilst some computer pornography uses as its source-material regular photographs and video, a significant departure starts to happen when the visual material is constructed from computer modelling and animation. In *Virtual Valerie II* and *Donna Matrix*, the eponymous characters are 3D mannequins, designed by somebody clearly under the impression that breasts are spherical objects (Figure 3.2).

These are, more than ever, symbolic sexual objects in an 'infinite, atmospheric space' of geometric furniture. The flesh itself is uniformly pink, and lacks even the occasional wrinkle or bulge of 'Readers' Wives'. Here therefore is another key area of difference from photo-pornography: the relationship between sexual fantasy and what is actually visually represented. Within more traditional pornography which uses photographs, the starting point of fantasy is (however much the models are chosen for bovine or equine proportions, however much silicon-filled and airbrushed) at least an actual body. In computer animation however, 'women' can have the 3D anatomical impossibility of a Barbie Doll, and on the rarely appearing men the fantasy 'phallus' can be actually hugely represented, rather than the humble penis. Again these things appear 'before your very eyes' rather than in that visual fantasy space exploited by telephone sex lines. Of course, sexual cartooning and comics have for a long time been stretching the boundaries both of the body and of the imagination (Mike Saenz, author of *Virtual Valerie* and *Donna Matrix*, used to be a cartoonist on Marvel Comics), but computer graphics enable these cartoons of sexuality to walk and talk in three dimensions. The major thrust of computer graphics has been towards 'realism' but of course

these mannequins are both much more convincing, and much less real – an interesting combination for any discussion of the relationship between fantasy, pornography, and actual sexual relationships.

The body part: meat and money

Machines and women have at least one thing in common: they are not men.

Sadie Plant, 1993[24]

When sexual cartooning starts to move into virtual reality, you hit the very belly-button of current theoretical debate. The position of 'the body' (or 'meat' as cyberpunks would have it) in information culture is a raging and thrashing one which would take a hefty tome to cover in any depth.[25] Calling on the gods of *Reader's Digest* I will rashly attempt to sketch out a few of the ideas involved, for whilst popular magazines pontificate enthusiastically about future whole-body-sensor-data-suits and virtual sex, theorists have been wrestling with the ramifications of virtual space: whilst Donna Haraway reclaims cyborgs as useful tricksters free of oedipal structures, Allucquere Roseanne Stone has suggested that cyberspace is 'womb envy' – the rooms and scenes are a female smoothness to be entered and penetrated. Stone also suggests that the most frequent stated pleasure for males using VR experiences is a 'sense of freedom from the body, and in particular perhaps, freedom from the sense of loss of control that accompanies adolescent male embodiment'.[26] Michael Heim points out who this 'womb' might belong to: 'The word *matrix*, of course, stems from the Latin for the Mother, the generative-erotic origin.'[27] To summarise rather crassly a debate which has much complexity – perhaps women are going to have a few more psychological problems with the idea of having sex inside their mother than men are?

Oddly enough in a society where there is so much pressure on the female body, it does indeed seem to be mostly men who have jumped in at the deep end of cyberspace by 'computer cross-dressing'; pretending to be women on the Internet, and communicating as a woman for reasons both sexual and social. This 'escape from the body' is highly ironic in view of the photographic work which has been so influential over the past few years – the work of Jo Spence and David Hevey[28] for example, to painfully articulate the working-class body politic. Are we fleeing from the body and from politics too? What about the rights of the body – can there be 'rape' of disembodied personae in cyberspace? Is cyberspace ever going to be a structure wherein women or 'others' could create erotic worlds?

Contexts of use: men at work

Hit the 'panic' choice on the screen menu, and a phoney data processing chart takes over to protect those who are dating *Valerie* on company time.

Marie Claire, 1993[29]

A clue to one of the ways in which computer-based pornography may have a different context of usage from other forms of pornography lies in the choice of 'buttons': On a screen in *Virtual Valerie* (Figure 3.1), she requests: 'Please remove my bustierre[*sic*] . . . it's a little snug', and the viewer can respond with buttons marked 'Yes,' 'No', 'Huh?', or 'Panic'. The Panic button is unfortunately not a humorous acknowledgement of men's fear of female sexuality, but instead a trigger for an instantly appearing fake data document 'to protect those who are dating Valerie on company time'. This pornography is for using *at work* (otherwise the fake data would perhaps be instead a game or a letter file). In the middle-class workplace the use of pornography as a territorial weapon against female colleagues has gone underground: less traceable or actionable[30] than a girlie calendar 'it's seen as a huge joke to program a woman's computer so that a pornographic image comes on to the screen . . . where individual machines copy to a central printer, printing out pictures of genitalia is a fun way to wind up the secretaries.'[31]

Adolescence

In *Amazing*, a new video from rave-rockers Aerosmith, a pimple-faced lad summons up an image of himself on his home computer and magically erases those zits ... donning the mandatory virtual reality gear, he steps into a higher, hornier hyper reality where all his lusts are gratified.

Time magazine, 1994[32]

In wandering through examples of interactive pornography, it has begun to strike me that the connection with comics and cartooning may not be just in the visual representation. The whole tone of the content of the pieces seemed to be much less about actual juicy sexual gratification, and much more about a sniggery chance to make the women characters do stupid things, in the setting of a clean and tasteless stage which reminded me of nothing so much as a 13-year-old computer nerd's bedroom. The absence of touch and smell (which to me appears to put most pornography at rather a disadvantage) might actually be a bonus for the antiseptic pubescent male. Bearing in mind the huge predominance of adolescent males in the marketing profiles for computer games software, are we seeing a kind of pornography which is specifically aimed at boys rather than men? Pornography magazines have of course often been part of adolescent initiation for

many years, but are not specifically marketed in adolescent contexts, nor specifically as 'games'.

Reasons to be cheerful? The cheapness of laser copy paper

GayBlade ... players arm themselves with tiaras, condoms and press-on nails to slay Angry Fundamentalists, Sleazy Publishers, Sluts and Homophobic Yuppies.

Alternative computer game review, *Future Sex* magazine no. 5

Kirk and Spock are sensitive in the slash stories, as well as kind, thoughtful, and humorous.

Constance Penley, 1991[33]

Mainstream computer-based pornography is relentlessly aimed at men (or boys), relentlessly heterosexual, and, to me, fairly relentlessly depressing. Our future however, may not be wholly Victorian. Whilst those 'others' with their hands on the means of production may be as yet few and far between, due to the blessed cheapness of laser copy paper there has for many years been evidence of sexual imaginings which take us into a future which is socially as well as technologically innovative. I have for several years been following with amazed interest the activities of those women who write 'slash stories' – pornography about sexual relationships between Kirk and Spock ('K slash S').[34] Due to the late arrival of 'new man' the 'K/S ladies' obviously decided to make their own, and have novels, pictures, scratch videos and many short stories to show for it. Constance Penley has written on the K/S phenomenon, and suggests that 'writing a story about two men avoids the built-in inequality of the romance formula, in which dominance and submission are invariably the respective roles of male and female ... [in a] fully automated world where there will never be fights over who has to scrub the tub'. The writers can choose from nature or culture, butch or femme, active or passive just exactly as they wish, and they certainly do, inventing the future as they go along in ways which are by no means only soft-core.

The 'slashers' (their name for themselves) include nurses, teachers, office workers or factory workers, and they circulate their work in ways that range from chain-letter-type mailing of their ten favourite stories, to e-mail and conferences where they share tips on making scratch videos from *Star Trek* footage. The Black hip-hop phrase 'droppin' science' has been defined as 'sharing knowledge, knowledge that is generally inaccessible to people'[35], enabling the growth of cultural forms such as scratch DJ/music making. This expressing of desires in the interstices of popular culture and street technology, with low-tech but convivial methods, is a familiar one. Black heroes make it into the future on the pages of some science fiction books (by writers such as Octavia Butler[36] and Samuel R. Delany[37]), and a few radical comics, but grow rarer and rarer the higher up the

technological and economic scale. The sexual and social 'others' have always had to adapt and reuse technologies rather than buy them off the shelf. When it comes to sexual technologies, women could be said to be some of the first mass users of 'sex machines' – vibrators. Nevertheless, the phallic shape of vibrators is rather more to do with male iconography than their practical use. Others who have adapted and re-functioned misshapen mainstream devices to their own ends include many disabled people who have fashioned standard technologies into warm and creative communication tools. All over Britain, 'Outsiders Groups' (social groups of people who identify themselves as outsiders because of disability or difference) could testify to technology-aided relationships of a diversity many times broader and richer than the dreams of commercial pornographers.

If Mike Saenz (creator of *Virtual Valerie*) had a sister with access to things more expensive than writing paper, what would she create? Interactive multimedia offers opportunities for mystery, sensuality, surprise, humour, education, and the possibility for many voices, different tongues. In three minutes of laughing over dinner with friends, we come up with 'Dot Matrix' (Donna Matrix's imaginary mum who shares tea and fun and mature knowledge) or the fun potentials of shape-changing and cross-gender role-playing, or maybe a 3D virtual reality landscape map to aid in the location of the clitoris, or maybe ... who knows! Certainly, despite harassment on the Internet, I know women who thoroughly enjoy expressing their fantasies on e-mail, and revel in the playground of a textual embodiment which is 'safer' than their actual embodiment, even 'safer' than the telephone.

One of the saddest things I read during my research was a quote from Mike Saenz, who said that 'Actually, the best product somebody could come out with right now would be a VR version of *How to Pick up Girls*. It would be a sort of cyberspace primer for shy guys. They could practice their seductive techniques on virtual women who will reward them for saying the right things and dis them for saying stuff that turns women off.' This longing for a friendly 'guide', and the idea that this can be supplied by a computer programme written by an equally clueless male, is perhaps an occasion for pathos. As ever, it's not necessarily the technology itself but the designers who get access to the means of production (and the society in which the products are used) which make the difference. There are indeed some women both inside mainstream companies and working on the fringes, but there is unsurprisingly a great deal of ambivalence over their identification, and a general rush to forget the analogue lessons of the past.

Having it both ways

AR: Isn't there a sense that this is a kind of 'bad girl' manifesto ...

DH: To a certain extent, yes.

AR: Because it's about pleasure and danger ...

DH: And it takes a certain analogical alignment in the pornography debates...

Penley and Ross, interview with Donna Haraway, 1991[38]

Hiding under the guise of populism, the liberation politics touted in the pages of *Mondo 2000* are the stuff of swashbuckling, irresponsible individualism that fills the dreams of 'mondoids' who, by day, sit at computer consoles working for (and becoming) corporate America.

Vivian Sobchack, 1993[39]

The sheer ambivalence of new technology in relation to culture is vast, swinging from utopianism to some kind of techno-holocaust, both of which are fairly media-sexy. Technology is certainly all about pleasure and danger, and certainly those women creating pornography have to deal with both of those things. Pornography itself perhaps has always been about 'having it both ways': desiring contact yet wanting to be alone; desiring control yet wanting surprise. There is in addition, however, the context of much 'technoculture' which seems to want to have its politics both ways too. Living for some time in California, I have had the privilege of experiencing cyber-hippies, who tell me that their lap-top computers are ecologically sound because they use less paper.

Those readers of *Mondo 2000* magazine referred to by Vivian Sobchack are having it both ways in a manner particularly embodied by this Techno-New-Age 'global village' utopia. The magazine features 'spirituality' (sort of 'bring-and-buy Buddhism' with crystals), 'lifestyle' (self-defence tazers as fashion accessories on sub-Barbarella babes), ubiquitous cowboy hacker heroes, and even 'free love'. The San Francisco magazine *Future Sex* is a close relation of *Mondo 2000*, and is bound up with much the same New Age soft politics/free love ideology. The magazine is edited by Lisa Palac, purports to be 'sex positive' and involved in new ideas and new technology, but still appears to be predominantly aimed at heterosexual men, even if some of the authors are women. Likewise the photographs seem to be very much modelled on mainstream pornography (some occasionally feature inept Photoshop additions, but nothing representationally very different). Strangely, it is not the representations of bodies but the representations of the technology itself which tend to be most fetishised and charged: silky-smooth computer graphics of 3D abstract shapes which could be machines or could be ejaculating tubes (definitely male anyhow), bits of electronic sex equipment which are laid out for view and tested rather like a funky *Which?* consumer report. Readers on the letters page appear to think that the representation of inter-racial couples is a radical new move, but the debate rarely gets any more involved than that. Obviously, the creation of a different pornography is an experimental process just starting, but nevertheless I found the magazine a big disappointment. I even found myself wondering whether, like mainstream pornography, those stories with women's names attached were actually written by men.

beryl graham

Lisa Palac has also produced *Cyborgasm*, a 'Virtual 3D Audio' sex CD which is certainly more polymorphous than the mainstream, including a lesbian track (by actual lesbians that is), and the deified Annie Sprinkle. It's a very interesting set of work in the light of debate over whether or not purely visual porn can work for women, and it is indeed a very intimate experience to have various people whispering (or panting) into your ears from different points in space, but again the content is rather more 'free love' than truly alternative: *Cyborgasm* seems to be disproportionately keen on female masochism, and includes a fantasy father–daughter incest scene, without comment. The editorial position of *Future Sex* is, unsurprisingly, resolutely anti-censorship, but without apparently being able to articulate why. In line with the prevailing New Age politics, it feels like this is more of a '*laissez-faire* anti-censorship' than any kind of a reasoned position.

The position from which both pornography and technology are able to be explored or controlled is of course a position of relative privilege and power – a very small space in which to work. Those who have gained the ground of that small space can sometimes forget that the work produced still has to live in the wider world where the words 'post-feminism' or 'classless society' may be greeted with a hollow laugh. Clashes at recent conferences such as the ICA 'The Body in the Virtual World'[40] highlight the fact that debates about pornography and representation are in danger of slipping wholly into '*laissez-faire* anti-censorship' but still have some harder, more difficult politics to deal with.

Groups of women artists such as the 'Caught Looking' group in the USA and 'What She Wants' in Britain may have arrived at an anti-censorship viewpoint, but still find themselves wrestling with many other questions. Is it enough to simply 'reverse the gaze'? What do we represent and is it actually sexually gratifying? Is the difference between erotica and pornography just one of class? Where do we draw the line? When thinking about computer-based pornography we have to deal not only with that ongoing battle over the links between pornography and actual sexual relationships, but also with the popular battle over whether video games are inherently 'bad' for children (and by extension, the further 'badness' of pornographic video games for all ages). Are the newer media characteristics of control, of added 'realism' of caricatures of the body, more 'bad' than regular pornography, or something which has been striven for in pornography all along? The advent of interactive technology has actually tended to blur the examination of exactly what is being represented. Again it is useful here to look back at the development of photographic pornography: the changes in form have of course affected how images are read, but the real changes in the content (different representations of sexualities, and a real range of choices) have perhaps only occurred recently in a small sector of photography, when women, people of colour, gay men, lesbians, and disabled people have fought for the mental and physical space to explore the picturing of sex.

This battle for the space to make 'other picturings' will no doubt have to replay itself on computer screens. The question is, will it take another 150 years for any kind of real choice to establish itself within these new media?

Notes and references

1 Charles Baudelaire, 'The Modern Public and Photography', in Alan Trachtenberg (ed.), *Classic Essays on Photography*, New Haven: Leete's Island Books, 1980.

2 Nicholas Lavroff, *Virtual Reality Playhouse*, Corte Madera: The Waite Group, 1992.

3 Amy Harmon, 'Seedy ROMs a Hit', *The Guardian*, 3 December 1993.

4 For more information about Alan Turing and the Turing Test see Benjamin Woolley, *Virtual Worlds: A Journey in Hype and Hyperreality*, Oxford: Blackwell, 1992, pp. 105ff.

5 Quoted in Elaine Showalter, *Sexual Anarchy: Gender and Culture at the Fin de Siècle*, London: Bloomsbury, 1991.

6 Suzanne Stefanac, 'Sex and the New Media', *New Media* (USA), April 1993.

7 Sandra Buckley, 'Penguin in Bondage', in Constance Penley and Andrew Ross (eds), *Technoculture*, Minneapolis: University of Minnesota Press, 1991.

8 The Internet is part of the electronic mail system (computers linked via telephone or ISDN lines to exchange text and image information), where lots of information is 'on-line' for people to look at or add to. The system can access so much information that it is often difficult to find what you want, and the interface is very 'user-unfriendly' with not-very-descriptive filenames, etc. Hence it does require one to be 'in the know' and to understand the obscure codes. In addition to this, the sexual topics tend to be kept hidden away, requiring you to know key code words. Images can be downloaded, but this takes a long time, and the images tend to be b/w and very low resolution. Getting sexual kicks on the Internet is therefore a highly codified and laborious process!

9 Quoted in Elaine Showalter, op. cit.

10 Quoted in Kathleen Rogers, 'Virtual Real Estate', *Variant*, April 1992.

11 See Donna Haraway, *Simians, Cyborgs, and Women*, London and New York: Routledge, 1990.

12 Authored by Roy Stringer for Liverpool John Moores University.

13 Talk by Roy Stringer at 'Media Active' conference, Liverpool John Moores University, 4–6 May 1994.

14 Jeffrey Weeks, *Sex, Politics and Society*, London: Longman, 1981.

15 N. Katherine Hayles paraphrasing Fredric Jameson in 'Virtual Bodies and Flickering Signifiers', *October*, Fall 1993.

16 Frances Barker quoted in Allucquere Roseanne Stone, 'Will the Real Body Please Stand Up?: Boundary Stories about Cyberspace', in Michael Benedikt (ed.), *Cyberspace: First Steps*, Cambridge, Mass.: MIT Press, 1991.

17 Ann-Sargent Wooster, 'Reach Out and Touch Someone: The Romance of

Interactivity', in D. Hall and S. Fifer (eds), *Illuminating Video*, New York: Aperture, 1991.

18 Suzanne Stefanac, op. cit.

19 ibid.

20 John Tagg, *The Burden of Representation*, London: Macmillan, 1988.

21 Sandra Buckley, op. cit.

22 Interactive CD Rom, produced by Reactor, a Chicago-based software company.

23 John Tagg, op. cit.

24 Sadie Plant, 'Beyond the Screens: Film, Cyberpunk and Cyberfeminism', *Variant*, May 1993.

25 Many theorists have written on the subject of the body and technology. Some of the key ones are: Donna Haraway, op. cit., N. Katherine Hayles, op. cit., Allucquere Rosanne Stone, 'Will the Real Body Please Stand Up?: Boundary Stories about Cyberspace', in Michael Benedikt (ed.), op. cit.

26 Allucquere Roseanne Stone, op. cit.

27 Michael Heim, 'The Erotic Ontology of Cyberspace', in Michael Benedikt (ed.), op. cit.

28 See Jo Spence, *Putting Myself in the Picture*, London: Camden Press, 1986, and David Hevey, *The Creatures Time Forgot*, London and New York: Routledge, 1992.

29 Carys Bowen-Jones, 'Hi-Tech Sex', *Marie Claire*, April 1993.

30 In the USA, however, women have successfully brought to court some cases of sexual harassment involving computer pornography.

31 Diane Butterworth quoted in 'Computer Porn Hurts Female Staff', *The Independent*, 6 September 1993.

32 Richard Corliss, 'Rock goes Interactive', *Time*, 24 January 1994.

33 Constance Penley, 'Brownian Motion: Women, Tactics, and Technology', in Constance Penley and Andrew Ross (eds), op. cit.

34 For further critical writing on this phenomenon, see Joanna Russ, 'Pornography by Women, for Women, with Love', in *Magic Mommas, Trembling Sisters, Puritans and Perverts: Feminist Essays*, Trumansburg Crossing, 1985. Lamb and Veith, 'Romantic Myth, Transcendence and Star Trek zines', in *Erotic Universe: Sexuality and Fantastic Literature*, New York: Greenwood, 1986.

35 Tricia Rose, quoted in Mark Dery, 'Black to the Future: Interviews with Samuel R. Delany, Greg Tate, and Tricia Rose', in *South Atlantic Quarterly*, 92: 4 (Fall 1993).

36. Octavia Butler, *Clay's Ark*, New York: St Martin's Press, 1984, and New York: Dawn Warner, 1987. Donna Haraway also writes about her work in *Simians, Cyborgs, and Women*, op cit.

37 See Mark Dery, 'Black to the Future: Interviews with Samuel R. Delany, Greg Tate, and Tricia Rose', and Claudia Springer, 'Sex, Memories, Angry Women', in *South Atlantic Quarterly*, 92: 4 (Fall 1993).

38 Constance Penley and Andrew Ross, 'Cyborgs at Large: Interview with Donna

Haraway', in Constance Penley and Andrew Ross (eds), op. cit.

39 Vivian Sobchack, 'Reading *Mondo 2000*', *South Atlantic Quarterly*, 92: 4 (Fall 1993).

40 'Seduced and Abandoned: The Body in the Virtual World', Institute of Contemporary Arts, London, 12–13 March 1994. The performance artist Orlan was challenged from the floor about the privilege of her position, and the challenger was accused of 'censorship'. A similar event happened at the conference 'Where do we Draw the Line', organised by Projects UK, Newcastle, 5–6 October 1991, when Karen Finley was questioned about the context of her audience, and accused the questioner of censorship.

beryl graham

medicine's
new vision?

sarah kember

Introduction

Our society is not one of spectacle but of surveillance.[1]

The photograph has always promised to take us beyond vision.[2]

This chapter examines the role of photo-mechanical and electronic imaging in the surveillance and classification of the body, and considers how that role is affected when photography fulfils its promise 'to take us beyond vision'. Kevin Robins is referring to the practice of psychic or spirit photography which took place alongside surveillance and other more 'honorific'[3] portrait practices in the nineteenth century. This, he suggests, 'aspired to reveal secret realities' and to afford access to the invisible and unknown.[4]

The concern here is with medical imaging and the question of how, whether and to what effect photography achieves visionary status in this context. How is the diseased body surveilled and classified at the point where the limitations of photo-mechanical realism appear to be superseded?

Despite apparent and rather obvious differences in the way in which old and new technologies represent the body (for example in concentrating respectively on exteriors as opposed to interiors, fragments rather than the whole, black and white versus colour), this chapter argues that there is in fact no clear separation

between photo-mechanical and electronic imaging in the context of the surveillance and classification of the body. New medical imaging technologies bring forward a discourse of domination and control over the body; a discourse which was institutionalised in the nineteenth century with the advent of photography, but which was always already unstable.

Historically, women's bodies have been of paramount interest to medical science and this is because from the Renaissance onwards science has symbolised nature as female and has sought a privileged access to it. Ideas about nature and femininity are conflated, and the female body is symbolically constructed as the female body of nature. Medical science seeks to know and to control this nature partly through the agency of viewing technologies, but paradoxically, the sovereignty it seeks is as much challenged as secured by both the technologies and the gendered relations it employs.

Medical and legal photography in the nineteenth century

Surveillance and classification are forms of social control which operate through the acquisition and organisation of information. Moreover, information is acquired through observation. Foucault identifies the association between observation, knowledge and power as being inherent in the positivist philosophy and epistemology of the Enlightenment period, and he identifies Jeremy Bentham's architectural model of the Panopticon as being an exemplary surveillance mechanism. The Panopticon consists of a central tower surrounded by individual cells. Light shines through the cells from windows on the outside of the building.

> All that is needed, then, is to place a supervisor in a central tower and to shut up in each cell a madman, a patient, a condemned man, a worker or a schoolboy. By the effect of backlighting, one can observe from the tower, standing out precisely against the light, the small captive shadows in the cells of the periphery.[5]

The Panopticon consists of spatial and temporal units which facilitate constant visibility and identification. It structures a relationship of power between the observer and the observed such that the physical presence of the observer is ultimately superfluous to the mechanism which instils in the observed the recognition of his/her status as a member of the class of the surveilled. As John Tagg points out, the Panopticon was the epitome of a disciplinary practice already carried out across a range of institutions including schools, prisons and hospitals. Here, 'a temporal-spatial technology, with its enclosed architectural spaces, cellular organisation, minutely graded hierarchial arrangements, and precise divisions of time, was set to work to drill, train, classify and survey bodies in one and the same movement'.[6] Foucault took the Panopticon as a metaphor for the

widespread operation of an economically and epistemologically productive form of power in society: 'seeking to procure the maximum effect from the minimum of effort and manufacturing docile and utilisable bodies'.[7]

The industrial revolution saw the development of an expanded urbanised labour force which was subject to conditions of overcrowding, poverty, disease and crime. It was thereby perceived as a potential threat to itself, its owners and the health of the national body at large. Disciplinary institutions were developed in order to cater for and to regulate this section of the population. The new technology of photography, together with practices such as physiognomy and phrenology[8] were employed in the establishment of a vast archive of information within which the bodies of the surveilled were brought into the light of knowledge and thereby controlled. Photographic practitioners such as Hugh Welsch Diamond, Francis Galton, Alphonse Bertillon and Havelock Ellis helped to establish a typology of the sick, insane, criminal and any section of the population which was considered to be 'other' than the defined norm. 'Otherness' was principally considered through the terms of economic productivity – the sick and criminal elements of society were not contributing usefully to the system of profit – and so hospitals and prisons institutionalised a visual record of reform in which bad citizens were seen to be made good. Before-and-after photographs became common, and Barnardo's use of them resulted in his imprisonment for vastly exaggerating the conditions of orphans who entered his home. Not only were identities regulated in terms of productivity, but as Elaine Showalter shows, the identity of women confined to disciplinary institutions was regulated in the dual terms of productivity and reproductivity. Attempts to regulate menstrual cycles and the performance of clitoridectomies signified the desire of doctors, institutions and the state to confine women's sexual role to that of reproduction. Mania was actively suppressed and the institution was organised so as to fully employ otherwise unproductive subjects in domestic roles. Laundry duties, for example, were seen to function as 'symbolised purgation'. Any sign of protest, especially that associated with feminism, was controlled in part through the creation and photographic documentation of the category of hysteric. Charcot, a specialist in this area, was also subject to allegations of fraud and of fictionalising the photographic document:

> Because the behavior of Charcot's hysterical stars was so theatrical, and because it was rarely observed outside of the Parisian clinical setting, many of his contemporaries, as well as subsequent medical historians, have suspected that the women's performances were the result of suggestion, imitation, or even fraud.[9]

Although photography played a central role in the institutionally authorised practices of surveillance and classification in the nineteenth century, it was never in itself a faultless instrument of surveillance. As John Tagg clearly demonstrates

in *The Burden of Representation*, it was the institution not the mechanical process of representation which endowed photography with the authority to 'tell' the truth. The camera as the instrument of optical realism was simultaneously the agent or a whole epistemological tradition of positivism which had become institutionalised and brought into the service of one section of the population. Positivism is a system of thought, attributed principally to Auguste Comte (1798–1857), which is concerned with the way in which society can be studied by the same principles and methods as the natural sciences. That is, positivism is concerned with the establishment of facts through observation and experience. Photographic realism served and reinforced the authority of positivism and its institutions by creating specific regimes of truth, but the nature of photographic realism was always already in question.

Allan Sekula remarks that 'if we examine the manner in which photography was made useful by the late nineteenth-century police, we find plentiful evidence of a crisis of faith in optical realism'.[10] In his attempt to establish a system of criminal identification, Alphonse Bertillon found that 'the early promise of photography had faded'. It had generated 'a massive and chaotic archive of images' and needed to be linked to other systems of classification. Bertillon resorted to anthropometrics, 'a refined physiognomic vocabulary' and statistics based on eleven different measurements of the body.[11] He was critical of inconsistent photographic practice and 'insisted on a standard focal length, even and consistent lighting, and a fixed distance between the camera and the unwilling sitter'. As well as contextualising the use of photography through statistics, he also devised the verbal portrait (or 'speaking likeness') in 'an attempt to overcome the inadequacies of a purely visual empiricism'.[12]

The technical limitations of early medical photography were such that it was for a time confined to recording diseases which affected the exterior of the body. Roberta McGrath has pointed out how medical metaphors such as 'moral leprosy'[13] relating to the supposed maladjustment of the working classes were supported within the medical institution by visual records of physical abnormalities. The metaphorical disease which was ascribed to one section of the social body, was realised (investigated, recorded and controlled) on the surface of the bodies of isolated individuals with physical deformities. The Royal Society of Medicine's photographic archives display a number of individuals with cancerous growths, ulcers, and other deformities which in other contexts have been described as 'freakish'.[14]

It is useful here to consider the role of photography in relation to psychoanalytic theory and to ideas about fetishism in particular. What many of these photographs in fact capture is a process of technological fetishisation in which the threat posed by labour to the ruling classes is like the threat of castration. Labour lacks political and economic power and access to representation, the ruling classes become more aware of labour and fear that they will suffer

the same fate. In psychoanalytic terms, power is symbolised by the phallus and the fetish is the object or part object which disavows the absence of the phallus, and reduces the threat of castration.

In the nineteenth century the new technology of photography operated as a fetishistic means of social control based on the disavowal of a threat posed by one section of the society to another. Control was articulated and inscribed on the body by subjecting the isolated individual to minute and detailed forms of visual, textual and statistical surveillance and classification. In the case of Bertillon (and Galton who produced composites) images were virtually computed, and in medicine the practice of photography was joined by photomicrography, endo-scopy and x-ray before the end of the century. These other forms of imaging were at least initially beset by problems of focusing and visual differentiation and in any case presented uncolonised territory to the medical gaze.

This shows that there is no clear historical separation between photography and other forms of technology and surveillance, and that photography never offered unmediated access to the real. It is precisely because photography was used to mediate between groups and organisations possessing different levels of power in society that it brought forward a discourse of domination and control, albeit unstable.

The discussion that follows has two sections. The first, 'Current medical imaging technologies', consists of a technical account of key forms of contemporary medical imaging technology and it aims to provide the basis for a detailed analysis of the way in which medicine now sees the body. The second section, 'Utopian vision and its critique', brings in the framework of debates on the relation between gender and science/technology, and gives a critical consideration to the way in which medical computer images represent the female body. This section is based on the argument that there is a 'special' historical relationship between medical science/technology and women's bodies, and that this relationship is based on domination. Where new forms of medical imaging seem to challenge the historical terms of domination, they in fact restate them in another form of technological fetishism.

The second section also investigates the concept of the 'mother-machine' or cyborg and investigates the extent to which Donna Haraway's model of the cyborg presents a challenge to the scientific tradition of domination and control over the female body.

Current medical imaging technologies

In medicine, digitised imaging, particularly in conjunction with CAT scans and ultrasound, is producing a new type of representation of bodily innards.[15]

This new type of representation may be said to be analogical – the most remote new surfaces of the body's interior appearing like pictures from outer space. A tumour can look like a nebula, and a cancer cell can look like a star. What is the significance of this to medical epistemology, the relation between subject and object, or to a culture in which digital and electronic images of the body are proliferating? And what is the significance of the development and implementation of technologies which supersede the capacity of the clinical eye in diagnosis?

The technical development of medical imaging began with the digitalisation and computerisation of traditional x-ray techniques which had not changed significantly for the eighty years since their invention by Roentgen. It is continuing now with a process called magnetic resonance imaging, which is capable of detailing not only the body's anatomy (structure) but also its physiology (function). The body can now be anatomised 'live' and functioning because the process of imaging can replace the practice of dissection in the search for medical knowledge.

Diagnosis is carried out within a massive optical system which literally encloses the body as its object. The body is subjected to the transmission, reflection or emission of energy in the form of radiation. Transmission imaging is centred on the traditional x-ray and its enhanced form known as computed tomography. X-rays are produced when electrons from a single source make contact with a target or receptor made of tungsten. They are directed straight through the body but are absorbed to varying extents. Bone absorbs more of the beam than soft tissue, air or body gas. Obviously, where the x-rays are absorbed there is less exposure or 'shadow' on the receptor film which then yields a picture of bony structures.

Computed tomography

Where a conventional x-ray film provides a range of 20 to 30 grey scale variations for interpretation, computed tomography can differentiate over 200 shades of grey. This is due to an advance in the way the x-rays are taken, and to a process of translation whereby x-ray information is digitalised by computer and then visualised. In computed tomography the body is enclosed within the x-ray mechanism or scanner which is generally described as 'doughnut-like'. The scanner containing the source and receptor is rotated around the stationary body, penetrating it with a thin fan-shaped beam which provides a cross-sectional image or 'slice' from any given angle. Conventional radiographs view the body from only one angle and so the shadows of bone, muscle and organs are superimposed.

From a cultural perspective, one of the more important features of computed tomography is that it overcomes the limitations of viewpoint, and also intervenes in the process of interpretation. The transmission of x-rays through the patient is measured with electronic sensors, converted to digital form and then sent to

sarah kember

the computer where the signals are processed by a reconstruction algorithm to yield an image of the anatomy.

The computer provides a matrix of numbers which are used to represent different tissues. The numbers are converted to a specific video grey level and represented at the correct position in the video display. Although the computer can provide 2,000 number levels, the human eye can only detect around 20 grey levels and so data is 'binned' into displayable levels which are controlled by the user in order to optimise visibility. An alternative to this radical concession to the limitations of the human eye is colour enhancement. The eye is reputed to be better at colour perception, being able to differentiate around 200 colour variants in a spectrum that runs from red to violet. In this case, each number density is assigned a colour in a way which can be either arbitrary or standardised.

Computed tomography has significantly improved the imaging of small bones and some soft tissue, but where the details are still represented two-dimensionally, they can be difficult to conceptualise in three-dimensional form, and this has led to the development of three-dimensional reconstructive imaging whereby all the slices taken of a particular area are reassembled in order to give a more complete view on the screen. The screen object can then be used as a model or simulation of the real object, for example, in reconstructive surgery.

In computed tomography, the search for anatomical detail supersedes any that the human eye/scalpel is capable of and the computer processes of colour enhancement and three-dimensional reconstruction serve as a retrospective concession to the viewer's need for recognisable form. Tomography is the word used to describe the way in which unwanted detail surrounding the target object is eliminated from the scanner's field of vision. It is eliminated by the blurring action of a moving x-ray tube with a fixed focus beam synchronised to a moving film cassette and targeted on a slice of the body as thin as one millimetre. All information of greater or lesser depth is obscured by the movement.

Magnetic resonance imaging

Magnetic resonance is a form of emission imaging (reflection imaging is principally characterised by ultrasound, which has been in use for about twenty years and is relatively limited) consisting of a tunnel-like magnet which sets up a magnetic field around the patient (Figure 4.1), and of generally similar image-processing equipment to that used in computed tomography. The magnetic field causes hydrogen atoms in the body to line up while a radio frequency signal is transmitted briefly in order to upset the uniformity of the formation. When it is turned off, the hydrogen atoms (it is actually the protons which are imaged) return to the line-up and in doing so discharge a small electric current. The computer measures the speed and volume with which the atoms return and translates this information into an image on a screen. Detail can be enhanced

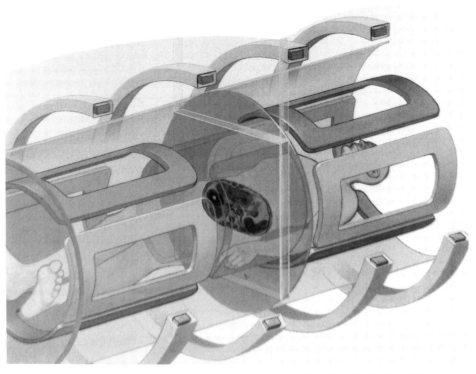

Figure 4.1 Diagram of a magnetic resonance body scanner. H. Sochurek, *Medicine's New Vision*, Easton, Penn.: Mack Publishing Company, 1988.

using surface coils placed on an exact area of the body, and contrast material introduced intravenously.

Because magnetic resonance does not rely on the detection (by a radiologist) of variations in density on film, and is centred on areas of high water (rather than bone) content, it is able to depict fine details of soft tissue including blood vessels and tumours. According to Howard Sochurek in *Medicine's New Vision*, the use and development of magnetic resonance imaging heralds a 'Golden Age' of diagnostic medicine.

Magnetic resonance is shown to be an immensely complex process and one which yields extraordinary images – extraordinary because of their diagnostic accuracy and their aesthetic appeal. In Sochurek's book and elsewhere[16] the more-than-global dimensions of this imaging process are described in the language of science-fiction. The magnetic field is '30,000 times stronger than the earth's', is 'supercooled with liquid helium to minus 452 [degrees]' or '4 [degrees] above the coldest temperature possible anywhere in the universe' and it could 'propel a family car at 100 mph'. The whole unit weighs 15 tons and costs one and a half million pounds to buy. Magnetic resonance is evidently daunting from the point of view of the patient who experiences considerable noise and must keep very still or be sedated. Nevertheless, the reward is of moving pictures from inside the body which are used by Sochurek as evidence of the glory of the new scientific order and the redemption of its new scientific object.

Sochurek's book of colour-enhanced images and imaging techniques is interspersed with narrative – that of his own discovery of diagnostic imaging, and that of his case histories. The young and old, ordinary working men and women, indigenous subjects and foreigners are all seen to be encompassed by this benevolent, semi-autonomous extra-global optic machine. Through it, or through having been in it, they are not only cured physically, but reformed morally and transformed aesthetically – on the whole. A soldier turned photo-journalist turned documentarist, Sochurek is described in *Photography* magazine[17] as 'the epitome of a perfect opportunist' who, on a mission for *Life* magazine, was told to investigate state of the art imaging and 'spent his last buck' on a computer that NASA was throwing out. The computer had been used to process and project information from spy, weather and survey satellites. He used it to tap into the latest advance in diagnostic imaging.

There are significant links between medical and astro-military imaging. Sochurek describes the computer graphics employed in computed tomography as 'similar to those used to reassemble pictures beamed back from distant space probes like Voyager'. In California, the 'equipment once used to create the mind-boggling effects for movies such as George Lucas's *Star Wars* is now being used to save human lives'. The Lucas computer, designed to process graphic images, is apparently sold in modified form to hospitals needing a quickly processed three-dimensional image from their computed tomography scans. Moreover, he claims

that the Department of Defense (in the United States) has long used image enhancement in evaluating aerial pictures for camouflage detection, and now this equipment is used in medical imaging.

The electronic imaging technologies used in medicine construct a new way of looking at the body in relation to space. But do they structure a new way of knowing the body, or represent a paradigm shift in medical epistemology?

Utopian vision and its critique

Where photo-mechanical images fragment the body in the process of diagnosis and identification, computer images can re-form the body, and through placing it in an analogical relation with space, make it whole. In this sense, medical epistemology – at least in as far as it is structured through representation – seems to be re-incorporating aspects of the medieval concept of microcosm/macrocosm in which the body and the cosmos were analogically mapped. This mapping was represented through figures such as the astrological Zodiac in which the body and the planets were enclosed within a system of concentric spheres, with 'man' at the centre (Figure 4.2).

Sochurek's labelled photographs and annotated drawings of the body lying within the scanner appear to literalise this pre-modern concept, re-centring the subject as a stationary object in a rotating global system (Figure 4.1). The revolving scanner corresponds with the celestial spheres as a semi-autonomous universe or scientific heaven. In Sochurek's illustration of a magnetic resonance scanner there is an outer and an inner circle, an external anatomy and a cross-section of the body revealing the inner organs. In place of the primary elements, qualities and humours are the protons, atoms and tissues, and in place of astrological symbols there are biochemical symbols which relate to the body but which are nevertheless independent.

What is at stake is whether medicine's 'new' analogical vision constitutes a different way of knowing the body, and a different relation of power between the subject and object of that knowledge. In other words, is the Foucauldian reading of photography as a panoptic instrument of surveillance also applicable to electronic forms of imaging in medicine? Is the body still subjected to the same monolithic operation of power/knowledge?

Howard Sochurek takes a utopian view of medicine's new visionary status, and others have argued that new medical imaging technologies are liberatory, not controlling. In *Body Criticism, Imaging the Unseen in Enlightenment Art and Medicine*, Barbara Stafford states that 'the marvels of non invasive body scans are but one small instance in our culture of an undeniable pictorial power for the good'.[18] For her they contribute towards the formulation of 'a new and non reductive model of knowing' which differs from that of the Enlightenment. The Enlightenment model of knowing, upon which Bentham's Panopticon is based, carried forward

sarah kember

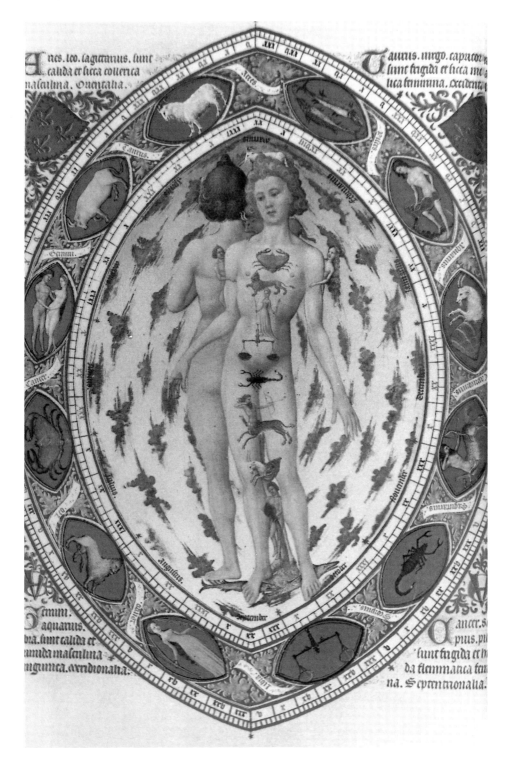

Figure 4.2 Zodiacal miniature from the *Très Riches Heures*. *Journal of the Warburg and Courtauld Institutes*, vol. 2, 1949, p. 1.

a concept of anatomy not just as a medical practice but as an intrusive 'intellectual method that uncovered the duplicity of the world'. By a process of uncovering, anatomy discovers the body as a guilty object – a barrier to interiority and truth. Anatomical practice perpetuates the Cartesian hierarchy of mind over body, method over material, with the underlying moral imperative 'to even out the odd'. Stafford names this hierarchical dualism as oppressive and patriarchal and claims that in the emerging unified world of electronic imaging:

> the opportunity exists not only to free the image from patriarchal rule, but to liberate other, supposedly lesser orders of being from domination and a false sense of superiority. These 'inferior' forms of nature include any sex other than male, races other than white, creatures other than man, and environments other than industrial or corporative.[19]

Whereas Sochurek and Stafford share in a utopian vision of a unified, egalitarian technological environment, Andrew Ross regards technology as an ideologically contested site. In *Strange Weather*, he rejects the view which regards technology as the autonomous agent of either liberation or control, and stresses the importance of recognising it as a fully cultural process. In order to critically evaluate Stafford's claim for the potential of new analogical imaging technologies to liberate – for example – the other sex, it is necessary to provide a gendered cultural history of specific technologies and investigate the modes of representation and relations of power structured within them.

A significant proportion of the work which contributes to the debates on the relation between gender and science/technology has focused on the construction and representation of gender in medical science, and in fact tends to argue that modern medicine perpetuates historic forms of control. In the introduction to *Body/Politics, Women and the Discourses of Science*, Mary Jacobus *et al.* suggest that:

> The last two centuries have witnessed an increasing literalization of one of the dominant metaphors which guided the development of early modern science. For Bacon, the pursuit of scientific knowledge was figured rhetorically as the domination of the female body of nature, illuminated by the light of masculine science.[20]

Due to the professionalisation of science and advances in technology, they claim, the metaphor of domination has developed into explicit material and ideological practice – specifically but not exclusively in relation to medical science and the control of reproduction:

> Viewed as medical events, pregnancy and childbirth can be monitored and controlled by the latest technology, while in the laboratory, women's role in reproduction is increasingly open to question; IVF and the burgeoning of genetic engineering offer to fulfill, with undreamt of specificity, earlier visions of science as the virile domination of the female body of nature.[21]

Ludmilla Jordanova examines the history of the relation between gender and medical science through the concept of unveiling and the association between unveiling and anatomy. In order to represent a privileged relation to truth and nature, science and medicine were drawn to the construction of nature as female and to the image of unveiling. Anatomical representations of unveiling figure not only the possession of a particular female body, but the knowledge and mastery of feminine identity and, by association, of nature itself.

Where Barbara Stafford maintains that current medical imaging signals a break between medical epistemology and the terms of domination established in the Enlightenment period, Jacobus *et al.* maintain that it not only perpetuates but fulfils those terms. They are not, however, arguing for the existence of a simple trans-historical mapping of scientific ideas and practices but a non-linear historical development organised around periods of marked social, economic and technological change.

> With the coming of the industrial revolution and our entry into the machine age, the Victorians were forced to address the interface between the human and the machine in terms very different to those employed by Descartes. Political economists of the era extolled the virtues of the machine which seemed to offer a corrective to the inefficiency and indiscipline of human labor, endowing machinery with the agency and productive powers previously assigned only to human life. Within this framework, woman, as reproductive vehicle, came increasingly under scrutiny as the forces of production and reproduction were drawn into ideological alignment.[22]

This alignment is also a feature of current medical discourse, but it is an alignment which elides the material presence of the female/maternal body within a technology which is constructed ideologically as both productive and reproductive. Thus the female body is not as much dominated as obliterated – in some sense lost or effaced. Sochurek's chapter on Ultrasound scanning of pregnant women substantiates Paula A. Treichler's argument that 'the role of the mother has been written out of the birth process which is now projected as an interaction between doctor and foetus'.[23] The scanning process eliminates the mother's body from view and the doctor has unmediated access to the image of the foetus. The body exists only as a vehicle for scientific information – receiving and transmitting high-frequency sound waves which are converted to electronic signals and then to an image on a screen. It becomes part of the imaging technology or process which itself seems to combine both productive and, reproductive status: the foetus is seen to be formed and contained as an image on a video screen. Sochurek claims that the 'psychological process, called bonding, now begins before the child's birth', when women 'want that first Polaroid snapshot of the TV screen showing the foetus in utero'.[24] Successful

reproductivity is bestowed onto the mother from the machine but it is still the mother's body which fails. Sochurek relates the tale of Dr Merritt who, at the beginning of the day conveys to the expectant mother the image of a living foetus, and at the end of the day is found consoling a 'sobbing expectant mother' after 'the US scan had determined that the child she was carrying had died'. This mother's foetus is described as 'a silent motionless form' on a 'still flickering screen'.[25]

The maternal body is present only in scientific discourses around gender and re-productivity, and the elision of body and machine is fetishistic in that it produces a hybrid which is at once a compensation for and a reminder of the lost/ effaced material object. Moreover this object is still figured as a guilty one – the absence of the maternal body signifying as its failure in the total optical machine.

> Technology promises more strictly to control, supervise, regulate the maternal – to put *limits* upon it. But somehow the fear lingers – perhaps the maternal will contaminate the technological.[26]

Doane's suggestion that perhaps the maternal will be seen to contaminate the technological problematises the assertions of Jacobus *et al.* that technology finally and fully delimits female subjectivity and reproductive power. For Doane, maternal identity refuses limitation, retains the anxiety which surrounds it, and contaminates the sphere of technology which was by implication previously stable. But it can be argued that neither gender subjectivity nor technology are stable categories, and that it is the anxiety which surrounds both which contributes to their association in medical and cultural discourse and representation. The anxiety is that of the viewing subject whose identity is no longer centred and affirmed by empiricism.

This point relates back to the significance of analogically mapping the body and the cosmos. New medical imaging technologies developed in order to enhance the possibilities of visual diagnosis, and serving to perpetuate the positivist principles underlying modern medical epistemology, actually challenge or throw into crisis those fundamental elements of medical tradition and authority. CT scanners overcome the limitations of viewpoint, data is 'binned' because it is in excess of what the eye can read and images are colour-enhanced and reconstructed in three dimensions to make them easier to see. Then there is Sochurek's case history of a man who had a brain scan which revealed the presence of a tumour. The surgeon who looked at the images and prepared to operate could not see the tumour when he opened the patient's skull. He thought there had been a mistake, and despite being reassured by an imaging specialist, declined to continue on the basis that he had been a surgeon for over thirty years and had never removed a tumour he couldn't see. The imaging specialist insisted on the accuracy of the scan and a biopsy was performed. The biopsy confirmed the presence of the tumour and the surgeon did have to operate blind.[27]

sarah kember

> Our ability to make pictures is greater than our ability to understand them, and our ability to find problems is greater than our ability to solve them.[28]

Because of this disparity, the performance of radiologists and other observers has come under scrutiny and become part of the process of observation. Performance can be measured by relative operating characteristic curves, and is measured against the fantasy of an ideal observer who would be able to detect and disregard 'noise', where 'noise' refers to extraneous information and interference generated by the technological equipment. Diagnostic skill seems to be heavily conflated with visual literacy, and to operate within the field of the computer as a microcosm of the contemporary clinic. The once sovereign clinical eye is incorporated into the optical machine almost as a design fault. The eye is the bug in the machine. Sochurek's book contains a striking image of the eye as metaphor of disease:

> This image is a dramatic example of 'red-eye' (the haemorrhaging of the tiny blood vessels of the eye) as viewed by infrared light. It is common in persons with a morning-after hangover.[29]

If the relation of power between the medical mind/eye and the body is challenged through the use of new imaging technologies, it is also recuperated through them. The image of the body made whole through its analogical relation to space is precisely a technological fetish, a simultaneous compensation for and reminder of the body lost to medical positivism. The fetish is a form of disavowal which enables the viewing subject to fend off anxiety only in as far as the body is continually objectified. Fetishism is therefore the relatively unstable means by which imaging technology secures the relation of domination between medicine and the body.

The fetish is a substitute for the body. Where Freud pathologised fetishism as a deviant practice, Lacan recognised fetishism as a gendered process in language and representation – simply the way in which men see women. When medicine represents the body it represents its 'other'; the material object is sought by the rational subject. Given the association in Enlightenment philosophy and medical epistemology between mind/body and masculinity/femininity, then the body is always implicitly feminine in medical science. In this way anyone can be fetishised, but the female body is afforded special status in as far as it has been used historically to symbolise medicine's privileged relation to nature and truth – or in other words to reproduction and origin. In substituting the female body with the fetish, science has the fantasy of unmediated access to reproduction and origin.

If the elision of body and machine in medical science is fetishistic, then what of the cyborg? The cyborg is the human-machine hybrid which is currently the focus of attention in certain forms of popular culture and in aspects of cultural

theory. Mary Ann Doane discusses the conjunction of technology and the feminine in relation to science fiction – 'the genre that highlights technological fetishism' and therefore is 'obsessed with the issues of the maternal, reproduction, representation and history'.[30] Doane argues that although *Alien* and *Aliens* contain no cyborgs as such, they consistently link technology and the maternal, for example in the way in which the interior of the ship '*The Nostromo*' mimics the interior of the maternal body and in the fact that the ship's computer is called 'Mother':

> The ship itself, *The Nostromo*, seems to mimic in the construction of its internal spaces the interior of the maternal body. In the first shots of the film, the camera explores in lingering fashion corridors and womblike spaces which exemplify a fusion of the organic and the technological. The female merges with the environment and the mother-machine becomes *mise-en-scène*, the space within which the story plays itself out.[31]

The alien in *Aliens* is 'a monstrous mother-machine, incessantly manufacturing eggs in an awesome excess of reproduction',[32] and it is this fear of excess in relation to the maternal which in Doane's view serves to contaminate the category of technology in science fiction. The maternal threatens to break boundaries; to exceed the prescribed limits of identity and confuse the distinction between subject and object.

> The horror here is that of a collapse between inside and outside or of what Julia Kristeva refers to, in *Powers of Horror*, as the abject. Kristeva associates the maternal with the abject – i.e., that which is the focus of a combined horror and fascination.... The threat of the maternal space is that of the collapse of any distinction whatsoever between subject and object.[33]

Doane and Kristeva are referring to psychoanalytic concepts, and to the Oedipal story of psychological development in which the role of the father is crucial to the separation of the child from its primary bond and unity with the mother. The mother's body is regarded as abject in this story in as far as it threatens to re-engulf the child and deny it a separate subjectivity.

Where Doane's cyborg or mother-machine is abject – a potential destroyer of subject/object boundaries – Donna Haraway's cyborg (in *Simians, Cyborgs and Women*) promises to respect the equal integrity of, and difference between, subject and object, self and other.

Haraway's work also stems from a feminist critique of the dominant discourses and modes of representation in science. It is not utopian in the same sense as Stafford's, in that nature, gender, science and technology are examined as historically and ideologically contested categories and not offered as universals or politically neutral panaceas. Haraway's cyborg is a partial, positioned feminist

construction which 'embodies' difference and represents a new model of knowing:

> There is no drive in cyborgs to produce total theory.... There is a myth system waiting to become a political language to ground one way of looking at science and technology and challenging the informatics of domination – in order to act potently.[34]

Feminist scientific knowledge, in Haraway's formulation of it, would replace the quest for apparently neutral universal knowledge with a quest for politically positioned partial knowledges. Her reinvention of nature through these terms is represented by the cyborg as organism plus machine and 'a fiction mapping our social and bodily reality'.[35]

Where Doane's cyborg is overrun by the natural/maternal function of reproductivity, Haraway's is not and therefore it does not inherit an origin story – it is more truly parentless. Thus it avoids the terms of domination inscribed in the Oedipal story of origin, but is unable to specify what kind of being it is. It may, by implication, be more adequately described by an intersubjective psychoanalytic model[36] than the Oedipal, but it nevertheless remains (for the time being) a myth system.

The abject maternal machine does not constitute a fetish, but stands to be fetishised, as fetishism is part of the process of objectification and representation through which the masculine subject distances itself from and regains control over the feminine.

The maternal in the *Alien* films is not just played out by the monster or the ship's technology as Doane suggests, but also by the heroine Ripley. At the end of *Alien* she survives the monster's advances along with her cat. At the end of *Aliens* she survives along with a child whom she has effectively adopted, and a man, Hicks, with whom she has exchanged numerous meaningful glances. In *Alien 3*, Ripley and the monster have eyes mainly for each other. Although she sleeps with her male doctor, who in the past accidentally murdered eleven of his patients, Ripley's main relationship is with the monster, who will not kill her because she is carrying her offspring. Ripley becomes impregnated[37] by an alien which, at the beginning of the film, is shown to have invaded the ship, killed the sleeping child (while 'Mother' watches and records the act on a computer screen) and caused a crash which also kills Hicks. Ripley survives the crash, which brings her to a desolate planet inhabited by a community of male convicts including rapists and murderers. Ripley and the adult monster are the only females in this place and are drawn together by a bond informed by the ambivalent desires of familiarity and the familial. 'Don't be afraid, I'm part of the family,' Ripley says to the monster, and: 'You've been in my life so long, I can't remember anything else.' Ripley seeks out the alien after having performed her own 'neuroscan'. She thinks she is ill, but a warden nicknamed '85' after his IQ level, reads the words 'foreign tissue' which 'Mother' projects

onto the screen and says: 'I think you've got one inside you.'

Ripley's physical intimacy with both doctor figures is short-lived, and it is interesting that they share a tragi-comic role within the film narrative. As the monster will not kill her, Ripley kills herself in order to destroy the monster inside her. As she falls to her death in a massive furnace, the infant gnaws through her chest and attempts to burst free, as another had done from the stomach of a male crew member in the first film. But Ripley struggles to hold on to it, thereby rendering the species (and the sequel) extinct. In this act of self-sacrifice, Ripley redeems herself from the crime of conception, and the stigma of monstrosity is dissociated from her own femininity and transferred to its proper object in the act of birth. In this final scene the monster is literally and metaphorically no longer inside her. Her face as she falls and is ripped open is saintly, beatific. Her monstrous femininity is transcended through martyrdom and fetishised through that aspect of the ship's technology which is able to represent it – namely 'Mother'. The word, mother, is already a representation in language. As the name of the ship's computer it also represents 'Big Brother' or the acquisition of knowledge through surveillance. When Ripley asks the android, Bishop, if 'Mother' knew that the alien had invaded and destroyed the ship, Bishop replies: ' "Mother" knows everything.' 'Mother' captures and controls the image of Ripley's monstrous femininity, thereby registering the prevalent power of technology over femininity in this film. Moreover, at its end point there is a significant transference of monstrosity from the mother to the offspring.

The monstrous feminine, then, is the reproductive maternal subject which technology is employed to harness and control. In the narrative of *Alien 3* it appears to succeed, but in medical discourse it does not. Its failure to do so is related to the gendered and unconscious relation between the viewing subject whose status is challenged by the crisis in empiricism and the object which thus remains anxiety-provoking. Where medical discourse and representation continue to pathologise the maternal body, this particular film narrative also puts forward the possibility of a monstrous offspring. Other horror films do this. The *Child's Play* films have received media attention in relation to the James Bulger case, and it is interesting to consider whether the concept of a monstrous or demonised child can be seen to be entering medico-legal discourse from other areas of culture.

References

1 Foucault, M., *Discipline and Punish*, London: Allen Lane, 1977, p. 217.

2 Robins, K., 'The Virtual Unconscious in Post-Photography', *Science as Culture*, vol. 3, part 1, no. 14, 1992, p. 103.

3 Sekula, A., 'The Body and the Archive', *October*, 39, Winter 1986.

4 Robins, K., op. cit.

5 Foucault, M., op. cit., p. 200.

6 Tagg, J., *The Burden of Representation*, Basingstoke: Macmillan Education, 1988, p. 87.

7 ibid.

8 Physiognomy and phrenology maintained that external features of the face and head bore the outward signs of inner character.

9 Showalter, E., *The Female Malady*, London: Virago, 1987.

10 Sekula, A., op. cit., p. 16.

11 ibid., p. 27.

12 ibid., p. 30.

13 McGrath, R., 'Medical Police', *Ten-8*, 14, 1984, pp. 13–18.

14 Mannix, D. P., *Freaks*, San Francisco: Re/Search Publications, 1990.

15 Rosler, M., 'Image Simulations, Computer Manipulations: Some Considerations', *Digital Dialogues, Photography in the Age of Cyberspace, Ten-8*, 2, 1991, p. 59.

16 Channel 4, 'Invasion of the Body Scanners', *Equinox*, November 1989.

17 Ang, T., 'Sochurek', *Photography*, August 1988, p. 30.

18 Stafford, B. M., *Body Criticism, Imaging the Unseen in Enlightenment Art and Medicine*, Cambridge, Mass.: MIT Press, 1991, p. 471.

19 ibid., p. 467.

20 Jacobus, M., Fox Keller, E., and Shuttleworth, S., *Body/Politics, Women and the Discourses of Science*, London and New York: Routledge, 1990, p. 2.

21 ibid., p. 3.

22 ibid., p. 5.

23 ibid., p. 6.

24 Sochurek, H., *Medicine's New Vision*, Easton, Penn.: Mack Publishing Company, 1988, p. 59.

25 ibid.

26 Doane, M. A., 'Technophilia: Technology, Representation and the Feminine', in Jacobus, M. *et al.*, op. cit.

27 Sochurek, H., op. cit.

28 ibid., p. 151.

29 Sochurek, H., op. cit., p. 152.

30 Doane, M. A., op. cit., p. 174.

31 ibid., p. 169.

32 ibid.

33 ibid., p. 170.

34 Haraway, Donna J., *Simians, Cyborgs and Women*, London: Free Association Books, 1991, p. 181.

35 ibid., p. 150.

36 See Benjamin, J., *The Bonds of Love. Psychoanalysis, Feminism and the Problem of Domination*, London: Virago, 1990.

37 See Doane, M. A., op. cit., regarding the confusion of the semes of sexual difference in *Aliens*.

sarah kember

surveillance, technology and crime:

the james bulger case

sarah kember

5

Introduction

Media reports on the James Bulger case produced conflicting and often confused ideas about childhood. On one level this can be explained by the extreme nature of the case, which involved the abduction and murder of a 2-year-old boy by two 11-year-old boys. Child crime of this nature is rare, and where there are precedents, there are not many. On this level it was difficult to know what to think about children who could do something so shocking.

However extreme the case, though, neither it nor the images and narrative constructed around it exist in a cultural vacuum. Once located in a wider cultural context, the representation of children in the James Bulger case can be seen to yield certain identifiable discourses – the most notable of which is a discourse of control.

Surveillance images produced by two security cameras which 'captured' the abduction played a central role in the investigation and reporting of the crime. The images were striking not only because of what they showed, but because of how inadequately they showed it. In one image it was hard even to make out the shapes of the children. These were not conventional surveillance images, and they raised issues about control in relation to surveillance technology.

In addition, the whole case became part of a pre-existing moral panic about child crime being out of control, and one of the arguments made in this chapter is that this moral panic is connected to issues about new technology, and the relation between children and technology. In contemporary society, children are not only perceived to be more computer literate than most adults, but to be the perpetrators of computer crimes (teenage hackers) and other excesses including addiction (game boy junkies). As in the relation between women and technology, that between children and technology seems to unsettle and reformulate ideas about both. In relation to technology, children are not seen as being innocent but worrying, dangerous, out of control.

The crime against James Bulger was reported in relation to surveillance technology and, less directly, in relation to child crime and computer game addiction in the Strand shopping centre where the abduction took place. The surveillance images bring up issues of control which are not purely to do with the children and their actions but also with the relation between the surveiller and the surveilled. The surveiller expects to be in a relation of power over what he or she surveilles. The security camera images in the James Bulger case challenge that power and present the viewer with a scene and with a subject over which they have no control. It is hard to see what is going on and it is impossible to prevent it – it has already happened.

As in the context of new medical imaging technologies, the challenge to the viewer is not just a technological one – it goes beyond indistinct and unfamiliar images which fail to offer up a visible and docile object. Again, issues of control are problematised by the gendered and unconscious relation between the viewing subject and the object.

The issue of gender and sexuality is one which has received little attention in this case. Both here, and in the wider moral panic about children and crime, it is primarily the deviance of boys which is at stake. Moreover, boys who are approaching adolescence. Concerns about masculinity and sexuality lurk at the margins of the narratives. Only the most recent writing on the James Bulger case has brought up the suggestion that the crime was sexually motivated. James may have been led towards the older boys' den. The attack took place in the dark. James was found naked from the waist down. A hard object – probably a battery – had been forced into his mouth and possibly into his anus. Earlier reports made no mention of these facts.

Whether or not they were suppressed for legal reasons, there is a sense in which they could not be tolerated in relation to a crime which was already so hard to understand or accept. It is not simply that this case disrupts conventional ideas about what a child is or is not. It also evokes and problematises the adult–child relationship as it exists in both the social and psychic sphere. That relationship is conventionally, though not invariably a benevolent one in which adult society and its institutions (the law, education, the family) serve to discipline and protect

more than to discipline and punish children. In some instances, the reporting of this case shows that in order to punish children severely, to be less benevolent, adult society seems to need to make them sound older (describing them as 'youths' for example) or simply inhuman ('evil' monsters).

This need is in part an unconscious one. The murder of 2-year-old James Bulger by two older boys evoked feelings of hatred and anger mixed with those of love and grief. These are powerful yet 'primitive' emotions which characteristically get played out by an infant in the early stages of development. The emotions are played out in relation to the infant's mother who, by a process of projection and splitting, is seen alternately as good or bad. Splitting is a defence against the anxiety caused by conflicting emotions.

The James Bulger case recreates anxiety and conflict in relation to children. In this case it is childhood identity which is split in an unconscious scenario in which the adult–child relationship is reversed. Splitting provides for the adult/child a phantasy of control over its other.

Part 1

The development of imaging technology in the detection and prevention of crime is historically and institutionally related to the development of imaging technology in the detection and prevention of disease. The technology in both institutions developed along the panoptic principle of surveillance and control, and now incorporates both photo-mechanical and computer imaging. The use of computers has not made photography redundant or completely revolutionised representation in a disciplinary context. Medical computer images of the body may look revolutionary, but inherit the same desire for knowledge and mastery encoded within photographic images and inscribed in medical epistemology from the Renaissance onwards. This desire centres on the female body of nature and is never finally fulfilled. Current medical images are marked both by the desire for mastery and by the frustration of that desire.

The surveillance technology used by the police is as varied and advanced as that used in medicine, and its object can be equally evasive. In *The Policing Revolution*, Sarah Manwaring-White argues that the use of video surveillance and the advance in television technology has not only transformed police methods but extended the role of policing further into the community. Many shops and businesses employ surveillance technology in the attempt to prevent or detect thefts and intrusion. Although there is 'no legislation to cover [the use of] this new type of surveillance', video tapes can be accepted as evidence in court. Dandeker points out how the rise of bureaucratic surveillance is linked to the military, police and business enterprise, and how it generates a degree of conflict between the control of and control on behalf of individuals and communities. When surveillance becomes an intrinsic part of capitalist bureaucracy, its power is at least in part the

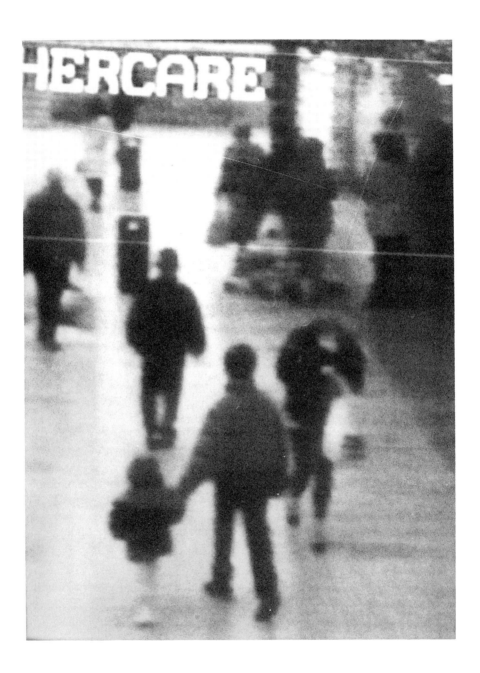

Figure 5.1 Video surveillance still of James Bulger being led away by a youth in the 'New Strand' shopping centre, Bootle, Liverpool. Reproduced by permission of the Press Association, London.

property of the public, and its role is intended to be pre-emptive.

These issues around surveillance and policing arise in press reports concerning the abduction and murder of James Bulger in February 1993. The case received, and continues to receive media attention because it figured a violent crime committed against a young child (2 years old) by other young children (10 years old at the time). In addition the children were 'captured' on two different security cameras, located in a shopping centre and outside a construction firm. James Bulger was lured away by two boys and later found murdered after he had become separated from his mother in a shopping precinct in Bootle. A security video camera in the precinct recorded James's abduction. The press printed a still showing a small child and an older child holding hands and walking away from the camera (Figure 5.1). They also showed a still from the camera of a construction firm near the shopping centre which shows James apparently struggling or being swung between the two youths who led him away. There is little detail on the first reproduced still and virtually no definition on the second. Both needed to be computer enhanced. According to the *Guardian* at least some of the anger aroused by this crime was directed at the overall inadequacy of the recorded images. Journalists wrote about 'heartless security video cameras' and 'the demonstrable fact that such "security" devices are clearly anything but'.[1] Another reports on the reactions of one particular local resident speaking on behalf of others:

> We are all totally frustrated. James Bulger didn't belong to his mother, he belonged to the people of Liverpool. Why are those video pictures so crap? Why didn't they go into Dixons and buy one of those home videos [*sic*] machines?[2]

This woman expresses the sense of a community which mourns its losses, but which also failed to protect one of its own most vulnerable members. The article which runs this comment is entitled: 'Heysel, Hillsborough and Now This'. The detective who led the investigation is reported as saying 'that he was "horrified" that no one had tried to intervene as James was being taken away'.[3] Bootle was also a community which felt failed by policing and security methods which were to all intents and purposes designed to protect the owners and perhaps the employees of business enterprise against theft or intrusion. The cameras failed to pre-empt the crime, and although they contributed to the detection of the culprits they could not identify them clearly, and in the manner expected. It is not just a question of poor equipment or the lack of a clear frontal image of the boys' faces. As represented in the reports, this crime seems to unsettle the whole process of surveillance and classification.

It should be noted that there are marked similarities and some differences in the way in which various papers reported on the crime and on the role of surveillance technology. The differences indicate, to an extent, the different political agendas of sections of the press. For example, *The Times*, 17 February 1993,

consistently employs a narrative of resolution – one which places emphasis on the role of the authorities in capturing the offenders and in restoring law and order. The role of the surveillance cameras is incorporated into this narrative and suppresses any discourse of anxiety around children and technology. *The Times* acknowledges that the quality of the images – especially the ones taken from the video outside the construction firm – was poor, but once subject to computer enhancement it claims that they 'have been a vital and unexpected source of information in the investigation of James's murder'. Nevertheless, anxiety creeps in at the margins of this narrative, as, for example, when *The Times* reports that:

> Police have also visited the video game arcades near the Strand Centre, popular with young people who hang around there. Police say that a lot of petty theft takes place in the shopping precinct to finance an addiction for the computer games available in the arcade. Two boys were reported to have accosted an elderly woman in the Strand centre earlier on Friday.[4]

The *Independent* and *The Times* reproduce the same sets of surveillance images as the *Guardian*. The *Independent* adds more emotive photographs, including those of the flowers and toys left near the site of James's death and of people mourning. The reporting in the *Independent* is relatively personalised – 'Coroner shaken by details of boy's murder' – and gives attention to the emotional responses of other parents and professionals. A law lecturer from the London School of Economics is reported to have said that the images from the security cameras were one factor which 'had elevated the Bulger murder in the minds of other parents'.[5] The *Independent* reports that the images were of poor quality and adds that the space agency NASA offered its help in the process of image enhancement.

The tabloids also concentrate on the surveillance images and photographs of James, and contribute to the moral panic with headlines such as: 'For Goodness Sake Hold Tight to Your Kids'.[6] The *Daily Mirror*, 15 February, gives quite detailed technical accounts of the first security camera sighting of the abduction, which John Stalker, writing for the *Sun*, 16 February, describes as 'fuzzy' and 'near useless'. Both papers contrast the 'cherub-like' face of one of the abductors which finally emerges from these images with the 'evil' crime which has been committed.

The surveillance images of James's abduction are disturbing on a number of levels which relate to common notions about children and about this sort of technology. What they actually depict is a familiar scene of protection – a small boy holding hands with older boys. Witnesses thought they were brothers. But we know they were not brothers and that the older boys did the very opposite of protecting James. Child murderers are rare, and it is hard to understand what motivated them. We have to think outside of what we would normally categorise as childhood identity and behaviour to do this. The images make us the witnesses of a horrible event before it has happened – producing a sense of impotence and guilt. We are in a sense involved but can do nothing because it is already too late.

The 'security' cameras have tricked us, failed to protect James on our behalf and cannot even offer us – capture – a clear image of the culprits. We become angry at a technology which failed to police our own boundaries between who, in society, is responsible and who is not; who is to be protected and who is one to be protected from.

In an article on electronic surveillance, Bertrand Giraud suggests that the process of surveillance effects a means of social control through the construction and regulation of boundaries between the watching and the watched. The efficacy of this means of control is weakened when the boundary is questioned or blurred:

> To shut out, exclude, map out frontiers is never a simple or straightforward operation. Who is left within the circle? Who is shut out?[7]

According to Giraud, the traditional spatial model of protection is of a centre (fortress or abbey) from its periphery, but modern surveillance technologies have shown this model to be too simplistic:

> We can illustrate this by a few examples of electronic protection in economic life: the department stores and big supermarkets who have long been using video surveillance cameras, and no longer invite us to 'Smile, you're being filmed', know that losses come from internal causes as well as external; and calling in a security firm often brings its own perverse effects.[8]

This spatial model of protection depends on a clearly defined interior and exterior, centre and periphery. But:

> How do you shut the sheepfold when the wolf is already inside? ... The circle now becomes a knot, the frontier crossing and recrossing the internal space it has defined. Any simple partition is finished. The centre no longer exists; it has been expelled.[9]

Without wishing to detract at all from the individual tragedy of James Bulger's death, this is one aspect of the wider dilemma it raises: how, given the widespread classification of children as centre and interior (as that which society protects, not protects against), does society protect them against each other? When, in the nineteenth century, disciplinary and surveillance institutions and technologies were new, urchins, orphans and petty criminals were shown to be brought back into the fold relatively easily. But the image of the child criminal is now more persistently wolfish. The *Guardian* hesitates to name them as children at all, tending to advance them in age to the status of 'youths' or adults. Some of the social factors which deprive children of their innocence today were clearly at least as prevalent in the nineteenth century; poverty, deprivation and abuse for example. There were child murderers then as well as now (and probably as few). One of the key areas which has informed the change in perception has been the

relationship children have to the mass media and technology. Of interest here is not the contention that the mass media or technology 'corrupts' children (although this has been raised by the judge in the James Bulger trial), but that there is possibly a new alliance being constructed between children and technology which shifts and disrupts the categorisation of both.

Part 2

In 'Childhood and the Uses of Photography', Patricia Holland describes the relationship between photography and childhood in the nineteenth century as 'the innocent eye in search of the innocent subject'.[10] These ideologies of innocence developed around the Romantic association of children and nature and the indexical qualities of photography. Holland argues that child poverty was aestheticised and even sexualised, and that an 'iconography of pathos' developed around the poor despite the harshness of their living conditions and treatment in Victorian society. Child criminals had, until this time, been treated in the same way as adults and could be hanged or imprisoned – often for trivial offences. 'Ragged Schools' were among the new disciplinary and reformative institutions which helped to establish 'the legal recognition of childhood as a separate state'.[11]

> As British society in the 19th century became increasingly disciplined, its wild children were being brought under control. 'The Child' became the focus for the improvement of society as a whole.[12]

Holland describes how children remain the focal point for social change, and tend to symbolise different qualities in different historical periods. While in the post-war period children tended to symbolise 'stability and cohesion', by the 1960s 'children are at the cutting edge of progressive consumerism':

> The advertising industry developed an image of exuberant children with mobile bodies and ubiquitous smiles, their desires easily satisfied by the monster in the cereal packet or the latest in sweat shirts and trainers.[13]

Holland also points to a nostalgia for the street urchin and a pre-technological age which is 'palpable' in the publications of The Children's Liberation Movement in the 1970s. It is the deconstructive work of photographers such as Jo Spence in the 1970s and 1980s which, according to Holland, brings about photography's loss of innocence. This work realised the constructedness of the medium, critiqued its truth status, and highlighted the relations of power between the photographer and photographed. Jo Spence in particular demonstrated how the image of the child as natural and innocent is an individual, cultural and ultimately commercial fantasy – the privilege of those with the power to represent those who do not have access to the means of self-representation. Photography is seen as a mechanism of power and ideology. What is more:

sarah kember

> The new technological revolution that has brought new ways of changing the photographic image using computers, makes the idea that photography has a true nature to express even more difficult to sustain.[14]

Holland isolates a predominantly domestic image of childhood at the end of the twentieth century; a childhood 'secure in the cosy heart of the family'. She defends the narrowness of this image as a possible and understandable reaction against horrific news images of war and famine. She thereby argues that there is now an iconography of childhood based on the need to protect children from a hostile world. What then of the relation between children and crime, and the way in which a medium which is no longer constructed as being innocent represents it?

Reporting on the crime against James Bulger, the *Guardian* highlights a climate of fear around children and crime – crime committed against children and by children: 'Young people are being simultaneously mourned and demonised.'[15] There is also a growing perception 'that teenage crime is now utterly out of control', a view supported by the Government in its wish to imprison young offenders between 12 and 15 years of age.

> The impression is being created that teenagers and even young children are responsible for the bulk of crime.... Outrage is mounting that such young people appear to be thumbing their noses at a criminal justice system reluctant to lock them up; the resulting climate is painting youngsters as the perpetrators, rather than the victims, of a culture of moral degeneracy.[16]

According to this report the representation of childhood and crime in the media seems to be subject to a process of splitting; on the one hand children are mourned and on the other they are demonised: 'The problem is that few people are prepared to put these two halves of the picture together. The antisocial, delinquent child is – almost always – the abused, damaged or neglected child.'[17] Melanie Klein describes the process of splitting in psychological development as a reaction against conflicting emotions. Feelings of love and hatred towards one person or object are difficult to assimilate, and so they may be split and assigned to two people or objects. The splitting process is not fixed and eventually gives way to a process of assimilation which Klein refers to as 'depressive anxiety'. Assimilation is painful and unstable but represents a stage of relatively advanced development or 'psychic reality' within which reparation can be made to the same person or object who is hated.[18]

As Andrew Ross has pointed out, technology is also subject to this process of splitting in the way in which it is represented. It too has been idolised and demonised and felt to be out of control. Since children started using computers in school there has been a prevailing notion that they are more computer literate than most adults. A recent *World in Action* programme entitled 'Welcome to the Danger Zone' investigated the idea that children – especially boys – are addicted

to computer games, and did little to dispel the mythical association of technology and corruption. A *World in Action* school survey showed that 60 per cent of teenage boys were addicted to computer games and 30 per cent of girls: 'If I couldn't play for like a month I would be so mad I would scream around the house' (girl); 'I would just rip my hair out' (boy). One boy was asked if he had tried out any of the moves he had seen in a fighter game: 'I tried to grab me [sic] brother, jump, spin and land ... on him, on his head.' Humorous on some level (at least in the way the comments were presented), this relation between children and technology raises conflicting emotions and reactions about both.

While there can be no doubt that James Bulger was the tragic and totally blameless victim of a horrible crime, the images reproduced in the press follow the process of splitting which is criticised by one of the *Guardian* journalists. The video stills from the shopping precinct and construction firm represent demonised childhood and technology; threatening, indistinct, illegible and unconventional. In contrast, on the cover page of the tabloid section of the *Guardian*, 16 February 1993, and in virtually all of the other papers is a large family portrait photograph of James (Figure 5.2). It is actually quite hard to write about; the knowledge of his death seems to overlay his features, which are those of an attractive small child whose gaze is slightly lowered to avoid the glare of the camera flash and whose expression is if anything quite blank. It is impossible not to read this as the image of the innocent victim which James Bulger was. It says little to nothing of who he was before his death, and rather like Barthes'

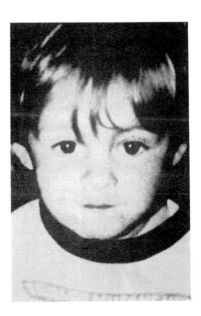

Figure 5.2 Snapshot of James Bulger used in press coverage.

photograph of a man who is about to be executed it seems to offer a 'certain but fugitive testimony'. Barthes writes:

> The photograph is handsome, as is the boy: that is the *studium.* But the *punctum* is: *he is going to die.* I read at the same time: *This will be* and *this has been;* I observe with horror an anterior future of which death is the stake.[19]

The certain testimony of the image is that his death will be and has been. What is fugitive about it, in Barthes' terms, is the death accorded to the photograph itself. Barthes writes about a photograph of his parents together:

> What is it that will be done away with, along with this photograph which yellows, fades, and will someday be thrown out, if not by me – too superstitious for that – at least when I die? Not only 'life' (this was alive, this posed live in front of the lens), but also, sometimes – how to put it? – love.[20]

As a representation of childhood and technology, the image of James Bulger is in every sense opposite to those of his abduction. This photograph inspires love and grief where the others inspire hatred and anger. The moral and legal distinction between James as innocent and his abductors as guilty informs the construction of childhood and technology in these images. Where photography connotes innocence, the computer-enhanced video stills connote guilt. This does not, of course, preclude the use of stills as evidence in law – the authority of images is a measure of the authority of the institution which employs them – but what it does is to facilitate and to consolidate in representation a process of splitting which occurs in relation to the subject, children. This process also occurs in relation to the published photographs of the abductors themselves once they have been found guilty of murder and named. On Thursday, 25 November 1993, school photographs of Jon Venables and Robert Thompson were printed on the front page of all of the national daily papers. Robert Thompson is the one with the cherub-like face and he is also the one who is supposed to have taken the lead in murdering James Bulger. Jon Venables is presented as being the weak one who was led astray by his friend. Their age and innocent appearance in these photographs cannot be assimilated with their 'evil' act, and the one who appears most innocent is presented as being the most evil. The almost frantic search for social and psychological explanations strives to, but does not seem in any way to bridge this gap. What is evidenced in the media's use of photography and electronic images in this case, is that conflicting attitudes towards children and technology are too difficult and too chaotic to assimilate. Splitting facilitates semblance of control.

Conclusion

As the use of surveillance technology in the context of children and crime facilitates and consolidates a psychological process of splitting in relation to the subject, it has also been argued that the use of surveillance technology in the context of women and medicine facilitates a psychological process of fetishism (see also Chapter 4). Both bring forward an unstable structure of control and domination in relation to the body – a refusal of chaos – from the early use of photography in the disciplinary institutions of the nineteenth century.

References

1 Phillips, M. and Kettle, M., 'The Murder of Innocence', the *Guardian*, 16 February 1993.

2 O'Kane, M., 'Heysel, Hillsborough and Now This', the *Guardian*, 20 February 1993.

3 Sharratt, T. and Myers, P., 'Three Questioned Over Boy's Killing', the *Guardian*, 17 February 1993.

4 Tendler, S. and Faux, R., 'Anatomy of a Child Murder Hunt', *The Times*, 17 February 1993.

5 ibid.

6 Troup, J., 'For Goodness Sake Hold Tight to Your Kids', the *Sun*, 16 February 1993.

7 Giraud, B., 'Electronic Surveillance – Or Security Perverted', *Science as Culture*, vol. 2, 1988, p. 121.

8. ibid., p. 122.

9. ibid.

10 Holland, P., 'Childhood and the Uses of Photography', in P. Holland and A. Dewdney (eds), *Seen But Not Heard?*, Bristol: Watershed Media Centre, 1992, p. 17.

11. Holland, P. and Dewdney, A. (eds), *Seen But Not Heard?*, Bristol: Watershed Media Centre, 1992.

12 ibid.

13 ibid., p. 35.

14 ibid., p. 39.

15 Phillips, M. and Kettle, M., op. cit.

16 ibid.

17 ibid.

18 Klein, M., *Envy and Gratitude and Other Works 1946–1963*, London: Virago, 1988.

19 Barthes, R., *Camera Lucida*, London: Flamingo, 1980, p. 96.

20 ibid., p. 94.

domestic leisure
and entertainment

part III

domestic photography and digital culture

don slater

Photography is intimately bound up with domesticity and the private world, and has been since its inception. This is evident in family photographs – portraits and snapshots, images of familial rites of passage such as weddings – in which the seemingly existential relation between photographs and memory folds individual and collective identities into familial narrative time. Less evidently perhaps, amateur photography is one of a range of consumerist hobbies which structure private (especially male) leisure time. Third, photography has been bound up with private life in the form of 'home entertainment' – photographic amusements stretching fairly continuously from Victorian stereoscopes through video and computer games. Finally, operating through a range of mass media from press to posters, photography – like any mass medium – mediates between private and public spheres: public images, as they enter the home, domesticate the public, and give public significance to the private (Thompson 1990).

Yet we need two further terms to make sense of these links between family and photography: first, *consumer culture*: photographic equipment and images enter the family in the form of consumer goods. The means of making, manipulating, presenting and consuming images constitute a major consumer market which – certainly since Kodak in the late nineteenth century – provide domestic life with

powerful means of self-representation, tools of symbolic reproduction. Yet they do so in the form of commodities. The means of representation are structured to produce and exploit profitable social relations and activities in domestic life. For this reason alone there is a pressure for photography to structure everyday life in the very process of representing it. This happens in a multitude of intersecting ways from the structure of camera technology as a consumer good, through advertising and marketing, on to links between photography and other consumer markets such as tourism and childhood (Slater 1991). Public images, too, in the form of posters, magazines and newspapers also enter the private world as commodities.

Second, photography is necessarily caught up in another, closely related structure of everyday life in the modern world: *leisure*. The symbolic reproduction of modern families obviously takes place across a great range of practices and relations. But leisure times and events are crucial in being largely conceived in consumerist terms, and at the same time holding a privileged place in the reflexive and generally idealising reproduction of family identity. As family albums and photographic advertising alike repetitively display, it is through the family at leisure, at play, at busy rest, in a time of extraordinary ordinariness, that we have come to represent the family to its members and its publics. It is in its 'free' time and activities that the family, and through it the individual, is to recognise meaningful personal life. Thus, it is in terms of leisure that family identity and consumer capitalism most potently meet, and this meeting is generally attended by the camera.

The photographic image in the everyday of digital culture takes its shape and force within this mélange of domesticity, consumerism and leisure. Essentially, new image technologies in everyday life overwhelmingly take the form of 'home entertainment': commodities which are conceived, designed and marketed in relation to private family leisure. Moreover, many home entertainment activities and technologies – new and old – are crucially image-based, and therefore bring photography into relation with leisure commodities even when the photographic technology is unchanged. For example, the CD onto which some photo-chemical snapshots are transferred may be normally used and perceived as a vehicle for games or, soon, feature films. Thus, family snaps – pictures of ourselves – need to be understood in relation to an enormous flow of images programmed into leisure commodities: video motion, computer game characters, even the computer 'graphic user interfaces' in whose image environments we may feel more practically at home than in our family album. 'Home entertainment' is not a clear cut category, of course: it can merge into other markets and activities such as amateur and hobbyist activities (often with professional pretensions or fantasies), into serious or pseudo-educational aims and into serious labour (as in the current industry buzzword, the 'SoHo' market of Small Office Home Office). The same computer with CD or PhotoCD and some image manipulation software

like Photoshop can be used for all these functions from playing games to running a small business. Certainly in most marketing, however, the core theme is home entertainment, with the other functions (especially education) often offered as justifications for major domestic expenditures of time and money which might otherwise feel frivolous.

The contemporary domestic image, then, either takes the form of, or takes part in, 'home entertainment'. The very notion of the convergence of information flows through digitalisation seems to be given concrete and marketable form through the image of the hi-fi stack or the old 1950s furniture which housed both TV and hi-fi: convergence in the form of multimedia means an integrated home entertainment unit which brings together already highly developed markets (tape and CD music delivery; video, laser disk and games; new modes of broadcast delivery such as cable and satellite; telecommunications in the form of fax, modem and messaging systems, etc.) with additional possibilities of combination and manipulation of these media through computers, audio or video mixers and so on.

Though many of these new commodities are still fledgling markets, it is evident that the everyday life of many people already involves a technologically extended range of images. Video (allowing the disruption and control of the flow of images) and computer games (bringing new forms of interaction with new forms of image flow) have probably pioneered most powerfully the new home economy of the image. Still photography, on the other hand, is a very late entrant to this world. More particularly, snapshot photography – images taken by ourselves of ourselves, the self-representation of everyday life – has barely any place at the new electronic hearth. It is very early days yet for the digital domestic snapshot, whether scanned, frame-grabbed from a video or taken on a digital camera. Private images have not yet entered the datastream of either telecommunications or digital convergence (for example computer-based multimedia which would integrate the photograph within a flow of manipulable public and private images, still and moving, with sound, text and other forms and organisations of information). This simply has not happened outside of advanced hobbyism. The very late entry of snapshots into digital culture may itself be a clue as to their future status, but discussion of these technological potentials at the moment involves rather unreliable futurology.

In sum, what is important in the development of domestic photography is not so much the digitisation of photographic processes, but rather the potential flows and convergences of images in the home as they are structured by digital domestic commodities. The dominant structure here is *leisure*. This characterisation of everyday photography directly links it to an increasingly central research theme in contemporary, and 'postmodern', thought: the 'privatisation' of leisure (see, for example, Tomlinson 1990). 'Privatisation of leisure' refers to the increasing home-centredness of consumer expenditure, and the centrality of spending on home

leisure and entertainment. The supposed substitution of TV for cinema is a prototype of this development. From TV to DIY to computer games, the home is increasingly structured as a leisure centre, and one which we need not leave for amusements in public places. Increasingly predominant is the image of a family whose idea of a night out is a trip to the video rental shop to programme an evening in. Even the youth of the subcultural era, beloved of cultural studies, seems to have retreated from the public street to the Ninsega console. These images seem a postmodern ironisation of the Victorian ideal of the family as self-sufficient privacy. The irony is increased by social fears that while contemporary home entertainment and leisure focus more activity on the home, they are mainly notable for their fragmentation effects on the family: the image of the two plus television family, in which each member is off in a different room watching different programmes, locked into different computer game universes and different sound spaces (walkmen and stereos), pursuing their different hobbies and not even meeting to eat – conversation ultimately replaced by the exchange of e-mail. This is a very popular fear-image: leisure commodities in the home far from being tools for engaging with everyday domestic life, structure it out of meaningful existence. Electronics, in this view, produces solipsism rather than sociality. Perhaps the future family will only exist in its snapshots, which are themselves integrated into the digital flow which destroyed it.

This is a long-term development, though currently being touted as 'post-modern'. Raymond Williams (1974) characterised it with more complexity through the concept of 'mobile privatisation'. This term captures the sense that modern domestic life is not so much home-based in a literal sense, but rather that the private character of everyday life arises from a dialectic of family privacy and modern mobility. Describing the origins of broadcasting in the structure of the radio manufacturing industry, Williams links it to the general expansion of new consumer durables in the 1920s (very much including the camera and the illustrated press), arguing that this complex of domestic transformations was characterised 'by the two apparently paradoxical yet deeply connected tendencies of modern urban industrial living: on the one hand, mobility, on the other hand the more apparently self-sufficient family home' (Williams 1974: 26). The car and the home, the holiday and the evening in front of the telly: both the commodities and the leisure experiences evoke a restricted private domain surviving in a landscape of space-annihilating modernity. Mobility and privatisation, Williams goes on to argue, are directly connected in their common emergence from industrialisation, in which labour markets, factory concentration and urbanisation required and obtained forms of geographical mobility of the population (as well as forms of social and status mobility) which broke down small communities and extended families. The mobile family is by force of circumstances smaller and more self-contained. Moreover – Williams again – this development coincides with an intensive separation of public and private (and male from female) at the

don slater

level of the everyday through the structure of the work day, work week and work year. Forged out of the struggles between capitalist factory discipline, bourgeois social regulation and working-class demands, notions of freedom and of family became increasingly identified with each other, and both became bound up with a time and space out of work, a free time which was also a family time, a leisure which was also (ideally) a space of personal meaning and fulfilment.

Everyday digital culture can be seen as an extension of these developments. Thus authors such as Morley (1992) and Tomlinson, rather than investigating a specifically media revolution, or focusing on changes in media technology under the impact of the digital, look instead at structures of domestic leisure in relation to family dynamics on the one hand, and new forms of commodification on the other. A framework for considering photography in digital culture might then involve looking not at a specific technological transformation of photography at all, but at the circulation of images within a domestic life structured around these forces of commodification and privatisation: what emerges more and more clearly are convergences of media and communications technologies in the home and on holiday but in the form of consumer leisure and entertainment.

In summary, then, the question of the fate of the photographic image in everyday digital culture resolves into the tangled structuring of leisure experience at the meeting point of consumer capitalism and the construction of family identity. The present discussion therefore begins by looking at the ways in which photography and leisure were historically constructed in relation to each other. This sets the backdrop against which we can understand the introduction of new digital commodities into domestic life, given that they too largely take the form of leisure goods. However, as already noted, looked at from the present moment, and without engaging in ungrounded prediction, it is not at all clear that domestic photography – in the sense of snapshooting – has been transformed in the slightest by digital technology. What certainly has been transformed is the domestic context in which snapshots exist, a transformation in the domestic economy of images: digital technologies patently involve a major extension in the volume and complexity of flow of public images through domestic time and space, an extension which seems a very appropriate extension of the logic of consumerism which snapshot photography does not provide. The final two sections of the discussion therefore consider, first, the possible marginalising of domestic photography as a practice of self-representation, and second, some of the political implications which arise from this.

Photography, leisure and identity

Photography has played a strategic role in bringing together family, leisure and consumerism into a private world which is a major site for the articulation of identity. Specifically, photography has seemed capable of shifting private

experience from the plane of the mundane, ordinary and insignificant onto a plane of idealised moments and images around which socially significant identities can be formed by people. I want to argue that this shifting from the ordinary to the significant has been historically bound up with the notion of leisure time, and increasingly so over the last century.

Jo Spence's pioneering work in *Beyond the Family Album* (1986) offered a demonstration of self-representation as self-construction: our active imposition upon ourselves of codes of gender, family, class, appearance within the processes of presenting ourselves to the camera, selecting photographable moments and selecting presentable photographs. Editing the family album is both an operation on memory and therefore upon personal and familial identity and their intense mutual dependency; as well as a construction of future memories in the photographic practice of the present. We construct ourselves *for* the image and *through* images. Spence and others have pointed to the complexity and variety of these image practices, but also to their limitation: limits on *what* is deemed photographable, and a considerable conventionalisation of *how* things can be photographed. Indeed, snapshot and amateur photography have been generally regarded as a great wasteland of trite and banal self-representation. Much of this limitation rounds on processes of idealisation of the self and family. A strong sense of idealisation is evident in professional photography: wedding photographs, school portraits, graduation shots are bought for the professional codification of certain private moments as exemplary, as the magical accomplishment of a perfect social conventionality. The representation of rites of passage is part of a ritual evocation of a social ideal, and through this a social identity. We tend to rely on professionals for this. Snapshots – and in a different way, amateur photography – are idealisations in the broader sense of imposing a filter of sentimentality. The most common photographs are of 'loved ones' – partners and children – taken during leisure time, times of play. Jo Spence, again, started off that line of thought by showing what is left out of the family album: on the one hand, moments of pain, horror, discord (even the traces of these: consider what photos are removed when a family or relationship splits up); unhappiness could only be included if in the sentimentalised form of the crying baby. On the other hand we excise a range of moments which are relegated to the 'ordinary' and 'mundane': ordinariness is equated with forms of labour, and neither domestic nor paid labour typically feature in the family album. Family photography is not documentary in aim or attitude: it is sentimental because it attempts to fix transcendent and tender emotions and identifications on people and moments hauled out of ordinary time and mundanity, the better to foreground an idealised sense of their value and the value of our relationship to them, in the present and in memory. Finally, this is 'sentimental' because the idealisation is indeed conventional, achieved not through the specificity of the relationship but the social acceptability of certain representational conventions for depicting these

values: domestic photographs are closely determined by their *genres*.

Over a long historical process, it is leisure time and experience that has emerged as the primary site for the sentimentalisation of family identity: it is seen as the time and activity in which real personal meaning is to be found. Leisure is a difficult concept. Its obvious sense – time and activities which are outside of 'labour', which are 'free' and subject purely to the privately formed preferences of the individual and family, which are done purely for pleasure, relaxation, recuperation – glosses the complexity of the relationships between private and public worlds (see, for example, Rojek 1985, Green *et al.* 1990). As a cultural ideal, none the less, it brought together over the nineteenth century three major themes: first, the liberal equation of freedom and authenticity with the private individual (and the absence of public interference) is located religiously, morally and sentimentally in family life, and in private, non-obligatory activities which symbolise its togetherness. Second, the very privacy of leisure time aroused social and political fears (for example of working-class idleness and vice) and led to intensive social regulation of free time: attempts to impose bourgeois norms of consumption took the form of reconstructing leisure in the image of the respectable and responsible bourgeois family (see, for example, Cunningham 1980, Rose 1991, 1992). Third, the regulation of leisure went hand in hand with its commercialisation: respectable leisure increasingly took the form of family consumption of goods, experiences, entertainments and events sold as commodities.

Leisure then largely arises through the increasing prestige of bourgeois structures of familial respectability, a social predominance which is increased on the one hand through paternalistic regulation, and on the other through attempts to capitalise commercially on 'free time'. Photography emerges into this setting in a doubled form: it is both a commodity and a meta-commodity, leisure and meta-leisure. That is to say, photography is – on the one hand – just one of the new types of activities and objects which make up the leisure time of the family; yet – on the other hand – it is a means of representing that time and its values, and for symbolically reproducing it and the family. For the Victorian bourgeoisie, domestic photography already played recognisable roles: photographs took their place on the mantelpiece, the family shrine, which sacralises the family and renders it respectable at the interface of religion and consumption. The family studio portrait monumentalises and substantialises, commemorates and reproduces an idealised moment and person outside of the flow of practical everyday life. Photographic portraits enter into the sentimentalisation of personal relations on the one hand, and into respectable fashionability on the other (for example, the craze for photographic calling cards in the 1860s). Photographic home entertainments like the fad for stereoscopes bring a history of image as spectacle (for example, dioramas and panoramas, out of which photography originally emerged) into the confines of the home, linking it to the idea of genteel

parlour games (Slater, forthcoming). Finally, images of celebrities (such as Queen Victoria) and of the exotic (usually of the Empire) link the household both to an 'imagined community' and a sense of the world as a consumable spectacle.

Mass domestic photography involved the continuation of all these themes, but added another: the modernisation of the family and everyday life. The emergence of modern consumer culture from the seventeenth century onwards can be told as a story of the rise to cultural and commercial importance of a series of 'middle ranks': first, the rise of urban, commercial and manufacturing middling orders in the eighteenth century which eventually solidify into the Victorian bourgeoisie. Second, as theorised by Aglietta (1979), the emergence of the new middle classes of white collar workers, junior and middle management, in the offices of corporate and government bureaucracies around the turn of the century and through the 1920s. These ranks connect up the concern for domestic respectability of their betters with a desire to modernise domestic life through the new mass-produced goods and experiences of modern industry. The new middle classes were rapidly allied to a project of the modernisation of domestic life and leisure through consumerism – modernisation of the home through domestic appliances (sewing machines, electric lighting, kitchen appliances, vacuum cleaners, as well as that great container of the respectable modern family, the suburban home); modernisation of leisure through holidays, tourism and other mobile forms of leisure (bicycling and motoring); modernisation through forms of respectable participation in cosmopolitan urbanism – notably the wider spread of fashionable dress and the fashion system; the modernisation of means of representation first through an expanding popular press and then through film, bringing animated aspirational images to a spectating public.

As I have outlined in previous articles (for example Slater 1991), Kodak's introduction of mass photography both stimulated and capitalised on all this: first, Eastman transformed photography from the 1880s onwards from a craft-based practice requiring high levels of technical skill and considerable investment of time and money into an easily consumable leisure activity through the introduction of prepared and pre-loaded roll film; by providing a simplified shutter and a lens/aperture combination which ensured reliable focus from five feet to infinity; by providing a film processing and printing service which obviated the need for chemical knowledge, hassle and uncertainty; and by providing all this at a price which jump-started a mass market and thus ensured further price decreases. Second, this not only allowed photography to become itself a leisure activity but to articulate with the general modernisation of leisure activities and domestic life amongst the new middle ranks, as outlined above. The camera accompanied them as another leisure commodity, and also represented them through its capacity as a *meta*-commodity. Thus snapshooting was both marketed and actually used as part of new activities such as holidays and tourism, was depicted in advertisements on holiday locations (especially the seaside), and often

don slater

in relation to other consumer leisure goods such as bicycles and cars. Third, both the technology and the leisure sites combined in an image of the modernising family: the camera was a central signifier of modernity in the home (industrial technology simplified and domesticated, allowing a similar automation of family life as that promised by washing machines or hoovers), while at the same time it was a means of representing the family being modern. In this regard, Kodak advertising was also very clear in being aimed primarily at women as mothers and homemakers, as producers – both practically and symbolically – of the modern home.

Tensions of consumerism

*Post*modernisation of the private sphere appears at first sight as an intensification of this production of family identity through leisure consumption. (Interestingly, it is also being increasingly theorised by authors such as Featherstone (1991) and Lee (1992), based on Bourdieu's work, in terms of the emergence of yet another wave of new 'middle ranks' – the new petty bourgeoisie.) This is what is suggested by the privatisation of leisure, as discussed above. The enormous popularity of video, for example, seems a direct continuation of the production of the means of self-representation as both commodity and meta-commodity, as both leisure activity and means of representing the family at leisure.

At the same time, however, digital commodities have tended to be about the consumption of images as commodities rather than about new means of producing images as self-representation; while photography – as already noted – has been at the margins of the new technologies (still photo-mechanical, still largely presented as paper prints or slides, still not widely manipulated through computer software or integrated into multimedia systems). Postmodernisation has signified for theorists an everyday world increasingly flooded with images and image-centred activities: the 'aestheticisation of everyday life', the transformation of things into signs, consumer culture as a drama of presentation of self through signifying goods, leisure and consumption as spectacle, as the consuming of the world as images. Digital commodities and home entertainment intensify this flood of consumable images and organise activities around images – TV, video, computer games, graphical software, etc. However, in contrast to snapshooting which, however conventionalised, involves self-representation, digital culture involves tapping into flows of images which originate outside the private sphere – the home as hacker.

Following this line of thought I want to suggest that the meaning of domestic photography is being changed less by any internal technical or commercial transformation of the way in which it is carried out, than by its relation to the dominant practices of the image in domestic life, practices which *are* evidently being technically transformed. I want to argue that whereas the latter are in tune

with contemporary consumerism and leisure, snapshooting probably is not. In brief, what is at stake in digital culture is the fate of self-representation through images.

We may start by going back to the image of the 'family album', which – partly through Jo Spence's work – has provided the most influential metaphor for thinking through domestic photography. The 'family album' may exist, and may be thought about, as an actual object (a book containing selected images); or more broadly as a privileged selection of images through which we represent family identity to selves and others, but which may be found on mantelpieces or desks, in wallets or framed on the wall. The metaphor of the 'family album', whatever physical form it takes, represents a process of editing images into icons and narratives through which a familial identity is constituted and stabilised. We may re-edit the family album (take out images we don't like, or people we no longer like) but what is constructed represents an identity which transcends the everyday (if only for the moment). The realism of photos as traces of the past seems to bolt a constructed identity into the natural flow of time. Spence's critical strategy was to demystify this process of turning culture into nature by showing the activity of selectively constructing narratives through codes, choices, idealisations. Little research has ever been carried out on family albums as actual objects, but for theorists the metaphor has powerfully crystallised the process of cultural reproduction through self-representation.

It is possible however that neither the practice nor the metaphor of the family album is any longer central to identity formation, and that this might be due to the intensification of consumer culture and privatised leisure. First, the 'family album' invokes a privileged relation to time, a sense that identity is constructed through continuity and memory. The images themselves have the status of icon: images with aura and halo, irreplaceable and materially bearing the past for us and for a family which transcends the individual. As an interesting piece of market research unearthed in 1982, 39 per cent of respondents rated their family photos as the possessions they treasure most and would least like to lose (out of a list which included jewellery and clothes). These figures ring true intuitively and correspond to the feeling of *existential* loss we might feel when a treasured photo is lost or destroyed. Even the most postmodern of consumers perhaps retains in this situation a feeling of responsibility to the past as something more than a fantasy.

Yet this hypervaluation of the family album sits oddly with our actual use of photographs: the same piece of research indicated that 60 per cent of respondents and their families looked at their family snaps only once a year or less (79 per cent look less than once every six months). Moreover, it is unclear how many people actually organise their photos into anything approximating a family album: most of them remain in the same envelopes in which the processing company returned them. Thus the family album – in a concrete or metaphorical sense – is

hypervalued yet plays little part in everyday life. *Taking* pictures is a taken for granted part of leisure activities; but *looking* at them is marginal. We need to know they are there (and in a persistently existential sense) but they are not part of the everyday practices which involve images. Interestingly, it would seem that the single well-marketed convergence of snapshooting with digital culture – PhotoCD – is a method of archiving and preserving images (and largely marketed as such) rather than an activity for using photos or doing anything with them (even organising them into narrative albums).

I think there is an alternative metaphor which might capture the active relation of domestic images to contemporary everyday life: 'the pinboard', or even, 'the wall'. Instead of gluing photos into albums (arranged narratively in books; or as icons on the shrine of the mantelpiece) and therefore into a history, we rather pin and blu-tack them haphazardly onto surfaces and therefore into the moment, into the display and self-presentation of the present. On the pinboard or wall, snapshots taken by us or friends, or bits of photo booth strips left over from arranging passports or various identity cards, take their place alongside images cut from newspapers, postcards sent by friends, Christmas or birthday cards, change of address cards, notices and advertisements, pictures of pop stars and celebrities, paintings and drawings by the kids, and so on. First, then, rather than a narrative or shrine, the pinboard evokes a haphazard, ephemeral and shifting collage which is produced by and within the activities of the present. We can see here the everyday circulation of domestic images. Second, in this practical context, the photograph takes its place within a flow of other images – photographic and non-photographic, public and private.[1]

The 'photographic wall' metaphor suggests a number of developments, none of which is new to digital culture but all of which are intensified within contemporary everyday life:

First, the images that have a live place in everyday life are those which are bound up with forms of practice rather than memory or commemoration, which are part of the instantaneous time of the consumerist present rather than a historical time marked by the family album. The images on the pinboard emerge from what is happening now, and are part of making it happen. For example, they are often acts of practical communication rather than reflective representation. The postcards, snaps and so on which are sent to us, for example, are not so much representations which are detachable from and reflective upon a relationship, but are rather forms of communication and presentation of a relationship, ways of acting out and embodying a relationship in the present. It is likely that digital commodities intensify this aspect: e-mail, the sending of birthday and Christmas faxes, the DTP facilities available in the cheapest word processors which – through typefaces, letterheads, clipart and photos – turn all communications into images. Digital communications offer more ways of *being there* through images.

Second, one could argue that it is very much in keeping with the logic of

consumerism that self-*presentation* rather than self-*representation* should play the largest role in identity formation. The image is always in the moment and need not take the form of a representation at all: images as means of identity formation are in our dress and on our bodies, the decoration of our homes, the car we drive, and so on down the list of style choices, where identity is produced through a presentation of self in the moment rather than in a reflective representation of it as (an imaginary) continuity over time. In contrast to the family album metaphor of representation, images seem less and less to constitute a metalevel or critical level standing outside the moment. In a developed consumerism, the image is the way we present ourselves in the heat of the moment rather than the way we represent that moment as an object of reflection.

It is quite in keeping with this that the metaphorical pinboard or wall includes public images alongside private ones. It is significant, for example, that Paul Willis in *Common Culture*, and the research on which it is based, did not even mention images taken or made by the youths they studied, but did make memorable mention of images purchased: posters. It was in the use of images of pop stars to decorate their rooms that Willis saw youths engaged in symbolic labour, appropriating images in the process of creatively making an environment filled with their meanings. Purchased images rather than personal representations constitute the main material for negotiating those publicly available image systems through which we manage personal identities.

Finally, actively *using* domestic photographs as opposed to taking them (whether still or video) is marginal because it is not structured into a leisure event. Leisure is often conceived of as free and idle time yet is generally experienced and lived as *activities*. Moreover, these activities are *structured*, whether in the form of traditional or home-grown pastimes, spectacles or social gatherings, or in the form of commercially purchasable events and objects. Leisure activities are events which are structured around forms of participation and spectatorship, rules of behaviour and activity, sequences of event.

Leisure as the structuring of events is intimately bound up with consumerism, with the commodification of time. For example, the structuring in the eighteenth and nineteenth century of popular pastimes like races and sports, masquerades, fairground attractions and animal spectacles into modern *leisure* pursuits is bound up with their transformation into events for which one buys a ticket from an entrepreneur who undertakes the delivery of a defined spectacle at a set time and place which fits a range of expected rules and conventions. Each moment of a leisure activity can be structured into a commodified, saleable event. As the very term 'spectacle' would suggest, a great deal of leisure event-structuring has been centred on the provision of events comprising images: from theatrical spectacle through sporting spectacle and on to TV (though radio pioneered that most influential of time-structuring models: broadcast time). Photography itself developed out of public image spectacles such as dioramas and panoramas

(themselves related to public amusements such as magic shows, carnivals and circuses). It also took the form of home entertainment events: the Victorian craze for stereoscopes is a clear example of commodifying leisure time into a programmed event (Slater, forthcoming).

Leisure, then, has come to mean the structuring of time through commodities (whether commodities like experiences and spectacles, or material goods with conventions of use). *Taking* photographs is itself structured (with Kodak mass photography as the paradigm of structuring a complex skill into a few simple actions – 'You press the button . . .'); and is regarded as an intrinsic part of other leisure event-structures: holidays, time-off, special occasions (Christmas or wedding). It fits into the commodification of leisure generally and is part of their commodification: we are encouraged to photograph our lives in such a way as to frame them as leisure events. *Using* photographs, however, does not fit the bill of leisure event, of a consumer practice or experience. At most, we look at photographs as a kind of one-off reliving of a recent leisure experience (a quick look at the holiday snaps when they come back from the chemist); at worst, they are a consumerist nightmare and social imposition (the dreaded slide show).

Programming leisure

While there appear to be no leisure practices of the snapshot, core leisure and consumerist domestic practices are centred on images. I have already noted that self-presentation as opposed to self-representation seems to place image, in the form of style, into every lived moment. At the same time, home entertainment is crucially image-based: images are successfully structured into leisure events such as 'watching videos', 'playing a computer game' and so on.

We might think of this structuring in terms of the idea of 'programming': first, we use the metaphor of programming to describe the sequence of programmes on television, for example: the leisure event is structured as a *flow*. There is choice here, but the main choice is between different flows (i.e. which channel to watch). The flow structures time into a prepared sequence which we enter and exit. Second, we use the metaphor of programming in the sense of the computer programme: this structures events too, but in the form of a *decision pathway*. The programmer tries to foresee possible and desirable events that could take place, offers a structured way of making a choice between a limited number of foreseeable events, then tries to programme in the consequences of any of these choices, with further choices down the line. If flow can be represented by the television channel, the decision pathway is best represented by the 'menu' in a computer programme.

In these ways leisure activities can structure domestic time and experience into calculable events. Both the technologies (TVs, videos, computers, CDs) which can

accomplish this structuring, and the events themselves, can be sold as recognisable, reified, rationalised events – as commodities. The contingency of human action over time – particularly over the 'free time' of leisure – can be disciplined into a standardised, reliable, repeatable, predictable event – both for the producer who wants to produce events efficiently and profitably, and the consumer who wants to get what they bargained for. Snapshots have to compete with a veritable tidal wave of image events which provide easily consumable structures of time and activity, a structuring of everyday life and leisure into programmed flows and pathways. The flow of television is the most obvious. The decision pathways of the computer game are possibly even more powerful: images structured over time as enclosed environments with internally consistent yet flexible rules generating a range of engrossing activities within a fictional world.

I am not arguing that these leisure image activities are simply manipulative or mass cultural. Only that they marginalise domestic self-representation because snapshots do not have ready-made leisure practices which involve them. We might have extremely creative and rewarding involvements with the image activities which make up leisure time; the point is simply that personal images of ourselves do not seem to find a place there. We might see this by contrast with the use of digital technology in music: new music technologies stimulate new forms of self-expression in ways which image technology does not. Rap, sampling, even karaoke or the simple process of putting together a party tape make for interesting contrasts to putting together a family album.

While snapshot photography seems shunted aside by this programming of imagery into leisure events, amateur photography probably fits in rather neatly. Hobbyist photography has always been intensively consumerist, being predominantly focused on technical choices, skills and equipment. Amateur photography has tended to reduce all concern with the content and purpose of images to a minimum, the better to focus on formal technical qualities (film, quality, depth of field and focus, printing skills, etc.). Thus the amateur press notoriously gives exhaustive details of film types, exposure and lens specifications, chemical details of processing and development, while reducing subject matter to rigid and taken for granted generic types (portrait, glamour, landscape, etc.). Structured through a concern with technical choices it is also mapped out onto the exercise of consumerist choice (I need that lens, that film, that tripod to take that picture) capitalising on a deep techno-fetishism.

Digital commodities build on hobbyism in many ways. First, there is a concern with exercising technically informed taste to produce an optimal system: whether one is putting together all the right camera gear, hi-fi elements or computer system with optimal speed, memory, graphic resolution, etc., the desire is to move lustfully up a ladder of technical powers. Second, the technical commodities are both marketed and perceived in terms of clearly structured technical options which each affords – much like a decision flow: this camera offers auto-focus

based on five different points within the frame, while that one offers only one or two. Playing with a programme like Photoshop is much like playing a computer game on the one hand, or doing amateur photography on the other: one is offered clearly structured options, organised into menus allowing different 'moves'. By choosing an option a different manipulation automatically results. One can go around this by combining options, by manipulating the image freehand, pixel by pixel if you wish (much as the most automated camera can still be used in manual mode) but the structure that confronts one is ease of use produced by conventionalising image manipulation into a decision pathway.

Critical baselines

Passivity is a crucial element in consumer culture, though passivity has many meanings and need not denote the 'culture dope' which is said to populate mass cultural images of modern society. Even so, pointing to this feature appears retrograde to contemporary postmodern perspectives, though the tide would appear to be turning (for example Morley 1992). The focus on the active consumer as a maker of meanings and as a producer of consumer practices has obscured the central fact of the consumer as *chooser*, as one who selects from an array of predetermined choices amongst highly structured objects and experiences. Freedom to manoeuvre within, as well as to choose between, these structures is no substitute for the power to create structures. Domestic photography itself appears as a paradigm case of this activity within passivity: looked at in terms of its semiotic and practical potentials, photography represents the widest proliferation of the power to represent coupled with an extreme circumscription of this power in actual practice. If this was the case with mass snapshot photography which – however conventionalised – did generalise a power of representation to a wide population, it is even more so the case when, on the one hand, even this limited power seems to be at odds with the practical, instantaneous and programmed structure of consumer leisure time in digital culture; and on the other hand when private images of even the most conventionalised kind cede pride of place to public images in the domestic world.

It is worth expressing these themes in the language of an earlier critical perspective and practice: the 1970s saw numerous currents of radical photography which considered the potential of photography for empowerment in everyday life: in education, documentation, alternative politics, etc. To some extent these currents touched upon domestic photography, particularly through Jo Spence's work. The family album appeared as the privileged text in which one could read one's active subjection. The very possibility of critical photographic practice in everyday life seemed contingent on overcoming familial privatism and attaining public status: another way of recognising that the personal is political.

The enormous tension between the real constraint, passivity and limitation of

photography and its capacity for empowerment – a contradiction, if you will, between domestic photography as a force of cultural production and the (familial) relations of production which constrained it – could be summarised in terms of three utopian demands or hopes:

1 Domestic photography held out the possibility of telling one's own stories: about oneself and one's life, about the life around one. Why could we not see people – cameras in hand – telling their lives – to themselves, to others – in a narrative cut to their own dreams, desires, anger? This is the potential of empowerment.

2 There was the possibility that by engaging in self-representation – critically *conscious* self-representation – people might come to critique the public and dominant representations of themselves and others in the media. Could that ultimate arch-enemy, the root of all representational tyranny – the myth of *realism*, of the factuality of the image, of the naturalness of meaning – survive the people's own experience of *making* images? This is the potential of demystification.

3 There was the possibility that the weight, power and truth of self-produced representation could counter the dominant media, cut through it. In a world of alternative magazines, films, poster production, theatre, counter-information services, voluntary organisations, could we not enlist everyday photography in the ranks of counter-hegemony and prefigurative culture? This is the potential of cultural politics: that a new political culture would emerge from a new cultural politics.

Now, if any of the core empirical and sociological claims of critical postmodernism hold any water, then these 'potentials' and the problems they address are if anything more crucial in the 1990s. Moreover, they should be more 'potent'. In fact, they appear not to be, and least of all in the leisure practices structured around the digital commodity.

First, if the postmodern subject is not only decentred but schizoid; if the fragmentation of identity stems not merely from dispersion but from the loss of any core, if the arbitrary is rampant – then not only is the ability to tell our own stories more urgent – it is *essential*, required. Empowerment in the sphere of self-representation is not an optional political extra proposed by utopian counter-culturalists, a tool of struggle for a better world, it is a necessary condition of actually surviving and existing as a sane social subject in the everyday of today. But it is also the common currency of consumer culture: the medium of dress and décor. Self-presentation through consumerist structures and structured leisure events *increasingly* takes over the role which critical thought would assign to self-*re*presentation. Domestic photography, on the other hand, is still the refuge of the myths of core identity. It is the very means by which we narrate our domestic lives as a traditional or even existential story of moments (birth,

marriage, death) exemplary in their transcending the flux of public presentations of the self. The potential of empowerment has been forced upon us but has not been taken up within photography. Domestic photographs are the *antiques* of the postmodern world.

Second, if the postmodern world is experienced as hyperreal, if the relation between sign and referent has not only been theoretically questioned but empirically reversed, then not only is realism a suspect hare for images to chase but an impossible framework even in which to read them at all. Yet the photographs we take ourselves are meant to tell the truth in a way which we would no longer expect of any publicly placed picture. Baudrillard may believe that the Gulf War happened mainly on TV, but the wedding damned well took place and here's the photo (and video) to prove it. The potential of demystification, again, has been thrust upon us but we decline it in domestic photography. The surrealism of the image is explored in the structured world of the computer game; while the snapshot – as we have argued – remains on the one hand sacrosanct as testimony to the past and on the other marginal as a trashy, instantaneous and disposable moment in the present. It is both too serious (as realism, as trace of the past) and not serious at all (as a means of exploring the present, it has no truth claim).

Third, if postmodernity is defined by dedifferentiation and dehierarchisation, with the substitution of horizontal difference for vertical topographies of value and subordination (high/low culture, dominant culture/subculture), then the potential for revaluing popular and lived culture as a political culture (or plurality of insubordinate political cultures) should be great. Everyday photography – to be visionary for a moment – should be a lever for shifting this plurality from a plurality of consumerist choice into a plurality of active construction of local and voluntaristic association, part of the rebirth of a civil society in which our private cultures have real public meaning (rather than being privatised in a sentimentalised familial fantasy world).

Digital technologies may well provide culturally productive and empowering resources for everyday life. All I am questioning here is the likelihood that this potential will emerge in relation to domestic photography as self-representation – crudely, whether the hopes that photography's erstwhile potential to empower, demystify and politicise everyday life are likely to be furthered by the introduction of digital culture in the form of intensified leisure consumption.

Note

1 The photographic album and the mantelpiece were always somewhat surrealist genres in the sense that they often included not only photos but also mementoes which might be found objects (tickets and programmes for events to be remembered, postcards; the traditional mantelpiece would mix framed photos with souvenirs,

commemoration plates and mugs). These photos and mementoes were disposable everyday objects transformed into valued and auratic ones. Both the tension between the ephemeral and the auratic and the transitions between them are considerably altered on the wall or pinboard: emotional investment in these images may be intense but is generally short – they gradually become invisible (often literally by pinning a new treasure over them).

References

Aglietta, M. (1979 (1976)) *A Theory of Capitalist Regulation: The US Experience*, London: Verso.

Cunningham, H. (1980) *Leisure in the Industrial Revolution, c.1780–c.1880*, London: Croom Helm.

Featherstone, M. (1991) *Consumer Culture and Postmodernism*, London: Sage.

Green, E., Hebron, S. and Woodward, D. (1990) *Women's Leisure, What Leisure?: A Feminist Analysis*, London: Macmillan.

Lee, M. J. (1992) *Consumer Culture Reborn: The Cultural Politics of Consumption*, London and New York: Routledge.

Morley, D. (1992) *Television, Audiences and Cultural Studies*, London and New York: Routledge.

Rojek, C. (1985) *Capitalism and Leisure Theory*, London and New York: Methuen.

Rose, N. (1991) *Governing the Soul: The Shaping of the Private Self*, London and New York: Routledge.

———— (1992) 'Governing the Enterprising Self', in P. Heelas and P. Morris (eds), *The Values of the Enterprise Culture: The Moral Debate*, London and New York: Routledge.

Slater, D. R. (1991) 'Consuming Kodak', in J. Spence and P. Holland (eds), *Family Snaps: The Meaning of Domestic Photography*, London: Virago Press.

———— (forthcoming) 'Photography and Modern Vision: The Spectacle of "Natural Magic"', in C. Jenks (ed.), *Visual Culture*, London and New York: Routledge.

Spence, J. (1980) 'Beyond the Family Album', *Ten-8*, no. 4, Spring.

———— (1986) 'Visual Autobiography: Beyond the Family Album', in J. Spence, *Putting Myself in the Picture*, London: Camden Press.

Spence, J. and Holland, P. (1991), *Family Snaps: The Meaning of Domestic Photography*, London: Virago Press.

Thompson, J. B. (1990) *Ideology and Modern Culture*, Cambridge: Polity Press.

Tomlinson, A. (1990) 'Home fixtures: Doing-it-yourself in a privatized world', in A. Tomlinson (ed.), *Consumption, Identity and Style: Marketing, Meanings, and the Packaging of Pleasure*, London and New York: Comedia/Routledge.

Williams, R. (1974) *Television: Technology and Cultural Form*, London: Fontana.

Willis, P. (1990) *Common Culture: Symbolic Work at Play in the Everyday Cultures of the Young*, Milton Keynes: Open University Press.

~~television~~, computers, technology and cultural form[1]

andrew dewdney and frank boyd

7

> *A dress becomes really a dress only by being worn, a house which is uninhabited is indeed not really a house.*
>
> K. Marx, *The German Ideology*

In this essay we discuss the cultural impact and contemporary production of multimedia as it exists in interactive CD Rom. In doing this we have been guided by an interest in the relationship technologies have to the social relations of production and the social contexts in which technologies and their outcomes are used. In this respect we draw upon strands of cultural study which discuss social and cultural meaning as complex outcomes of the forms and institutions of production. In taking this approach we are indebted to Raymond Williams, whose *TV, Technology and Cultural Form* (1974) continues to afford valuable insights.

Such a grounded and situated approach as we wish to take towards new technologies does not sit easily within a current mode of writing in which a high degree of general abstraction and metaphor is used to make connections between the development of technologies and their social and cultural effects. At its extreme this tendency to both abstract and generalise the effects of technology becomes conjoined with a discussion about future forms of social life. Whilst it is important to speculate about future possibilities and recognise the extra-ordinarily rapid pace of technical development, their collapse produces an uncomfortable 'futurespeak'. This can then take the place of a more careful analysis of how technologies are themselves produced and form part of a complex

set of determinants upon media production and consumption within any given society. What is being identified in the shorthand of the term 'futurespeak' is a technological determinism, a trapped discussion, located in a prescient moment where technological developments, especially those of total interactivity, global networks and virtual reality are forever immanent. Futurespeak is the language of a tautological realm and amounts to a flight from the present in which technology is isolated and ultimately mystified. We do, however, recognise that it is an established and ingrained habit of thought which is hard to shake off. We may well fall into it unwittingly in what follows! Its power comes precisely because it is much harder to speak or think the actual complex relationships between technology and society at any given time. But there seems little point in focusing on technological moments of radical departure, whilst failing to notice that new technologies are continuous extensions of presently employed ones.

What is multimedia?

In what follows we attempt an engagement with ideas about the transformative nature of multimedia from the standpoint of the current organisation of multimedia production and its increasing markets. We look specifically at ideas about greater public access to and freedom of information, the user as author and the idea that interactivity brings with it a new imaginative freedom from older 'linear' forms of expression. These ideas constitute the underlying currency and rhetoric of multimedia and are by no means clear or settled. Multimedia is in its infancy, yet is already a rapidly growing field. Multimedia production also stands in a complex relationship to existing forms of media production, film and photography most significantly. It is in the relationship between the chemical and digital image that the rhetoric of media supercession is most noticeable. For no other reason than to try to dispel the clouds of rhetorical hype surrounding current interest, it is worth starting by being clear about what we mean by multimedia.

Multimedia is a generic term being used to refer to a specific range of audio-visual technologies which have converged in digital information processing. Digital scanning and storage of the still photograph, full motion video, animation, stereophonic sound and text, have created the conditions for previously separate forms of representation to be used in simultaneous combination. In addition to the convergence of all these previously separate media on screen, current digital-based multimedia also includes increasing and various forms of end-user guidance and control. These latter aspects of multimedia are being termed 'interactive'.

Whilst interactive CD Rom programmes have already taken on a number of different cultural forms, e.g. mystery games, image or text databases, magazine formats, expanded books, etc., they share common features.

andrew dewdney and frank boyd

Figure 7.1 Screen shot from *Alice to Ocean*. The typical multimedia screen contains text, illustration and photographs. CD © 1992 Against All Odds Productions; photographs © 1992 Rick Smolan Interface; design, artwork and programming © 1992 Magnum Design.

Figure 7.2 Screen shot from *Myst*, Brøderbund, 1994. In *Myst* the full screen acts as the metaphor for the user's line of vision, or the window on the world.

Were you to be using a CD Rom programme now you would, most likely, be sitting at a desk, looking at a high resolution colour monitor, with a keyboard and mouse in front of you. The CD programme would invariably have an animated screen interface. The interface is, in effect, a conceptual device linking the physical apparatus of the screen, mouse, and keyboard to the stored data. The interface operates as a navigational or instructional metaphor, e.g. designed to look and function like a control panel, console, desktop, contents page, etc. On screen, more often than not, it consists of a set of visual symbols, icons, buttons or sprites, which represent the different pathways or files which you activate by use of the mouse, keyboard or touch screen. At any one time the screen would be displaying the navigational tools and material from a section of the programme. Increasingly interface designs 'hide' the navigational tools, menu bars, icons, etc., so that they do not interfere with, or detract from, the main programme material. In such designs the navigational tools appear on screen only when the mouse arrow 'rolls over' an active area of the screen. In detail you would be looking at a screen which will have a number of concurrent elements, i.e. graphic illustrations, photographs and motion video (Figure 7.1). In addition there would be a related soundtrack. The design of the interface establishes the actual as well as imaginative relationship to the programme material, which is why we say that the interface functions metaphorically (Figure 7.2). Programmes can currently contain thousands of images, up to 80 minutes of video, and millions of words. The quality of still photographic and graphic images and sound is very high.

What is driving the development of multimedia?

Multimedia represents a convergence of previous media in a digital screen-based form. Multimedia applications have been developed for a wide range of military, scientific, commercial, educational and domestic situations. Current multimedia technology has arisen from elements of applied technologies which were originally designed to meet specific and often singular interests. Interests which have had a shaping effect on the subsequent wider use and form of multimedia. For instance, the development of computer-based flight simulators for training military pilots has been extended to the training of train drivers and firefighters. Screen-based simulation is also incorporated into the entertainment forms of video games and education programmes.[2] In a more detailed analysis it would be possible to recognise something of the selective interest(s) of the separate components of technological development which have now combined in multimedia; simulation, virtuality and rapid computation being only the most obvious. For those, especially feminists, writing about the gendered nature of technologies, there are significant understandings to be teased out about the way technologies develop in relationship to institutional discourses.

andrew dewdney and frank boyd

Whatever the starting points of the technologies which combine to produce and support multimedia it is clear that they are now developing in an environment of rapid commercial application. The consumer electronics and computer industries, spearheaded by multinationals like Sony, Phillips, JVC, Nintendo, Apple, IBM and Commodore, have invested heavily in developing multimedia hardware and software for home and business use. Alongside the giants of consumer electronics who are shaping the ways in which most of us will meet multimedia technology, is the parallel and potentially bigger development of computer-driven communication industries. Digitisation has created the conditions for a global network of satellite and cable transmission of information on a previously unimagined scale. Telecommunications companies like AT&T, publishers and broadcasters like News International and, of course, the all-powerful Bill Gates, of Microsoft, are all looking hungrily at the developing markets for information services.

Multimedia is then a constituent part of a larger scale of technological development referred to as the information revolution. In this revolution, the capacity of computers to handle, store and display ever increasing quantities of information in new and novel ways is being seen to lead to a dramatic qualitative change in media forms. At its largest, the claim is made that the information revolution is bringing about a fundamental reorganisation in the social life of the rich and advanced post-industrial cultures. However, to heed our own warning, whilst such a general assertion supports the attempt to see a larger picture of change, it carries with it a sense of passivity. One where the future is perceived again as unfolding according to an inevitable set of outcomes. Technologies don't just arrive or develop by themselves. What is more they always have a material history which stands in a determining relationship to future development.

Multimedia may not yet be a familiar term or concept in industrial and post-industrial societies, but it is, and has been, for most of the twentieth century, a common part of the experience of living in one. The designation of a specifically multimedia form within digital technology at the end of the twentieth century serves as a reminder that combined audio-visual technologies have been in continuous use since the mid-nineteenth century. Victorian dioramas, silent cinema, slidetape presentations, theatre sets, happenings, Disneyworld rides, are all examples of public forms of multimedia. The term multimedia could reasonably have been applied to early television, in so far as broadcast programming, containing live dramatic performance, was interspersed with recorded film footage and accompanied by musical soundtracks as intermissions.

In recognising that there is a longer history to technical forms of combined media technologies, it is also possible to see that available media are combined and become multiple in forms of use. Watching TV with the sound off, whilst playing an audio cassette would be one form; listening to the radio whilst looking

through a magazine or book would be another. The developed habit of attending to more than one source of stimulus or information is a recognised human value involving both convergent and divergent forms of attention. On the one hand, many, often stressful, forms of contemporary wage labour demand single-minded attention to a range of information relayed through various levels of technology, working on the floor of the Stock Exchange for instance. On the other hand, much of leisure time involves similar, if differently paced, forms of multiple simultaneous concentration, the pleasure of conversing with a friend, registering the ambient music, in a pub or on a picnic, where attention shifts back and forth from what is said to what is seen. Our point is that developed social forms of complex stimulus and attention come to be reflected in the cultural forms of media we develop. Nowhere is this more obvious than in advertising. The contemporary television commercial, lasting no more than 30 seconds, will typically draw upon a range of visual referents, styles and techniques drawn from different media forms and genres. Successful advertisements depend upon our familiarity and relationship to a range of both historical and contemporary media texts. The intertextual advertisement is increasingly conditional upon a saturated, multimedia environment. Indeed it has been suggested that in the context of future multimedia in the domestic environment, advertising will cease to be distinct from any other source of information with which we will interact.[3]

The shaping of a visible, consumer-based multimedia industry over the past two years has required the convergence of a number of significant technological advancements. The most important of these have been the development of economical and reliable digital storage devices, e.g. CD Rom, improved image compression capabilities and increasing microprocessor speeds. Additional hardware-related trends which have helped form the market include the introduction of personal multimedia products, notebook computers, pen-based computing capabilities, wireless communication capabilities, and, particularly, appropriately equipped laptop computers. In effect the elements of a 'consumer led' market, based upon consumer durables, have been put in place and what follows is the demand for product (Figure 7.3). One of the most interesting and noticeable recent moments of multimedia development was the investment of the electronics manufacturers which led to a high street selling Phillips CDI and Kodak PhotoCD players upon which there was precious little to play. The Apple strategy of selling CD Rom players at cost has probably done more to ensure the development of a CD Rom user base. In the rush to capture new computer markets we can see a historical parallel with the early moment of different and incompatible video formats. However, the development of the domestic market for multimedia products and services needs initially to be understood in the larger context of the social and economic organisation of screen-based computer technology.

A useful popular characterisation of the increasing ubiquity of the screen (its

andrew dewdney and frank boyd

Figure 7.3 'New' consumer durables, products for the whole family. Advertisement in *PC Plus*, Issue 98, December 1994.

pervading presence is not lost on us now as we read these words through its luminosity) has been given in the formula of three primary social locations in which it is met, couchware, deskware and streetware.[4] CDTV, CDI, 3DO, Jaguar, MegaCD, SuperNes are all developments based upon existing social patterns of the TV screen as a source of entertainment watched from the comfort of the couch. CD Rom and CD Rom XA are based upon the desk as a place of education and research, whilst PDA and Electronic Book are the current forms of personal portability, like the Walkman, designed for the street. These distinctions about the organisation of the consumption of multimedia applications help us see how the drive for distinct market spheres is based in the existing organisation of the multinational electronics companies, which in turn reinforce and build upon existing cultural forms and social habits. But whilst these distinctions hold, it is also necessary to see that a different, but related kind of convergence is being sought in the shaping of an even larger organisation of media technologies. Here, much bigger markets are foreseen which suggest that current high street products are a knowing form of preliminary market exploration, written off as loss leaders.

In persuading investors to support setting up the Media Lab at MIT in 1978, Nicholas Negroponte argued that by the year 2000 there would be an almost complete overlap in the interests of three industries: Broadcasting and Motion Pictures, Print and Publishing and Computing (Figure 7.4). This was a bold prediction for the time and one which looks in the 1990s to have been fairly

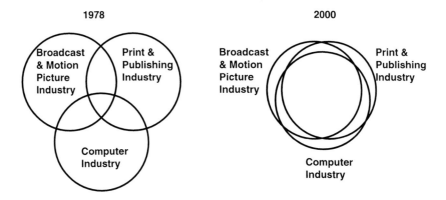

Figure 7.4 Negroponte's diagrammatic prediction.

accurate, but, if anything, conservative about the acceleration of convergence. With hindsight we can see that Negroponte left one crucial industrial sector out of his model, which we, and indeed he, can now see as pivotal. Tele-communication technologies in both satellite and fibre optic cable form are creating the digital superhighways which fuel the current discussion of global information networking. The implication for current multimedia of what are quite likely developments, is not lost upon Negroponte's current thinking. Interviewed via e-mail for the *Guardian*, prior to his lecture for the *Financial Times* Multimedia Conference in London, July 1994, he continued to expound the same convergence thesis, but now with the benefit of a technology in place to deliver his prediction.

In the interview he conjured up an image of a domestic technology, the black box in the living room, which would function rather like an 'English butler who knows when to disturb, to contradict or lie low'. This digital butler, a kind of personal digital assistant, would be characterised in computer terms as having 'extreme intelligence' and would act in a society of machines, an agent in the network. In effect the digital butler represents one more convergence in which the domestic television receiver is combined with a computer to edit and select from a bigger spectrum of media information. In the characteristic style of further prediction Negroponte updates his earlier prediction with the media sound bite, 'by the year 2000, which is real close the media landscape is likely to be unrecognisable'.[5]

Remembering our own imperative to be wary of thinking that the matter of the future shape of media communications is settled and is, simply, a matter of waiting for all the technological components to be put in place, we have, yet again, to return to the ground of the social and economic. How will new products for both consumer durables and services build upon existing social patterns and

andrew dewdney and frank boyd

cultural forms? First, we have already recognised that the interests of the transnational electronic companies are clear. They want the continued development of lucrative markets for sophisticated hardware within the economic reach of those who currently own a phone, television and personal computer. Second, the interests of the hardware manufacturers are tied up with the markets for software, in which the demand for more and more sophisticated screen interfaces and delivery systems is expressed in the metaphor of the digital butler. However, the digital butler needs to serve something up, the digital meals which will satisfy our appetite. The digital cooks, to carry this through, are clearly to be the media industries of print, publishing, TV and film. The very industries which, as we have noted, converged and are now striving to be both producers and distributors of the digital menu. The increasing organisation of pay-as-you-view television in the United States, where public service broadcasting has little cultural resonance, together with global satellite TV, suggests that digital information of whatever kind and source will be organised along similar lines. Profit is made through production of technology and the ownership of information. Ownership of the domestic black box which will enable you to receive global information is only one part of the equation; the other will be your ability to buy into the network services.

Multimedia products and their cultural forms

Whilst it is important to see that multimedia may well be delivered in future through online services rather than on disc, the current multimedia market for CD Rom needs to be seen as a parallel delivery system, and more importantly, prefigurative in its forms of use. In the last nine months CD Rom titles have expanded to such a degree that they can now support two new UK CD Rom magazines.[6] *CD Rom Today* claims in a recent review that more encyclopaedias are now sold on disc than in hard copy, whilst the gross turnover in computer-based games production in the US now equals that of Hollywood. For all of this one of the strongest criticisms of the multimedia market is that it contains nothing new or of real interest or significance. The most damning comments being made are that multimedia CD Rom is just a bigger delivery system for the techno-nerdish world of established computer gaming. A glance at CD Rom title lists would have to give some credence to this view. However, it would be a mistake not to recognise, in outline, a complex shaping of multimedia forms which build upon and extend existing and wider forms of media use. Here there are concrete examples of media convergence as film and television production companies, publishers and the music industry see opportunities either to repurpose their existing media assets, or to find new outlets for their production facilities. Most current CD Rom titles fall somewhere within these two categories. With image compression making full motion video and feature length film possible on CD,

TV and film studios are now making new pay agreements with 'digital actors' for the production of interactive adventure games or for what are being marketed as interactive movies, e.g. *Double Switch*, starring Debbie Harry (other titles in this emerging genre include *Night Trap*, *Sewer Shark*). The repurposing of text or still image based 'media assets' on CD runs parallel to the newer interactive film versions of adventure games. In this respect CD Rom resembles conventional publishing with titles including *The Illustrated Holy Bible*, *The Concise Oxford Dictionary*, the *Financial Times*, *Compton's Family Encyclopaedia* and *Time/Life* coverage of the Gulf War. Repurposing of assets is not limited to press or reference sources; CD Rom titles include the works of Shakespeare, Mozart and the Beatles.

In getting closer to what multimedia CD titles actually contain we see initially how closely they resemble the forms from which original material has been taken. It is possible to divide the forms of multimedia into three constituent and dominant forms which have been identified as converging within digital technology: print, the moving image and the Arcade game.

The most established of CD forms is that of the expanded book, non-fiction or reference works making up the bulk of titles which can be found in most educational libraries. The problem multimedia faces in appropriating text, of whatever kind, is that it is much easier to read continuous text on the printed page than it is on screen. To overcome this, expanded books develop multimedia's potential for quick search and find functions, together with providing additional and often illustrated or animated comment and notation. Expanding established text through animation sequences has also led to a successful reworking of children's literature in the *Living Books* series. The fastest growing list of titles fall into a general knowledge and leisure category. Based upon encyclopaedic or magazine formats, this expanding genre takes much from weekly print-based part series. Drawing upon established hobbyist interests, from sports, collecting and gardening, these titles are often very limited in scope whilst, of course, promising everything you need to know. The haste to establish CD Rom titles in these areas is reflected in work being badly researched, poorly referenced and with limited indexes.

In characterising the making of the early CD market we cannot leave the development of the Phillips CDI format out of account. In a marketing dreamworld Phillips CDI was conceived as 'the electronic hearth', a smooth black box to be sold to sit under every one of the world's billions of domestic television sets. Phillips originally marketed their CDI player as an extension of the 'home entertainment centre' or in plain terms, the hi-fi stack. The 'electronic hearth' was a powerful concept which extended the 'space' of the TV, already the centre of the domestic living room, as an even more riveting, compelling place in which the family could interact. CDI fully embodied the couchware concept, where, with a growing diversity of discs, children could play interactive games, whilst parents could get handy information to improve their photography, plan a

andrew dewdney and frank boyd

holiday or learn more about Impressionist painting. But, as we have noted, the players arrived before the titles, and sales, once thought of in terms of millions, on lowest estimates, have only reached the 100,000s and at the highest 300,000. Phillips have now repackaged the player to compete with the Sega and Nintendo games market.

Kodak's development of its own PhotoCD and player looked towards both of its traditional areas of market operation, photographic products for the professional and amateur photographer. PhotoCD was selectively marketed in both of Kodak's divisions along very traditional lines. For the amateur market, PhotoCD was presented as a new means of storage and retrieval of the family album, a marketing strategy which has been acknowledged not to have been taken up in any significant way, possibly because at present it seems a second best to the camcorder. For the professional, PhotoCD was presented as a link in the industrial chain from chemical to digital, whereby the professional photographer would increasingly store, transmit and ultimately sell images digitally, which had been made chemically. This fits a market where image origination is still largely silver-based. The larger point about the digital image is that the incalculable collection of the world's photographs have for the last 150 years been produced chemically and constitute an enormous archive which can now be digitally repurposed. The same is of course true for film and TV archives. CD Rom titles currently draw upon such archives in predictable but interesting ways. *The Hulton People Disc* (Atticus Cybernetics) contains 10,000 images from its collection, whilst *A Hard Day's Night* (Voyager) contains the complete film, script, film stills and an essay by film historian Bruce Eder.

With the expansion of many more reference and educational titles, multimedia CD Rom is asserting a kind of respectability in the face of its earlier origins in computer games. It is worthy of note in passing that *CD Rom Today*, still trying to find out who their readership is, have made editorial statements in response to readers' letters, asserting that they don't consider reviewing the soft edges of CD pornography appropriate. HM Customs seized illegal copies of *Virtual Valerie* in the last year. But as cultural writers on computers have pointed out,[7] the games phenomena should not be underestimated or dismissed. Its significance lies in the generational base of its users or players. The spread of computer technology and screen-based interactive systems follows those generations growing up, and feeling comfortable with, screen-based computers over the last fifteen years. For one generation the increasing audio-visual sophistication of domestic broadcast TV is coupled with the video games consul and the joystick attached to it. TV has increased both the quality and coverage of contemporary music broadcasting. Music TV, Video and Games form a particular conjuncture for a significant generation ready and waiting, if not actually producing, multimedia. Peter Gabriel's *Xplora 1*, published by his own company (Realworld), is an example of the combination of the genres of pop video, musicology and computer games in

Figure 7.5 Screen shot from Peter Gabriel's *Xplora 1*, Realworld, 1994. An example of the convergence of pop video and video games. © 1993 Peter Gabriel, published by Real World.

what is a seamless and polished product (Figure 7.5). This emerging form of multimedia incorporates a combination of puzzles, mysteries, journeys or chases as the narrative devices to take the user through the material.

The most important point in this brief characterisation of the cultural forms of multimedia is not that a direct translation can be made between either the book, film or game and individual multimedia products. By definition multimedia can, and indeed does, exploit the use of all these sources on screen. What these previous forms define in multimedia terms is the direction and character of interest for an audience, or, in the language of multimedia, its users.

Multimedia and the concept of interactivity

A closer look at two currently available titles will serve to explore this point. Marvin Minsky's *The Society of Mind* (Voyager, 1994), is an expanded book. In *The Society of Mind*, Minsky, currently the Toshiba Professor of Media Arts and Sciences at MIT, describes the mind as a complex interconnected series of functions. He sees the book as an attempt to provide a working hypothetical model of the mind. This book sits within the tradition of writing about artificial intelligence. The cover notes claim that the CD breaks new ground in how ideas can be

andrew dewdney and frank boyd

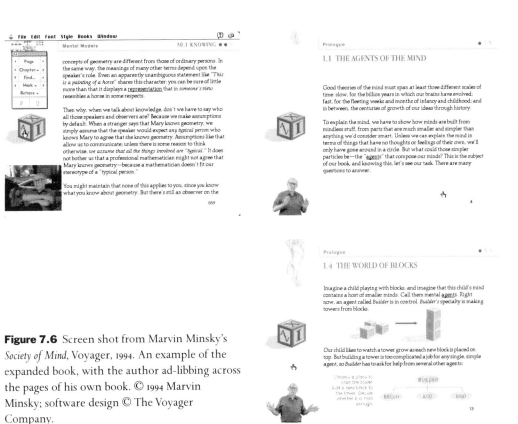

Figure 7.6 Screen shot from Marvin Minsky's *Society of Mind*, Voyager, 1994. An example of the expanded book, with the author ad-libbing across the pages of his own book. © 1994 Marvin Minsky; software design © The Voyager Company.

communicated, 'at last a medium to match Minsky's mind – in a CD Rom as original as its author'. The contents of the CD consist of the complete text of the book, other essays of Minsky's, plus an interactive tour of Minsky's living room together with over 100 minutes of quick time video of original and archival material. Minsky appears animated on the pages of his book for most of this, gesticulating and smiling as he gives mini lectures on key aspects of his theories. (Figure 7.6). For the rest, the screen consists of the pages of the book, given a pastel yellow and slightly textual quality. There are three ways of moving around the book: (a) by means of a colour brick cube which appears on every page and which, by clicking on the three visible sides, accesses the video animations or moves you through the book's key ideas, (b) a standard menu bar at the top of the screen, plus a 'search and find' command allowing you to move to any page, and (c) by means of key words which are underlined and which take you to other references to that word, or by any word taking you to the next example of its use. The central conceptual aspect of the designed interface is to make it difficult to travel through the book in a linear fashion. It is clear you are not supposed to read page two after reading page one. Rather, through key words highlighted in the text, you are expected to travel through the material on the basis of your interest or response to the ideas. If you get bored or lost you can always go to Marvin, who

appears from the bottom of the page, talking and smiling away. The programme is run as a hypertext, in which any word, paragraph or page can be linked to any other. Hypertext is an established part of database software. What are we to make of *The Society of Mind*? At one basic level it is a republishing in electronic form of an available print title with additional comment by its author. Given the nature of the author and the subject of the book, we are tempted into thinking that the interactivity will in some way allow for a more creative dialogue with Minsky's ideas. In fact we are presented with a programming package of a fixed number of options and a word cross-referencing function. However interested in the subject of Minsky's book we might be, there is an inevitable sense of disappointment, even of being cheated, as the expectation of dialogue dissolves into routine 'search and find' commands. This is a very clear example of where an appeal to a concept of interactivity is running ahead of the programmed possibilities. It is all the more the case since the subject of the book stresses the importance of a method of lateral and novel problem-solving.

In contrast, Pedro Meyer's *I Photograph to Remember* (Voyager, 1993), makes much less claim to interactivity and is in fact deceptively simple. Meyer, a North American documentary photographer for many years, had made an extensive black and white photographic documentary record of the time he spent with his parents in the last months of their lives. His father was dying of cancer and his mother, who was nursing him, died unexpectedly from a brain haemorrhage. Meyer somehow managed to approach the project of documenting their death with professional detachment. This resulted in a detailed collection of photographs which eventually show the bodies of his parents laid out prior to burial. The photographs are also an intimate and gentle record of the time he spent with them. The CD Rom consists of these photographs, high resolution black and white images which sit within a black screen, photographs digitally rendered to sustain all the qualities of chemical photographs. In addition the disc contains other photographs from his parents' own family archive which show moments in their life together. Meyer sequences the entire collection of images to tell a simple story of his parents' life and adds his own commentary. The interactivity of the work consists in being able to move through the material in either a straightforward narrative from beginning to end, or to go to sections on his parents' history, or his mother's or father's death, or access a desktop 'contact sheet' of the images in each of the sections. There is a further choice of whether to view the images with or without Meyer's sound track. In effect the interactivity is 'limited' to the choice of, go forward, go back or go to one other section. But to see it as limited is to miss the point. We are presented with a programme which is coherent, sensitive and involving. It is in this respect very interactive in the ways in which it draws us into an intimate and emotional family narrative. Our ability to choose the speed with which we go through the programme, to stop and think, go back and listen again, is a translation of the cultural forms of conversation, the

andrew dewdney and frank boyd

lecture and the slidetape. In comparison to *The Society of Mind*, which wants to make a claim for an interactivity specific to the technology, without being able to specify what it is other than random connection, *I Photograph to Remember* limits our choices to those it considers are necessary for us to relate to the narrative. In making this comparison we are drawn to the larger point about multimedia's relationship to previous cultural forms. The repurposing of the text book as a CD Rom fails to add to the original power and function of the book, whereas slidetape, a form which never developed in any sustained way, is given new impetus through the computer screen.

The common feature of all multimedia CD Rom is its claim to be an interactive media in which the end user has an active and purposive relationship to the material and programme. Initially the experience of interacting with a multi-media programme is fascinating in itself. It is easy to overlook the actual responsiveness of the software and the jejune content of a programme, given the sense of magical power conveyed by first exposure to the 'point and click' experience. I can choose, I can interrupt, I can control. This early enthusiasm is not dispelled swiftly, but is accompanied by a vague sense of disappointment. Much commercial multimedia presents an illusion that the user can make decisions, determine the outcome of a narrative or make original connections. In practice what is on offer is a menu of predetermined choices which move towards a very limited range of fixed outcomes. Computer interactivity is fed by a number of discourses, not least that of Artificial Intelligence where, to put it crudely, the interest is in interacting with a machine that thinks. Possibly the most complex use of an available CD Rom programme which 'thinks' can be found in *Sim City*. This is a simulated urban planning programme where future scenarios for City development are 'worked out' by the programme according to the social and economic co-ordinates fed in. Not surprisingly it was recently reported that *Sim City* was a programme enjoyed by Ken Livingstone, who can now, at least, put his plans for London into simulated form.

Pointing out that the ways in which we interact with a multimedia programme are dependent upon the programming belies a mechanistic concept of inter-activity. The screen interface and the navigational metaphors of interactive programmes are clearly the result of the combined work of scriptwriters, designers, directors and producers working with available software and the programming rules. The use of the programming software set the limits to how the end user can and should access information, engage with a collection of material, navigate a programme. These aspects of production are no different in kind for multimedia than they are for the production of a film or magazine. What is different is that writing multimedia programmes is ordered by the degree of conceptual coherence which can be given to a user being able to interrupt a programme. In contrast a film is designed as an uninterrupted flow. In the same way as we wished to illustrate that multimedia is not itself a new form of human

attention and activity, so we would assert that interactivity, other than in the most mechanistic of senses, is not a new feature of a new medium. Rather, it is an established media concept which has scope for development. Looking at a painting, reading a book, watching a film cannot be reduced to a process of passive reception. If we do not interact, or as Williams put it, actively participate in the work of art, then no communication can take place. That said, interactivity in multimedia poses the hardest and most interesting questions of what is undoubtedly a new medium. In exactly the same way as we have pointed out that multimedia borrows its cultural forms in a continuous relationship to existing media, so too does it gain its concepts of interactivity. Browsing for instance embodies the open endedness which at times characterises our relationship to libraries or bookshops. Navigation embodies the active process of setting a known course, i.e. reading a map, or discovering a new one, i.e. mapping or remapping.

Institutions and audiences for multimedia

The discussion of interactivity can be extended to thinking about who currently uses CD Rom. The stress upon interactivity belies a certain set of current value judgements which owe much to a language of consumption and competition, rather than co-operation and contemplation. Books and paintings are still thought of as objects for contemplation rather than consumption. Possession or ownership of the painting or book is distinguished from being a reader or viewer able to share in the understandings or experiences to which books and paintings refer. Williams' model of the artistic process stresses that both writer and reader, painter and viewer are in some ways part of a shared community of ideas and experiences. Equally the educative aspects of CD Rom interactivity, i.e. its participatory and purposive modes, can suggest either competition with the machine for mastery, or co-operation with the programme in a community of shared interest. Competition or co-operation, consumption or contemplation, these are the opposed terms in which forms of interactive use are most starkly poised. Set against the known contexts of use it is not difficult to see where the different emphases are being placed. The generation of mostly young, white male games players, the lone ranger of the bedroom, may well have internalised a highly competitive model of relationship to screen interfaces, clicking frantically through a chase, clocking up power, energy or points set arbitrarily by the programme. Similarly the family concern for social advancement through interactive educational programmes can easily be seen to build upon established patterns of acquiring collections of encyclopaedias. Public uses of digital technology have so far shown more co-operative educational interests, most noticeably where CD Rom is being used in libraries, schools and colleges. Another and as yet little explored route is the use of multimedia interactive programmes in galleries and museums. The National Gallery's Micro Gallery is a singular

andrew dewdney and frank boyd

example, as are the few examples of contemporary galleries co-operating with photographers and artists in the production of independently produced CD Rom. Pedro Meyer's *I Photograph to Remember* (Voyager, 1993) and *Silver to Silicon* (ARTEC prototype 94) are at present the only two current examples.

What we have just rehearsed is, in most respects, the establishment of a consumer-based market for CD Rom which, over a very short period of time, has been built upon existing and conventional patterns of media organisation. CD Roms, like their counterpart in Music CD, have become one more delivery system for existing patterns of media consumption.

New forms, new relationships?

What then of the promise that multimedia fundamentally alters the relationship between producers and consumers. The two significant ideas about the productive relations of multimedia are that it extends access to otherwise remote bodies of knowledge and information, and that it provides accessible media tools for the production of new responses. Essentially the two points are part of the same argument: that the computer changes the relationship between author and reader, and therefore changes the ways in which knowledge is acquired and controlled. This is a recognisable argument which in the past has been applied to other mediums; cable community television in the 1970s for instance. The new emphasis applied to multimedia is that access to a potentially limitless source of information and a means of producing further communication is contained in one set of technologies, which, it is thought, are available to anyone for the price of a desktop machine. The argument is a real one and needs to be taken seriously; however the possibility of extended authorship through ownership or access to technology has to be set against the dominant ways in which we have already suggested multimedia is being shaped. The market for computers with multi-media capabilities is as sectioned as the market for video or photography equipment with a professional 'high' end and all that follows (Figure 7.7). Multimedia technology is marketed to a growing sector of commercial multi-media producers, further and higher education, and the domestic privatised user. Whilst there is a continuously available set of technologies between these market sectors they are bounded by assumptions about different uses reflected in the formatting of machine capability and pricing. There is little difference here between the way Pentax or Olympus produce plastic point-and-press, amateur gizmo, or solidly professional cameras. The manufacturers have no interest in dissolving their highly sectionalised market. They are only interested in the fluidity between market sectors in so far as this reinforces and feeds specific forms of consumption, i.e. they will use professionals to endorse amateur markets. Without a wider and public discussion about the possibilities for the technology, whatever its capabilities, there can be no fundamental shift in established patterns

Figure 7.7 Photoshop file from Annie Lovejoy's *Intimate Lives*, in *Silver to Silicon*, ARTEC prototype 94.

of authorship and media production. Yet, where there is an existing or established interest and understanding about the ways in which knowledge is selectively controlled, the use of multimedia is at once clear. Tony Benn's current attempt to put his diaries, consisting of 12 million words, on CD Rom so that they can be accessed and cross referenced is but one recent example. Like many people Benn has kept diaries since he was a child. First handwritten, then typed, and for some years put onto audio cassette. Obviously it is Benn's position as a vigilant parliamentarian and socialist which underwrites the significance of his multimedia project. His diaries will be held by the British Library after his death. Benn's project is potentially a project for everybody. Diaries, home videos, letters, snapshots, reminiscences, form the substance of personal and family histories which, whenever they cross the boundary of the private to the public, offer an important alternative source for assessing the quality and history of a culture.

The skills involved in the production of successful CD Rom products should not be underestimated and no doubt Tony Benn is receiving the help of many people.

What can be achieved from the domestic desktop using available software is potentially impressive, yet, as our own experience tells us, meeting the sophisticated demands of a media-literate audience is a technically demanding task. *Silver to Silicon* (ARTEC 1995), is, to our knowledge, one of the only

andrew dewdney and frank boyd

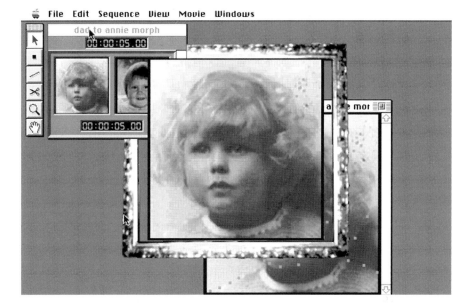

Figure 7.8 Photoshop file from Annie Lovejoy's *Intimate Lives*, in *Silver to Silicon*, ARTEC prototype 94. 'With the Daguerrotype everyone will be able to have their portrait taken – formerly it was only the prominent; and at the same time everything is being done to make us all look exactly the same . . . so that we shall only need one portrait' (Kierkegaard 1854).

independent UK CD Rom projects in production.[8] As its title suggests, it takes as its subject matter how the photographic image is being rethought and repositioned by digital technologies. It consists of commissioned work by a range of artists, photographers, multimedia designers and academics, all of whom have approached the question from their own area of interest and practice. Each piece of work explores aspects of photographic use in various social sites and is connected to a central visual essay which gives a historical overview. On 'startup' the screen displays a pentagonal iris, in which five sites of the photograph, intimate lives, the official eye, the arcade, public media and the city are represented by each of the iris's leaves (Figures 7.8, 7.9 and 7.10). The overview is in the centre. It is possible to travel back and forth between the essay and individual multimedia pieces. *Silver to Silicon* started out as an exhibition proposal and a training workshop. Most of its contributors had little or no experience with the technology. ARTEC had not produced a CD Rom before. Such a project was only possible because several different kinds of institutions collaborated to provide access to equipment, training and funding. It had a shoe-string budget which nevertheless required raising £35,000 of hard cash and an equivalent in research time from the three participating colleges. The level of organisation necessary for

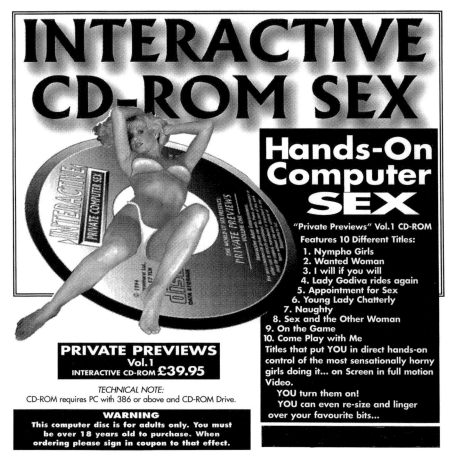

Figure 7.9 Advertisement for *Interactive CD Rom Sex*, reinforcing existing sexist and stereotypical patterns of media consumption. From *CD Rom User*, Issue 5, December 1994.

the production of *Silver to Silicon* is a long way from the 'desktop electronic publishing' model and still at some distance from commercial production. Its great strength lay in its many layers of collaboration which provided dialogue between different kinds of cultural production, primarily educational and artistic, and in providing, albeit unevenly, access and training.

The issue of whether multimedia will extend the diversity of voices in a culture is ultimately one of where and how people meet the technology. In effect, how interest in, and the possibilities of, the medium are glimpsed, understood and worked upon. This must be a matter of existing cultural institutions, the school, the family, community organisations, the library, colleges and universities. At present we can see the obvious and expected repetition of highly insulated marketing to each of these institutions. We can also see a contrast in the rapid growth of multimedia computer use in domestic entertainment against a slow

andrew dewdney and frank boyd

Introducing Explorer. The Next Wave Of Multimedia Excitement.

Figure 7.10 Advertisement for Multimedia Sound Upgrade, using the same advertising language to sell sophisticated electronic products. From *PC Plus*, Issue 98, December 1994.

and uneven use of computers in schools. And yet multimedia is being marketed very clearly as an educational medium. The educational agenda of the last fifteen years now accords well with a market philosophy. The stress on competitive individual attainment, and the reinforcement of education as an instrumental route to preselected ambitions, is the narrow definition of education which the marketing of multimedia meets. Against this, there are those, ourselves included, who see in multimedia a quite different educational agenda and agency.

Multimedia's promise of the combination of an increased access to information and the ease with which sophisticated media tools can be used, more than rekindles an educational agenda which developed in the 1960s and 1970s. This stressed the need for a more open and challenged curriculum, a widening of what was thought relevant to know and study, and placed an emphasis upon greater participation. Changing the curriculum and widening the scope of expression further entailed an educational methodology which valued co-operation, cultural difference and the cultural forms of educational work. It is not difficult to see an echo of this agenda in some of the current rhetoric about technology. Only now, it is stressed that these are promises of a technology rather than of institutions.

Of course in reality they are the aspirations of groups and communities.

Much of Apple Macintosh's educational advertising reinforces ideas of creative freedom and the liberation from laborious separate processes. Apple Macintosh's vision is given in the junior high school boy who presents his dinosaur project to his class using a large multimedia screen in place of the blackboard. In the advertisement this is presented as a glossy media spectacle for which he gets a roar of applause.

The reality is, of course, much less than this, but, putting what are now standard word processing, graphics and spread sheets together on a database, is an example of a powerful and available learning environment. With increases in memory size, image compression and simple digital scanners, the level of quality input rises proportionately. The simple point is that the tools of multimedia production can be made available and organised if there is a commitment to their use and significance in an educational project. One of the unlooked for outcomes of the digitisation of image and word is an increased interest and speculation about previous forms of their technical reproduction. The digitisation of the photograph, for instance, makes its previous mediation through silver salt crystals an object of cultural interest.

There are in our view good reasons for regarding digital technologies as tools for the creation and discovery of really useful knowledge and hence the need to ensure their proper organisation within institutions which recognise that access means more than a simple open-door policy. The point of development of such a project is within schools and colleges, where we have already seen the signs that educational projects, based upon the use of multimedia in learning programmes, is taking place. Beyond this, there is no reason not to consider that multimedia has a place in other public and community-based institutions; hospitals and health centres could well use multimedia for both health education and diagnostic purposes. Social Service day centres and youth provision could also build upon previous interests in community education projects using multimedia to create local history archives. We have in the UK a national network of independent Art and Media centres which are ideally placed to develop an access point for technology and a base from which to develop collaborations on both a local and international scale. Beyond even this, we can envisage newer kinds of public institutions, medialabs, interactive museums or networked community centres. Without the necessary links between the private consumption of new media and public institutions where communities of users can discover new purposes and intentions and recognise communities of interest, multimedia will continue along predictable lines. The powerful interests of the multinational communications and media industries have already made it clear that the private domestic user is the paradigm point of profitable consumption.

Notes

1 From R. Williams, *TV, Technology and Cultural Form*, London: Fontana, 1974.

2 This point is amply developed in Tim Druckery's 'Deadly Representations', *Digital Dialogues, Ten-8*, 1992.

3 N. Negroponte in the *Guardian*, 13 July 1994.

4 Tim Carrigan used these terms in the ARTEC/Arts Council Course which arose from the Very Spaghetti report.

5 Negroponte, e-mail interview, the *Guardian*, 13 August 1994.

6 *CD Rom Today* and *UK CD Rom*.

7 Sherry Turkle.

8 Martin Lister and Andrew Dewdney conceived of an Arts Council Touring exhibition, produced by Watershed Media Centre in 1991, with the working title, 'The Photographic Image in Digital Culture'. It was to have had a catalogue consisting of essays and illustrations. The subsequent collaboration with ARTEC led to rethinking the exhibition as a CD Rom.

there's no place like home

ruth furlong

8

Professor Bell is convinced that in the near future it will be possible to see by telegraph, so that a couple conversing by telephone can at the same time see each other's faces. Extending the idea, photographs may yet be transmitted by electricity, and if photographs, why not landscape views? Then the stay-at-home can have the whole world brought before his eyes in a panorama without moving from his chair.

'The Industrial Development of Electricity' 1894,
quoted in Marvin 1988: 260f.

And from the tourist's standpoint, why queue for hours to visit churches or museums, get crushed in airports, squashed in tourist class and run a real risk of getting stomach trouble, robbed, mugged or worse? The point will be made that with Virtual Reality you don't need to go anyway. . . . Certainly more people will work, shop and play from home, but they will also be able to meet, talk and touch their colleagues in a virtual world.

Written about the development of virtual reality,
Sherman and Judkins 1992: 131.

In the discourses predicting the future of any new technology, home is a familiar theme. The writers whose statements are reproduced here, whilst separated by nearly one hundred years, share the vision that home will be the site where public experiences can be enjoyed in private. Thus the pleasures, horrors and uncertainties of physical human contact with other people or places can be translated through technological systems into experiences which can be enjoyed vicariously or avoided altogether.

'Home' is a central but highly elusive concept in debates surrounding the implications of new technologies on the social world. It is a place which is both constructed *by* us, imaginatively as well as materially, and constructed *for* us by, amongst others, architects, planners, broadcasters, governments and promoters of material goods. As public markets become saturated with a new technology, home becomes the prime site where fortunes can be made as long as we can be persuaded that the particular item in question is an indispensable piece of household equipment. As electronic information becomes increasingly powerful and its constituent elements increasingly integrated, the home is perceived as the centre for enjoying an ever more sophisticated range of services and experiences via the screen rather than the street. If we are to understand the symbolic,

cultural and material implications of technological systems therefore, we can not 'run away from home'. At the same time we need to search continually for ways of conceptualising the complex relationships between technological systems and privatised human behaviour if we are to avoid simply reproducing the idealised versions of home which continue to flood the literature surrounding new technologies.

I want to examine here some of the meanings that have been attached to the idea of 'home' in relation to how technologies become part of everyday culture. My own research has been conducted through interviews with a small group of 12–15-year-old boys living in a South Wales village 6 miles outside of a major city.[1] As writers such as Turkle (1984) have argued, different technologies should be seen as central in the formation of identity; this search for a sense of 'self' being particularly acute in the period approaching adolescence.

Is there a possibility, which Turkle identifies in relation to the computer, that interaction with machines becomes a 'safe' option for some young people experimenting with new relationships whereby the user can assert power, be in control but can avoid the complications, uncertainties and complexities involved in human contact? Furthermore, have such possibilities, together with the proliferation of technological experience within the domestic interior led to a new 'mobile privatisation' (Williams 1974) for a sample of media users (teenage boys) who are most often depicted in social theorising as being on the public side of the public/private divide?

If home is central to the formation of identity so, too, in discourses surrounding new technologies are metaphors of travel which enable the writers to escape its confines. Home can therefore be used to make the strange and exotic comprehensible. Public experiences can become translated and adapted for private worlds so that (as with relationships) uncertainties, complexities and bodily discomforts can be avoided.

Another question I set out to examine, therefore, is whether the increasing range of technological experience within the household meant that the boys in my study were able to be ever more adventurous in terms of metaphorical or imaginative travel yet increasingly restricted in terms of occupying specific or literal domestic space. Does 'home' come to signify a bounded space for the safe containment of human bodies so that, in terms of 'Late twentieth century machines. . . . Our machines are disturbingly lively, and we ourselves frighteningly inert' (Haraway 1985: 69). What I shall argue is that a great deal of work has been done on the idea of 'home' in academic study, but that we need a cross-fertilisation of what have often been disparate ideas in order to more fully understand the profoundly complex social ways in which new technologies are incorporated in to our personal lives. In particular we need to be highly cautious of what could almost be seen as a 'new wave' of theorising which sees 'home' as an unproblematic site or a neutral space. As a number of family members know

to their cost, domestic space like public space is not neutral territory and in this sense the feminist request not to keep 'our lives out of our knowledge' (Gallop 1988: 4) takes on an air of urgency if this denial of knowledge means that the spaces of the future are as exclusionist and dangerous as the spaces of the past.

All this means that we have more work to do in examining the relationships between new technologies and what we mean by 'home'. It may be that we need more innovative ways of conceptualising such relationships in what is claimed to be the new electronic age. However, the 'paradigm shift' towards a global information system whereby the home becomes simply a plug-in point does not mean that we are all yet cyborgs. Before proceeding to such hypotheses (which recur historically with surprising predictability) we need to do some 'housework' in order to examine the implications of the way in which the home has been conceptualised in relation to technology.

I wish to focus here on four key ways in which the idea of 'home' has been analysed in relation to the invention and incorporation of technology into everyday life; home as the site for the promotion of a new technology, home as the site for ethnographic research, home as the place where the 'family' resides and home and the postmodern.

The promotion of a new technology: domesticating the body

Most parents feel it's a complete godsend.... They'd much rather they were upstairs playing their video games than outside doing who knows what.

Nick Alexander, Sega, quoted in C. Bennett, the *Guardian*,
2 December 1993

There are certain themes which recur throughout the history of discourses surrounding the promotion of new technologies. A consistent way to 'sell' a new technology to the public, whether it is electricity, the radio, television, the computer or virtual reality has been to domesticate it. Home in such scenarios becomes the familiar territory from which ever more fantastic discoveries and journeys can be made from the safety of the armchair. The dweller in the domestic hearth can, like the early anthropologist, remain at home, but through interaction with a new technology experience the exotic, the 'other', the exciting or the feared. Here the public world is viewed with fascination but also anxiety. Home symbolises a haven, the known environment in which to locate the human body.

If a technology is to be successfully domesticated it has to be 'made safe'. Designers, aware of potential anxiety about the intrusion of a new invention into the home, have encased and disguised the technological equipment to render it familiar, often imitating existing domestic objects; a cocktail cabinet encasing a radio, a telephone in the shape of a Mickey Mouse toy or the recommended

designing of virtual reality nail varnish and jewellery to attract women users.[2] More futuristic designs symbolise being part of a 'brave new world' and are accompanied by attempts by their promoters to 'catch' family members wherever they happen to be. Thus meal-times and work patterns which *were* stable points around which broadcasters could plan their schedules are now being replaced by a more individualistic targeting of domestic dwellers sharing family space but not necessarily traditional family rituals.

Whilst broadcasters and salespeople have needed to be sensitive to the needs of the human body, the body and its reproductive capacities has proved something of an inconvenience for writers excited by the possibilities of domesticating a new technology. It is common, therefore, for the body as physical entity to be denied altogether. Home in such scenarios is not a site of labour for the essential reproduction of life; users do not therefore eat, defecate, reproduce the human species or do the housework. Home is the unproblematic site from which to buy one's ticket, to start one's journey, to 'go travelling'. Perfection may come when both the home and the body can be abandoned completely:

> Users will leave the limits of the fragile, mortal body to exist in realms of pure thought, eventually, perhaps, downloading their immortality in the software universe.
>
> (D'Amato 1992: 98)

'Let's get physical . . .'

In contrast to such discourses, I found my respondents frighteningly physical. Far from denying the human body, the boys' talk was full of references to bodily activities which took primacy in relation to the particular technology they were talking about. In the course of my discussions with them they talked about eating, fighting, sexuality and 'farting'.

Their ability to indulge in sights, sounds images and experiences offered by any particular medium was also noticeably constrained by practicalities associated with the home, such as 'mess'. Mess was a potential source of tension, a deterrent to comfortable media use. Almost without exception, parents were described as beings who were 'fussy about houses', resulting in extreme cases in the banning of specific rooms for media use. In such cases, the boys would simply go elsewhere, either to their own rooms, where rules concerning dirt were more lenient, or to other houses where a parent or parents were known to be less concerned with tidiness.

One of the activities they showed most open enthusiasm about when a 'safe' location had been found was the eating and preparing of food. The boys were proud of the fact that they did not eat with their families on a regular basis ('hardly ever') and described one of their favourite activities in relation to home technologies as 'meeting three or four times a week in

someone else's house' when they would 'buy oven chips, or order a pizza' as an accompaniment to watching a video. The boys cooked for themselves in microwaves or, for a special treat, ordered a delivery service pizza – the equivalent of 'going out for a meal'.

Far from using electronic technology for 'the thrill of escape from the confines of the body' (Springer 1991: 306) these boys used such technology as a means to explore its potential. The availability of sets such as video recorders and sound systems in bedrooms clearly had the effect of opening up what would have historically been taboo areas of the domestic interior for entertaining members of the opposite sex. The boys were clear about media which they believed the girls were generally uninterested in, such as video games. Watching films on video was the favoured media activity in mixed sex groups.

Obtaining such videos was in itself a social activity. These were hired in most cases from the local garage where they would go in a group, read the covers of the videos and recommend them to each other or ask the girls what they wanted, not seen as a problem since the girls whom they befriended 'acted more like boys than girls'. Money could influence choice – 'whoever has the money chooses' – but in general the boys showed remarkable ambivalence about the *content* of the material chosen. They declared that the films in the garage were 'rubbish' – they had seen most of them. When watching with girls they chose 'mainly comedy'; otherwise they could not remember much about them. It was clear that such videos were used as a background to other activities. The fun seemed to be more in the 'gatecrash – sitting around and having a laugh'.

The sheer joy of physicality for the boys was, however, reserved for when the girls were *not* around. On such occasions video watching was used as an incidental backdrop for more uninhibited behaviour. As the boys themselves put it: 'when girls are there you can't tell jokes and muck about like jumping, going mental and farting'.

As Springer (1991) has argued, the denial of the human body in the discourses surrounding new technologies is often represented as an orgasmic metaphor. We enter other worlds where physicality is replaced by pure sensation. However, in the case of my respondents, rather than deny the human body and immerse themselves in a technological universe, they showed considerable ambivalence about the technological universe and great enthusiasm about their physical bodies.

Home as the site for ethnographic research into new technologies: the 'power point'

> our research was 'at home'.... For us that task was, on the face of it, both deceptively simple and terribly ambitious.... It was to 'understand' the ways in which families in households 'lived with' their information and

communication technologies (their televisions, their videos, their tele-phones and their computers).

Silverstone, Hirsch and Morley 1991: 207

There is an important technical issue which the choice of families to study within this research to some extent glosses over. It relates to the different and complex meanings attachable to the terms 'household' and 'family'.

Silverstone, Hirsch and Morley 1991: 224f

For the ethnographic researcher interested in exploring the ways in which 'families in households "live with" their information and communication technologies', 'home' is the physical site where the ethnographers must position themselves in order to begin to understand the impact of new technologies on our social worlds. For researchers such as Silverstone, Hirsch and Morley, even if 'home' comes to mean, for their interviewees, something other than their own domestic worlds, for example a sense of belonging to a wider family, a nation, or an international community, it is through the politics of the 'sitting room' and the technologies contained therein that such abstract 'belongings' become comprehensible to their respondents.

If we want to understand what it means to be 'at home', therefore, in either a metaphorical or a literal sense, we need to visit the domestic interior. However, unlike the discourses surrounding the promoting of new technologies, ethno-graphic researchers such as Morley recognise the home as a highly problematic site. It is a location of unequal resources and of gendered politics demanding complex interpretations. Questions like who has access to technological equip-ment contained within any household, who has control of the technology, and the geographical division of space within the home complicate any simple idea of 'audience'. Furthermore, the 'symbolic networks' (Morley 1992: 288) made possible by new communications technologies increasingly disorientate any simple correlations between space and place, between location and identity. Research conducted 'in the sitting room' may therefore reveal a great deal about power relations outside its walls and, importantly, how 'public' issues are translated and used within 'private worlds'.

Such private worlds are, of course, themselves structured and constituted to a large extent by policies, ideologies, laws and events from the public sphere. The ability to capture such intricacies within any particular space may therefore seem daunting. Nevertheless, despite the difficulties and complexities of the task, theorists such as Morley insist on the necessity of home-based ethnographic research gathering. Home therefore becomes, if you like, the power point at which a bewildering complex of communications intersect; it becomes the focal point where we may begin to understand some of the implications of new communications systems in establishing identities.

On who *resides* within the domestic interior, Morley is less convincing. Whilst acknowledging that 'Households are not families' and 'Families extend beyond households' (Morley 1992: 203) so that ultimately we need to understand relationships across and between dwelling places and cultures, he focuses on 'the family' as a legitimate unit of research. Thus, in his book *Family Television* (Morley 1986) and in subsequent work, he justifies his focus on the 'normative' nuclear family because it is 'representative of the ideological (if not empirical) heartland of the television audience' (Morley 1992: 164).

'Running away from home?'

The problem with the idea of home as a space for the containment for family members is that it tends to obscure the extent to which 'the family' and 'home' is daily constructed and recreated by its constituents. The boys in my study spent considerable energy moving in and out of, challenging, disrupting and re-creating these 'things' called 'home' and 'family' in their daily lives.

It was clear from my research that there was a complex interplay between the boys I spoke to and their environments. The domestic sphere, for these boys, was an enclosure marked by a different set of relationships in each case. There were many occasions when the domestic arrangements of their own families proved inhibiting in terms of their desired use of particular technologies. Sometimes such problems were dealt with within their own homes. The abundance of techno-logical equipment within any household did not necessarily lead to non-problematic use of particular technologies (as Morley frequently acknowledges in his work). Despite the fact that equipment might be mobile ('We have more than one video and we move it around different bedrooms') frequent tensions over use were reported. Even in homes with seven televisions, three VCR machines, two hi-fi's, three computers and a microwave oven, a great deal of negotiation was entered into in order for one user to enjoy his favoured technology. One solution was to use media that would block out the immediate environment, such as stereo headphones, and tension was avoided by entering metaphorical space, thus enlarging the physical environment.

It was clear from the way these boys used different media that there were disjunctions between the physical site of particular media use and the met-aphorical site of the use of media content. Therefore the 'safety' of home could be used as a physical site for particular media participation, the content of which would be transported elsewhere. The privacy of home was also used as a means of participating in forms of media use which were considered 'soft', such as watching television. Watching television programmes as a group activity was frowned upon, a sleight to their masculinity, although they happily reported watching such programmes with a parent or sibling. However, debating the *content* of these same programmes was not considered 'soft'. The boys happily reported

how they discussed soaps and other programmes at school and how they would try to write alternative plots and scenarios for such programmes. In this way, the boys would 'transport' images, ideas, fantasies, stories and experiences which, although they may be originally absorbed in the confines of their individual domestic environments, would be translated and adapted to be used in other spaces and places.

Whilst a great deal of time was spent trying to escape the confines of a particular family situation (microwaving to avoid the family meal, moving technical equipment around the house) there were times when the intimacy of a family situation was actively sought. So, for example, there were occasions when a boy would 'watch the telly in the lounge with my Dad'. More frequently, however, the boys used the wide availability of technologies amongst different households as an opportunity to avoid parental control altogether. The abundant availability of media systems in homes *in general* meant that, rather like the Samoan children quoted in the famous study by Margaret Mead (1969),[3] the boys could choose residences in which to reside, albeit temporarily. In this way, the possibility of control of media use by parents was weakened and the possibility of power to control media use by the boys themselves was strengthened. Furthermore, this fluidity allowed for escape from the confines of a particular domestic situation. Thus, for example, a single-parent household might be preferred where it was anticipated that there might be a greater freedom from parental control, either through the number of parents being reduced or through the single parent being out working.

Such strategies call into question the fixity of concepts like the public/private divide in relation to new technologies. The body, for these boys, was the vehicle whereby a range of experiences were sought *and transported* from their place of origin. Home may therefore be actively discarded or actively sought. Sometimes the boys' own home was used for uninhibited enjoyment of a form thought of as 'soft' in the public domain. However, the same form could become 'hard' in another context. One could speculate therefore that the content of viewing experienced in places other than 'homes' might be coped with by transporting such experiences back in to a 'safe' familiar environment. Identity could thus be formed, in part, by patterns of consumption that are detached from 'the family' but also dependent upon it.

Despite the historical over-emphasis on the analysis of the public sphere in social theorising and the tendency to relegate boys and men to the public side of the public/private divide, I found considerable complications to any attempt to locate my respondents straightforwardly away from or at home with regard to their use of communication technologies. Furthermore future academic researchers studying such technologies may also need to abandon entrenched rituals and imitate 'the market' in 'following users wherever they happen to be'.

Home in studies of 'The Family': 'Home, Sweet Home?'

> categories like 'the family', 'the state' and 'the economy' *were* fixed and solid anchor points for theory. Today, there is little we can take as fixed. 'The family', so long reified in theory looks more like an improvisation than an institution.
>
> Ehrenreich in McDowell and Pringle 1992: 146

Despite the attention to studies of the family in historical, anthropological and sociological writing, contemporary theorists of the family point out that we are still profoundly ignorant about how people co-habit within 'the home' and the wider implications that this may have for understanding human interaction. Social scientists have in the past acted rather like the state in working with an *ideal* of the normative nuclear family and the struggle then becomes to contain family members within a controllable, analysable unit, this 'universal' thing contained within a domestic space called home.

The transference of the *ideology* of the contemporary Western family on to the study of 'home' has another, perhaps more sinister side. It is that, too often, it is the 'happy family' of mother, father and 2.2 kids which becomes the norm by which other living patterns are judged. Thus we often have no sense from the many studies of 'home' in relation to modern consumptive practices of struggle, of violence, of mess, of the desperate need of some individuals to escape its confines, to forge an identity in other places and the role that different technologies might play in such processes.

Recent research in what can broadly be called 'family studies' has been concerned to question a number of myths concerning the category 'family' in British culture. Such studies point out that the 'normative' nuclear family which has underpinned so much of social theory and social, legal and administrative policy is a form of social organisation which is in fact now a statistical minority.

Consequently, many of the categories which were traditionally used to analyse the perceived universal category called family are now problematic. If we therefore take factors like economic class, racial origins, patterns of residence, reproduction or sexuality, we would find that human behaviour within what we traditionally think of as 'home' in relation to such categories is a great deal more complex than we suppose and indeed we should perhaps question the usefulness of such categories at all.

We do not, therefore, necessarily live in families, we live in relationships with ideas of what the family should be. The decline of 'traditional' family patterns has been accompanied by a strengthening of the *ideology* of the conventional family form. Consequently there is often a dichotomy between theory and practice as family members strive to attain this 'thing' called family, this coherent unit bound by emotional as well as physical space.

A great deal of pressure and promise is therefore placed upon the idea of

ruth furlong

'home' as the place where families reside. Home is the place, we are told, where we can gain individual sustenance, moral, physical and intellectual. It is alternatively a place of work, a place of leisure, a site for consumptive practices and a 'safe haven'. What is less public is the 'dark side of family life'. Problems associated with sexuality, reproduction and violence towards family members within the household are most likely to be dealt with within family/feminist studies.

Theorists studying the family have therefore worked to demystify the reification of home as the unproblematic site for the containment of household members and any smooth transitions for the young towards the complex and difficult roles of adult life. What, until recently, they have paid less attention to has been the part played by communication technologies in constructing or deconstructing the idea of home and family.

Home is where the heart is

'Home' for a significant proportion of my respondents meant their place of residence during the week, but also another physical space and set of relationships visited periodically where their fathers resided. Furthermore their own mothers had boyfriends who visited or dwelt in their own domestic situations. Family, in such instances was, if you like, a movable feast.

Home, even for the boys who lived in conventional nuclear family forms, involved, in their own terms, a number of constraints which led to confusions, anger, frustrations or uncertainties. In such situations, the wide availability of leisure-based technologies meant that such uncertainties could sometimes be avoided and more congenial social situations sought.

The boys in my study were artful in their dodging of different spaces and places, and creative in their use of different media for such purposes. As I have already demonstrated, moving *between* houses was a frequently quoted example of spatial freedom. Considerable research was conducted about the appropriateness of particular locations for the most advantageous use of specific technologies. In this way, the boys successfully worked an 'alternative economy' to the economy of their particular households which was both material and psychological.

Whilst within the confines of this study I was not able to question the boys about conflicts within their families, for example violence between adult family members, or from their parents to them, they did report moving between households as a way of avoiding conflict over media use with siblings. When such mobility was not possible, other methods quoted for coping with such difficulties were to switch to another medium or to use a particular medium for cathartic purposes: 'I take out my anger by hopping on a (computer) game and killing some people.'

Computer games playing was both an activity clearly associated with

masculinity ('the girls do play on them, but they find it a bit boring') and a symbol of status if a new game had been acquired. Of all the technologies we discussed, it was such games which seemed to illicit the most potential conflict: 'my brother lashes out when I beat him'. However, owning a new computer game was also a way to impress male friends. Such games were most frequently played in the boys' bedrooms. On such occasions, when the boys gathered in friendship groups to try out a new game, etiquette seemed high. Those without controls would wait their turn in a clearly ordered way. Here again an alternative economy to that of individual households was successfully operated by the boys. When referring to computer games their talk turned to their roles as consumers. Whilst informing me that new games were 'addictive', they also wished to impress upon me that they were 'a complete rip off' in terms of cost. Consequently, the sharing of games and the use of specific households for specific games was common.

Despite the addictiveness of computer games, the boys were unable to articulate the pleasure they gained from playing them. They reported that they became quickly bored with a particular scenario and the activity became relegated from an obsession to an activity mostly indulged in 'when friends come round'. In this sense they seemed cynically aware that the aim of the games' promoters was that after consuming one, they would desire another. Their talk in relation to such games was much more related to the principles of capitalism and forms of resistance (sharing, copying, bartering and varying machine use between households) than to content and fantasy locations.

The same technology, then, could either be an obsession, a bartering device, a source of conflict or a way of avoiding conflict depending on the social uses to which it was put. Similarly a particular location, such as a bedroom, could either be a site of aggression or a space for a display of masculinity and the gathering of a friendship group. The meanings of a particular technology could also change, for example from a private consumer indulgence to a public activity engaged in only occasionally.

What is clear is that, in terms of all these choices, the boys did considerable work both within and between their own households in adapting the idea of 'home' to avoid conflicts and uncertainties. Home was not straightforwardly a space containing a number of fixed relationships but rather a range of possibilities, some threatening and some inviting, through which they, sometimes precariously, tried to forge a path.

Home and the postmodern: on the road again

'Home is within me'

Eartha Kitt, quoted in Rutherford 1990: 24

Perhaps the most comprehensive whilst elusive examinations of 'home' are to be

found in postmodernist writing. The development of electronic technology, we are told, has eroded conventional ideas of space, time and place. Identity, family or home are therefore mental constructs whereby the characteristics we have historically expected to find within the domestic sphere such as belonging, closeness or love could be found as much from technological link-up as from face to face interaction within conventional kinship groups.

At the same time, if any joy is to be had it is through everyday consumption habits that a plurality of styles can be celebrated. There is even a hint of Marxist struggle in such local practices. Home then becomes a personal leisure centre, a crèche for consumers. So, whilst many postmodernist writers have abandoned the idea of solidity, of certainty and of any simple overarching theory with which to explain their subject matter, many have retained an almost romantic optimism for local creativity.

If rationality or mapping of social space has been attempted in postmodern enquiry, however, it is mostly in relation to the exterior not the domestic world. The effect of such theorising is, of course, to turn attention away from home as bounded space, as an architecture containing kinship groups.

Whether indoors or outdoors, writers such as Fredric Jameson, following Lacan,[4] argue that postmodern society is characterised by a lack of history; we live a schizophrenic existence in the here and now with no clear reference points. Having no past and no future, we live in a permanent present surrounded by a confusion of signifiers which have become fragmented and separated from their signifieds; indeed there are no necessary connections.

At its most extreme, we lose subjects and objects altogether:

> Normal space is made up of things, or organized by things. Here we are talking about the dissolution of things. In this final moment, one cannot talk about components anymore. We used to talk about this in terms of subject–object dialectics, but in a situation in which subjects and objects have been dissolved, hyperspace is the ultimate of the object-pole, and intensity the ultimate of the subject-pole, though we no longer have subjects and objects.
>
> (Jameson in conversation with Stephanson 1989, p. 7)

It is perhaps no surprise that in the schizophrenic postmodern world travel has become a familiar metaphor. If we can no longer locate ourselves in a safe, private world called home, surrounded by familiar objects and experiences with their own pasts and their own futures, we are at least offered the possibility of escaping to other realities.

As Janet Wolff points out, 'vocabularies of travel seem to have been proliferating in cultural criticism recently' (Wolff 1993: 224). Wolff's argument relates to the central point that metaphors of travel have, in postcolonial, postmodern and post-structuralist discourse, been gendered in a way unacknowledged by authors and

with profound implications for social theorising generally. Her main assertion (which she argues in relation to women) is not that women do not travel or have not travelled or that metaphors and vocabularies of travel are always inappropriate. Rather, she wishes to point out that such vocabularies are often not situated or located, suggesting free and unrestricted mobility. Her point here is that we don't all have 'the same access to the road' (Wolff 1993: 229).

Running away from home?

The postmodern desire to 'map' the social world must be approached with caution, therefore, if it implies equality of opportunity to 'run away from home'. The boys in my study were at an age where they were experimenting with the potential of travel, both literal and metaphorical. In terms of metaphorical travel they found it hard to articulate their preference for particular fantasy locations. Whilst, for example, stating a preference for violent and comic imagery they could not find words to explain why, other than the fact that such material was 'a laugh', or full of 'action' or 'excitement'. Going out to choose a video seemed more to do with the freedom to choose the opposite to their parents' preferences or trying to gain access to 'over-18's than a careful choice of visual subject matter. Without exception they declared that their parents' choice of viewing material was 'crap' and their parents tried to make them feel guilty about what they watched.

The postmodern tendency to dissolve the relationships between subject and object, or between signifier and signified, should also be approached with caution in that it obscures the considerable human activity expended in trying to sustain such relationships. Whilst the boys' ability for local creativity has already, I hope, been amply demonstrated, it was also evident that they had clearly ordered locations and rules for particular experiences. Thus video games were for masculine groupings, videos were for mixed sex groups and watching 'telly' was an excuse for an intimate experience alone, with siblings or with a parent or parents. A clear indication of the confusion that could arise when the 'rules' were not known was provided by one of the group. Despite being one of the most avid media users and the most enthusiastic about violent imagery, he produced a terrifying description of his encounter with a virtual reality system. Because the rules of the game were not explained to him before he started, he found himself lost, being 'killed' and being unable to escape. He was clearly troubled and disoriented by the experience.

In terms of literal travel, as I have already demonstrated, the wide availability of media systems and technology in general facilitated mobility *between* houses and the weakening of the association between material goods and economic status within any one household. Thus I found little evidence that the increased availability and proliferation of home technologies was leading to an increased

privatisation for this group of boys, if privatisation is taken to mean a form of 'solitary confinement' within any particular home setting. However, they did seem to look to the home or rather 'a' home for most leisure pursuits. Thus, 'going in to town' was an activity reserved for 'when we are really bored', when they clearly saw themselves as potential consumers of *products* which they differentiated from other experiences. Going in to town meant usually 'going window shopping or looking at sport shops and shoes'. Going to the cinema, for example, was seen as restrictive because the local cinema 'unlike most places' did not have '14 screens'; therefore they felt that much more choice was available to them in choosing and watching videos at home.

However, leaving the home, the domestic and the technologies contained therein was itself an important statement of identity and masculinity. The boys were very insistent in wishing to impress upon me that they were a group who could be seen to abandon the domestic altogether and 'go out' in their local vicinity. They were universally condemnatory about their older brothers, whom they described as sitting at home playing computer games or watching the television. Despite the fact that they too enjoyed such activities, they clearly saw themselves as a group who were prepared to 'go out', when they would 'hover' round the village, 'tell jokes, go up the rec and play frisbee or football'. Furthermore, just as their private worlds were clearly categorised and ordered, so too was their public life. They saw themselves as one substrata of a number of groups who 'went out' and had clearly based locations which were appropriate for their needs. Other groups were the 'heavies' who frequented the park or 'rec', were '18–20 with long hair, jackets, no jobs'; one drove a tractor. The other identifiable group were the 'trendies – in fashion, hang out by the telephone box, have gang fights, some work, for example at the garden centre, but they do not have very good jobs'.

Travelling, then, for these boys is both literal and metaphorical and involves both public and private spheres. Their freedom of mobility is constrained, however, by external factors such as parental control, age, law (for example inability to drive legally) and a range of similar structural factors. Whilst dodging such controls may be an important aspect of creating identity, there was considerable evidence that any alternative structures which the boys created were themselves ordered in such a way as to avoid danger or ambiguity. Rather than living in a perpetual present surrounded by a confusion of signifiers which have become fragmented and separated from their signifieds, the boys did considerable work in categorising their activities, both physical and metaphorical, to avoid such confusions.

Conclusion: home-work

In looking at the relationship of information technologies to everyday life we are therefore left with a number of questions surrounding the idea of home. In

discourses surrounding the promotion of a new technology, home is essential for the marketing of that technology which, once firmly embedded inside it, then becomes the means by which we escape from the confines of the domestic. For academic researchers interested in the relationships between new technologies and social actors, home is the site for collecting data which will illuminate the relationships between family members and wider local and global issues. Far from escaping the domestic, it is therefore the place where we should *start* in order to begin to grasp the complexity of the relationship between human actors and media systems. For theorists interested in the family, however, it is questionable whether categories like 'family', 'family members' or the 'domestic' exist in any knowable form. We cannot therefore resolve the relationships between mass-produced culture and local experiences until we examine more carefully what that local experience involves. For the postmodern theorist, home as a discrete, physical bounded space occupied by family members is both eroded in the sense that electronic circuitry enables us to construct alternative identifications of 'family', 'unity' and 'kinship' whilst at the same time providing a crèche where we can play with a variety of domestic objects in forms of consumptive creativity.

Of course, these frameworks which I have identified for analysing the idea of home are not as discrete as I have suggested. There is considerable overlap, for example between the interests of the domestic ethnographer and the post-modern. However, at the end of the day we are left with a confusing picture. Is home a state of mind, a place for the location of physical bodies, an enclosure in which is located a knowable kinship group, a site for local creativity or perhaps a focal point where some of these phenomena are united, however fleetingly, in time and space?

If we are to believe the promoters of communication and information technologies, home is set to become an increasingly important site for a range of interactions between domestic dwellers and a range of services, such as shopping, watching a movie, accessing information, communicating with friends, doing research or playing computer games. Increasingly a number of facilities and services which have, historically, required mobility and face to face interaction will be presented entirely via the screen. The technologies which will 'speak to us' will become increasingly 'intelligent', so that in order to guide us through a bewildering choice of information and facilities, programmes (whether that be TV, shopping, games or information) will be able to be pre-selected to suit the individual consumer/viewer. All this will mean that we may spend more time at home.

However, statistics on divorce, research into 'the family' and reports in the popular press indicate that 'home' does not signify an architecture containing 'happy families' clustered around whatever particular technology or technologies are contained within any particular domestic space. Home, rather, should be seen as complex territory where a number of people, objects, ideas and experiences intersect.

At the same time, home, for those who are not home-less, is the place where the body is fed, nurtured and reproduced. Far from abandoning the body, home is the place where we are most likely to keep control of it. In terms of cultural theorising we need to pay as much attention to 'mapping' the interior as the exterior world. However, we will not begin to understand the complex relationships between interior and exterior, public and private, domestic and public until we understand more fully how individuals live in social groupings within the world called 'home'. This may involve abandoning such fixities as public/private or even categories like 'family' in favour of an approach which recognises that identity may be formed as much from rejecting such categories as embracing them.

All this means that there is no 'safe haven' from which we can explore the impact of new technologies on human behaviour. Whilst this does not imply that we simply 'run away from home', it does mean that we need to be more sensitive to the struggles involved in sustaining the *idea* of home and family, and the inequalities with regard to the possibilities for individual members to leave its confines. Such issues are indeed global as well as local, but social theorising would be richer by far by acknowledging that, just as we do not all have the same access to the plurality of experiences so often depicted as being outside the home, so too we need to explore more deeply the plurality of experiences within it.

Notes

1 The research for this paper is based on home-based interviews with six boys living in the same South Wales village. The respondents were from a variety of family backgrounds including single parent, and parents of first and second marriages. The analysis takes an approach which Moores (1993b) describes, in relation to his own work, as 'broadly ethnographic'. Thus the informal interview material has been incorporated into the work in order to raise questions and address theoretical uncertainties. For a study which uses a 'broadly ethnographic' approach to technology and the domestic see S. Moores (1988) '"The Box on the Dresser": Memories of Early Radio and Everyday Life', *Media, Culture and Society*, 10 (1) and S. Moores (1993a) 'Satellite TV as Cultural Sign: Consumption, Embedding and Articulation', *Media, Culture and Society*, 15 (4). For fuller debates about audience ethnography see D. Morley (1992) *Television, Audiences and Cultural Studies*, London and New York: Routledge, and S. Moores (1993b) *Interpreting Audiences: The Ethnography of Media Consumption*, London: Sage.

2 See B. Sherman and P. Judkins (1992) *Glimpses of Heaven, Visions of Hell: Virtual Reality and its Implications*, London: Hodder & Stoughton, p. 164 for descriptions of the perceived problems of virtual reality equipment for women users, such as the helmet being too heavy and 'messing' the hair. Predicted solutions include 'DataGloves [which] will be reduced to conductive nail varnish and rings, and DataSuits shrunk to body jewellery.' Interestingly similar debates were held in the 1920s about radio headphones ruining women's hairstyles. See W. Boddy (1994) 'Archaeologies of Electronic Vision and the Gendered Spectator', *Screen*, 35 (2):112. Central to both

historical periods is the idea that 'To sell to the home, you must sell to the woman' (quoted in Boddy, p. 112).

3 Mead makes it clear that, in the Samoan households she studied, there were strict rules concerning contact between boys and girls, which became marked in the period approaching adolescence and continued into later life. However, household living patterns were not determined solely by biological familial ties, allowing for a fluidity of relationships. As Mead herself observed 'So the intrigue, the needs, the obligations of the larger relationship group which threads its carefully remembered way in and out of many houses and many villages, cut across the life of the household' (M. Mead (1969) *Coming of Age in Samoa*, Harmondsworth: Penguin Books, p. 44).

4 Jameson 'borrows' Lacan's theory of schizophrenia to describe a state of being in which certainty is replaced by bewilderment. He extends Lacan's linguistic model of schizophrenia as a disruption in the unity of meaning between signifier and signified to argue that we live in a decentred culture. Time has lost all historicity and become a 'perpetual present' of spatial possibilities. However, having lost the subject–object dialectic, social positioning becomes bewildering. Schizophrenia is extended by Jameson from a linguistic to a spatial problem in that we lose our ability 'to position ourselves within . . . space and cognitively map it' (Jameson in conversation with Stephanson, 1989, pp. 6–7).

References

Bennett, C. (1993) 'Game Boys (and Girls)', The *Guardian*, 2 December, Second Front, pp. 2–4.

Boddy, W. (1994) 'Archaeologies of Electronic Vision and the Gendered Spectator', *Screen*, 35 (2): 112.

Crowley, H. (1992) 'Women and the Domestic Sphere', in R. Bocock and K. Thompson (eds), *Social and Cultural Forms of Modernity*, Cambridge: Polity Press.

D'Amato, B. (1992) 'The Last Medium – The Virtues of Virtual Reality', *Flash Art*, XXV, no. 162, January/February.

Ehrenreich, B. (1992) 'Life Without Father: Reconsidering Socialist-Feminist Theory', in McDowell and Pringle (eds), *Defining Women: Social Institutions and Gender Divisions*, Cambridge: Polity Press.

Furlong, R. (1991) 'Housewives' Choice?: A Study of Women and Radio', unpublished MA dissertation, Goldsmiths' College, University of London.

Gallop, J. (1988) *Thinking through the Body*, New York: Columbia University Press.

Gray, A. (1992) *Video Playtime: The Gendering of a Leisure Technology*, London and New York: Routledge.

Haraway, D. (1985) 'A Manifesto for Cyborgs', *Socialist Review*, 2.

Harvey, D. (1989) *The Condition of Postmodernity*, Oxford: Blackwell.

Heatly, R. (1993) '"Virtual Reality", The Discourse of a New Technology', unpublished MA dissertation, Middlesex University.

Marvin, C. (1988) *When Old Technologies were New*, New York: Oxford University Press.

Mead, M. (1969) *Coming of Age in Samoa*, Harmondsworth: Penguin Books.

Moores, S. (1988) ' "The Box on the Dresser": Memories of Early Radio and Everyday Life', *Media, Culture and Society*, 10 (1).

———— (1993a) 'Satellite TV as Cultural Sign: Consumption, Embedding and Articulation', *Media, Culture and Society*, 15 (4).

———— (1993b) *Interpreting Audiences: The Ethnography of Media Consumption*, London: Sage.

Morley, D. (1986) *Family Television*, London and New York: Comedia.

———— (1992) *Television, Audiences and Cultural Studies*, London and New York: Routledge.

Putnam, T. and Newton, C. (eds) (1990) *Household Choices*, London: Futures Publications.

———— (1993) 'Beyond the Modern Home: Shifting the Parameters of Residence', in J. Bird *et al.* (eds), *Mapping the Futures, Local Cultures, Global Change*, London and New York: Routledge.

Robins, K. (1991) 'Into the Image: Visual Technologies and Vision Cultures', in P. Wombell (ed.), *PhotoVideo: Photography in the Age of the Computer*, London: Rivers Oram Press.

Rose, G. (1993) 'Some Notes towards Thinking about the Spaces of the Future', in J. Bird *et al.* (eds), *Mapping the Futures, Local Cultures, Global Change*, London and New York: Routledge.

Rutherford, J. (ed.) (1990) *Identity: Community, Culture, Difference*. London: Lawrence & Wishart.

Sherman, B. and Judkins, P. (1992) *Glimpses of Heaven, Visions of Hell: Virtual Reality and its Implications*, London: Hodder & Stoughton.

Silverstone, R. and Hirsch, E. (eds) (1992) *Consuming Technologies*, London and New York: Routledge.

Silverstone, R., Hirsch, E. and Morley, D. (1991) 'Listening to a Long Conversation: An Ethnographic Approach to ICT in the Home', *Cultural Studies*, 5 (2).

Springer, C. (1991) 'The Pleasure of the Interface', *Screen* 32 (3).

Stephanson, A. (1989) 'Regarding Postmodernism – A Conversation with Fredric Jameson', in A. Ross, *Universal Abandon? The Politics of Postmodernism*, Edinburgh: Edinburgh University Press.

Turkle, S. (1984) *The Second Self: Computers and the Human Spirit*, London: Grafton Books.

Williams, R. (1974) *Television: Technology and Cultural Form*, London: Fontana.

Wolff, J. (1993) 'On the Road Again: Metaphors of Travel in Cultural Criticism', *Cultural Studies*, 7 (2).

Wolff, J. (1994) 'The Invisible Flaneuse: Women and the Literature of Modernity', in *The Polity Reader in Cultural Theory*, Cambridge: Polity Press.

drawing attention to
the image: computers and comics

martin barker

> *Cyberpunk started out as a genre of science fiction, but it introduced a critical mode into science fiction, put together around asking what kind of a future we're going to have. This was linked with the idea of the information revolution. It was a future that tied up with the effects of computers – the imaginative world of digital technology. It's moved on from that since then. These days the term 'cyberpunk' means, well, it's rather like the characters in the novels have moved on to play around with their own computers. All the characters were on the outside, marginalised, had a grudge. Now digital technology has become more widely dispersed. High tech has fallen into the hands of a kind of digital underground. It has brought into play a context where at the cutting edge are the Hackers. They are linked with the artists, the activists.[1]*

> *. . . Circle of Death . . . Farmers of Doom . . . The Federation . . . Feds R Us . . . Justice League of America . . . Knights of Shadow . . . Legion of Doom . . . MAD! The Marauders . . . Phlash . . . SABRE . . . Spectral Force . . . 2300 Club . . . The Warelords . . .[2]*

This essay is written in response to a number of analyses from the past few years of the new computer culture, which I find very unsatisfactory, but whose approaches have become common currency.[3] The two most obvious elements of this consensus have been, first, that computers are to be understood as a component of postmodern culture, for which older categories like 'class', and 'exploitation' are hardly relevant; and second, that the most obvious strands of digital culture – computer games, virtual reality, and cyberpunk – should be conceptualised first and foremost as gendered, about which the primary question is whether they are ineliminably masculinist, or whether there are 'gaps' for feminist appropriations. This analytic terrain is worryingly narrow and misleading – not least because of its almost wilful ignoring of the history of computers.

There is not the space here to review this literature properly. I can only draw attention to features that directly engage with my alternative account.

First, Donna Haraway's essay: this has had enormous influence. Presented as a manifesto, it contains awesome claims such as that 'our machines are disturbingly lively, and we ourselves frighteningly inert' (p. 69). The literal untruth of this has not undermined its emotional appeal – this is one sentence quoted approvingly by, for example, Claudia Springer. My concern with the

overall tendency of Haraway's argument, of which this metaphoric hyperbole is a fair sample, is that she seems to have taken on trust the emphatic opportunism of the computer systems managers of the early 1980s. Her descriptions of what cyborgs seem to be are prompted by *their image of* the machines they were trying to develop. Writing about computers has suffered enormously from self-inflation; and left-wing critics have taken on trust far too much of what the systems enthusiasts had to tell us.

Haraway's ideas got direct application to comics in Claudia Springer's essay. Springer argues strongly for the Haraway view that images of digital culture are essentially about gender, and a resexualisation of the body, driven by a crisis of masculinity. There are many grounds for questioning her account, not least that the comics she uses as evidence were marginal, of limited sales and life, and grossly untypical. This is not just an objection to the status of her evidence, but also to her conceptualisation: her essay is riddled with claims about 'popular culture's cyborg imagery' – as if it might be possible to identify, from any small sample, one view which constitutes 'popular culture'.

The problem is that these authors have an a priori agenda which over-determines their readings of their materials, without any care for their historical placement, or their generic properties. One mark of this is the tendency to abolish all mediations between image and reality, between ideology and power, and between discourses and social processes. One recent contribution reveals this very clearly: writing on William Gibson, David Tomas asserts without argument that:

> Cyborg transformations are clearly of more than topical interest in distinguishing new and emerging socio-cultural forces. The continuous manipulation, for example, of the body's ectodermic surface and the constant exchange of organic and synthetic parts can produce rewritings of the body's social and cultural form that are *directly related* to the reconstruction of social identities.[4]

This is unsatisfactory at any time, but in relation to comics it is simply bizarre, since the (multiple) imagery of computers within comics cannot be detached from the *particular production, circulation and audience circumstances of the comic book industry in this period.*

My argument is that four strands need particular attention:

1 that images of computers are not new – having been partly in place well before the microchip was created;
2 that we need to examine the patterns of production and incorporation of computers within capitalist society, if we want to explore their imagery;
3 that the images were not detached responses to their introduction, but played a necessary role in their introduction;
4 that the contrary images of, for example, cyberpunk generally, or within

comicbooks specifically, must be 'read' as partial but socially-specific responses to the perceived power of these emergent forces.

1 Any viable study of digital culture has to begin from the history of computers – not just because, in principle, image studies need historical placement, but because there are particular processes at work in this history. In fact computers were being expected, even sought for, before they ever existed. In complicated ways, prior to the development of the first significant computer in 1945, and well prior to their practical availability on a wide scale after the invention of the transistor in 1947 and its commercial availability after 1954, then of the microchip by the late 1960s, there were perceived social issues and pressures demanding their invention which had strong social and political resonances. And the moment the computer arrived, it was surrounded with questions, fears and hopes.

We can see this very clearly in any history of science fiction. For example Paul Carter's careful history of magazine science fiction recalls a debate in *Astounding* in 1943, about the difficulties of establishing and maintaining a galactic government.

> John Campbell got out pencil and paper and came up with some appalling conclusions in an editorial called 'Arithmetic and Empire' [*Astounding*, 32, November 1943]: if there were 400 million inhabited planets in this galaxy, even averaging a population of no more than a billion each, at one civil servant per million citizens, there would be 400 billion galactic federal employees! What kind of manageable-sized parliament or congress could be had, if the representative had to speak for literally billions of con-stituents? 'Has anyone any workable suggestion for a galactic govern-ment?'[5]

Yet, as Carter points out, though computers offered a possible solution with their vast capacity to handle information, few writers took that course.

Carter suggests that this was because, in this period, science fiction dissociated itself from demands for governmental control. In the 1950s, as Frederick Pohl (among others) proudly recalled, opposition to McCarthyism came from very few areas: one of those was the corpus of science fiction writers. (Another, interestingly, was a section of the comics industry, notably EC comics, hardest hit by the anti-comics campaign of 1953–6.) Instead, from the very earliest days, science fiction began to speculate about the future of computers. I want to suggest that the relation of story-forms to politics is a touch more complicated than Carter allows, and those speculations tell us important things about the relevance of computers to society. Not least is the careful *avoidance* of thinking about how and why computers came to be developed – in particular their close association with the military.[6]

It is true that few SF writers glorified the possibilities of bureaucratic computer control of the world. In fact, at first sight, most writers seem intensely ironic about the whole thing. A good example of this is Isaac Asimov, physicist and

successful SF writer. The inventor of the 'Three Laws of Robotics' (whose essence is that robots may neither cause harm, nor allow harm to be caused to, humans), in the mid-1950s he wrote two stories which sum up these tendencies. 'All the Griefs of Earth' (1957) tells of Multivac,[7] a computer given the task of regulating all human intercourse. Multivac is fed with all available human data, and is used to predict all the bad things that might happen – first, all crime. This allows human government to prevent it occurring. Then Multivac is given the task of predicting illnesses, to enable preventative treatment. One day the computer warns of an impending crime: an attempt on its own 'life'. As its terrified controllers work to try to prevent this, they only succeed in increasing the computer-predictions of the likelihood of the attack succeeding – until they slowly realise that the computer is trying to cause a self-fulfilling prophecy. At the story's end, they ask it a question: what do you, Multivac, most want in the world? 'I want to die.' The weight of human misery is too much for it.

This smilingly doleful story is interesting: it links computers with the future, and with the future of human social organisation. It is an early sign of a view of computers as potentially more alive than humans. And, as story, it plays the computer at its own game. There is an attempt to make a story-form as involuted as computer thinking was believed to be. Asimov was past master at this. His *Foundation* trilogy[8] is a tale of a super-prophetic galactic computer, around whose predictions history is to be shaped. But the tale is as 'tricky' as the predictions, as though we are being shown how to think from within the whorls of a superior mode of thought. Our pleasure is in second-guessing this subtle power of planning and control, within the story.

'The Last Question' (1956) reveals another facet. Using the same writing mode as the *Foundation* trilogy, in which prismatically we touch down on a sequence of dissociated incidents, Asimov shows us a series of people (drunkenly, or absentmindedly, or to distract the children) asking their computers: how can entropy be reversed? Each computer is more advanced than the last, but each has to answer 'Insufficient data' – until the final pan-galactic computer is left operating outside time and space with this last question to work at. After timeless time, it solves the question and makes its move. ' "Let there be light", it said. And there was light.'[9] Computer as future, as designer and creator of its own subsequent generations, as ultimate thinker and controller, as 'god'.

2 These images of computers as super-alive, as the future, were necessary to the role computers were intended to play, I want to argue.

Consider, first, the role of computers within the development of post-war capitalism. In his ground-breaking book *Labour and Monopoly Capital*, Harry Braverman had little to say about the role of computers in the de-skilling of work.[10] While he did deal with automation's tendencies to fragment work and make it meaningless, he had little to say about the evolution of robotic systems

of production, computer-design work, and the like – all the kinds of work naïvely celebrated as 'post-Fordist'.

One book that advances Braverman's argument is David Noble's study of the processes and motivations for the development of computer-controlled production systems in America after the Second World War. In 1946, the president of General Electric and later White House adviser Charles E. Wilson summed up what he saw as America's problems: 'Russia abroad, labor at home'." Noble argues that automation, and then computerisation, of production, were conscious mechanisms for undermining what elements there were of workers' control over production processes. Using case-studies from both military and civilian industries, but crucially from the 'weathercock' machine tool industries, he gives a powerful demonstration of the ways in which computers emerged as an implement of class conflict.

In a connected way, Kenneth Flamm has shown that the development of computers derived its energy not so much from creative brilliance (as the story is usually told) as from the drive of the American military for solutions to problems:

> It is important to observe that the early development of the US semi-conductor industry was driven by government funding, particularly by the military services. The original invention of the transistor at the civilian Bell labs also built in part on the foundations laid by a large government research program in semi-conductor materials, used in detectors for radar, carried over during the war. About 25 percent of the Bell labs semiconductor research budget over the period 1949–58 was funded by defense contracts, and all of the early production of Western Electric, the Bell system's manufacturing affiliate, went to military shipments. Direct grants and premium prices received from the Department of Defense paid for much of the industry's research, and funds were paid out to refine production methods and build up capacity far beyond prevailing levels of demand. As late as 1959, a congressional committee estimated that 85% of US electronics R&D was paid for by the federal government.[12]

3 From the first, the introduction of digitised procedures was accompanied by an excess of publicity. This publicity had several facets. Within political discourse, computers were the 'sunrise industries', associated with hypermodernity, with a clean future. 'Silicon Valley' became the iconic representation of the new industrial order, with which American presidents must associate themselves. This rhetoric was also full of self-glorifying predictions about the future of computers:

> … the experts were *selling*. They were in the habit of extrapolating astonishing 'megatrends' for the press, the public, the funding agencies. It was only when I applied skeptical pressure – say, with respect to machine translation, or the ability of computers to 'read' and 'summarise' a book,

martin barker

a story, a lecture – that I might finally evince an honest admission of how deucedly difficult such problems really were and how far off a solution might be.[13]

Almost without exception, the predictions were wildly exaggerated. But still they were made, and their making constructed much of the atmosphere within which computers were received.

At another level, a number of these publicists were themselves science fiction writers who were working with the American government. The most notorious case is the involvement of Larry Niven in the development of the SDI ('Star Wars' initiative) in the 1980s. In the reverse direction, at least one Presidential science adviser, Carl Sagan, has ventured into science fiction writing. In fact, these writers' involvements were a main factor leading to the first great split in science fiction, over the Vietnam War. And it was quickly to become a split not only among the writers, but between their subject matters and styles of writing.[14]

My argument is this: computers were born and introduced as forces of production. Their contribution seems to have been threefold. First, they enabled military competition to proceed apace, and the arrival of the Cold War at the end of the 1940s revved this engine almost uncontrollably. Second, they enabled the effective bureaucratisation of information, which in turn enabled massive expansion and monopolisation of commercial sectors. Third, they functioned to undermine trade union power in crucial sectors of employment through selective automation. But in all three cases, one of the enabling contributions was the representation of computers as *the good future*.[15] The imagery of computers, arguably, constitutes the imagery of American capital stripped of its overt political coating, operating like a computer virus by disguising its own intentions. Like any good virus, it hides its true nature from the body/programme into which it smuggles itself, lest counter-viral programmes begin to sniff it out.

4 And of course like real viruses, eventually antibodies begin to form and to operate. This took two connected forms: in the real world, the emergence (and demonisation) of 'hackers';[16] in the imaginary world, the emergence of cyberpunk;[17] and in the interface between those the emergence from the California Underground of ideas of computer interactivity. This last produced as its first crop the Macintosh computer, famous in its early years as a symbol of countercultural technology. Its different, user-friendly operating system, and delight in outfacing IBM, seemed to signal a break-out from the chip-bureaucracy.

The launch of the Apple Macintosh in 1978 opened up new graphic possibilities, including those for comic artists. It was also much more than that. Apple was itself product of a new political/cultural configuration. Rozsak summarises this story brilliantly, showing how the very idea of a microcomputer, and especially one which *interacted*, or seemed to interact, with its user, had its roots in a technophilic underground in mid-1970s California. Early hackers (before that

word was associated primarily with entering-and-breaking) began to meet outside the confines of the big companies:

> By the mid-1970s, small groups of these hackers had begun to meet in informal rap sessions where computer lore was freely swapped like gossip over the cracker barrel in a country store. The feel of these meetings was deliberately down-home; a self-conscious rejection of the stilted corporate style. The names told a good deal about the spirit of the times. One start-up company of the period was the Itty-Bitty Machine Company (an alternative IBM); another was Kentucky Fried Computers. Here was an ambience where scruffy and unshaven types in jeans could freely congregate to discuss the machines they were developing in attics and garages. The Homebrew Computer Club in Menlo Park … was the most colourful and productive of these funky town meetings…. It was at Homebrew that Stephen Wozniak unveiled his new microcomputer in 1977. The name he gave it – the Apple – brought a new, organic, slightly rustic quality with it.[18]

The Apple emerged from the settling embers of the old counterculture, as that turned to Whole Earth politics and dreams of small-scale electronically-bonded communities. (This utopian dream turns up elsewhere, for example in Marge Piercy's powerful *Woman on the Edge of Time*, a feminist utopia owing much more than has usually been acknowledged to this technodreaming.)[19] It certainly shook IBM deeply, not simply because of its commercial success, but because of its challenge to IBM's systems approach. IBM responded with the launch of the PC. The difference is the degree of loyalty Apple commanded, for many years. People *used* PCs, but they were Macintosh *fans*.

When (among other things) Apple Corporation proceeded to behave much as any other corporation, a second crop of social viruses emerged, in the form of small but significant networks of anarcho-technicists closely associated with ideas of cyberpunk, aiming to produce counter-information flows and propaganda. This group, and their publications such as *Mondo 2000*, have a large part in the rest of my story.

In looking, then, at digital culture, we need to hold in mind the centrality of processes of *disguise* and *mystification*.[20] But we need to be alert to the *particular differences* with comics, with their own circuit of production and consumption, genres, history and patterns of use.

Computers and comics

Comics are particularly worth considering because their intersection with computers was simply inevitable. For comics (and especially American comics) have been the medium *par excellence* for imagining near futures. Stifled by the monomaniac demands of the superhero tradition, even so a great deal of thinking

martin barker

about the directions of society has been going on. In fact, it was only the extraordinary introversion of the comics industry until the mid-1970s that delayed the response as long as it did. The transformation of the comics industry is symbolised in the creation in 1974 of the Direct Sales system. From here on, spaces quickly emerged for more complex and imaginative considerations, even if the residues of the older story-forms have been hard to shake off.[21]

Our story therefore begins in 1980, first with two one-shot giveaway comics from DC, in association with Radio Shack. The mini-computer had just arrived, and it was already being hyped as an educational tool.[22] Such hopes would fade.[23] In the first of the two comics, Superman has gone to a teacher-friend's class to introduce them to the exciting possibilities of the new TRS 80 computer. A politically correct girl and boy pair get very involved, just as Superman is called away on an emergency. But unwittingly, in rescuing people caught up in a tornado, he inhales tiny crystals of kryptonite powder that 'Major Disaster', guest villain for this episode, has seeded there. The kryptonite reduces his brain power, and when the Major announces on TV (an access that villains never have any problems with!), Superman has to call in young Sharon and Alec to do his computing for him – like, how to intersect with a falling plane in flight, how much heat he needs to evaporate a flood, and finally how to dissipate a cloud of radioactive gas into the upper atmosphere. His new pupils of course do not fail him, taking a mere 20 seconds to input all the data they need! The second comic sees Supergirl join her brother to introduce the new TRS 80 pocket computer, and then to use its modem links to enable the same two incipient computer-freaks to save her and Superman from a Lex Luthor trap.

What is interesting about these two comics is their plain preachiness. More than a third of the first, and half of the second comic is given over to an 'educational' introduction to how computers work, and what they do. The whole premiss of the stories is that computers are the new future, almost the equivalent of Superman himself in their powers – and an iron factuality and teaching rationality prevails.[24]

The second significance of 1980 is the launch of the comic *Dazzler*. *Dazzler* was the first comic produced by Marvel directly for the specialist comic shops. It was therefore produced within the nexus of the fan relationships that were developing at that time – one of whose premisses was an interest in action-adventure films, science fiction, and soon cyberpunk. *Dazzler* itself does not go far in this direction, but its success (it sold 400,000 copies) marked the start of a whole shift in Marvel and DC's publishing strategies. It also enabled many new writers and artists, and some smaller companies, to begin to make their mark, since they could now also sell direct to the shops.

In a complex set of changes, which included rising cover prices, substantial changes in the quality of paper, artwork, and general production values, one major development was a growing interconnection between comics and films.

More comic book characters were made into films. (Examples range from the obvious *Superman* and *Batman*, to the less well known *Punisher*, the *Spiderman* and *X-Men* cartoons, and the spoof *CondorMan*). It also became more common for popular films to carry a simultaneous release of a comic book version. This growing-together particularly happened for those films seen to have a teenage audience. And for these, that amalgam of action-adventure, near-future violent fantasy has been particularly potent. The general result was the rise of the cyberpunk story, to the extent that it really makes no sense to ask if RoboCop, or Terminator, or Edward Scissorhands was first a film, or a comic character.

This was cyberpunk at its lowest common denominator. In a recent Channel Four programme on Marvel Comics, one comic shop owner gave this stripped-down definition of cyberpunk:

> I've definitely noticed a cyberpunk influence, of making yourself better through machinery and prosthetics. Whereas superheroes in the past were 'I'm going to make myself better through training and dedication...', this is more about becoming disassociated from the corporal body and building on it and adding swords and guns into your arms.[25]

This is an apt summary of what he also called a 'cultish, secret society' narrative form. And it fairly describes some 70–80 per cent of most months' releases of comics over the past ten years. But these are also the run-of-the-mill products of all the production imperatives and compromises currently governing the comics industries. They are the comics most trapped within the self-enclosed world of comics fandom.

There are other 'mainstream' uses of computers in comic stories. Take, for instance, *The Twilight Zone*, the comicbook offshoot of the TV series. Issue 2 (Now Comics 1993) tells of Joyce Fernall, who creates a computer programme called 'Life'. Its purpose: to create the electronic equivalent of the primeval soup, then to allow the computer to model evolution. One night, it begins. Fascinated, Joyce becomes fixated on the unfolding process, especially after it appears that after a hectic series of changes all her new 'species' suddenly seem to be dying out. When they recover, and variegate again, she shuts herself wholly away from her world. Gradually, she realises that she herself is the object of their 'worship', is their 'god'. But then things start going wrong, as the newly dominant species starts inventing war. Joyce decides to intervene to rebalance the process. Somehow her attempts fail, or are blocked. Using her status as 'god', she delivers an outspoken message to her people, warning them not to continue. When they reject her message, she throws the off switch on the computer – and it continues running. The outcome is not at all as she intended ...

This story belongs to an older tradition of 'stranger-than-fiction' stories in which science fiction has long dabbled. Computers provide the *scenario* for the story, not its motive. But in one respect it signals an important element. The

Figure 9.1 A simple attempt to render graphically a digital encounter between human and machine. A programmer is 'wiped' by the creatures she has created in her computer. The comic was a spin-off from the TV series *The Twilight Zone*. Now Comics 1992.

clever denouement depends on the graphic rendering of Joyce being 'wiped' (Figure 9.1). There is a play here with the idea of 'manipulated images' to which I shall return.

Preaching digital morality

If the 1980 Superman comics preached a simplistic educational ethic, their right-thinkingness would soon return in subtler form. From both Marvel and DC, in particular among those sold from the news-stand, have come stories making good moral points through their association with ongoing popular figures. Good examples of these are in the main Batman series. *The Joker's Wild* (1991) sees the Joker escaping from his high-security cell, and threatening the life of Gotham City by commandeering its telephone systems, traffic controls, banking computers and general communications. Batman is abroad, so an ill-prepared Robin has to fight

alone. After a series of defeats, he outwits the Joker with the help of a laptop, a modem, and a small programme. He breaks through the barrier of drugs with which a kidnapped computer-genius has been 'persuaded' to help the Joker, by showing him a picture of his pet dog. The story is very traditional: the computer system itself is no focus of interest, only the uses (criminal or otherwise) to which it could be put. 'Hacking' is allowable only because of the enormous threat already posed to the integrity of commercial and civic life by the Joker. All corruption comes from outside the system. And of course the 'little man' wins, on the basis of lesser forces. (See 'Mind Games', described on p. 208, for another example of this kind.)

This sort of narrative moralising hardly deals in digital culture at all. And it is interesting that the *same story*, effectively, can be translated into other media or technologies. So, 'Library of Souls' (*Batman* 643, April 1993) tells of a mad librarian who murders people for their Dewey classifications – and is eventually defeated by his own books. Or 'Video Nasties' (*Batman* 597, February 1989), which has a film-maker commissioned to capture shots of Batman suffering torture for a 'snuff movie'. Inevitably each comeuppance is appropriate to the crime.

Celebrating the technology

To learn more about the cultural significance of computers, we need to look in particular at those comics produced at the margins of the big companies DC and Marvel, or at least in their 'author-controlled' divisions, Epic Comics (for Marvel), and Vertigo (for DC).

In 1985 Mike Saenz produced the first computer-generated comic, *Shatter* (Figure 9.2). *Shatter* tells of a freelance cop in a near-future world. He takes on a contract to hunt a woman who has just assassinated fifteen managers at megafirm Simon Schuster Jancovich. He soon discovers he's been set up, and the story devolves disappointingly around an idea of a fraudulent claim to be able to transfer skills between brains by injection. If the story is unconvincing, the mode of production is relevant – *Shatter* celebrated its uniqueness. Produced on a Macintosh using scanned and then altered line art, afterwards hand-painted, the comic delights in its grainy artwork.[26]

Mike Saenz's next project for Marvel's Epic label was *Crash*. It is a story of IronMan, alias Tony Stark, whose powers revolve around a high-tech suit. The suit itself has evolved during the character's time from a hulking grey armour to a tight-fitting muscle expansion body-stocking. In Saenz's story, Stark is an old man, and is selling off his technical knowledge 'for the good of the future', only gradually realising that his buyers are less than innocent. They turn out to be a group of deadly Japanese recidivists, who want to recover Japan's honour with a force of body-armoured samurai. There are curious twists in the story. Stark, being old, knows he can't defeat the emergent samurai alone, so he summons the

martin barker

Figure 9.2 Mike Saenz's *Shatter* was the first computer-generated comic, and delighted in its grainy look. First Comics 1985.

aid of a 'slave' copy of himself. This half-intelligent robot can follow digital instructions but can also act semi-independently at need. At the end, he has with its aid defeated the bad guys. The last Japanese commits suicide with a giant bomb. In the ensuing near-terminal chaos, IronMan's slave inexplicably becomes a free being. After saving Stark, it departs forever.

This story revels in technical language. It is the work of a digital DIY fanatic. Of 65 pages, no less than 10 and a half are built around a narrative monologue as the armour-computer interface is activated. A sample:

> Third layer. Kinaesthetic amplifiers, accelerant modules, adjuvant synthmuscles, chromalloy endoshield. Thermal shield, coolant matrix, EM field generators, ischiadic subsystems truss. Flex value control input and hi-res position-sensing generators, carpal, metacarpal and ante-brachial weapon effector assemblies. How does it go again? The mind … the mind.

This hymn to the future-machines is reflected also in an editorial postcript where Saenz takes his readers through the technology and software that enabled its production. 'Being a technocrat myself', Saenz writes that he chose IronMan as one of the few characters whose superheroism might become literally possible:

> I like to entertain the idea that my fascination in military technology is from an interest in powerful technology first and foremost. Superhero comics are power fantasies and utilise what I call the power riff: 'Flame on!' and 'It's clobbering time!'. The power riff is the battle cry or the declaration of power that captivates the audience. In CRASH, IronMan's power riff is the rolling techno-poetry of his sophisticated weaponry. My intent was to depict Stark as a powerful technocrat trapped in the world of his own making. If there is a lesson or moral in the story, it could be that good ideas are often perceived as 'free' to those with none of their own. The application of computer graphics to the science fiction story is intended to incise a kind of 'digital aesthetic' into the fabric of the art and story.
>
> (Mike Saenz, *Crash*, Epic Comics, 1988, p. 67)

This story reveals something that Saenz himself is not aware of; a deep *unease* about bodies and machines. There is unease implicit in Stark's having aged so much (as has Nick Fury, a bit-player in this story). There is unease in his loss of memory and uncertain control of his 'armour'. There is unease at the system failures it undergoes. And there is unease over the nature of the 'slave'. If body is a metaphor, here the metaphor is that of social power generally – and the story is double-edged in its attitude to this, offering a naïve paean to machines' power to bolster failing bodies; on the other hand querulously aware that the machines may last, but we won't. But the point is: Saenz represents *mainstream celebratory imagery* in comicbooks, not the digital underground.[27]

DC's major foray into computer comics was *Batman: Digital Justice* (Figure 9.3). Its creator, Pepe Moreno, had his roots in American punk. Ever since Frank Miller's *Batman: The Dark Knight Returns*, DC have experimented with the mythos, allowing various writers and artists to propose new scenarios for Batman's life, often as high-prestige graphic novels. Moreno's was one of these. The flyleaf introduces the book thus:

> By the end of the century, almost all of mankind lives in huge sprawling metropolises. Every facet of human existence is controlled by a vast computer system called the *Net*. Only a very few know that it, in turn, is

Figure 9.3 With a purity rarely achieved so far, Pepe Moreno sought to enact the feel of computer images on the pages of his *Batman: Digital Justice*. DC Comics 1992.

controlled by an insane entity known as the Joker, whose agenda is to dominate all life on Earth.[28]

To defeat this mad virus, a lone cop called (of course) James Gordon reactivates a computer system called Batman. In the opening pages, we follow Gordon as he begins to realise that a series of 'misadventures' in which innocent people are gunned down by Servopolice are not malfunctions or accidents, but deliberate acts of the computer. Only gradually (in terms of both plot and visualisation) does the figure of the Joker reveal itself. The story is complexly plotted and interestingly worked throughout, and has Batman able to defeat the Joker only because his programme is stored in a lone independent computer, outside the Net.

By the late 1980s, of course, the graphics capacities of the Macintoshes had developed exponentially, and the artwork to *Digital Justice* is miles ahead of *Shatter*. Even so, the graphic novel was not a great success – perhaps because it has a 'purity' both in its story-line and its graphic presentation. It is a *tour-de-force* of computer effects and of images of computer effects that lift it away from the action-adventure.

Hacking their way, the punks

I said earlier some 80 per cent of current monthly releases are influenced, in some fashion, by ideas of cyberpunk. To illustrate these, take a look at some Marvel UK releases. After several false starts (the earliest in the 1960s), Marvel has recently tried again to establish a publishing base in Britain. Its releases here have been directed to a very fannish element of readers, being devoted to narrative and visual amok. For example, *Cyberspace 3000*: this opens on a vast spaceship, big enough to have some six species in residence and religious sects operating in out-of-the-way corners, hitting a crisis. As its central computer fails, and bizarre phenomena start to happen, the ship's captain, a woman, first finds herself confronting one of the sects declaring the impending end of the world and wanting to send a few souls in advance; then, as its cliffhanger, she meets the cause of it all – the old, classic Marvel 'villain' Galactus – a behelmeted world-eater who originated in Marvel Comics in the 1960s. The presentation is a farrago of exploding panels, chaotic fight scenes and anguished faces.

The second comic, *Doom 2099*, is again centred on an old villain, Dr Doom. We meet him as a superannuated villain who has become trapped inside a vast computer programme, thrown up against old superheroes whom he thought long dead. *Wild Thing* (again, interestingly, with a female central figure) is similar – Nikki Doyle is a former games addict in a world where the games have become so powerful, they actually modify the brains of players. Now she is employed to 'rescue' addicts lost inside their games. In all these stories, in both plot and visuals,

cybernetics has become simply a source of exciting settings. The common thread is the projection of old characters into a future in which they have to survive in a cyberspace games environment, where everything is simulation. We might call them cyber-nods, without misleading.

Into the digital underground

Finally, there has been a number of comics, mini-series and graphic novels that have tried to use the *theme* of digitality, none perhaps more interestingly than *Hacker* (Figure 9.4). This DC series is remarkable for a number of things. It is written by one of the most important figures from the computer underground, Lew Shiner. It is 'authentic' in important ways. For instance, one key event in Bruce Sterling's account of the 'Hacker Crackdown' concerns document E911, property of Bell Telephone Corporation. In itself a pretty innocuous document about company organisation, it was 'hacked' from the depths of their files by a

Figure 9.4 *Hacker* is without doubt the premier association between comics and the computer underground. Its authenticity lies more in its story-line and central character than in its graphic rendering. Lewis Shiner and DC Comics 1992.

hacker keen to prove his capabilities. It was then sent around various bulletin boards, and was eventually used as the excuse for a series of police raids, seizures and prosecutions. Absurdly, Bell put a price of thousands of dollars on its value as intellectual property, when it could be bought from them for a small sum. E911 turns up within the story-line of *Hacker*, when the comic's hero, Jack Marshall, finds a series of network buddies being raided and charged with having the document on their hard disks.

Marshall is an anti-heroic hero. Stubbled, pale-faced, bad-tempered, and a loner, he lost his job with Digitronix (a not-very-fictitious lately-grown computer giant) when his brilliant but anarchistic style no longer fitted their emergent corporate objectives. At the start of the series, however, he gets called back in when the entire Pentagon/military Net goes down. First Marshall has to isolate the bug that caused the crash – along the way running into serious trouble with his old employers; then he has to try to trace the virus to its source – which turns out to be Digitronix itself; finally, he uncovers a global corporate plot to introduce surveillance via computers, which underpins such real events as the massacre in Tiananmen Square.

By and large, *Hacker* is an excellent comic. Smartly scripted and executed, it creates a real three-dimensional world of characters, plots and counter-plots. It is rich in the beliefs and mythologies of the computer underground, from which it has issued. It does have one appalling concession to its place in the DC world, when Green Lantern, one of the superheroes DC were trying to breathe new life into, guest-stars in episode 4, and then again near the end of the series. This yukky intrusion undercuts the sharp 'realism' of most of the stories. At the heart of that 'realism' is a paranoia at business corporations and their growing cyberpowers (which are all too clearly backed by some mean physical powers, too). The episodes from China are disturbing in their intensity.[29] In some ways the artwork is quite traditional, as if, because the story is so intense, the means of telling can be relatively 'quiet'.

Also relevant to this strand are some comics coming from the 'adult' publishing sector – which in comics is now coming to mean more than a measure of sexual content. These comics reveal a different response to computerisation, one which relates comics back to an older tradition in American culture: a tradition of challenging alienation and social isolation.[30] In these comics, computers provide – sometimes accidentally – new forms of interconnectivity between isolated people. *Cyberpunk* (Innovation), for example, is the future-story of Topo, a juggler in a world-wide matrix game, who is faced with having to rescue old love, Juno, whose mentality has been stripped from her body and encoded within the computer.[31] (The villain is again a corporate boss.) Issue 2 introduces itself with a quote: 'Solitude – almost the highest human bliss.' In this episode Topo rescues Juno, after a lengthy cyberbattle, by merging her mind with his own. When they surface, therefore, their minds have become fused, and a new

and unique love flowers between them. In related vein, *Interface* (Epic/Marvel) supposes a lonely band of people with ESP abilities who find themselves threatened by a giant 'corporation' to which they represent a threat. They are hunted down, but find and build links with more of their own kind – and in saving themselves, discover new forms of human relatedness.

There is something important here, which takes me back to my opening quotation. Computers are here being seen as allowing new modes of inter-connectedness of humans – and the enemy are 'faceless corporations'. This, I suspect, is a new mode of rebellion, founded on a sense of helplessness currently endemic to a section of the intellectual middle class.

Conclusion

Any estimation of the meanings of all this must begin with the admission that these comics are (*contra* Haraway, Springer and others) not all the same. It might help to see them as pulled between three magnetic poles: first, the pull of technology and a 'boyish' delight in machinery and software for their own sake. This can express itself in a number of ways. It shows itself in the fascination with the idea of computer-generated comics; or in the possibilities of recreating the *feel* of computers through the look of comics. And it shows itself in the tendency to play with the notion of machine/body interfaces. However, particularly with those comics distributed through the news-stands, older moralising and pro-tective attitudes have pushed a number of these comics towards a preachy 'don't be a hacker' morality.

The second pole is that of the comics world itself, with its current desperately tight and tense circuit between publishers, creators, distributors and fans. This is a hermetic world, dominated by simple notions of action-adventure. The influence of computers here is definitely second-order, mediated via the demands for new modes of 'realism'. If confrontations of heroes and villains can be displaced to a future in which simulations fight simulations, and thus retain conviction, that is enough reason. And if new production techniques, whether using computers or using techniques to give the 'look' of computers, can make comics look 'authored' with the style signature of their creators, that is more than enough.

The third pole is the pull of the hackers, and their chaotic Underground of magazines, bulletin-boards, anti-corporate piracy and partly radical politics. Perhaps the most important insight into the state of this world comes from Bruce Sterling, who relates a meeting in March 1991, when leading hackers (many of them in the aftermath of convictions for invasion of data-privacy, theft of intellectual property, etc.) came together with systems managers and representa-tives of the federal computer-crime squad:

> CFP [Computers, Freedom, Privacy] is a stellar gathering, with the giddi-
> ness of a wedding. It is a happy time, a happy ending. They know their world
> is changing forever tonight, and they're proud to have been there to see it
> happen, to talk, to think, to help. And yet as night falls, a certain elegiac
> quality manifests itself, as the crowd gathers beneath the chandeliers
> with their wine-glasses and dessert plates. Something is ending here,
> gone forever, and it takes a while to pinpoint it. It is the End of the
> Amateurs.[32]

But while 'hacking' itself might be turning a corner, in the heads of those who
dream of gaining a kind of freedom through entry into a world beyond rules,
nothing need change for a while. There, the 'law of the amateur', the lover of
the wild frontier, can persist a while longer.

These poles are not simplistically opposed to each other. In many ways they
can coexist quite happily. But what will exactly please those at one apex of the
triangle – because of their primary reasons for involvement – will disappoint and
irritate those inhabiting the others. The desire to feel (through) digitality may be
common to all three, but there is no single meaning to digital culture which can
encompass all their hopes, fears and desires.

So is there one general influence on comics from 'digitality'? One possible

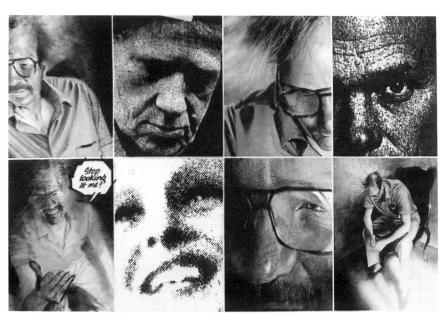

Figure 9.5 The 'look of digitality' running hand in hand with 1980s style culture:
Gaiman and McKean's *Signal to Noise*, first published in *The Face*, in which authenticity
equals appearing manipulated. Neil Gaiman and Dave McKean 1992.

martin barker

candidate seems to me a tendency we can identify within the *look* of many recent comics. There is a conviction, even a commitment among many comic producers outside the mainstream to the idea that *to be 'real', all images must look manipulated.* As a result a rising number of comics go for an intervened-on look. No image is natural. All have been tampered with. Perhaps taking their lessons from a good old politics of semiology, it's as if their authors are declaring that by wearing their interventions on their sleeve, they are saved from further political commitments. Exemplary would have to be Neil Gaiman and Dave McKean's *Signal to Noise* (Gollancz 1992) (Figure 9.5). Originally published in *The Face*, this striking graphic novel explores the thoughts and responses of a film-maker dying of cancer, dreaming his last film. With a title referring to communication theory, fascinated by issues of representation (including quoting from Roland Barthes), its artwork may be wholly painted, but it is painted to *look as if it has been digitally manipulated.* This isn't much of a politics, but it may be the most widespread single influence of digital culture on comics.

Comic-ography

The following list of comics and graphic novels dealing with computers and digital culture is far from complete, not least because there is no tidy boundary round 'computer-related comics'. It is intended to point up main examples and different kinds of comic for which computers have in one way or another been a significant influence.

Superman (DC Comics with Radio Shack): free giveaways advertising the TRS-80 Home Computer: 'The computers that saved Metropolis' (1980) and 'Victory by computer' (1981) – see text for description.

Shatter (First Comics) 1985: five issues, written by Peter Gillis and produced on computer by Mike Saenz – see text for description.

Crash (Epic/Marvel) 1988: an IronMan graphic novel written and produced on computer by Mike Saenz/William Bates – see text for description.

Hellblazer (DC Comics) no. 7, 1988: written by Jamie Delano, artwork by John Ridgway, Brett Ewins, Jim McCarthy, Lovern Kindzierski and Todd Klein. This offshoot of *Swamp Thing* focuses on John Constantine, a man who finds himself endlessly battling against forces of Darkness. In this episode, his friend Ritchie goes prospecting inside the computer net for information about a group of 'evangelists' called 'Tongues of Fire'. Their digital defences catch him, and his body (outside the computer) fries – leaving a mind trapped inside, waiting for the plug to be pulled. . . .

Batman: Digital Justice (DC Comics) 1990: story and art by Pete Moreno – see text for description.

Cyberpunk (Innovation Corporation) 1990 ongoing: written by Scott Rockwell, artwork by Darryl Banks – see text for description.

Detective Comics 618–21 (DC Comics) 1990: 'Rite of passage', written by Alan Grant, artwork by Norm Breyfogle, Dick Giordano, Todd Klein and Adrienne Roy – see text for description.

Interface (Epic/Marvel) 1990 ongoing: written by James Hudnall, artwork by Paul Johnson and Ellie deVille – see text for description.

Captain America (Marvel Comics) 1991 ongoing: Cap. has his own volunteer network of 'crime-watching computer hackers' called 'Stars & Stripes'. See for example fiftieth Anniversary edition, 'I am Legend', vol. 1, no. 383, written by Gruenwald, artwork by Lim, Bulanadi, Rosen and Christie Scheele.

Detective Comics 635–7 (DC Comics) 1991: 'Mind Games', written by Louise Simonson, artwork by Jim Fern, Steve Mitchell, John Costanza and Adrienne Roy. This mini-series counterposes the pursuit of a computer bandit who is stealing corporate funds, with the kidnapping of Tim (the new Robin)'s parents by a Haitian Obeah-man. They are paralleled by a threat of 'chaos', and by the forces of 'darkness'. The bandit turns out to be a boy-hacker, giving away the funds in the name of 'anarchy' – he is summarily stopped. The Obeah-man meantime is using the fears of the poor Haitians to scheme his own wealth and power. This is a grim story, ending with an awful death for Tim's parents.

Robin II (DC Comics), 1991: Four-part mini-series 'The Joker's Wild!', written by Chuck Dixon, artwork by Tom Lyle, Bob Smith, Adrienne Roy and Tim Harkins – see text for description.

The Hacker Files (DC Comics) 1992 ongoing: written by Lewis Shiner, artwork by Tom Sutton, Mark Buckingham and Lovern Kindzierski – see text for description.

Hard Boiled (Dark Horse) 1992: Frank Miller and Geof Darrow. A tale that circles back on itself, of a robotic tax collector programmed to use any means necessary to collect. Through mayhem, black humour and repeated destruction of his personality, he returns – to a 1950s retro-wife.

Signal to Noise (Gollancz 1992): Neil Gaiman and Dave McKean – see text for description.

The Twilight Zone (Now Comics) 1992: written by Pat McGreal, artwork by John Picha and Jay Massey – see text for description.

Cyber Force Zero (Image) 1993 ongoing: written by Marc and Eric Sylvestri, art by Walter Simonson. Stryker of Cyber-Force discovers that he and other agents have been 'programmed' by implants to exhibit uncontrolled aggression, by their 'employer', the American International Dynamic Corporation. Experiencing at close quarters their willingness to wipe out innocent parties, he turns on his employers . . .

Cyberspace 3000 (Marvel UK) 1993 ongoing: written by Gary Russell, artwork by Steve Tappin, Michael Eve, Steve Whitaker and Caroline Steeden – see text for description.

Doom 2099 (Marvel) 1993: written by John Francis Moore, artwork by Pat Broderick, John Nyberg, John Costanza and Christie Scheele – see text for description.

Wild Thing (Marvel UK) 1993 ongoing: written by Simon Jowett, artwork by Duke Mighten, Steve Whitaker and Elitta Fell – see text for description.

Notes

1 Steve Edgell of *Underground* magazine, conversation with the author, August 1993.

2 These are a selection of the names of hacker groups active in America in the late 1980s, listed from the underground Bulletin Board publication *Phrack* in Bruce Sterling's *The Hacker Crackdown: Law and Order in the Electronic Frontier* (London: Viking 1993), pp. 73–5. My selection is intended to show both the overt references to comicbooks, and a more general and delighted association with a kind of countercultural view of the world.

3 I have in mind particularly the following: Donna Haraway, 'A manifesto for cyborgs', *Socialist Review*, 1985; Claudia Springer, 'The pleasure of the interface', *Screen*, 32 (3) 1991: 303–23; Gillian Skirrow, 'Hellivision', in Colin McCabe (ed.), *High Theory/Low Culture*, Manchester: Manchester University Press, 1986.

4 David Tomas, 'The Technophilic Body: on Technicity in William Gibson's Cyborg Culture', *New Formations*, Summer 1989, pp. 113–29, this quotation p. 114 – my emphasis.

5 Paul A. Carter, *The Creation of Tomorrow: Fifty Years of Magazine Science Fiction*, New York: Columbia University Press, 1977, p. 81. See also Carolyn Rhodes's interesting essay on the early image of the computer in science fiction ('Tyranny by Computer: Automatic Data Processing and Oppressive Government in Science Fiction', in Thomas D. Clareson (ed.), *Many Futures, Many Worlds: Theme and Form in Science Fiction*, Kent, Ohio: Kent State University Press, 1977, pp. 66–93).

6 One of the reasons of course for this not being openly acknowledged was that it was deliberately shrouded in secrecy. As Kenneth Flamm says, 'historians now also

recognise a lesser known history of the computer, one whose roots run deep into the most sensitive and secret corners of a modern military establishment' (Kenneth Flamm, *Creating the Computer: Government, Industry and High Technology*, Washington, DC, Brookings Institution, 1988, p. 29) The point I am adding is that, in rather classic fashion, one of the covers for the secrecy was *an enormous amount of publicity*. The rhetorics of computers as the future, as pure research and technological innovation were the best cover the confidential world of military research could get.

7 The name 'Multivac' is an unconcealed reference to the first stored-programme computer Univac, commissioned in 1947. Note: the entire development costs of Univac were borne by the US Army and Navy.

8 Isaac Asimov, *Foundation*, London: Panther 1960; *Foundation and Empire*, London: Panther 1962, and *Second Foundation*, London: Panther 1964. The trilogy was originally written between 1949 and 1953.

9 Isaac Asimov, 'All the Griefs of Earth' and 'The Last Question', both in his *Nine Tomorrows*, London: Pan, 1966 – originally published 1957. This quotation, p. 203.

10 Harry Braverman, *Labour and Monopoly Capital*, New York: Monthly Review Press, 1974.

11 Quoted in David F. Noble: *Forces of Production: A Social History of Industrial Automation*, New York: Alfred A. Knopf, 1984, p. 3.

12 Kenneth Flamm, *Creating the Computer*, p. 16. Two examples to illustrate the kinds of relations. One of the earliest functional computers was ENIAC (the Electronic Numerator, Integrator and Computer), developed at Pennsylvania State University in 1944. ENIAC was funded entirely by the US Army, who needed a computer for the calculation of increasingly complicated artillery trajectories. Built too late to function in the war, one of the first significant uses of ENIAC was in fact to solve difficult equations on the design of the H-bomb.

One of the myths associated with the development of computers has been that of the high-powered intellects breaking away from older companies to form new cutting-edge industries. In 1954 Kenneth Olson was sent to learn by IBM lessons from the development of the SAGE (Semi-Automatic Ground Environment) computer developed for the Air Force. Leaving IBM, he formed the Digital Equipment Corporation – which by the mid-1960s was a major supplier of mini-computers to the Navy, for submarines.

13 Theodore Rozsak (*The Cult of Information: The Folklore of Computers and the True Art of Thinking*, Cambridge: The Lutterworth Press, 1986) gives many examples of this. This quotation is from p. 31.

14 See Adrian Mellor, 'Science Fiction and the Crisis of the New Middle Class', in Geoffrey Pawling (ed.), *Popular Fiction and Social Change*, London: Macmillan, 1984, and Patrick Parrinder (ed.), *Science Fiction: A Critical Guide*, London: Longman, 1979.

15 'Completed in 1943, the [IBM] Mark I was an impressive sight. It was eight feet tall, fifty-one feet long, and two feet thick, weighed five tons, used about 750,000 parts, and according to physicist Jeremy Bernstein, sounded "like a roomful of ladies knitting". At Watson's insistence – he had a keen eye for public relations – the Mark I was encased in a shiny stainless steel and glass skin that gave the machine a snazzy science fiction look and left a strong impression on the public, which got its first glimpse of the new mechanical wonder in August 1944; the future was here, courtesy of IBM'

(Stan Augarten, *Bit By Bit: An Illustrated History of Computers*, London: Unwin, 1985, pp. 105–6). A third of the money for the Mark I's development came from the US Navy.

16 For a marvellous introduction to some of the stories and issues involved, see Katie Hafner and John Markoff, *Cyberpunk: Outlaws and Hackers on the Computer Frontier*, London: Fourth Estate, 1991.

17 See in particular the work of William Gibson and Bruce Sterling.

18 Theodore Rozsak, *The Cult of Information*, pp. 141–2. Wozniak was also involved in making and selling to friends the illegal 'blue boxes' that hackers used to use the telephone systems without paying (see Augarten, p. 277).

19 Marge Piercy, *Woman on the Edge of Time*, London: Women's Press, 1979 – originally published 1976.

20 For a general argument about the role of mystification in the history of science, see Joseph Schwarz, *The Creative Moment: How Science Made Itself Alien to Modern Culture*, London: Jonathan Cape, 1992.

21 I say symbolically since the process was much deeper and had been developing since the late 1960s. Among the developments contributing to the process were the Underground Comix, with among other things their assumption of the rights of creators, the emergence of fandom and the rise of the comics shops, and the arrival of a readership who did not give up on comics at 15 years old. See, for good accounts of these processes, Roger Sabin, *Adult Comics: An Introduction*, London and New York: Routledge, 1992, and Matthew McAllister, 'Cultural Argument and Organisational Conflict in the Comic Book Industry', *Journal of Communication*, 1, 1990, pp. 55–71.

22 These hopes were expressed, typically, as part of a generalised predictive extravaganza. A good example of this is Christopher Evans's *The Mighty Micro* (London: Gollancz, 1979) which unabashedly predicts such computer-induced changes as: the reduction of the working week to 20 hours by 1990; and the virtual de-professionalisation of teaching by the same date. Such 'optimism' is at the heart of DC's super-vision.

23 See Marc S. Tucker, 'Computers in the Schools: What Revolution?', *Journal of Communication*, Autumn 1985, pp. 12–23 for evidence on these collapsed hopes.

24 There is nothing new about the use of such media for 'teaching purposes', of course. The most famous source of such 'documentaries' has to be the sequence of wartime Disney cartoons, which taught everything from identification of enemy aircraft, to how to strip and reassemble a gun. Since then, comics have been used repeatedly in America for overt propaganda, by a range of organisations including the Catholic Church, various right-wing institutes, and (more occasionally) radical organisations. For information on Disney, see among other things Richard Shale, *Donald Duck Joins Up: The Walt Disney Studio During World War II*, Ann Arbor: University of Michigan Press, 1976.

25 Brian Marshall, New York Comics store owner, in 'Marvel Comics', *Channel 4*, 21 August 1993.

26 There are contradictory stories about its success, with comic dealers reporting it sold very badly, and the publishers First Comics claiming it as one of the best-selling

comics of that year. Indeed, curiously Saenz's publishers went into print in defence of him – see Mike Gold, 'Technocomics', *The Comics Journal*, no. 101 (August 1985), pp. 94–6.

In an interesting essay, Arlen Schumer has traced the evolution of graphic styles in American comics, suggesting that recent comics have seen a growing separation of art styles from the needs of the narrative. Citing *Shatter* as one end of a spectrum running from hand-painted fine-art work, he quotes a comment from Frank Miller about his own collaboration with Bill Sienkiewicz: 'The illustrations are not really illustrations of what's going on. The narration isn't really describing what's going on, either. There's a gap there, and somewhere in the gap is reality' (cited in Arlen Schumer, 'The New Superheroes: a Graphic Transformation', *Print*, November/December 1988, pp. 112–31; this quotation p. 131). This is a valuable insight, but it has to be said that the comics are rare that so balance narrative and artwork to produce a very significant 'reality'. *Shatter* was not among those.

27 It is interesting that Mike Saenz was closely involved in one of the first commercially available examples of computer 'pornography', called 'Virtual Valerie' (see Chapter 3 above). Since then, he has been working on a computer-generated character 'Donna Matrix', whose fetishistic costume and liking for hurting men with whips is more than a little symptomatic. See Kim Howard Johnson, 'Hello, Donna Matrix', in *Comics Collector*, 37, 1993, pp. 34–6.

28 Pepe Moreno, *Batman: Digital Justice*, London: Titan Books 1990.

29 The only comparison I can find for this direct commentary is some of the stories carried by *Crisis*, the relatively short-lived offshoot of the British *2000AD*, which did indeed itself carry a powerful story on Tiananmen Square. (See issues 42 and 45, Fleetway Editions, 1990.) *Crisis* died in the end because in the eyes of too many of its readers it had abandoned story-telling for preaching. *Hacker* avoids this by its integration of these real events into the flow of the narrative.

30 See, for example, G. K. Nelson, *Spiritualism and Society*, London and New York: Routledge, 1969, and David Riesman, *The Lonely Crowd*, New Haven: Yale University Press, 1966.

31 Note that this is one of the two comics which Springer uses as the basis for her essay.

32 Bruce Sterling, *The Hacker Crackdown*, London: Viking, p. 313.

References

Asimov, Isaac (1960) *Foundation*, London: Panther.

——— (1962) *Foundation and Empire*, London: Panther.

——— (1964) *Second Foundation*, London: Panther.

——— (1966) 'All the Griefs of Earth' and 'The Last Question', in *Nine Tomorrows*, London: Pan.

Augarten, Stan (1985) *Bit By Bit: An Illustrated History of Computers*, London: Unwin.

Braverman, Harry (1974) *Labour and Monopoly Capital*, New York: Monthly Review Press.

Carter, Paul A. (1977) *The Creation of Tomorrow: Fifty Years of Magazine Science Fiction*, New York: Columbia University Press, p. 81.

Evans, Christopher (1979) *The Mighty Micro*, London: Gollancz.

Flamm, Kenneth (1988) *Creating the Computer: Government, Industry and High Technology*, Washington, DC: Brookings Institution.

Gold, Mike (1985) 'Technocomics', *The Comics Journal*, 101 (August), pp. 94–6.

Hafner, Katie and Markoff, John (1991) *Cyberpunk: Outlaws and Hackers on the Computer Frontier*, London: Fourth Estate.

Haraway, Donna (1985) 'A Manifesto for Cyborgs', *Socialist Review*, 2, pp. 65–107.

Johnson, Kim Howard (1993) 'Hello, Donna Matrix', *Comics Collector*, 37, pp. 34–6.

McAllister, Matthew (1990) 'Cultural Argument and Organisational Conflict in the Comic Book Industry', *Journal of Communication*, 1, pp. 55–71.

Mellor, Adrian (1984) 'Science Fiction and the Crisis of the New Middle Class', in Geoffrey Pawling (ed.), *Popular Fiction and Social Change*, London: Macmillan, pp. 20–49.

Nelson, G. K. (1969) *Spiritualism and Society*, London and New York: Routledge.

Noble, David F. (1984) *Forces of Production: A Social History of Industrial Automation*, New York: Alfred A. Knopf.

Parrinder, Patrick (ed.) (1979) *Science Fiction: A Critical Guide*, London: Longman.

Piercy, Marge (1979) *Woman on the Edge of Time*, London: Women's Press.

Rhodes, Carolyn (1977) 'Tyranny by Computer: Automatic Data Processing and Oppressive Government in Science Fiction', in Thomas D. Clareson (ed.), *Many Futures, Many Worlds: Theme and Form in Science Fiction*, Kent, Ohio: Kent State University Press, pp. 66–93.

Riesman, David (1966) *The Lonely Crowd*, New Haven: Yale University Press.

Rozsak, Theodore (1986) *The Cult of Information: The Folklore of Computers and the True Art of Thinking*, Cambridge: The Lutterworth Press.

Sabin, Roger (1992) *Adult Comics: An Introduction*, London and New York: Routledge.

Schumer, Arlen (1988) 'The New Superheroes: a Graphic Transformation', *Print*, November/December, pp. 112–31.

Schwarz, Joseph (1992) *The Creative Moment: How Science Made Itself Alien to Modern Culture*, London: Jonathan Cape.

Shale, Richard (1976) *Donald Duck Joins Up: The Walt Disney Studio During World War II*, Ann Arbor: University of Michigan Press.

Skirrow, Gillian (1986) 'Hellivision', in Colin McCabe (ed.), *High Theory/Low Culture*, Manchester: Manchester University Press.

Springer, Claudia (1991) 'The Pleasure of the Interface', *Screen*, 32 (3): 303–23.

Sterling, Bruce (1993) *The Hacker Crackdown: Law and Order in the Electronic Frontier*, London: Viking.

Tomas, David (1989) 'The Technophilic Body: On Technicity in William Gibson's Cyborg Culture', *New Formations*, Summer, pp. 113–29.

Tucker, Marc S. (1985) 'Computers in the Schools: What Revolution?', *Journal of Communication*, Autumn, pp. 12–23.

art and
public media

part IV

digital encounters:
mythical pasts and electronic presence

michelle henning

<div style="text-align:right">

10

</div>

On my way to the shops I am distracted by an enormous panoramic photograph. It shows a man's back, his white T-shirt and cropped hair. He leans on a fence. In the middle distance is a pick-up truck, and beyond that, mountains. The back of his neck is a sunburnt red, the rest of the image is black and white (Figure 10.1).

Is this a 'digital' image? It's hard to tell, at least for the uninitiated. Certainly, the image has been manipulated, but the red flush could feasibly have been produced using an airbrush. If it was produced on computer, this new technology is merely performing a task as old as photography itself: retouching.

Perhaps there are other manipulations, so sly that I cannot notice them. What does it matter to me? I have no interest in whether this man, his T-shirt or his truck ever existed. It is the image, its presence here, in front of me, which strikes me so forcefully.

In other words, my relationship with this particular advert seems to have little to do with its possible status as the imprint of a real scene, what Roland Barthes called the 'having-been-there' of the photograph.[1] Yet, historically, the chemical photograph's most powerful claim to truth is in its basis in an encounter with the physical world, and the idea that at a fundamental level, photography has an

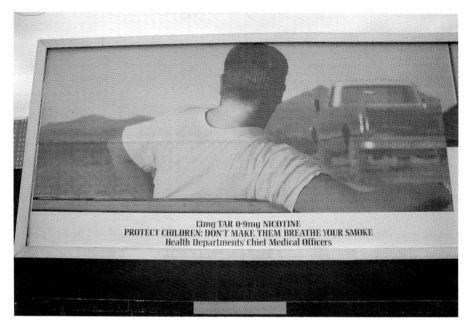

Figure 10.1 Image from the 1994 Marlboro campaign in Britain. Reproduced by permission of Philip Morris.

element which is beyond manipulation, a thread of evidence as unmediated as a fingerprint.

Even though many writers and photographers have effectively shown this truth claim to be no truth at all, and photography no more innately 'realistic' than any other medium, we may continue to feel its pull. For example, the documentary photographer Fred Ritchin described his own encounter with some advertisements on a subway train.[2] His perception of the ads and of the people around him on the train changed as he meditated on the idea that digital technology presents the possibility of photographically 'real' images of people who had 'never existed'. As the advertising images 'began to seem unreal', so too did the people who surrounded him, and he became overwhelmed by anxiety.

Ritchin's sensations may be felt but they depend nevertheless on certain assumptions about technology and a belief in the truth of the chemical photograph. The significance Ritchin attaches to the development of electronic or digital forms of representation is summed up in the term 'derealisation'. The reduction of the photographic image to numbers implies the possibility of its reversal, in other words the creation of fictional but photographically 'real' imagery (and spaces). As Gerard Raulet says, 'The significance of simulation is missed if it is seen as imitation. Simulation does not imitate; it creates.'[3]

Chemical photography, on the other hand, may have constructed reality, but

michelle henning

at least we could be reassured by the fact that ultimately the photo had resulted from an encounter with the visible world. It appeared to have some scientific truth claim, however slight. It held a mirror to reality, reassured us that our senses did not deceive us.

But in what contexts would we seek such reassurance? Is Ritchin's experience one that many would have, if familiar with the idea of digital simulation, or is it particular to someone with a certain stake in photography and its documentary functions? To answer these questions we need to take into account differences in the social functions of photography, in the content of the photographs in question, in contexts of interpretation, and use. To give a simple example of the first point, I might expect or desire that images presented to me in the news, act as a 'window on the world'. Faced with a billboard like the one I described at the start of this essay, such expectations hardly seem relevant. What is most surprising about Ritchin's account is that the photography to which he refers is advertising. Yet how common is it, in the ad-saturated West, to expect or require that advertising has the status of a document? If the questioning of the objectivity of representation has entered popular common sense and felt experience at all, it is surely in relation to advertising.

So much of what has been said about the 'digital image' seems to centre around the idea of the 'loss of the real' or 'derealisation'. Such arguments may rely to some extent on ideas of photographic truth, but, even where they don't, they rely on a belief that the main way that people interpret and engage with visual images is through treating them as documents of reality. In some versions the concept of the 'loss of the real' suggests that the user (or viewer) of computer-generated imagery will eventually lose the ability to distinguish between the 'simulated' or 'hyperreal' world and the real one.[4] In other versions, often stimulated by the 'postmodern' theories of Jean Baudrillard, we find the argument that reality has, in effect, been replaced by the world of simulation.

In some accounts then, the loss of the real is a crisis in the consciousness of an individual (often perceived as deluded or vulnerable), whilst according to the Baudrillardian account simulation is experienced as our collective 'reality', not because we are necessarily deluded or deceived, but because social interaction has been reduced to an exchange of signs unrooted in material existence.

It has often been claimed that new digital imaging technologies will precipitate radical changes in perception, in consciousness, and ultimately in society. Not only will we never see the world in the same way again, it will never be the same again. Commentary on digital technology appears to be dominated by utopian and dystopian prophecy. Utopian versions predict 'radical and liberating breaks with the past' whilst in the dystopian view 'cherished certainties are threatened and the world as nightmare is glimpsed'.[5]

Walter Benjamin wrote that 'Overcoming the concept of "progress" and the concept of "period of decline" are two sides of one and the same thing.'[6] In this

case, these prophecies are linked by a shared belief in the immense significance of recent developments in technology, or, to put it another way, what they share is a kind of technological determinism. This leads to a one-dimensional reading of social changes that ignores the social relations already in place (divisions of labour, available cultural resources) which affect not just how a technology is used or experienced, but also its emergence.

That said, I don't want simply to dismiss these arguments on such grounds, but to examine the ways in which the insertion of a new technology into existing social relations and cultural forms might be thought of in terms of transformation. I am going to do so partly through an interpretation of certain aspects of the writings of Walter Benjamin, in particular two essays: 'On Some Motifs in Baudelaire' and the famously ambiguous 'The Work of Art in the Age of Mechanical Reproduction'.[7] That this is not an unusual starting point is evidenced by the number of essays and books on electronic image/communication technologies which parody the title of the latter.[8]

However, it is precisely *because* this essay has become canonical that I wish to use it here. It is usually read as technologically determinist, and has become renowned, certainly in film studies, as a celebration of the radical potential of what was, when Benjamin was writing, the relatively new technology of film, as against older, high-cultural media (such as painting). It is this selective interpretation which is canonised, and which paves the way for the use of Benjamin's work in arguments about the electronic image.

In fact, there are many aspects of the 'Artwork' essay which would seem to militate against its use in discussions of the 'digital image' altogether. For one thing, the relationship Benjamin envisages between film technology, forms of attention, and changes in consciousness is dependent on a highly particular historical analysis of social and cultural changes in Europe. In addition, it would be surprising if essays written nearly sixty years ago could explain the digital image.

Even so, Benjamin's writings do seem useful in that they offer different ways to think about technology. Far from simply reaffirming ideas about the determining role of technology and the 'loss of the real', these writings can be used to reconsider the bases of such ideas. For my purposes, Benjamin's work offers insights into the possibility that a new technology might make certain interpretations (meanings) more available than previously; the nature of the experience of technological change; and the general possibility of a transformed perception and mode of attention in relation to new image technologies. These are the aspects which I want to explore in the remainder of this essay.

The newness of technology

In much recent discussion of computer imaging there is a tendency to focus on its newness, rather than the ways in which there might be repetition, or an

apparent continuity (of meaning or use). In order to understand exactly what *has* changed we need to pay attention to these unacknowledged aspects.

One of the things that Benjamin noted (and which I will discuss in more detail further on) is that technical newness is not always apparent, and that this would affect how we conceive of it in relation to social newness. This is one reason why I chose to describe a particular advertisement at the beginning of this essay, instead of a more spectacular and unambiguous deployment of digital imaging techniques. It seems that the very possibility of ambiguity, of the confusion of the digital image and the chemical photograph, is at the heart of arguments about 'loss of the real'. After all, what matters to Ritchin seems to be the likelihood of mistaking the digital image for the photograph.

Here, it matters that I can't be sure that this is a 'digital image', not just because I might attribute to a digital image the truth claim of photography, but because we experience new media and technologies in old and familiar contexts and not necessarily in a 'pure' form. It would be possible to gather together enough instances of this intermingling to demonstrate that what we have is not so much a digital culture, in the sense of new media overtaking and displacing old ones, as the increasing digitalisation of older media.

If a new technology cannot be conceived of in isolation, but only in relation to the means it displaces, and the media it affects, then the idea that it might be the determining factor in social changes and changes in consciousness becomes difficult to maintain. In addition, in this ad, newness and oldness are bound together, in terms of the formal aspects of the image, and in terms of what it represents. If a new manipulative process is used, it is used to take us back to an earlier form (photographic retouching); similarly the imagery is contemporary and up-to-date yet it declares at the same moment its place in a photographic tradition or genre (of images of the American West).

In these respects the moment of the arrival of the new is simultaneously a reinvention of the old, yet in reinventing it also transforms. To explain what I mean by this I want to place it in the context of more general arguments about 'revivalism', a phenomenon which can be traced back to the beginnings of modernity.

Perhaps the most influential study of the effect and uses of revivals in social change is Karl Marx's study of the circumstances leading to Louis Bonaparte's *coup d'état* in 1851, *The Eighteenth Brumaire*. Marx noted the way in which a class, in the process of revolution, dons the costumes of a past era in order to act. He recognised the danger in this kind of revivalism, amending Hegel's statement that all important historical events occur twice, by adding 'the first time as tragedy, the second as farce'.[9]

But Marx doesn't portray all such revivals as negative. Sometimes such borrowing can serve a critical function, that of 'magnifying the given task in the imagination', as in the 1789 revolution, in which the bourgeoisie deceived

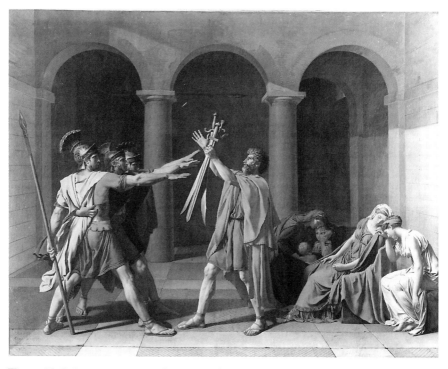

Figure 10.2 Jacques Louis David, *The Oath of Horatii*, 1785, Musée du Louvre, Paris, copyright Photo R.M.N. This painting can be read as both rhetoric and anti-rhetoric: it stands as an example of the Roman rhetoric of the French Revolution, but its stylistic awkwardness appears to have been understood by pre-Revolutionary radicals as equivalent to their own rejection of the deceptive mask of aristocratic 'style'. See Thomas Crow, *Painters and Public Life in Eighteenth Century Paris*, New Haven: Yale University Press, 1985, pp. 226–8.

themselves as to their own limitations, and through Roman costume and rhetoric were able to conceive of their actions on the 'high' plane of tragedy. However the actors of the 1848–51 revolution attempt to escape the reality of their situation through costume drama. In this farce the successful character is Bonaparte, who recognises the situation for what it is, and is able to exploit it to his own ends. But even Bonaparte mistakes fantasy for reality; 'under the Napoleonic mask' he 'imagines he is the real Napoleon' and thus becomes 'the victim of his own conception of the world'.[10]

For Marx then, revivalism can be progressive as well as farcical, although ultimately he argues that if the communist revolution is to end class struggle, then all inherited language, all borrowed costumes, are insufficient.

How does this argument about social revolution get translated into an argument about technology and its social implications? Siegfried Giedion, in

Building in France (1928), recalled Marx's observation as he described the way in which, in the nineteenth century, new building technologies emerged masked as older forms. Giedion pointed out the way in which constructions in iron and glass were veiled in stone, or imitated the styles of stone architecture.[11] But it was Walter Benjamin who brought Marx and Giedion together, joining the discussion of repetition in revolution to this observation about the 'masking' of new technologies. In doing so he related technical change to social change.

Marx had already suggested that the mechanisation of the workplace was a crucial factor in the emergence of an alienated workforce and its (self) transformation into a revolutionary class. Benjamin extended the Marxist analysis to consider the parallel emergence of leisure and the ways in which the new means of reproduction which come to occupy this space have the potential to increase alienation, but also to enable this self-transformation. For him, as for Marx, revivalism is a crucial issue. What difference does it make if people encounter these technologies, not as the absolutely new but in the form of repetitions, continuities or revivals? Benjamin distinguished between two types of repetition or reworking: one which, in returning to a distant past, de-naturalises the present, reminds us of the unfulfilled promise of earlier times; the other which smooths over change, presenting the new in continuum with the old, as the heir to what went before.[12]

So revivalism can be seen to have no *inevitable* political outcome: it can work in a positive way, enabling people to imagine how the world could be 'otherwise'; or it can work in a reactionary way, giving the impression of a 'false continuum' of history. If technical 'newness' is not immediately apparent because it is embedded in the reworking of past forms, it is also the case that the technical means of production will shape the form of this reworking – it is never simply repetition but always the 'new old'.

Mobilising technology

The significance or value of a technology is not innate but determined by the ways in which it is 'mobilised'.[13] In other words a technical development only gains meaning through the social uses to which it is put. I'm aware that certain traditional versions of this argument would take 'social uses' to refer particularly to issues of production and control, but we can take it to include the ways in which the cultural forms which employ a particular technology are used and negotiated by an audience. Theories of language and interpretation suggest that no text is firmly and inevitably fixed in its meaning; thus it is not possible to categorise one cultural text as inevitably working in this way or that, since to do so would be to assume a stable and unvarying relationship between the viewer and the image. How an object, image, film, etc. stages its relationship to the past, its place in history, is dependent not just on its own qualities or form, but on this

encounter. This isn't to say that everything is open to an infinite plurality of readings. Any form of culture offers a number of available readings, or is *more or less* available to being negotiated or used in different ways.

This idea of texts being more or less available, of 'open' and 'closed' texts, has been used to displace traditional left-wing views of culture. It can throw into question, for example, the idea that mainstream 'mass' culture is simply a vehicle for dominant ideology, whilst 'high' culture may criticise and present opposi- tional views of the world (at the price of being locked in its ivory tower).[14]

I want to take some of these distinctions, of open and closed, new and old, and map them onto the 'text' with which I began this essay. It is an advertisement. The ad, the cultural text which Roland Barthes chose to analyse because its meanings were explicit – 'emphatic' – can now be seen as highly ambivalent.[15] Taking this image as a starting point, I want to explore the relationship between the available range of interpretation and uses of an image, and the factors which determine it. In this way we might consider the relation of technical means of production, to availability of meaning. Do certain technological means offer the possibility of more or less open texts? Is there any sense in which technology can be said to determine meaning? In what follows I offer some examples of the ways in which a complex range of factors as well as technology determine the appearance of the image.

My encounter with a digital image, if this is what it is, is an everyday encounter and it occurs in a public space: the image is available to (if not addressing) all social classes. It is an advertisement for Marlboro cigarettes, a brand produced by the US tobacco conglomerate, Philip Morris. The Philip Morris company make it their business to market the American West. More precisely, they mythologise this landscape and its inhabitants: in the famous 'Marlboro Man' ads they did this through the image of the cowboy (Figure 10.3).

The current Marlboro advertisements stage their relationship to the myth of the West in more complex ways. I have mentioned that the new and old intersect on technical and formal levels as well as on the level of content: these ads declare an affinity with film, not just in the photographic style, or in terms of what is depicted but in their very shape. As with many cigarette adverts, the compulsory health warning is the means by which the type of product becomes identifiable, but it also enables certain filmic associations, changing the format of the billboard to 'cinemascope'.

The 'Marlboro man' ads were also filmic, but if they imitated the cowboy film, the new ads resemble recent art-house cinema. They allude not just to the longstanding myth of the West, but to a critical reworking of that myth. Films such as *Baghdad Café*, *Paris Texas* and *Gas, Food, Lodging* depict a landscape of borders, not frontiers, of life lived at the margins.[16] In the classic Western the myth of the West is simultaneously a myth of white male subjectivity and its relationship with an untamed nature.[17] These 'road movies' do not explicitly debunk this myth,

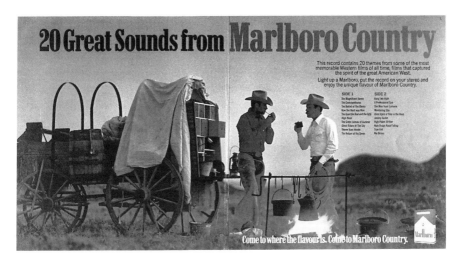

Figure 10.3 Marlboro merchandising: *Sounds from Marlboro Country*, LP, 1976. The 'Marlboro Man' is a cowboy mediated by film, so it is not surprising that the 'Sounds from Marlboro Country' turn out to be '20 themes from some of the most memorable Western films of all time'.

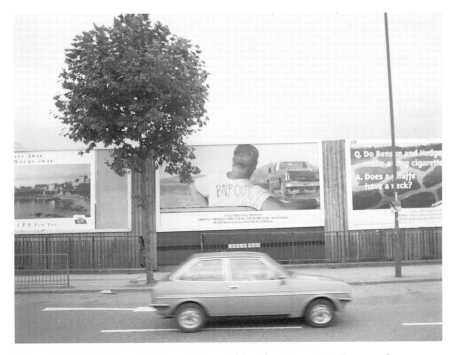

Figure 10.4 Graffiti on a Marlboro billboard (the advertisement in Figure 10.1). Photograph by John Parish, Bristol, 1993.

although it could be argued that they render its constructedness explicit.

The original Marlboro man is often used to epitomise the link between ideas of the West, ideas of white masculinity, and right-wing politics.[18] In the advertisement I've described this link is more problematic. This man's political colouring is made explicit through a visual-verbal pun: the image is retouched to make him literally a 'redneck'. The old 'Marlboro man' ads may have been more or less explicable in terms of some assumed viewer 'identification' with the cowboy, but the 'redneck' is not a contemporary cowboy. It's even possible that, in Britain, familiarity with this word is linked to a rejection of, or distance from, the political conservatism it implies (Figure 10.4). On one level this advertisement works very much in the tradition of British cigarette advertising, whereby the intended audience is distinguished by its ability to recognise the colours of the Marlboro packaging, and to 'get' the pun (i.e. by a certain knowingness about US culture as well as the Marlboro brand image).

It is possible to argue that the Marlboro ads to which I refer are relatively 'open' texts, that they allow or invite a plurality of readings, even though we know that ultimately they are promoting cigarettes. Contrast this to another version of American mythology which extends beyond the production of images to the physical transformation of the landscape. The same conglomerate, Philip Morris, finance the Mission Viejo company. This company has attempted, in the phrase of one employee, to 'fulfil the Californian Promise' in the construction and management of a pseudo-Spanish settlement in Orange county. In a familiar irony, Mission Viejo is populated by white exiles from a Los Angeles whose fastest growing population is Hispanic. This 'old mission' is a hyperreal copy of an 'original' (the Spanish Mission) mediated via an earlier 'Mission revival' (which began in the 1890s).[19]

Mission Viejo is a kind of 'hyperreality', a kind of 'simulation', although it has concrete physical form. Its 'oldness' is related to Benjamin's more negative sense: in offering a 'safe haven' of 'traditional Spanish' homes to its inhabitants, it reinforces the image of them as rightful heirs to the Spanish past. It proffers an image of 'communal harmony', and erases past and present social tensions with a wash of Californian sunshine.

As with Mission Viejo, the form of the advert, the way in which it addresses us, and the meanings produced in this encounter, are all determined not by the technological means of production alone, but by a complex range of social, economic and institutional relations and constraints. Indeed, these play a strong role in determining how/which technologies are deployed. For example, in Britain cigarette advertising on television is prohibited, and at the beginning of the 1990s, the threat of a total ban on cigarette advertising by the European Community appears to have led to a 'last-minute' boom in billboard advertising.[20]

However, it is not just law, in its actual or potential application, which plays a part in 'shaping' the ad. The orientation of capitalism toward profit demands

that companies continually seek out new markets. In the case of the cigarette companies this expansion is hampered by the association of smoking with disease and 'anti-social behaviour'. As cigarette manufacturing became increasingly considered a disreputable business, and the US market for cigarettes declined, US tobacco conglomerates have acquired subsidiaries dealing in more 'respectable' products (for example, food and pharmaceuticals). At the same time they have aggressively marketed their tobacco products amongst less affluent communities. To this end, the association of Marlboro cigarettes with the 'American dream' remains central.

The advertising agency is constrained by British law from explicitly extolling the virtues of smoking, so it has the job of turning a warning (the compulsory Government or EC Health warning) into an appeal, of making danger and discomfort attractive. Advertising since the mid-1980s has seldom conveyed a sense that cigarette smoking is relaxing. What the recent Marlboro campaigns share with the films I have mentioned is a sense of disturbance, a slight tension, a 'buzz' which almost seems to be embodied by the scenery, by the landscape itself. The grain of the images, the turbulence of the skies, contribute to this. These pictures are constructed as if they are extracts from a narrative, frozen moments of waiting or anticipation from a moving sequence of images. In addition the areas of red in each image, the sunburnt neck, a light on top of a police car, a traffic light, glow like the

Figure 10.5 Detail from another advertisement from a recent campaign. Reproduced by permission of Philip Morris.

tips of cigarettes. Smoking has taken on new meaning: in the close-ups of burning cigarettes in David Lynch's film *Wild at Heart* and here, in the Marlboro ads, it signifies the romance of living on the edge (of death).

If this is a 'digital image', it is perhaps ironic that it gains its aura or 'presence' through resembling film. I will discuss the concept of 'aura' more fully further on, for now it is worth pointing out that it is this resemblance which enables it to aestheticise a certain type of destruction, so that instead of experiencing the (possible) pleasures of smoking, we are asked to experience the dangers of smoking *as* pleasure.

Even from these brief observations it is evident that the content of the image and the uses to which different technologies are put are determined to an extent by economic imperatives. The forms that an ad might take are also affected by ideological shifts, in this case the changing meaning of smoking. However, we should also note that the changes we may observe at the levels of production and distribution (diversification, targeted markets, etc.) are more generally seen as characteristic of a shift from Fordism to 'post-Fordism' and are changes which have been enabled by the application of computer technologies.[21]

In other words, wider technological changes are related to ideological changes and changes in the availability of interpretation, but it is clear that this is not a simple one-on-one relationship. Such technical shifts can only be made sense of as part of a complex range of things which affect the image.

Digital encounters

If technology alone cannot determine shifts in meaning, it nevertheless seems that technological developments substantially change our everyday experience. From the machines in the workplace to telephones and computers in the home, to video surveillance in the shopping centre, we can see how it affects our behaviour, the ways in which we interact with one another and the ways we move.

But who is this 'we'? There is a high degree of uneven development in social modernisation. A number of writings on women's experience of modernity have debated the extent to which women's restricted access to spaces, forms of leisure and forms of labour would have meant an experience of technological change qualitatively different from that of men of the same class.[22] It's clear that modernisation would be experienced differently or to different extents according to the social position of a person. This is a consideration which so often seems missing in contemporary theories of postmodernism and of the new electronic technologies. Jonathan Crary has pointed out that,

> The inescapable yet continually evaded truth is that participation in the emerging information, imaging and communications technologies will

michelle henning

never (in the meaningful future) expand beyond a minority of people on this planet.

He adds,

> The north/south or center/periphery split (wherever these peripheries might be) needs to be examined in terms of the psychic and social hierarchies being created by the extreme disparities in the machinic arrangements that constitute everyday life.[23]

If people's experience of technological change is differentiated according to social identity, place and so on, current 'utopic' and 'dystopic' views tend not to recognise this (and the possible social consequences it might have).

Here again, Benjamin's account is useful in that it does not universalise human sense perception and 'human consciousness' in the way that the rhetoric around the digital image might suggest. In his analysis perception is differentiated, determined by changes in social and economic relations which lead to the emergence and formation of what he terms the 'historical collectives' and which I take to mean social classes. Changes in perception are merely an 'expression' of these social revolutions which have taken place.[24]

Changing forms of attention and perception

This returns us to the question of technological determinism. According to Benjamin, the new technology of film did not produce a change in perception, and hence in consciousness. Rather 'a new and urgent need for stimuli was *met* by the film' (my emphasis).[25] This 'need' Benjamin sees as a means of 'adjustment' to the 'dangers' inherent in the 'shock' experiences of modern everyday existence.

These 'shocks' are the result of changes in material reality, which do, therefore, determine forms of attention and modes of perception. He suggests that the modernisation of everyday urban experience, which involves new types of social relations and new technologies, leads to an increasing rapidity and abruptness of life. In the urban environment human sense perception has to deal with an accelerating number of shocks: the crowd jostles; the speed of the traffic produces collisions, or sudden jumps to avoid collision; technological innovations in all aspects of everyday life involve 'countless movements of switching, inserting, pressing and the like'.[26]

Amongst these movements Benjamin lists the pressing of the camera button, the snapping of the shutter. As a form of representation, film matches shock with shock: through the necessary disjointedness of editing, the shifting of viewpoints and rapid changes of scene, it provides a representational equivalent to the disjointedness of life.

Figure 10.6 Steven Marshall, *Revolver II*, collage, 1994.

So, through its physical structure cinema contributes to what Benjamin terms 'loss of aura'. This phrase has frequently been interpreted, and commonly 'aura' is associated with the ideas of genius, authorship, uniqueness and originality which are invested in the canonical works of high culture. As I suggested earlier, Benjamin's essay is used to bolster the belief that film, and now computer technology, promises the breakdown of cultural (and ultimately social) hierarchy.

Certainly this link to high culture and traditional critical categories is one aspect of the concept of aura. But I want to place emphasis on another side of 'aura', which returns to the notion of history. Whilst Benjamin's 'Artwork' essay is vague on the subject of aura, another essay 'Some Motifs in Baudelaire', links aura to the idea of memory. Here, aura is defined as 'the associations which, at home in the *mémoire involontaire*, tend to cluster around the object of a perception'.[27]

The term *mémoire involontaire* (involuntary memory) is derived from Marcel Proust. Proust described the experience of eating a certain pastry or cake – a Madeleine – and the way in which certain forgotten aspects of his childhood came flooding back upon tasting it. He uses the term involuntary memory to characterise this experience in which the past seems to be present in a material object or at least in the sensation produced in the encounter with that object.

Benjamin argued that this kind of experience of the past becomes an increasingly private and chance occurrence, as contemporary life offers fewer and fewer possibilities of producing knowledge out of experience: in other words, possibilities of using subjective experience to act upon and understand the world. He explicitly connected this change to the rise of mass reproduction (his example is the newspaper) and to unskilled factory labour (in which the worker, like the gambler, is unable to gain knowledge through experience, and can only repeat the same actions over and over again).

This account differs from the one in the 'Artwork' essay in that the idea of aura is explicitly linked with the idea of historical consciousness. However, this is not a positive consciousness of history which enables people to understand their contemporary situation. Indeed Benjamin suggests that involuntary memory is not what it appears (a genuine experience of historical continuity), 'Concerning the *mémoire involontaire*: not only do its images not come when we try to call them up; rather they are images which we have never seen before we remember them.'[28]

These images come into consciousness as the result of a defence mechanism, Benjamin uses Freudian theory to make the point: in this account consciousness provides, not a means of making sense of sensory stimulation, but a shield against it, against 'the excessive energies at work in the external world'.[29] In mastering these stimuli, which are experienced as 'shocks', consciousness protects us against trauma. If this shield is broken, and trauma does occur, we attempt to 'master

the stimulus retroactively':[30] in dreams or through recollection, we try to translate it into something manageable.

It's a difficult argument, but it seems that aura, for Benjamin, is the sensation or impression of historical experience, produced in the attempt to cushion the abrupt 'shocks' of everyday modern life. An auratic experience is one which deals with historical discontinuity by replacing it with an illusion of continuity. So when Benjamin writes of the 'loss of aura', what is 'lost' is not the real but the 'false continuum of history'.[31]

It is through enabling the 'loss' of this aura that film technology had the potential to be 'progressive'. One of its aspects that gives it this potential is the fact that it is experienced collectively, en masse. Interestingly, Benjamin argues that mass consumption increases the quality of consumption. His analysis of film is oriented around a recognition of the relationship of cinema as 'mass' enter-tainment to the 'mass' on the factory assembly line and the politics of the 'mass', Communism and Fascism.

Benjamin links the rise of the masses and increase in alienating labour to the increase in a new mode of attention. As with the shifts in perception this is not produced by film, rather film 'meets it halfway'. In other words this new mode of attention occurs in relation to all spheres of culture and everyday life, but it appears most appropriate in the cinema: it is 'distraction' or 'diversion' (Zerstreuung). Many critics of the day railed against film as merely diversionary or distracting, contrasting it to what is required of the audience by other forms of culture (the term distraction is rather misleading, as it implies a lack of absorption or involvement, whereas what seems to be at stake here is a distinction between forms of involvement rather than levels of involvement). Contemporary arguments about the over-absorption or apparent passivity of users of computer games tend to presuppose this polar opposition between distraction and concentration – in which distraction is seen as passive reception and concentration as critical engagement. Yet Benjamin argued against it. In his writing, distraction becomes a term which undoes the opposition between entertained, unthinking absorption and distanced or disinterested criticism. The collective experience of cinema can bring together these 'critical and receptive' attitudes. Through distraction, Benjamin suggests, we gain tacit knowledge and 'new tasks have become solvable by apperception'.[32]

Apart from the fact that it is experienced collectively, the aspect of cinema that most decisively contributes to loss of aura is its capacity to reproduce objects and in doing so detach them from their high cultural and distanced context and 'bring them closer'. Many writers on computer technology recognise the computer's capacity to 'bring things closer', enabling people to see and communicate across physical and national boundaries (for a different kind of 'closeness' enabled by computer technology, see Beryl Graham's essay in this volume). Benjamin sees this 'bringing closer' as a potentially empowering development, opening to

michelle henning

analysis aspects of reality which until then had been hidden to the viewer (through, for instance, the aerial view, or the frame by frame breakdown of motion). Yet the 'postmodern' analysis of digital technology comes to very different conclusions, seeing it in terms of bodily invasion, infection, schizophrenia.[33]

What are the implications of this? For Benjamin the way of thinking which erects a hierarchy between critical 'distance' (associated with 'high' culture) and the closeness and absorption which is linked to cinema-going, is useless. Social changes (most particularly the spreading of the principle of exchange to all aspects of life) have produced a sense of the 'universal equivalence of things', a demand *met* by film.[34] Film has the potential to be used as a tool for the understanding of the real conditions of existence; as stated earlier, Benjamin sees it as having a role to play in the formation of a revolutionary consciousness. Changes in forms of perception and attention are not the result of film technology, but, in Benjamin's study at least, catered for by film.

As I have suggested, in contemporary dystopian accounts the old notion of 'distance' is upheld, in so far as 'closeness' is perceived in terms of infection leading to an inability to grasp the real, or a closing of the 'gap' between representation and reality. In addition the idea of 'loss of the real' assumes that once there was a simple correspondence between representations and reality, a kind of a priori authenticity, which has somehow been lost. The concept of 'loss of aura', however, suggests that what has been lost is this illusion. Indeed the contemporary arguments can be seen as highly gendered, since the loss of the real is linked to loss of mastery and the inauthentic, as well as fear of invasion and infection, ideas historically associated with the fear of being 'feminised'.[35]

I would like to suggest that if we shift the agenda from the idea of 'loss of the real' to the idea of 'loss of aura' (in the sense I have given it), then we might move away from technological determinism and the belief in the (comparative) authenticity of the chemical photograph, to an understanding of the profound ambivalence of new technologies. The digital image, like the chemical image, has the potential to disrupt but also to reaffirm aura.

Notes and references

1 Roland Barthes, 'Rhetoric of the Image', in *Image, Music, Text*, London: Fontana, 1987, p. 44.

2 Ritchin describes this in his book, *In Our Own Image: The Coming Revolution in Photography*, New York: Aperture, 1990. I based my account on Martin Lister, 'The Living Death of Photography and Walter Benjamin's Ghost', in *Ffotofactions* exhibition catalogue, Chapter Arts Centre and Ffoto Gallery, 1993.

3 Gerard Raulet, 'The New Utopia', *Telos*, 87, 1991, p. 40.

4 See for example Kevin Robins, 'The Virtual Unconscious in Post-Photography', in

Science as Culture vol. 3, pt 1, no. 14.

5 Martin Lister, op. cit.

6 Walter Benjamin, N2,5, quoted in Gary Smith (ed.), *Benjamin, Philosophy, Aesthetics, History*, Chicago: University of Chicago Press, 1989, p. 48.

7 Both essays are in Walter Benjamin, *Illuminations*, London: Fontana, 1992.

8 See for example: Bill Nichols, 'The Work of Culture in the Age of Cybernetic Systems', *Screen* 29 (1), 1988; P. Wombell (ed.), *Photo-Video: Photography in the Age of the Computer*, London: Rivers Oram, 1991; Roger F. Malina, 'The Work of Art in the Age of Post-Mechanical Reproduction', *Leonardo*, Digital Image – Digital Cinema Supplemental Issue, 1990.

9 Karl Marx 'The Eighteenth Brumaire of Louis Bonaparte', in *Selected Works*, London: Lawrence & Wishart, 1968, p. 96.

10 ibid., p. 137.

11 Siegfried Giedion, *Building in France*, Leipzig: Klinkhardt & Biermann, 1928.

12 See Susan Buck-Morss, *The Dialectics of Seeing*, London: MIT Press, 1989, pp. 114–15; also pp. 79–80 where she argues that Benjamin was persistent in attacking mythic theories of history, and saw history as having no *inevitable* social outcomes.

13 This point is argued by John Tagg in 'Totalled Machines: Criticism, Photography and Technical Change', *New Formations*, 7, (Spring 1989).

14 Nevertheless it seems that when this concept of 'open' texts is used, it frequently reinstates canonical distinctions: the 'open' texts just happen to be those already deemed worthy of serious consideration.

15 Roland Barthes, op. cit., p. 33.

16 Respectively: Percy Adlon, Mainline/Pelemele/Pro-Ject, 1988; Wim Wenders, Road Movies/Greno, 1984; Allison Anders, Mainline/Cineville Partners, 1991. Also, the use of colour and black and white recalls Francis Ford Coppola's *Rumble Fish*.

17 According to Deborah Bright it was the cowboy movie which 'succeeded as no other form in masculinising the Western landscape', 'Of Mother Nature and Marlboro Men: An Inquiry into the Cultural Meanings of Landscape Photography', in Richard Bolton (ed.), *The Contest of Meaning: Critical Histories of Photography*, Cambridge, Mass.: MIT Press, 1989.

18 See for example the photographs of the Marlboro ads by Richard Prince. For Abigail Solomon-Godeau, Prince's work 'pointedly addresses the new conservative agenda [of the Reagan administration] and its ritual invocations of a heroic past', see 'Living with Contradictions', in Carol Squiers (ed.), *The Critical Image*, London, Lawrence & Wishart, 1991, p. 73. Richard Misrach also re-photographed a Marlboro ad which had been used as a shooting target, as part of his *Violent Legacies: Three Cantos*, Manchester: Cornerhouse, 1992.

19 Open University programme, *Los Angeles: City of the Future*, from the course D213, *Understanding Modern Societies*.

20 *Campaign* magazine, April 1993.

michelle henning

21 Robin Murray, in Stuart Hall and Martin Jacques (eds), *New Times*, London: Lawrence & Wishart, 1989.

22 Key texts on this are: Patrice Petro, *Joyless Streets: Women and Melodramatic Representation in Weimar Germany*, Princeton, NJ: Princeton University Press, 1989; Janet Wolff, 'The Invisible Flaneuse: Women and the Literature of Modernity', in *Theory, Culture and Society*, 2 (3) 1985; Griselda Pollock, 'Modernity and the Spaces of Femininity', in *Vision and Difference: Femininity, Feminism and the Histories of Art*, London: Routledge, 1988; Elizabeth Wilson, 'The Invisible Flaneur', *New Left Review*, 191, January/February 1992.

23 Jonathan Crary, 'Critical Reflections', in *Artforum*, February 1994.

24 Benjamin, 'The Work of Art', p. 216. In my reading of this section I have been helped enormously by numerous alternative translations of phrases and paragraphs, in particular those in the essays included in Smith, op. cit.

25 Benjamin, 'On Some Motifs', p. 171.

26 Benjamin, ibid., p. 171.

27 Benjamin, ibid., p. 182.

28 Walter Benjamin, from 'A Short Speech on Proust', 1932, quoted in Miriam Hansen, 'Benjamin, Cinema and Experience: "The Blue Flower in the Land of Technology"', *New German Critique*, 40, Winter 1987.

29 Freud, quoted in Benjamin, 'On Some Motifs', p. 157.

30 Freud, quoted in Benjamin, ibid., p. 158.

31 See Buck-Morss, op. cit., for an exploration of this concept in relation to Benjamin's 'Arcades' project.

32 Benjamin, 'The Work of Art', p. 233.

33 See for example Robins, op. cit.

34 Raulet relates computer technology to the principle of equivalence. He argues that in capitalism, as exchange value and use value are separated, things become 'interchangeable. Losing their particularity they become derealized', and, for Raulet, 'The computer is both the father and child of this evolution.', op. cit., pp. 41–2.

35 See for example Klaus Theweleit, *Male Fantasies*, Cambridge: Polity Press, 1989.

desert stories or
faith in facts?

ian walker

Way back in 1988, the critic Andy Grundberg, writing about 'Photography in the Age of Electronic Simulation', noted the 'wide new field of possibilities' opened up by advancing technology.[1] Architects and city planners can 'pre-visualise' their buildings on site; banks can insert holograms in credit cards to prevent fraud. But, as he noted, 'these are relatively mundane examples of future technology alive in the present; one can be sure the Pentagon has much more dramatic ones under lock and key'.

Well, it was barely three years later when that Pandora's box flew open and Desert Storm swept out. It was an event which had some immediate repercussions for rather a lot of Iraqi troops. What happened to them will be hovering throughout this essay. I want, however, to move on rather guiltily to discuss instead the implications of the Gulf War for photography as we know it. I am not alone, though, for, since 1991, anyone concerned with the subject of 'photography in the age of electronic simulation' has had to take account of what was revealed during those few weeks. And – more precisely – what wasn't revealed.

Over the last half century, we have come to expect that the 35 mm camera will bring us the intimate horror and drama of war: 'If the picture isn't good enough, you aren't close enough' (Robert Capa). And we might want that brave act of

recording to make some difference: 'Is anyone taking any notice?' (Don McCullin).² This role reached its zenith in Vietnam, and it can still operate in comparatively traditional, dirty, hand-to-hand wars like that in the 'former Yugoslavia'. But in the hi-tech 'virtual' war that was Desert Storm, the camera simply couldn't – and wasn't allowed to – get close enough to see the carnage. As William J. Mitchell has commented,

> There was no Matthew Brady to show us the bodies on the ground, no Robert Capa to confront us with the human reality of a bullet through the head. Instead the folks back home were fed carefully selected, electronically captured, sometimes digitally processed images of distant and impersonal destruction. Slaughter became a video game; death imitated art.³

Paul Virilio began his book on the Gulf War by referring to himself as 'un téléspectateur attentif'.⁴ So were we all, more or less attentive, and probably we can all still remember the dumbfounding experience of sitting in front of the television in those days of the conflict. But this was a different sort of televisual experience from that, say, of Vietnam, where the medium has been credited with changing the public perception of the war through highly editorialised commentary by respected figures such as Walter Cronkite. Instead, the Gulf War reportage consisted of three things: reports from the war-room, where the American military's version was presented verbatim, endless talking heads back in the studio standing round their sand-pit pretending they knew what was going on, and of course, most dramatically, reports from the front line, CNN in Baghdad *live*. But, as Virilio notes, the fact that all this was 'live', 'verbatim' and in 'real' time doesn't mean it was true.

For, in many ways, the journalists who were 'there' were no more 'there' than we were in front of our screens. They either sat in Saudi Arabia, attending press conferences being shown precision hits by smart bombs, or they sat on ships in the Gulf watching the Cruise missiles being fired, or they stood on their hotel balcony in Baghdad watching those missiles come down the street and turn left at the traffic lights. Or they sat in front of their television sets like the rest of us, and reported the war from there. In other words, they could not get *at* the war.

Partly, this was because of the peculiar nature of this war, covering many hundreds of miles of inhospitable terrain, and perhaps it would be different elsewhere. But it was also because this was a new type of war, in Virilio's words 'la première guerre électronique totale' – a phrase that one can take in two ways, to describe how the war was fought *and* how it was represented. Though, indeed, what was particular in the Gulf was how those two aspects were elided – the most potent images were those taken by the military themselves. And the presentation of such images to the world's media demonstrated just how well the military had since Vietnam learned the vital skill of keeping journalists exactly where they wanted them.

But what, specifically, about the role of the photo-journalist in this war? For several commentators, a note of doom was struck. Tim Druckery remembers: 'As Lt. Colonel Horner pointed to the headquarters of "my Iraqi counterpart" ... photographers in the audience raised cameras to image this *moment*.' Such information could not be questioned: 'What is played on the screen is absolute. Narrated by military spokespeople, it is information not subject to scrutiny.... Smart bombs neutralized both criticism and targets.' Never mind that we now know about, though we have never really seen and can't really quite imagine, the 'near Apocalyptic' destruction of the Iraqi army. At the time, the heat of conflict was cooled to mind-numbing euphemism, and Druckery is adamant: 'Journalism failed in the Gulf.'[5]

Or, again, Fred Ritchin, a writer more evidently sympathetic to the tradition of a socially responsible documentary photography, writing on 'The end of photography as we have known it':

> Never has 'spin control' and 'photo opportunity' been so easily embraced in the world, nor so successfully. The tradition of the war photographers ... was circumvented and very likely ended with another first – pictures seen from a bomb's point of view. The world of Robert Capa and W. Eugene Smith and Don McCullin begins to fade next to the technological wizardry of a 'smart' bomb taking its own images.... The subjectivity of the photograph – its obvious ability to bring bad news when one would rather not know – was replaced by the more trustworthy evidence from the video-guided bomb.[6]

So a consensus is arrived at: the Gulf War changed the nature of photo-journalism and its most precious tenets have been cut out from beneath it. On the one hand, the advent of digital imaging is undermining its indexical link with the real – that talismanic quality that enables us to invest so much faith in these images. On the other hand, the awkward subjective viewpoint of the individual reporter is allowed no access to material that can only be processed through official channels. (It may seem that these two qualities of traditional photo-journalism are rather contradictory. In fact, they have more often reinforced each other in an amalgam we might call 'subjective truth'.)

This view has a simple drama – a doomsday scenario for the millennium. But two other less publicized commentators have challenged that scenario, albeit from radically different perspectives. John Taylor, developing a stage further his historical examination of war photography,[7] has argued that from the Great War to the Falklands, the media have always imposed a self-censorship in the name of social cohesion and that the non-visibility of the Gulf conflict was little different.[8] The newness of the technologies involved in the Gulf War should not make us think that such control over what the public gets to see is anything new. (However, several wars of the past are now represented for us by images that were

hardly seen at the time. Do such images even exist for this war?)

When Steve Mayes, Managing Editor of the photographic agency Network, came in 1992 to put together his exhibition 'Creating Reality', he argued from a different perspective.[9] The exhibition as a whole was a potent sequence of case studies in how documentary does not (only) 'record' reality, but (also) 'creates' it. (It was a project all the more effective in that it came from the heart of the photo-journalism industry rather than from a lecturer in cultural and media studies.) As part of this, Mayes juxtaposed a sequence of images of how the Gulf War was reported (a gung-ho boys' own adventure story) with a sequence showing how it might have been (with rather more irony and scepticism).

In some cases, this was done through contextualisation. In others, it was achieved within the picture itself: one image (by the Iranian photographer Abbas) showed a soldier with a weapon on his shoulder next to a newsman with a video camera on his. Mayes was arguing that a certain sort of photo-journalism was possible in such a situation, but it would be engaged in creating an oblique commentary on the events which it could not record directly. And it would be overt in its use of all the photographic tropes which documentary photography has traditionally concealed (but which it has increasingly taken on board as part of the self-reflexivity I comment on below).

Of course, the differing accounts of Taylor and Mayes are not in fact contradictory. We might well follow Mayes's argument about the different pictures that could have been and, as he showed, in some cases were taken, while agreeing with Taylor's analysis as to why those sorts of pictures never in fact made it into the mainstream press coverage of the war. But in both cases we are still moving around what seems to be the basic problem that photographs which addressed *directly* the physical awfulness of the war were few and far between, couldn't be easily made and certainly couldn't be published. Is the 'Great Tradition' of Brady, Capa and McCullin slipping away before our eyes?

A comment by Esther Parada, a leading exponent of digital photography, is apposite here. Questioned about David Hockney's vision of the impending 'death of photography' ('We had this belief in photography, but that's about to disappear because of the computer.'),[10] she says, 'I actually welcome this development; I'd like to think that more overt recognition and discussion of the manipulation which has always been inherent in photographic representation is healthy.'[11] But then equally important is Fred Ritchin's closing lament: 'Photography becomes poetry, and those whose position is less than lyrical suffer the most. How many poems in recent years helped to affect the course of world events the way Eddie Adams's photograph of the point-blank execution of a member of the Viet Cong did?'[12]

So it seems that face to face with certain (though not yet all) contemporary events of great political import, photography has suddenly found itself in an era which we might call 'post-reportage'. 'Post' in several ways: certainly in that such

events throw the efficacy of photo-journalism into doubt, perhaps in the threat that the manipulation of these new technologies poses to the believability of the 'straight' photograph. But the use of such a term here also of course aligns this shift with a range of other 'post' phenomena, for recent documentary photography, including to an extent photo-journalism, has been affected by postmodernist, postcolonialist doubt and uncertainty. What might, then, seem a defeat from one perspective, from another can also be regarded as a necessary and positive process of self-interrogation.

I will return to such questions. There is however a final sense in which I use that term 'post-reportage', to suggest not what photography cannot do, but what it *can*: record, document what comes *after*, what has been left when the war is over. It can still speak in considered retrospect. Two years after the war, I did see some photographs of its effect. Not scattered images but a body of work, made not by a reporter but by an artist. They are by the Frenchwoman Sophie Ristelhueber, who went to Kuwait six months after Desert Storm, quite independently of any official institution or agency. Both walking and flying across the battleground, she made images of all the debris left behind: from a pair of empty boots covered in oil to the weirdly beautiful patterns of trenches and shell-craters (Figure 11.1).

Figure 11.1 Photograph by Sophie Ristelhueber from *Aftermath*, 1992.

I first saw the work in The *Guardian*, as a few cropped images accompanying a journalistic essay.[13] As I discovered later, the conventions of this format didn't really suit the images, converting them back to (somewhat ineffectual) bits of reportage. But because I knew Ristelhueber's previous work,[14] I was sufficiently intrigued to seek out more. And so I found myself experiencing the work in its primary form: buying the little book of the photographs, *Aftermath*,[15] and visiting the exhibition of the work at the Imperial War Museum.[16]

On a sunny spring day, I traverse South London on a red bus and walk through the gates of the Imperial War Museum. Passing beneath the giant naval guns that protect the museum, glancing at the piece of the Berlin Wall to the left of the entrance, I go through the grand porticoed entrance and into the main hall. It is chock-a-block full of hardware, tanks squatting below, planes swooping overhead, video screens flickering, café to the left, souvenir shop to the right, the 'Blitz Experience' straight on. I can't help but recall the building's previous role as the Royal Bethlem Hospital – Bedlam. Then, tucked away over in one corner, there is the gallery of contemporary art.

In the bare, quiet space of the gallery hang Ristelhueber's photographs, silent, formal, even dumb (Figure 11.2). After all the explication, all the activity elsewhere in the building, these images in this space have a quietly disorientating effect. Disorientating because so quiet. Though the photographs are large, they aren't

Figure 11.2 Installation of *Aftermath* by Sophie Ristelhueber in the Imperial War Museum, March–April 1993. Photograph by Ian Walker.

fetishized as individual images, but displayed unframed in blocks, sliding from black and white to colour, though the mucky colour in fact operates as an overall, slightly distasteful lack of colour. Likewise, one's eye must move from abstracted aerial shots to details of objects, long shot to close-up, tiny tanks to huge boots.

At the end of the rooms used for this exhibition hangs Sargent's huge painting, *Gassed* – blinded soldiers from the Great War, staggering along in line. Ristelhueber has incorporated the painting into her exhibition (Figure 11.3), and it is remarkably parallel to the photographs in its sandy colour and in its theme – the futile aftermath of war, the muteness after the apocalypse. But in a broader sense, Ristelhueber has made the whole Museum (its Imperial Warness) part of her exhibition.[17] Caught between Sargent's traditional image – which may be realistic but also grandiosely refers to the friezes of antiquity – and the hyperactivity of the rest of the museum, the photographs just sit there.

One wants to move into the pictures, to see what's there, but as one gets closer, they start to disintegrate, for in fact many of them are far from sharp. But then this isn't a passive experience. Such dumb yet deliberate presentation, such precise illegibility unsettles and provokes me. This stillness hangs in front of me, envelops me, and I know I will need to spend some time here. I walk away, turn around, look again. I experience the images and I experience myself experiencing them.

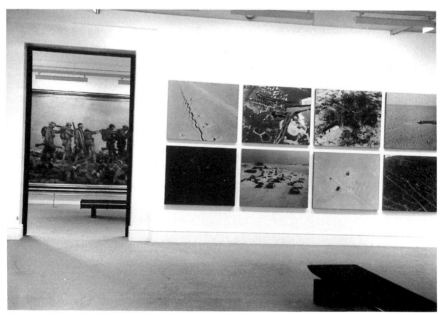

Figure 11.3 Installation of *Aftermath* by Sophie Ristelhueber in the Imperial War Museum, March–April 1993, with J.S. Sargent's *Gassed* in the far room. Photograph by Ian Walker.

They don't tell me what to think, what to feel. I work it out for myself. (Or rather don't, can't.)[18]

In a parallel experience, I was initially discomfited when I saw the book *Aftermath*. It's a small, dark volume, almost purposely designed so that one can't look at the pictures very easily. The images are small, filling the pages, demanding an intimate examination which is frustrated as the photographs are often muddy and are constantly interrupted by the book's gutter. In fact, Ristelhueber has sacrificed the integrity of the individual photographs to an overall effect of disturbance, to a questioning of the very possibility of legibility.

The physicality of our relationship with such a book is as important as that we experience in a gallery space. Pulling it off the shelf, holding it, opening it, putting it in one's pocket, are part of the same process as looking at and reading it. On the *Late Show*,[19] I heard the architectural critic Martin Pawley arguing that the new British Library building should not be a repository for actual books, but rather an opportunity to put all they contain into newer technological forms. What this ignores is the role that the very particular physical nature of a book has in inflecting, even constructing, what its contents say. (This is evidently true of books of images; it is surely in another way also true of books of words.)[20] Just a month earlier, I had had the frustrating experience in the Bibliothèque Nationale of trying to look at Surrealist publications from the 1920s on microfilm, trying to project what I was seeing back on to actual pages between actual covers.

The process of walking round an exhibition or holding a book is profoundly *interactive*. I use that word precisely, provocatively, because it has become integral to the language of new technologies. In one sense, it is merely a technical term for something that humans and computers do together. But like all such apparently neutral words, it has an ideology simmering below its surface, suggesting that other, earlier experiences are now lessened in value because they are *un*interactive. Which is nonsense. The ways in which our relationship with a computer screen can be interactive have to be emphasised because that process is itself actually rather uninteractive, one's body locked in front of the screen, one's eyes straining in its cold glow, one's hand twitching over the mouse. But let such (counter) prejudices lie. Let me merely assert that the ways in which one's mind and one's body can interact with large photographs hung on a wall or small photographs in a book remain rich, ambiguous and potent – and not at all devalued by the 'newness' of other sorts of experience.

Before I saw *Aftermath*, I wondered how these pictures could possibly compete with Werner Herzog's stunning post-Gulf War film *Lessons of Darkness*, which I'd seen a year before.[21] In Part Three of the film ('After the Battle'), a Stedicam on a helicopter floats across the same desolate landscape to the thunderous strains of Mahler. Like one of Rilke's angels, it sweeps across the desert debris and hovers above the ruins of shattered bunkers and demolished oil tanks. As always, Herzog deals here in grand metaphors, something which Ristelhueber herself resists. She

finds his film not merely dramatic but melodramatic.[22] Her photographs can't of course compete on those terms; she doesn't want them to. But they can do something different, more modest but worth attending to, something that photographs do so succinctly: provide moments of silence, caught in the uneasy space between what was experienced *there* and what is being experienced *here*.

When I saw Sophie Ristelhueber's images, they also reminded me of another body of work: the photographs made by Richard Misrach in the desert of the American West – particularly his images of the military bombing site called 'Bravo 20' and the site of 'Project W-47' where the atom bomb was developed in 1945.[23] Both Misrach and Ristelhueber deal with the scattering of clues left after an event, an event which can't itself be photographed, can't really be understood. They must work in the gap between what they see and what they know. But Ristelhueber's tactics are also very different from those of Misrach, who in his large format, immaculately crafted colour photographs remains the heir of the photographers who had previously staked out the American West. And he's angry about the despoilation of that landscape.[24] Whereas Ristelhueber, far from home, is much more dispassionate, a displaced European ironist.

Different as they are, both bodies of work point to a contemporary photographic dilemma: how to photograph that which cannot be photographed? This is not, of course, a new problem, when one remembers the much quoted statement that Walter Benjamin originally borrowed from Brecht: '. . . less than ever does the mere reflection of reality reveal anything about reality. A photograph of the Krupp works or the A.E.G. tells us next to nothing about these institutions.'[25] But an event such as the Gulf War does seem to raise the stakes here. How can an event of such global significance be so difficult to *see*?

In her survey of the post-war landscape of Kuwait, Ristelhueber may act dumb, but she isn't. It is rather that she adopts the distanced, ironic stance that is to be found throughout twentieth-century art practice. It is a sign of the ambiguous placement of her work that one of her stated sources for the aerial photographs of the desert is an image from a very different site. In 1920, in New York, Marcel Duchamp asked Man Ray to photograph the *Large Glass* covered in dust. The resultant image looked very like an aerial photograph and was ironically described as such when first published in the Dadaist magazine *Littérature*.[26] The ambiguity, the instability of Ristelhueber's imagery lies not only in the work itself – these marks on the desert, which, seen from the air, might well be an archaeological dig or even a 1970s 'earthwork' – but also in its positioning between art and documentary, neither one nor the other, or both at the same time.

Ristelhueber's original French title for the work was *Fait*. It strikes a much flatter tone than *Aftermath*, which suddenly sounds rather doom-laden and elegiac. But the resonance of *Fait* could not have been conveyed by the English 'fact', because, although the two words have the same source (the Latin *facere*: to do), the French still primarily suggests 'that which has been done' where the English

term has moved away to connote something that is rather more stable and fixed. But of course it isn't; a fact always has a cause, and one can hardly understand it without knowing how it came to be a 'fact'.

Perhaps 'evidence' is a better term (as long as we don't think of it as 'self-evident'). Here is the evidence, Ristelhueber's images seem to say; work out what happened – if you can. But this dumbness, let me repeat, is not naïvety. For it is curious that, through the 1970s and 1980s, as documentary, 'straight' photographers have strained to exploit the paradoxes of their medium by twisting it through ever more contortions, many 'artists' who use photography have done so in ways that emphasise its blunt, flat, evidential factuality, and render that apparent directness ambiguous. Ristelhueber's artfulness finally, paradoxically, rests in the documentary 'straightness' of her images.

Yet that term 'straight' is a problematic one. In the 1930s in America, it was used as a polemical term to describe the work of certain modernist photographers (Weston, Adams, Strand) and to say that is how photographs should be. There have understandably been waves of reaction against such prescriptiveness. In Europe, the term has perhaps been less fraught, merely describing a sort of photograph that isn't staged by the photographer before nor wilfully manipulated after the event. But isn't every photograph in some way constructed, every print in some way manipulated?[27] Of course it is; every photographer knows that from their own experience, for the image they make is evidently not the same as the situation they photograph. But at the same time, the image could not be as it is if the photographic process had not taken an indexical trace from that which was before the camera when the photograph was made.[28] Complex as this process turns out to be, nevertheless the distinction between 'straight' and 'manipulated' or 'staged' photography *is* still worth making, to embody a belief that finding is as valuable as making, recording as valuable as imagining.

But, while holding to that, documentary *has* changed dramatically in the last decade. In the 1970s, documentary was an honourable and straightforward area of photography to work in. Then, through the early 1980s, it was problematised almost to the point of paralysis.[29] In the last decade, however, it seems to me that the genre has re-invigorated itself by self-reflexivity, by a refusal of mastery, by an acceptance of ambiguity, fictionalisation and an ironic relationship with its own history.[30] It has, in other words, been inflected by postmodernism (though some of its practitioners might not know the concept, they would recognise the results). But some might rather say 'infected', and ask if it is possible to thus throw into doubt so many of the key concepts of photographic realism without also fatally undermining, rendering meaningless the very concept of the document, the fact.

Both Misrach and Ristelhueber, from their respective positions, have taken on board the critique of documentary of the last decade, and both know 'facts' aren't what they used to be. Facts are troublesome, difficult, unreliable. Ristelhueber

earlier studied the work of Robbe-Grillet, whose novels offer a world where the more information we have the more unreliable becomes our grasp of it, and she has quoted his epigram: 'Man looks at the world and the world does not return his look.'[31] Even Misrach, as I have suggested a more rooted photographer than Ristelhueber, has acknowledged that 'traditional genres (of photography) . . . have become shells, or forms emptied of meaning'.[32] But, moving through that, both have decided, in their different ways, that it is still possible to work with 'facts', with eyes wide open to the problems they raise, aware of one's own subjectivity at work on them, aware of the powerful political forces manipulating them. Because, in the end, it is only by studying the evidence, the 'facts of the case', that one can extend and underpin the otherwise undevelopable tenets of that subjective response to the world. And only thus can any sustained challenge be mounted to the structures which those political forces build over the facts: structures they call 'normality'.

To put it too epigrammatically, it is still worth acquiring a 'faith in facts' (remembering that faith should always be something to grapple with and not a blind acceptance). I use that phrase of course to echo and counter Umberto Eco's *Faith in Fakes*, a phrase which might be taken to exemplify the (again the summing up here must be too simple) postmodern idea that we are coming to live in a state of 'hyperreality' (*Travels in Hyperreality* was the other title of that book),[33] surrounded by screens of information and pleasure that cut us off, divorce us from that we have called 'reality' up to now: you know, that messy place where foreigners get killed by our bombs and the land poisoned by our waste.

To step sideways for a moment and consider a development in another field which yet offers a remarkable parallel to the issues I've here been trying to explicate in terms of images: on the eleventh of January, 1991, Jean Baudrillard published an article claiming that the Gulf War would not happen.[34] Then it happened and Baudrillard wrote another article stating that 'La guerre du Golfe n'a pas eu lieu': The Gulf War has not taken place.[35] Baudrillard's argument on one – let us call it the acceptable – level is hardly to be argued with: that the screen of media interference and state control through which we viewed the war has made it difficult to judge what happened. To push it closer to the edge, one might say that we can't judge, that we can't know indeed whether the war took place or not. To go all the way over that edge with Baudrillard: therefore the war may as well not have taken place, therefore we might say that it didn't.

Well, one might call this a typical piece of French intellectual excess, pushing a proposition as far as it will go until it drops dead from absurdity.[36] But Baudrillard's excessiveness enraged at least one writer on contemporary theory, the deconstructionist scholar Christopher Norris, who responded with his own extended polemic, *Uncritical Theory: Postmodernism, Intellectuals and the Gulf War*.[37] A good deal of Norris's invective goes beyond the scope of this essay, concerning itself with an attack on the reluctance of 'postmodern' philosophy to engage with traditional

philosophical questions of truth and value, indeed to even admit that such categories have meaning in the late twentieth century.

But the dilemma that Norris outlines has a broader resonance – how to acknowledge that this war was quite hidden from view by a screen of disinformation while still believing in the importance of cutting through that screen to find out what *actually* happened. He tellingly refers to an article by Dick Hebdige, which begins by endorsing a Baudrillardian vision of 'the most thoroughly mediated war in history': 'In this screened space anything can happen but little can verified.' But Hebdige, unlike Baudrillard, goes on to see in this not inevitability but malaise: 'the world's first screened war has placed a mirror at our disposal. In it we can see reflected the ecological, psychological, spiritual damage and the massive human waste of this war.'[38]

Cut to a fine image. It's not true to say that there were no photographs of dead bodies from the Gulf War. One at least sears the memory: an Iraqi soldier inside his tank, burnt to a dusty cinder, his mouth a ghastly grin (Figure 11.4). It was printed in the *Observer* and raised a minor scandal over whether or not it should have been published.[39] I guess we don't want to see such things. Because we – still – believe them. I find I *can* look at that face because it doesn't look real (it looks – another little irony – like a piece of desert landscape).[40] But I am unnerved

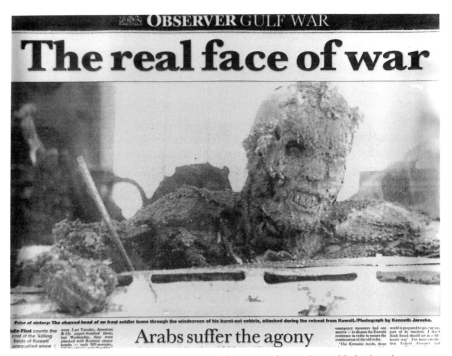

Figure 11.4 *The Real Face of War.* Photograph by Kenneth Jarecke, published in the *Observer*, 3 March 1991.

because I know it *is* real. And I am moved because he (it?) stands for all the other dead Iraqis we don't have images of.[41] For all these reasons – its unique position in regard to this war, its combination of a direct factuality with a haunting 'otherness' – this photograph escapes from that general malaise identified by (among others) Susan Sontag: the law of diminishing returns, whereby the more atrocity pictures we see, the less they affect us.[42]

I don't know if, when a Gulf War happens again in fifty years' time, such an image will still have that power. Anyone who does claim to know is giving voice to desire, not knowledge. I suppose it *is* likely that this will be the very sort of image whose status will have been affected by advancing technology. But bodies will still be mutilated and destroyed in war – it's unlikely we will have put an end to that – and if we don't have images that get as close as they can, and voices that ask 'Is anyone taking any notice?', how will we be able to think about them? I guess we will find a way. I guess we will have to.

The desert stretches beyond this text, both a potent reality and a potent symbol. For Richard Misrach, the 'severity of the landscape sets cultural artifacts off in dramatic relief. The paucity of life there … is a reminder of how fragile human existence is.'[43] Thus, the desert can stand for an extreme reality, where things are clearer, purer, more sharply focused. For Baudrillard, however, the desert seems to represent an ultimate 'hyperreality': 'The desert of the real itself',[44] unknowable, unfathomable, a seductive but dangerously ambiguous space. Is that a fact out there or a mirage? A real stealth bomber, a real dead soldier or a series of flickering hallucinations? The desert turns out to be as fraught and uncertain a place as our own lived-in landscape. But just because we can't tell what's real and what's a mirage doesn't mean that all we can do is close our eyes and pretend there's nothing there.

Flashback: another final image, this one back in history. In 1855, at Balaclava in the Crimea, Roger Fenton photographed the 'Valley of the Shadow of Death', an undistinguished place, almost a non-place littered with cannon balls.[45] Perhaps this is not the picture Fenton wanted to take, but the one he *could* take with his mid-Victorian technology. All the same, it is a great war photograph with its own chill fascination, placed against the mythologising hyperbole of Tennyson's poem. But what if that was the only sort of war photograph we had? We have needed the images of Brady, Capa and McCullin *and* we have needed those of Fenton, Misrach and Ristelhueber. If we aren't careful, the argument between artist and journalist here will be like the two men in one of Goya's black paintings battering each other to death as they sink irrevocably into the mud.

In this respect, we seem to have advanced little from Adorno's description of advanced art and mass culture as 'torn halves of an integral freedom, to which however they do not add up'.[46] Much as one may revel in popular culture, it does seem, in general, that Adorno was right to be suspicious of the possibilities it has

offered for transformation rather than confirmation. For what has been popular about it has not been in its making but in its consumption. The present advent of 'interactive' media in turn offers little advance in this respect, for most of the examples given that tag are no more genuinely two-way than a Hollywood blockbuster. You may interact with them, on their terms, but you can't make them interact with *you*, on yours.

It may seem that the interaction offered by an artwork in a gallery context is no greater. But, in fact, its terms are rather different. The image on the gallery wall (or in the pages of an artist's book, like *Aftermath*) offers a subjective contemplation rather than instant gratification. It offers a sidelong series of feints that may be more effective than a more aggressively direct address once they are engaged. As long as they *are* engaged. And that, of course, is the rub. For this work appears in sites (books and galleries) that are at present comparatively removed, some would say elitist. Nevertheless, they continue to be sites of great potential, and not only as refuges from the world that whirls by outside. Their relationship with that 'outside' can also have an important critical dimension.

Such ambiguity can of course be frustrating. But one way such work can connect is by its placement within a more public context. Ristelhueber's *Aftermath* is powerful enough in itself; within the framework of the Imperial War Museum, that effect was redoubled. In the visualisation of a dramatic but problematic event like the Gulf War, work such as Ristelhueber's offers, directly, plainly even, a polemical view of those events which, at the same time, does not betray their essential difficulty. It keeps asking awkward questions, without pretending that the answers are easy or reassuring. In a world of glowing screens and flying logos, the persistence of a stilled presence may yet prove rather valuable.

Notes

1 Andy Grundberg, 'Photography in the Age of Electronic Simulation', *Crisis of the Real*, New York: Aperture, 1990, pp. 222–9. A note indicates that the essay was originally written in 1988 for Polaroid's *Close-Up* magazine, but was unpublished at that time.

2 This is the title of one of McCullin's books of war photographs (Cambridge, Mass.: MIT Press, 1971).

3 *The Reconfigured Eye: Visual Truth in the Post-Photographic Era*, Cambridge, Mass.: MIT Press, 1992, p. 13.

4 *L'écran du désert: chroniques de guerre*, Paris: Galilée, 1991, p. 11.

5 Tim Druckery, 'Deadly Representations, or Apocalypse Now', *Digital Dialogues*, *Ten-8*, vol. 2, no. 2, 1991, p. 18.

6 'The End of Photography as We Have Known It', in *Photovideo: Photography in the Age of the Computer*, ed. Paul Wombell, London: Rivers Oram Press, 1991, p. 11. Ritchin has also written on contemporary Latin American photography and the work of Sebastiao

Salgado. His book *In Our Own Image: the Coming Revolution in Photography*, New York: Aperture, 1990, is a previous discussion of the present subject from a viewpoint sympathetic to the documentary tradition.

7 *War Photography: Realism in the British Press*, London and New York: Routledge, 1991.

8 John Taylor, 'Editing the Truth', *Professional Photographer*, April 1992, p. 13.

9 'Creating Reality' was shown at the Canon Image Centre and the University of Brighton in 1992 and at the National Museum of Photography in Bradford and Picture House, Leicester in 1994.

10 The original source for this comment is an interview with David Hockney by William Leith, *Independent on Sunday*, 21 October 1991.

11 Esther Parada interviewed by Trisha Ziff (who also selected the Hockney quotation), 'Taking New Ideas Back to the Old World', *Photovideo*, p. 132.

12 'The End of Photography as We Have Known It', p. 15.

13 The *Guardian Weekend*, 30 January 1993, pp. 16–18, with text by Edward Pearce. There was also an essay by Mark Holborn, 'Leaving Scarred Earth', in the *Independent on Sunday*, 21 February 1993, pp. 10–12, where the photographs were reproduced more effectively in blocks and were placed by Holborn in the context of an account of war photography. I did not however see this until rather later.

14 In particular, the images in her previous book, *Beirut*, London: Thames & Hudson, 1984, which, while more traditional, likewise ambiguously record the scars of war left on a place.

15 Published in Britain by Thames & Hudson, London, 1992.

16 Shown there 10 March–25 April, 1993. The present essay has been developed from a short review of this exhibition in the magazine *Untitled*, Spring 1993, p. 14.

17 The exhibition must have looked rather different in a previous incarnation at the Centre National d'Art Contemporain de Grenoble (26 September–15 November 1992) where it was shown at the same time as the work of Barbara Kruger.

18 The impassivity of Ristelhueber's display was in contrast to the effect of a previous exhibition of Gulf War art at the museum: the large and powerful expressionist paintings of John Keane, one of which included Iraqi family snapshots found on the Basra road. See the catalogue: John Keane, *Gulf*, text by Angela Weight, London: Imperial War Museum, 1992.

19 28 September 1993.

20 A more detailed discussion of this issue is to be found in Geoffrey Nunberg, 'The Places of Books in the Age of Electronic Reproduction', *Representations*, 42 (Spring 1993), pp. 13–37.

21 *Lessons of Darkness* (original title: *Lektionen in Finsternis*) was shown on BBC2 on 29 February 1992 in the documentary series *Fine Cut*.

22 This and other comments herein come from a conversation with Sophie Ristelhueber in Paris, 13 September 1993.

23 See Misrach's books, *Bravo 20: The Bombing of the American West*, Baltimore: Johns Hopkins University Press, 1990 and *Violent Legacies: Three Cantos*, Manchester: Cornerhouse, 1992: 'Desert Canto IX: Project W-47 (The Secret)'.

24 For a polemical and political reading of Misrach's work, see Mike Davis, 'Dead West: Ecocide in Marlboro County', *New Left Review*, no. 200, July/August 1993, pp. 49–73.

25 Walter Benjamin, 'A Small History of Photography', in *One Way Street*, London: New Left Books, 1979, p. 255 (translation by Kingsley Shorter).

26 Issue no. 5, 1 October 1922. It was titled 'Vue prise en aéroplane par Man Ray – 1921'.

27 For a development of this argument, see Joel Snyder and Neil Walsh Allen, 'Photography, Vision and Representation', in Thomas F. Barrow, Shelley Armitage and William E. Tydeman (eds), *Reading into Photography*, Albuquerque: University of New Mexico Press, 1982, pp. 61–91.

28 On the conflicting claims for the 'indexical' and 'arbitrary' nature of photographic language, see Terence Wright, 'Photography: Theories of Realism and Convention', in Elizabeth Edwards (ed.), *Anthropology and Photography 1860–1920*, London: Yale University Press/Royal Anthropological Institute, 1992, pp. 18–31.

29 The key critique of documentary photography was Martha Rosler's (much referenced) 'In, Around and Afterthoughts (On Documentary Photography)', originally published with her work *The Bowery in Two Inadequate Descriptive Systems*, in *Martha Rosler: Three Works*, Halifax: Nova Scotia College of Art and Design Press, 1981, and reprinted in Richard Bolton (ed.), *The Contest of Meaning*, Cambridge, Mass.: MIT Press, 1989. (In later essays, Rosler herself has emphasised that she is looking for a re-positioning of documentary rather than its destruction. See 'Some Contemporary Documentary', *Afterimage*, Summer 1983, pp. 13–15).

30 The best examples of this work are to be found in photographic books (the book has always been the most complex of photographic sites), such as Gilles Peress, *Telex Iran*, New York: Aperture, 1984; Paul Graham, *Troubled Land*, London: Grey Editions, 1987; Julian Germain, *Steel Works: Consett – From Steel to Tortilla Chip*, London: Why Not Press, 1990; Larry Sultan, *Pictures from Home*, New York: Abrams, 1992. A discussion of this shift is in the special issue of *Perspektief* magazine: 'Repositioning Documentary Photography', no. 41, May 1991.

31 Her quotation is in turn quoted by Jérôme Sans in his text that accompanied the exhibition of *Fait/Aftermath*.

32 Melissa Harris, 'Postscript: An Interview with Richard Misrach', in *Violent Legacies*, p. 90.

33 In Britain, the book was published in hardback as *Faith in Fakes*, London: Secker & Warburg, 1986, and in paperback as *Travels in Hyperreality*, London: Picador, 1987.

34 'The Reality Gulf', the *Guardian*, 11 January 1991.

35 *Libération*, 29 March 1991.

36 There is an ironic little detail here, for in Britain, the Baudrillard books published by Verso (*America*, *Cool Memories* and *The Transparency of Evil*) all have Richard Misrach photographs on the cover! Perhaps their calm lucidity is intended to balance the fevered overdrive of the texts they enclose. (An intriguing parallel was also drawn between Ristelhueber's earlier work on Beirut and Baudrillard's writings by Ian Jeffrey, *Creative Camera*, no. 239, November 1984, p. 1609.)

37 London: Lawrence & Wishart, 1992.

38 Norris, ibid., pp. 123–5. Hebdige's article 'Bombing Logic' was originally published in *Marxism Today*, March 1991, p. 46.

39 The photograph – by Kenneth Jarecke – was published in the *Observer*, 3 March 1991. On the controversy, see the *British Journal of Photography*, 14 and 21 March 1991, p. 4 in each issue. A colour version of the image is reproduced in *World Press Photo: Eyewitness, 1992*, London: Thames & Hudson, 1992, p. 63.

40 Ristelhueber herself has made this connection and has more recently been photographing wounds on the human body which parallel the 'wounds' she photographed in Kuwait.

41 I'm grateful here to photography students at Newport School of Art for their comments on this work. This particular comment was made by Chris Cox and has stuck in my mind. Sarah Pascoe's paper 'Blood Money' was also very useful.

42 Susan Sontag, *On Photography*, New York: Farrar, Straus & Giroux, 1977, pp. 19–21. Tony Harrison made this Iraqi soldier the central character of his poem *A Cold Coming*, Newcastle: Bloodaxe Books, 1991. It was also a final object of discussion in Kevin Robins and Les Levidow, 'The Eye of the Storm', *Screen*, 32(3), Autumn 1991, pp. 324–8.

43 Melissa Harris, p. 84.

44 'The Precession of Simulacra', in *Simulations*, New York: Semiotext(e), 1983, p. 2. Baudrillard's most extensive writing on the desert is in *America*, London: Verso, 1988.

45 See Valerie Lloyd, *Roger Fenton*, London: South Bank Centre, 1988, cat. 58.

46 Letter to Walter Benjamin, 18 March 1936, in Ernst Bloch *et al.*, *Aesthetics and Politics*, London: Verso, 1980, p. 123. Adorno is here critiquing Benjamin's own view of the revolutionary potential of (then) new technologies in 'The Work of Art in the Age of Mechanical Reproduction'.

index